Stupid TV, Be More Funny

Stupid TV, Be More Funny

HOW THE GOLDEN ERA OF THE SIMPSONS CHANGED TELEVISION—AND AMERICA—FOREVER

Alan Siegel

GRAND CENTRAL

New York Boston

Copyright © 2025 by Alan Siegel

Cover design by Micah Kandros. Cover copyright © 2025 by Hachette Book Group, Inc.

Hachette Book Group supports the right to free expression and the value of copyright. The purpose of copyright is to encourage writers and artists to produce the creative works that enrich our culture.

The scanning, uploading, and distribution of this book without permission is a theft of the author's intellectual property. If you would like permission to use material from the book (other than for review purposes), please contact permissions@hbgusa.com. Thank you for your support of the author's rights.

Grand Central Publishing
Hachette Book Group
1290 Avenue of the Americas, New York, NY 10104
grandcentralpublishing.com
@grandcentralpub

First Edition: June 2025

Grand Central Publishing is a division of Hachette Book Group, Inc. The Grand Central Publishing name and logo is a registered trademark of Hachette Book Group, Inc.

The publisher is not responsible for websites (or their content) that are not owned by the publisher.

The Hachette Speakers Bureau provides a wide range of authors for speaking events. To find out more, go to hachettespeakersbureau.com or email HachetteSpeakers@hbgusa.com.

Grand Central Publishing books may be purchased in bulk for business, educational, or promotional use. For information, please contact your local bookseller or the Hachette Book Group Special Markets Department at special.markets@hbgusa.com.

Print book interior design by Marie Mundaca

Library of Congress Cataloging-in-Publication Data

Names: Siegel, Alan, author.
Title: Stupid tv, be more funny : how the golden era of the Simpsons changed tv-and America-forever / Alan Siegel.
Description: First edition. | New York : Grand Central Publishing, 2025. | Includes index.
Identifiers: LCCN 2024060281 | ISBN 9781538742846 (hardcover) | ISBN 9781538742860 (ebook)
Subjects: LCSH: Simpsons (Television program) | LCGFT: Television criticism and reviews.
Classification: LCC PN1992.77.S58 S46 2025 | DDC 791.45/72—dc23/eng/20241227
LC record available at https://lccn.loc.gov/2024060281

ISBNs: 978-1-5387-4284-6 (hardcover), 978-1-5387-4286-0 (ebook)

Printed in Canada

MRQ-T

1 2025

To Julie, for always giving me the push that I need.

CONTENTS

Introduction — 1

CHAPTER ONE: Smashing the Snow Globe — 7

CHAPTER TWO: Breaking Through the Clouds — 17

CHAPTER THREE: The American Family in All Its Horror — 35

CHAPTER FOUR: So Stupid It Was Kind of Smart — 53

CHAPTER FIVE: Limitless, Limitless, Limitless — 65

CHAPTER SIX: Bart vs. Commerce — 91

CHAPTER SEVEN: Bart vs. Bill — 107

CHAPTER EIGHT: Bush v. Bart — 137

CHAPTER NINE: Beyond Bart — 161

CHAPTER TEN: How Not to Screw Up *The Simpsons* — 179

CONTENTS

CHAPTER ELEVEN: Worst Episode Ever 193

CHAPTER TWELVE: The *Simpsons* Diaspora 213

CHAPTER THIRTEEN: *Simpsons* World 229

Acknowledgments 249
Notes 255
Index 273

Stupid TV, Be More Funny

INTRODUCTION

"WHO WOULD HAVE GUESSED READING AND WRITING WOULD PAY OFF?"
— HOMER SIMPSON

This story begins in that unforgettable spring of 1990. The Cold War was finally coming to an end. America was on the verge of a crushing recession. And NASA was receiving the first mind-blowing photographs from the Hubble Space Telescope.

Alas, I knew nothing about any of that.

Back then, I was a first grader in suburban Boston. The intricacies of the world's sociopolitical climate would have to wait. I was way too busy collecting Wade Boggs baseball cards, watching *Teenage Mutant Ninja Turtles*, and playing *Super Mario Bros. 3* on Nintendo. I was also just starting to hear about a new animated TV series called *The Simpsons*. At school, it seemed like all my classmates were wearing Bart Simpson T-shirts over their billowy Z. Cavaricci pants.

The primetime cartoon had begun as interstitial shorts on *The Tracey Ullman Show*, a sketch comedy series that aired on Fox, which in those days was still a fledgling network. Even without really knowing what the show was about, it didn't take long for me to succumb to peer pressure. I asked my parents if I could watch. My dad had gone to Woodstock and managed a band in the '70s. My mom loved movies and TV and celebrity gossip. They weren't prudes. But

before giving me the green light, they wanted to see *The Simpsons* for themselves.

None of my friends seemed to know that the series was made for adults, not children. In the episode my mom and dad recorded on a VHS tape, Bart snaps a photo of Homer canoodling with a belly dancer at a bachelor party. Marge finds out, and then temporarily kicks him out of the house. Unluckily for me, "Homer's Night Out" was the most risqué thing the sitcom had done to that point.

The titular character eventually learns an important lesson: it's wrong to treat women as sex objects. My liberal folks surely appreciated the message, but they decided that the sight of a half-naked lady named Princess Kashmir was too much for their seven-year-old to bear. And so *The Simpsons* was thereby outlawed in the Siegel household. Left out as I felt at school, I wasn't alone. Concerned parents across the country kept it from their kids. Naturally, the ban only made me want to watch it even more.

Looking back on it, Stuart and Debbie Siegel made a reasonable decision. Even that episode's writer understands. "We have multiple friends who don't let their kids start watching *The Simpsons* until they get older," Jon Vitti says. "And I'm fine with that. I don't *urge* it, but I totally get it. Sometimes it's really fun with friends' kids as they grow up and they reach the age when they're allowed to watch *The Simpsons* and it's a new show to them."

Thankfully, I didn't have to wait all that long. After tolerating my whining for a few weeks, my parents lifted the ban. They don't remember having a change of heart. I think the show's pull was too strong for them to fight. In the early 1990s, it was *everywhere*. Tens of millions of people were tuning in. It was a remarkable feat for a series that aired on Fox, which one TV executive called "a coat hanger network"—as in you needed to use a coat hanger as an antenna to get reception. I talked about *The Simpsons* incessantly with my buddies,

INTRODUCTION

even if series creators Matt Groening, James L. Brooks, and Sam Simon didn't make it for us.

"It was never written for children, it was always written for grown-ups," Yeardley Smith, the voice of Lisa Simpson, once told me. But it still felt accessible to kids, who could enjoy the show even when the adult jokes were flying over their heads. "There's so much physical comedy, and the colors are primary colors," Smith reminded me. "Red, blue, yellow. The animation is simple and pleasing. An eight-year-old can go, 'Oh my God, Bart's the funniest kid I ever saw,' and a parent can go, 'Holy shit, that was a joke about sex in a marriage.' A lot of the success of *The Simpsons* is that it's multigenerational." When parents got past the subversiveness, they started watching with their kids. It brought families together.

Now '90s kids who grew up on *The Simpsons* have become taste-makers and power brokers. The animated series is a true American institution. It wasn't only a water cooler show. It altered the way we talked while crowded around the water cooler. Ever describe something mediocre as "meh"? Thank *The Simpsons* for helping push the word, as well as dozens more, into the lexicon.

But its current status as a beloved sitcom that's still going after thirty-six years on the air undercuts the fact that it was revolutionary. In its decade-long heyday, the show was so radically different from everything else on TV that it hooked us. It wormed its way into our collective consciousness, influencing American culture in ways that nothing ever has. The story of the early seasons of *The Simpsons* and the story of this country in the '90s are intertwined. You can't tell one without the other.

The Simpsons helped turn Fox into the fourth major TV network while also poking fun at the institution of network TV. It sent up celebrity worship while becoming a global phenomenon. It rolled its eyes at the culture wars while finding itself in the middle of them. It

ripped corporate grift while piling up billions of dollars shilling thousands of products. And it ridiculed media saturation but also inadvertently contributed to its insidiousness.

The show managed these contradictions because it was, well, so damn good. Its legendarily talented cast and writers teamed up to reinvent the sitcom and change comedy for the better. The primetime cartoon was both groundbreakingly subversive and surprisingly wholesome. Nothing in the '90s was better at showing us where America was headed. It pointed out the cracks in the country's facade while somehow allowing itself to be *slightly* optimistic about the future.

And by the late '90s, as the optimism of the early part of the decade was curdling, the show reached uncharted territory. It reached an impossibly high comedic peak and the only way to go was down. Later seasons are often funny and worth watching, but they're not the ones we reference all the time, sometimes even subconsciously. They're not memed into oblivion.

Since I was a kid, I've been obsessed with *The Simpsons*. In the late '90s, my summer camp bunkmates used to stay up late reading the first official episode guide out loud to each other, howling at all the best lines and bits we missed on first viewing. As I grew up, my fascination with the show, and particularly its golden age, never waned.

I've spent the last fifteen years of my professional life trying to figure out how and why, exactly, the glory days of *The Simpsons* were so influential to my generation. I'm admittedly not alone. Since the premiere in 1989, journalists and critics have written countless words about the series' creation. By now, it's no secret that the show's three principal architects didn't always get along. But to me, the tension among Groening, Simon, and Brooks is far less interesting than the tension between the show and American society in the '90s. The country didn't realize it yet, but it was ready for *The Simpsons*.

INTRODUCTION

"I always say the basic dynamic of show business is: give people what they want," says *Simpsons* writer Jeff Martin. "But if you give them something they didn't *know* they wanted, then they'll follow you anywhere."

This is the story of how the early days of *The Simpsons* changed pop culture forever. It was so prescient in its prime that it basically became a coherent worldview. The way the show saw it, American life was one crushing defeat after another. And still not a lost cause. That contradiction remains one of the only ways left to make sense of a reality so absurd that not even *The Simpsons* could've imagined it.

Thank God my parents caved.

CHAPTER ONE
SMASHING THE SNOW GLOBE

"WE WANTED TO HAVE OUR OWN STANCE ABOUT LIFE."

—GEORGE MEYER

George Meyer spent his childhood in front of the television. He grew up in the '60s and '70s, when TV was sucking up American attention spans like an unchecked blob. By then, ABC, CBS, and NBC had become a three-headed monster. The major networks were where people went for sports, sitcoms, and news. They'd started to trust what they saw on the tube. As frequent *Simpsons* target Richard Nixon once said, "The American people don't believe anything's real until they see it on television." Back then, Meyer and his seven siblings weren't paying attention to how the rise of TV was affecting their brains. They just needed something to do that wasn't a logistical nightmare. So they tuned in. To everything. For them, it wasn't really even entertainment. It was a mirror world that taught them things about the real one.

"I watched so much and from such an early age, in fact, that I didn't understand what TV was for," Meyer said in a 2000 interview with the *New Yorker*. "I say this to people and they think I'm kidding, but I didn't realize that *The Dick Van Dyke Show* was supposed to be

funny. I thought you just watched it. The people said things, and they moved around, and you just waited till you saw the kid—you know, you liked to see Richie. My brothers and sisters and I rarely laughed at anything we watched. We watched more to learn what the world was like and how adults interacted, and what a cocktail party was, what a night club was, what you did on a sea cruise—although I did like shows where the joke would be that somebody got shot or fell out of a window. When you're a kid, you like to see adults getting away with stuff, because you hope to join them one day in anarchy and mayhem."

At some point, in hopes of improving picture quality, Meyer's parents bought an antenna. "It spun around on the roof. You turned a dial and it went, 'MMMMMMM,'" he says, making a humming noise. "And then the show that had been all fuzzy and snowy and double-imaged, it would kind of round into focus. And that was almost like a magical process."

It was hard for Meyer not to be influenced by what he saw, no matter what was on the screen. There *was* something magical about that box. It had a hold on Meyer. And it had a hold on the other original *Simpsons* writers. When they were young, it activated something in them. Something that took them decades to understand and then harness. After reaching adulthood, they realized that their television-addled minds could actually be a force for good.

That's the thing about TV: watching too much as a kid might rot your brain. Or lead to the creation of *The Simpsons*.

In their formative years, the future writers of *The Simpsons* didn't always grasp everything they saw on the tube. But that made them more curious about what they were watching. Jon Vitti remembers writer John Swartzwelder saying he loved when a show did something he didn't understand. "It was like, 'Wow, that's grown-up stuff,'" Vitti recalls. "It was exciting."

They knew all the tropes, all the clichés, all the one-dimensional archetypes that became staples in even the *popular* midcentury TV shows and persisted for a long time—the defining features of traditional network programming. The mostly strife-free families, the regressive marital dynamics, the too-precocious kids who leaned on catchphrases, the cookie-cutter episodes that ended tidily every week, and the ridiculous plotlines that seemed to come out of nowhere when there were no better ideas. Series like *My Three Sons*, *Leave It to Beaver*, and *Dennis the Menace* were often funny and inoffensive, but they had no teeth.

"The function of network TV is to make people feel that everything is OK," *Sopranos* creator David Chase once said, "and they should buy the product that we're selling during the commercials."

As they got older, the budding comedy writers learned to separate the good stuff from the bad. "All of us had been disenchanted with regular TV and had various grievances," Meyer says. "I would say we felt that the aims of regular TV were not ambitious enough. They just aimed to ingratiate and entertain."

One exception was *Batman*. The nerdy guys who went on to write for *The Simpsons* adored it. And not Tim Burton's brooding 1989 blockbuster. I'm talking about the '60s TV show. "The basic hybrid that creates *The Simpsons* is *Batman* crossed with actual emotional stories of *The Mary Tyler Moore Show*," Vitti says. At once exciting, absurd, and deeply tongue-in-cheek, the superhero series was heavily shaped by screenwriter Lorenzo Semple.

"He didn't create the characters, but he did create the sensibility," says Meyer, whose longtime partner was author Maria Semple, Lorenzo's daughter. "He had an incredible eye for what kind of camp sensibility would work on television."

Batman starred a deadpan Adam West as the Caped Crusader and featured a variety of goofy villains, gadgets, cliffhangers, self-serious narration, and fight scenes punctuated by exclamations like

"WHAMM!" and "KAPOW!" The *Simpsons* writers revered West, who they eventually enlisted to play himself in an episode.

"All of us who were there when he recorded for *The Simpsons*—it was like we were in church," Meyer says. "I mean, just to look at this guy. Talk about nailing a part of a lifetime. That was *his* role. That's what he was born to do. And I love when that happens."

Before he was a late-night TV host, Conan O'Brien was a *Simpsons* writer. In the '90s, he and Robert Smigel co-created an NBC show for West about a former action hero who foolishly thinks he can solve real-life crimes. They shot the first episode of *Lookwell*, but it never became a series. "We cut our teeth on *Batman* and that's why Robert Smigel and I ended up writing a pilot just to bring Adam West back to TV," O'Brien once told me. "That's how devoted we were."

To O'Brien, *Batman* worked on two levels. The first, he told me, "is just an action-adventure TV show, and it delivers. It's a home run because there's fight scenes and bad guys and great costumes and outrageous traps and excitement and thrills and chills. 'Batman's in trouble, I hope he gets out of it.' We all watched it on that level."

But O'Brien eventually began to see *Batman* in a different light. "The '70s roll around and you keep watching it, you start to realize—and now I'm fourteen, fifteen, sixteen—this is hilarious," O'Brien said. "These scripts by Lorenzo Semple are amazing. It's the perfect writing meeting the perfect actor. Adam West is killing it. The tone is perfect."

Meyer had a similar epiphany when he noticed that the two most reasonable voices of *Batman*, Commissioner Gordon and Chief O'Hara, were kind of clueless. "It was a satirical show in that it took on authority and made authority figures look kind of ridiculous," he says. "And the criminals were even more ridiculous. I mean, they're carrying around umbrellas." (As weapons, not to stay dry.)

When Meyer was a kid, the most alluring thing about *Batman* was that it was totally off the wall. "The rules seemed to have been tossed out the window, and that was such an exhilarating experience for a young viewer," he says. "Because a lot of the shows, as well done as they were before that, seemed kind of square and stale and tame compared to that."

The Simpsons, I should point out, is not a clone of *Batman*. The '60s superhero show was, in truth, only one strain of influence. Each of the writers had a unique sensibility, but for better or worse, they had similar points of view. They were a group of straight white guys. Over the years, the show has been correctly described as subversive, progressive, and groundbreaking, but the makeup of the staff was absolutely of its time. Back then, that's who shaped TV comedy. This also meant that many of their favorite pop culture references and influences were shared.

"We brought a lot of stuff to the table," *Simpsons* writer Jay Kogen says. More than any other show that came before it, *The Simpsons* was the product of mass media. It was an elevated mix of *all* the stuff the writers saw as kids, from the madcap brilliance of *Looney Tunes*, to the silly farce *Gilligan's Island*, to the traditional *Dick Van Dyke Show*, to the working-class comedy of *The Honeymooners*, to the spy parody *Get Smart*, to the kitschy family comedy *The Brady Bunch*, to the biting satire *All in the Family*, to the socially conscious and emotionally resonant *Mary Tyler Moore Show*, to the groundbreaking sketch fest *Saturday Night Live*.

Long before streaming gave kids push-button access to any TV show or movie that they were curious about, pop culture was far less accessible. Future *Simpsons* writers had to work to find new stuff. And whatever they got their hands on, they devoured.

As a boy, Kogen read *Mad* magazine religiously. It mixed zany jokes and sharp satire and appealed to the same kind of kids that later

got into *The Simpsons*. "I see a really direct line between *The Simpsons* and *Mad* magazine," Kogen says.

The *Mad* philosophy was pretty simple. "What can we make a joke about?" Kogen says. "That's exactly how *Mad* magazine approached everything. They seem like culture warriors, but really they were just like, 'What could be funny?'"

That included lots of political satire and cartoons by artists like Don Martin and Sergio Aragonés. There was a mix of high- and low-brow humor, though Kogen wasn't scouring issues for social commentary. "Sometimes *Mad* magazine takes itself seriously and tries to talk about ecology," he says. "And when they did that, it was sort of like, 'Oh, OK.' But that's not why I read *Mad* magazine. I would laugh at the silly drawings in the margins."

Mad also featured Mort Drucker's illustrated parodies, in which he, frame by frame, meticulously recreated—and made fun of—blockbusters. "I used to read parodies of movies I'd never seen," said Kogen, whose father, Arnie, wrote for *Mad*. "And then later I would see the actual movie and go, 'That's what the parody was about.'"

In the late '80s, *Mad* was still very much alive. But the bulk of the counterculture movement of the writers' youth was long dead. They'd lived through the tail end of the civil rights movement, the Vietnam War, and Watergate. The rage and upheaval that spilled over into the '60s and '70s led to a strain of nihilistic irreverence that started to run through pop culture. *SNL*, *National Lampoon* magazine, and New Hollywood films—starting with *Easy Rider* in 1969—briefly captured the country's general distrust of authority. But that era didn't last.

When Ronald Reagan was elected president in 1980, he effectively pulled mainstream pop culture to the right with him. The Cold War was very much still on. With anti-Soviet sentiment peaking, jingoistic action movies ruled the box office. Pop stars, even the supposedly edgy ones, became ultra-profitable corporations that used MTV to promote

their product. And TV shows started to reflect the fact that hippies had aged into yuppies. One of the most beloved TV characters of the decade was Alex P. Keaton on *Family Ties*, a money-obsessed Republican teenager.

Even worse, sitcoms were still relying on cute kids (and sometimes quirky adults) to repeat catchphrases for cheap laughs and "aww!" moments. Think: lovable nerd Steve Urkel asking, "Did I do that?" on *Family Matters* or young Michelle Tanner saying, "You got it, dude!" on *Full House*.

Because of conventions like that, Meyer had long before developed an aversion to TV comedy. It had been stripped of originality—if it ever had it at all. Sitcoms didn't just bore him. They *offended* him. And millions of people still regularly watched! "The audience proved its own tyranny by laughing at stuff that wasn't that good," Meyer says. "You know, cackling at the ten millionth time when a character would say a catchphrase."

Even most *good* live-action shows seemed stuck in one location, and because of that, the past. Meyer remembers visiting the set of a traditional sitcom. He didn't like that almost every scene was confined to small rooms. The action only rarely spilled out into the outside world, where real life happened. Just thinking about writing for shows like that made him feel creatively claustrophobic.

"They were just stuck in this little snow globe," Meyer says. In the world of empty kids' cartoons and cookie-cutter comedies, he wanted to make something that would, at the very least, smash through TV's little snow globe. He just wasn't sure who would let him take a hammer to the glass.

There were funny mainstream sitcoms, but none that quite matched Meyer's anarchic sense of humor. And there was no sign that the American public was clamoring for something more experimental. Something like, say, a cartoon. That kind of thing wasn't exactly trendy.

The genre was pretty much dead. There hadn't been a hit primetime animated series since Stone Age family comedy *The Flintstones* went off the air in 1966. Network executives didn't want to even try such a thing. The genre was, like Dino the dinosaur, *extinct*. "The old guard looked at it like, 'Oh, it's just cartoons.' Or, 'It's for children,'" says Rich Moore, an early *Simpsons* animation director. Saturday morning cartoons were homogenous fluff. Most were shot from the same static perspective. "There were lots of cheap tricks that studios would use to make things simpler," Moore says. "This is gonna sound really weird, but it's like they would never show a ceiling in a shot, because that means you're putting the camera low." Characters like Scooby-Doo, you see, were hard to draw from that angle. "So you're never gonna drop the camera low," Moore says. "You're always gonna keep it right at eye level, because then you're tracing off the model sheet."

For young animators like Moore, there weren't very many opportunities to do cutting-edge work. Future computer animation juggernaut Pixar was brand-new. The Disney Animation Renaissance—which led to classics like *The Little Mermaid, Beauty and the Beast, Aladdin,* and *The Lion King*—was just starting. And inventive cartoon/live-action hybrids like *Who Framed Roger Rabbit?* were few and far between. "At the time, well, it was *He-Man* and *My Little Pony*," Moore says. "And they were long, glorified commercials for toys and breakfast cereals."

And it wasn't just animation. As a whole, television needed a jolt. Young viewers felt like Homer, who would one day be so exasperatedly bored with what he was watching that he started smashing the family set with his fist. "Stupid TV," he yells at the screen, "be more funny!"

Up-and-coming comedy writers could feel it, too. They yearned to make a sitcom that did more than just provide background noise. The kind of show that they loved growing up but was all too rare. A show that played with and occasionally even blew up conventions. A show that practiced anti-intellectual intellectualism—one that was

smart but didn't take itself too seriously. A show that was like nothing else on TV.

"We wanted to go a step farther and we wanted to have our own stance about life," Meyer says. "Which is that it's absurd, and punishing, and undignified. But it might be worth living."

CHAPTER TWO
BREAKING THROUGH THE CLOUDS

"YOU DON'T KNOW WHAT IT IS THAT CREATES SOMETHING. IT'S ALWAYS THIS WEIRD ALCHEMY."
—JAY KOGEN

"IT MAY BE ON A LOUSY CHANNEL, BUT THE SIMPSONS ARE ON TV."
—HOMER SIMPSON

The Fox network was nothing. At least that's how *Simpsons* writer Jay Kogen saw it at first. "We did not envision it as a success," he says. "We did not envision building a network."

Kogen's skepticism was well reasoned. ABC was the last major TV network to launch. And that was in 1948. He and the other writers didn't realize it yet, but times *were* changing. It was the mid-'80s, and Congress had just passed the Cable Franchise Policy and Communications Act. The legislation helped to deregulate the TV industry, loosening restrictions on station ownership. In the Reagan era, the number of independent channels exploded. It was the perfect time to try to take on ABC, CBS, and NBC.

Fox Broadcasting Company was the brainchild of 20th Century Fox chairman Barry Diller, who seemed unfazed by the fact that others before him had tried, and failed, to create a viable fourth major network. "To the risk-taker, as always, comes the spoils," he said at the time.

The owner of Fox, Australian Rupert Murdoch, backed the move. He'd built a cross-continental print and broadcast empire that he was intent on expanding in the United States. And to the media mogul, it was obvious: the future was TV. "Television is today's new mass communication media," he said back then. "It's taking over the role of newspapers."

Fox TV first hit the airwaves at 11 p.m. on October 9, 1986, with the premiere of *The Late Show Starring Joan Rivers*. Voluntarily going head-to-head with *The Tonight Show Starring Johnny Carson* to start was a genuinely splashy move. But it was also a little *too* ambitious. Ratings-wise, Joan proved to be no match for Johnny—no late-night host ever was—and Fox unceremoniously fired the legendary comedian the following spring. But by then, the network had introduced original programming on weekends.

On April 5, 1987, Fox debuted its primetime lineup. Leading off was the network's first live-action series: *Married...with Children*. It starred Ed O'Neill as Al Bundy, a chauvinist caricature who made Archie Bunker seem enlightened. He was perpetually annoyed with his pretty wife, perpetually disappointed in his son, and perpetually bewildered by his airheaded teenage daughter. An early commercial for the show described the Bundys as "a family like you've never seen."

At least not on TV back then. Sitcom families tended to be a bit more, well, perfect. Think: *The Cosby Show* or *Growing Pains*. Al Bundy wasn't upwardly mobile. He was a world-weary shoe salesman. That made him sympathetic, even when he was being a pig. The audience laughed with him *and* at him. People tuned in to see what line Al would cross next.

"The way I know a show is working is I'll be in the supermarket checkout line and the woman in front of me or the guy in front of me is talking to the checkout person about an episode of, in this case, *Married...with Children*," says Garth Ancier, Fox's first head of programming. "I'm listening to this, thinking, 'Oh, that's cool. I get to hear real people talk about the show.' And then the person behind me goes, 'Yeah, did you see the one last week where they did *this*?!'"

Married... was a symbol of the new network's willingness to take chances when its competitors were mostly playing it safe, sticking with sitcoms that looked and felt like all the others. Ancier himself was proof of Fox's creative direction. When Diller, Murdoch, and FBC president Jamie Kellner hired him, he was only twenty-eight years old. The Princeton grad *did* already have years of experience working at NBC on sitcoms like *Cheers* and *Family Ties*, but it was still a bold move. As soon as he took the job, Ancier knew he'd have to start thinking outside TV's square box.

"Barry Diller had this saying, which I think is really right. 'As long as we're not doing anything antisocial, there aren't any boundaries,'" Ancier says. "That's how I thought."

Not *every* out-there idea worked. Do you remember the spy comedy *The New Adventures of Beans Baxter*? The horrorfest *Werewolf*? Or the sitcom version of *Down and Out in Beverly Hills*? I didn't think so. But Fox *did* have modest early success with unusual shows. One was *Married...with Children*. And another was the police procedural *21 Jump Street*, which featured attractive young undercover cops posing as students to investigate crimes at high schools. It was the network's first big hit, and helped make cast member Johnny Depp a teen idol.

There was one more unconventional Fox series in the network's opening primetime slate. But there was nothing anti-establishment about the man who championed it. In the mid-'80s, filmmaker James L. Brooks had signed a development deal with 20th Century

Fox. He'd spent the last two decades making some of the most beloved American comedies of all time. In the '70s, he co-created megahit sitcoms *The Mary Tyler Moore Show* and *Taxi*. And at the Academy Awards in 1984, he won Best Adapted Screenplay, Best Director, and Best Picture Oscars for his dramatic romantic comedy *Terms of Endearment*. Diller hoped the producer would bring his magic touch to the company and its brand-new TV network.

"I was frankly begging him to do a show for us," says Ancier, who'd gotten to know Brooks while working as an executive on *Taxi*.

The first Fox series that Brooks produced was a variety show starring Tracey Ullman. The British comedian, who used makeup and prosthetics to transform into different characters in every episode, was not very well known in the United States. But Brooks's endorsement brought her credibility. Brooks had cachet. The network wanted it, too. So it green-lit *The Tracey Ullman Show*. "Fox was desperate to establish itself," Kogen says.

Kogen and his creative partner, Wallace Wolodarsky, were two of the variety show's youngest writers. "It was a great environment," Kogen says. "We wrote tons and tons and tons of sketches. Writing sketches means you have to set up and pay it off in a very short amount of time. It was a really good education." They learned the ropes from their colleagues, who happened to be "some of the greatest comedy writers on the planet," Kogen says. One of the co-creators was Jerry Belson, who'd worked on *The Dick Van Dyke Show* and had a big hand in bringing *The Odd Couple* to the small screen. Executive producers Heide Perlman, Ken Estin, and Sam Simon came from *Taxi* and/or *Cheers*. But Kogen knew the series existed for only one reason.

"Jim Brooks said, 'I want to make this show. I like Tracey Ullman. We're gonna make this thing.' And they said, 'OK,'" Kogen says. "Not because they didn't think it was going to be good, necessarily. They

hoped it was going to be good. But they just took a shot at something. And honestly that's how people should operate today."

During the development of *The Tracey Ullman Show*, the producers ran into a problem: they couldn't figure out how to transition between disparate sketches. What could they use to fill those small windows of time?

At any other network, the answer surely wouldn't have been "animated shorts created by an underground cartoonist." But this was Fox. It was the kind of place that might give someone like Matt Groening a shot. And without him, there is no *Simpsons*. "His influence on the show is profound," Jay Kogen says. "... His sensibility—the weirdness, the sort of broadness, the love of pop culture—is all infused inside *The Simpsons*."

In 1977, Groening moved from his hometown of Portland, Oregon, to Los Angeles. The wannabe journalist and cartoonist had several odd jobs and gravitated toward L.A.'s braided punk rock and art scenes. With the encouragement of his friend Gary Panter, who became a legend in the world of underground comics, he embraced the community's DIY ethos.

Groening's new concrete-encrusted city inspired *Life in Hell*, a black-and-white comic about rabbits Binky and Bongo and a gay couple named Akbar and Jeff. Groening later described the strip as "crude" and "full of alienation, angst, fear, and grief, not to mention self-loathing and laughs." First he self-published the strip and sold issues of it out of Licorice Pizza, the record store on Sunset Boulevard where he worked. The first professional publication to run his cartoon was *WET*, "the magazine of gourmet bathing." *Life in Hell* started appearing in 1980 in the *Los Angeles Reader*, an alternative-weekly newspaper that employed Groening as an editor, reporter, music critic, and phone answerer. He eventually moved the comic to the rival *L.A. Weekly*. And

over the next few years, it was printed in hundreds of alt-weeklies across America. In the '80s, syndication and merchandise sales helped *Life in Hell* build a cult following.

In those days, George Meyer spent his free time seeking out the city's "fringey cultural stuff." When cartoonists like Robert Williams or R. Crumb made public appearances, or the performance art group Survival Research Laboratories put on shows with hand-built battling robots, he'd make sure to attend. They were great places to meet interesting people. "When I would go to these oddball things, I would run into Matt Groening," Meyer says. "Which I thought was a really good sign. I mean, he just had great taste." Naturally, Groening's irreverence appealed to comedy writers. "We were comfortable with this kind of renegade image," Meyer says.

At the time, James L. Brooks was no renegade. But he still knew what was funny. The often-told story about why he got into animation is that his friend and collaborator Polly Platt, a production designer on *Terms of Endearment* and later the executive vice president of Brooks's company Gracie Films, gifted him Groening's original art from a *Life in Hell* strip called "The Los Angeles Way of Death." The comic depicts all the ways Binky can die in L.A., including by gun, car, drug, sea, air, cop, war, and finally the two worst of all: failure and success.

The rich and famous Brooks must have still appreciated existential dread, because he loved the cartoon. Groening has said that Brooks called him in 1985 and asked if he'd like to collaborate on a future animated project. But that connection is not exactly how they first teamed up.

Fortuitously, Ken Estin was also a fan of Groening. Brooks's producing partner and right-hand man Richard Sakai had given Estin a *Life in Hell* strip as a present. Estin loved it. While developing the variety show, he had an idea: fill the time between sketches with brief, animated *Life in Hell* "bumpers." Brooks liked the idea. And so did Groening.

The indie cartoonist, however, didn't want to sign over merchandising rights to the strip. But he wasn't against working with a corporate behemoth. It just had to be on his terms. So he offered a counterproposal: he'd create new characters for the shorts. Brooks signed off, and America's favorite cartoon family was born. Groening doodled them into the world in black ink. He borrowed their surname from a character in Nathaniel West's 1939 novel *The Day of the Locust*: Homer Simpson. (Here's how the author described him: "For all his size and shape, he looked neither strong nor fertile. He was like one of Picasso's great sterile athletes.") Homer also happened to be Groening's father's name. Marge was named after his mother, and Lisa and Maggie for his sisters. The fifth Simpson's name, Bart, was purposely close to "brat." Inspired by the look of one of his cartoonist friend Gary Panter's signature characters, the aggro antihero Jimbo, Groening gave the boy a spiky haircut.

"Bart certainly looks like some weird version of Charlie Brown," Kogen says. Like in *Peanuts*, each character was instantly recognizable. Groening made sure of that. Dad Homer had permanent stubble, mom Marge had a blue beehive, daughter Lisa had a starfish 'do, and baby Maggie had a pacifier and onesie.

"The Simpsons, they're pure," *Simpsons* animation director Rich Moore says. "Their design is pure shape and volume. They're very, very simple shapes to draw in space. Homer's a light bulb, basically, with this kind of dome cylinder for a head, and their eyes are spheres, and their mouths are like two melons, a bigger one and a smaller one. A Pac-Man. And that's easier to draw. You can draw from above, low, and behind them, and they still hold up. They look like themselves."

Groening's influence also went beyond visuals. "Matt knows everything about animation," Vitti says. "And kids." Vitti recalls Groening mentioning that he had a friend who was a teacher. At the end of the school year, this teacher would collect and save all the papers and

notes the kids left in their desks. At some point, the pal gave Groening the stash. When *The Simpsons* eventually became a series, he dropped the papers off with the writers for inspiration. He wanted the show to feature animated kids who spoke and acted like real kids.

Fox and Gracie Films still needed a way to bring Groening's characters to TV. "Jim asked his producers, 'OK, find a cheap animation studio,'" says animator Gábor Csupó. He and his then-wife, Arlene Klasky, owned Klasky-Csupó, a small company in Hollywood that made things like commercials, trailers, and title screens. The company had never animated a TV show before, but it was definitely cheap. Which is why Klasky-Csupó got hired.

Csupó was a Hungarian immigrant who came to the United States in the '70s and worked for Hanna-Barbera, the studio that produced *The Flintstones*, *The Jetsons*, and *Scooby-Doo*. The company had a track record of making iconic cartoons—on a budget. Brooks expected the same thing from Csupó.

"When we got the go-ahead it wasn't that easy actually, because they went back and forth with the price, and I *already* gave them the absolute bare minimum price for an animated show," says Csupó. "But even Jim thought it was too expensive. He never did anything animated before, so he had no idea how labor-intensive it is to draw twenty-four frames every second."

Csupó recalls his first meeting with Groening going well. "He was very smart and kind of shy and modest, which I immediately liked about him," Csupó says. "I didn't think he was a good artist by any means when I saw his drawings. But that primitive style actually had its charm."

Groening had never worked in television. He hadn't considered that his black-and-white aesthetic might not pop onscreen. Csupó suggested using color. Brooks initially shot that idea down.

"Jim wanted to do it exactly like he saw it on the white paper, with

the Sharpie lines," Csupó says—in other words, stark, just like *Life in Hell* looked. "And I said, 'So you don't want any color?' And he says, 'No, because it's gonna be more expensive.'" Then Csupó pled his case. "I'm gonna paint it for the same price I already quoted you," he recalls telling Brooks. "I think it looks good on a newspaper or magazine as a single drawing. But line drawings in animation, for a three-minute short in a festival, maybe works. But not when you're telling stories. It's just not gonna hold up on TV."

Csupó says that he had Brooks at "paint it for the same price."

"Well, if it's free," the producer replied, "then go ahead and do it."

With Brooks on board, Csupó went to a colorist at his company, Gyorgyi Peluce, showed her the *Simpsons* characters, and told her to "come up with something shockingly crazy" for the palette of the shorts to grab viewers' attention. Peluce came into work the next day with several different character styles. "Some of them were painted regularly, you know, like brown hair and blonde hair with the pink skin like you usually see," Csupó says. And some were much bolder. Like the Simpsons painted yellow. She was reluctant to show her boss that color scheme, which also gave Marge blue hair. "She said, 'You told me to go a little bit crazy, so I went crazy. What do you think of that?'" Csupó remembers. "And when I saw it, I said, 'That's it!'"

Csupó recalls Groening approving it. Brooks was less pleased. "When he came back and saw the colors we chose, he basically wanted to strangle me," Csupó says. "He didn't like it at all, the colors. And he said, 'What the fuck is this?' Because in his mind, when he saw cartoons, *Bugs Bunny* or whatever, everything had their own little realistic colors and humans were usually painted pinkish."

Csupó tried to sell Brooks on the color scheme by pointing out its uniqueness. "I was telling him there are all these channels and Fox is so new," he says. "But if they're just channel surfing and they stopped at this crazy-looking thing, they'll need to stop for a second to figure

out, 'What the hell is this? I've never seen anything like this.'" The plea worked. And that's how the Simpsons turned yellow.

"I somehow convinced him," Csupó says. "And then I remember his remark was something like, 'Oh, this is all only little bumpers.'" It was true: the stakes for the shorts were low. And so was the budget for the voice cast.

Tracey Ullman Show regulars Dan Castellaneta and Julie Kavner were enlisted to voice the typically blustery sitcom dad Homer and the put-upon Marge. Nancy Cartwright, already an accomplished voice actor, was cast as oldest child Bart. Yeardley Smith, a seasoned theater actor who'd appeared in a handful of mainstream movies, would play middle child Lisa, who at the outset didn't have much of a personality of her own. Maggie, the baby, didn't speak; she only sucked on her pacifier. Actor Hank Azaria later also came on board to play a handful of supporting characters, like Moe the bartender, police chief Wiggum, and Kwik-E-Mart owner Apu. So did Harry Shearer, who voiced, among others, Kent Brockman, Mr. Burns, Smithers, Ned Flanders, and Reverend Lovejoy.

The fact that a woman was voicing a little boy eventually became an object of public fascination. But it wasn't all that radical. "Our voices don't change," Smith once told me. "How many Barts would we have been through if we had an actual ten-year-old boy?"

The cartoon's days as a time-filler were not glamorous. "We were in a makeshift sound booth, behind the audience bleachers of *The Tracey Ullman Show*, which wasn't really soundproof at all," Smith said. "Matt Groening was writing all the scripts, and running in late every time."

Young Klasky-Csupó animators David Silverman, Wes Archer, and Bill Kopp pieced together the shorts on the fly. They got the assignment for the first interstitial in March 1987 and worked long days to complete it as fast as they could. "It took three weeks to do

one segment on *The Tracey Ullman Show*," Silverman said. "We were essentially making a short film once every three weeks."

On April 19, 1987, the first *Simpsons* short aired. "Good Night" features Homer—whom Castellaneta voices gruffly, like Walter Matthau—and Marge trying to tuck in their children. Instead of falling asleep peacefully, the kids develop various fears and then end up in bed with their parents.

By the second season, one *Simpsons* story, split into twenty-second segments, appeared in every episode. But its regularity didn't mean the cartoon was a national sensation. News stories about Groening from that time usually focused on the popularity of *Life in Hell* and didn't spend much time on his new animated project. In an *L.A. Times* profile, the artist described the stars of the vignettes as a "mutant-'50s-Father-Knows-Best Family in Hell," though the article didn't mention that family's name. Another profile of Groening referred to the "angst-ridden Simpson family" but didn't elaborate beyond that.

To Fox, the animated clips were just filler. "The studio did not want to do them," Ancier says. "Because they didn't seem to add any real value to the show. But I argued. I said, 'Look, there's something here.'"

The cartoons were brief, crudely drawn, and had simple plots. But the very basic DNA of *The Simpsons* was there. The family both fought like hell and loved each other. Early on, though, it didn't seem like they were destined for their own series.

"While I liked them, and I enjoyed their energy and their kind of anarchic, almost bestial spirit," George Meyer says of the shorts, "I didn't necessarily see a show there."

On his first day on the job as a marketing executive at Fox Broadcasting Company, Sandy Grushow picked up the latest edition of Hollywood

trade magazine *Variety* and looked at the front page. One headline immediately slapped him in the face: "FBC Swallows Whopping $99 Mil Year-End Loss." In the story, published in September 1988, a Fox spokesman is quoted blaming the deficit on "write-offs and failed programming."

Two years in, Fox TV wasn't close to being on the level of the other networks. The report Grushow read mentioned two expensive flops. The first was *Mr. President*, a sitcom starring Academy Award winner George C. Scott that lasted for only two seasons. The second was a TV reboot of World War II movie *The Dirty Dozen*, which got canceled after seven episodes.

"It was into that that I walked," Grushow says. He tried not to panic. After all, Fox was still new to American TV.

Grushow had started in 20th Century Fox's film division, which was a blockbuster factory. In the '80s, the studio produced *The Empire Strikes Back*, *Return of the Jedi*, *Cocoon*, *Aliens*, *The Fly*, *Big*, *Die Hard*, *Working Girl*, and Brooks's Oscar-nominated dramatic comedy *Broadcast News*. Grushow enjoyed working on big movie campaigns. So when Diller asked him to shift to television—"to start what he referred to as the first proper marketing department at the new network," Grushow says—he wasn't thrilled.

Fox TV was still a startup. Many of its affiliates were broadcast backwaters. And in its early years, it only aired original programming on weekends. There were a handful of successful series that stood out from typical major network fare, but the Big Three were still crushing the new network. With more than a half century of accumulated viewer loyalty, ABC, CBS, and NBC had a tight grip on TV.

Fox couldn't compete with that by being a copycat. By the late '80s, the network started to fully embrace the need to innovate. It helped, not hurt, to take a different approach to programming than its competitors. Frankly, that meant throwing shit against the wall and

seeing what stuck. Not everything this approach led to was creatively high-minded.

Like *America's Most Wanted*, a show packed with reenactments of fugitives committing scary crimes. It debuted in early 1988 and became, at least for a little while, the network's biggest hit. Designed to turn suburbanites into hypervigilant watchdogs, it even had a tip line: 1-800-CRIME-TV.

The next year, Fox fell even farther down the freshly dug reality TV rabbit hole. In March 1989, *Cops* premiered. The premise of the cinéma vérité–style docuseries was pretty simple: a camera crew shadowed local police forces on the job. "That show was all handheld cameras," says Ancier, who left the network that year. "There wasn't writing. It was just like, 'Let's follow the cops around.'" Episodes consisted of low-level drug busts, foot chases, and the occasional case of paint drinking.

Cops was indisputably exploitative; most of the officers were white and many of the alleged offenders were poor and Black. But it was the '80s, when conservative politicians made being tough on crime a talking point. A show about good guys taking down criminals was bound to be popular. "We are reminded several times that 'this program shows an unpleasant reality,' and that 'viewer discretion is advised,'" an early *New York Times* review pointed out. "That should keep them from switching to another channel."

America's Most Wanted and *Cops* were relatively low-budget, grotesquely salacious, and hugely successful—*The Simpsons* eventually parodied both. Those shows pushed the boundaries of good taste, but the network didn't mind. Edginess brought much-needed eyeballs to Fox, which was desperate to grow its audience.

"When I first did an ABC show, we got called in to a meeting with the censor, and the censor was this beautifully dressed woman with a giant diamond ring," *Simpsons* writer Jon Vitti says. "I'm sure

the censor is the highest-paid person in ABC. And she says, 'Let me explain something to you. ABC sponsors are soap companies and Fox's sponsors are beer companies. And if you think you're going to get away with the things you've been doing on Fox at ABC, you're very much mistaken.' And it was actually nice to have somebody explain to me how it worked like that. Something that no TV writer likes to think about is you're actually not working for the network, you're working for the advertisers. And Fox's advertisers did not care if we pushed the limit on what we could broadcast."

To a point.

In 1989, a Michigan anti-obscenity activist started threatening the advertisers of *Married... with Children* with a boycott. Her name was Terry Rakolta and she charged the sitcom with "blatant exploitation of women and sex and anti-family attitudes." She cited an episode where Al Bundy stares at a naked department store model—who's only shown from the back. She made the front page of the *New York Times* and it led several companies, including Procter & Gamble and McDonald's, to pull their commercials. The letter-writing campaign was a public relations nightmare for Fox, but amid (or maybe because of) the controversy, the already hit series *gained* viewers.

"It was actually the best thing that ever happened," Ancier says. "We would be very respectful about the audience having a say, but we're not gonna cancel the show because Terry doesn't like it."

By the time Rakolta took on Al Bundy, Fox had gone from the coat hanger network to the fourth network on the back of its edgy programming. In the summer of 1989, it was finally on the verge of turning a profit. The ratings had shot up, especially among 18-to-49-year-old men. The younger viewers didn't come for traditional sitcoms. They came for shows they couldn't get anywhere else.

STUPID TV, BE MORE FUNNY

As Fox was gaining steam, *The Tracey Ullman Show* had made it to a third season. The critically acclaimed series got middling Nielsen ratings, but Fox stuck with it. In an interview with the *L.A. Times* in 1988, Jamie Kellner had called Ullman "a real star" and acknowledged one of the obvious reasons why she still wasn't a household name: "It's true that it's harder to discover Tracey on Fox than on NBC."

Relatively few Americans knew about Tracey Ullman. And presumably even fewer knew about the *Simpsons* shorts. According to one marketing study from that time, only 14 percent of Americans were familiar with the characters. Ullman wasn't their biggest fan either. "Once, Tracey said to me, 'When are these horrible cartoons getting off my show?'" says producer Larina Adamson, who worked on both *Ullman* and *The Simpsons*. Ullman later sued Fox for a cut of the *Simpsons'* profits. Unsuccessfully. "Maybe I shouldn't have been so cavalier," she later said in a press conference after winning an Emmy Award for her variety show performance. "Maybe I should have taken those two minutes in the middle of *The Simpsons*. I breast-fed those little devils."

If there was one group that *did* like those little devils, it was the live studio audience at the *Ullman Show*. You see, it used to take hours to film every episode. So during Ullman's extended costume and makeup changes, the producers got the idea to occupy the antsy crowd by playing a bunch of *Simpsons* cartoons in a row. "And they would laugh," Kogen says. A lot. It was the kind of passionate reaction that ratings just couldn't measure.

Brooks took notice. He began wondering if the shorts could seed something bigger. At the time, David Silverman had similar thoughts. He eventually gathered up the courage to share them with his boss,

but only after having a few drinks. "The *Simpsons* series began like many things begin: with an animator getting drunk at a Christmas party," Brooks later said. "David Silverman cornered me and poured out his heart about what having a primetime *Simpsons* show would mean to animators."

Groening and Brooks then began pushing to turn *The Simpsons* into a half-hour sitcom. Some Fox executives backed the pitch, but Diller didn't. He wasn't convinced primetime animation would work. It hadn't, after all, since the '60s. It was also expensive. Even as the idea languished, Brooks refused to give up. At first, Diller only softened enough to offer something far less costly: standalone *Simpsons* specials.

Brooks, however, had no interest in making only one episode at a time if there was no guarantee of more. At one point, ABC expressed interest in financing the animated series. And Fox, which didn't want to lose him as a movie director, finally bit, ordering thirteen episodes of *The Simpsons*. It was a victory. But the deal didn't guarantee that the show had a future.

Sam Simon knew this. He's the writer-producer Brooks handpicked to run *The Simpsons*. By then he'd worked in television for a decade. He knew how the business worked. Most shows, even the hot ones, fizzled out. He assumed the series would get thirteen episodes and no more.

In fact, he once recalled in an interview with comedian and podcaster Marc Maron, he'd talk about that all the time. "I used to say, 'We're thirteen and out.' Might as well make 'em great."

Simon may have been skeptical, but if there was a primetime animated series that might actually succeed, it was *The Simpsons*. Groening's vision, Brooks's sensibility, and Simon's smarts gave it a chance. For the last thirty-six years, fans, journalists, and critics have debated which of those three founding fathers is most responsible for the show,

like its iconic title card, breaking through the clouds. I don't know. No one does.

"Without any one of them, it probably wouldn't have become what it was," Kogen says. "You don't know what it is that creates something. It's always this weird alchemy. If you know how to make a hit, we'd all make hits. But we don't. It just had to be that group of people, it had to be that time, it had to be that place, it had to be that network. So, you know, onward."

CHAPTER THREE

THE AMERICAN FAMILY IN ALL ITS HORROR

"THESE AREN'T CARTOONS. THESE ARE HUMANS."
—JAMES L. BROOKS

By his midthirties, when he started at *The Simpsons*, Sam Simon could've written a manual for how to make a funny sitcom. "Sam was just real good at TV," Jeff Martin says. "His three big rules were: love your characters, story is king, don't be afraid of the quiet moments. I think he was just kind of your basic full package."

Someone needed to run the show on a daily basis. Brooks, a busy Hollywood filmmaker, and Groening, who had never worked in television, couldn't make the animated series alone. Simon had, and he was the perfect person to be in charge. Just ask the people who worked for him.

"He understood story, he understood the emotional drive," Martin says. "If Matt created the characters, the feel of it, the basic skeleton, I would say Sam was by far the main guy who took that and made it into a half-hour sitcom."

His influence was felt in all areas of the show, not just in the writing. "Sam was the guy who could do anything," Vitti says. "He was good at jokes, character, story, verbal and visual comedy. Anything

he tried. He was such a complete talent, I think, no two people will describe him quite the same way."

Simon's rise in the TV world was swift. He grew up in Beverly Hills—across the street from Groucho Marx—graduated from Stanford University, then became a San Francisco newspaper cartoonist and animation storyboard artist on kids' shows like *Fat Albert and the Cosby Kids*. Before long he was writing and producing live-action shows. He ran the final season of Brooks's *Taxi* and worked on *Barney Miller, Cheers, It's Garry Shandling's Show,* and *The Tracey Ullman Show*. "He got hired at *Taxi* in his twenties, and I think within a year they were pretty much handing the show over to him," Martin says. "Which speaks for itself."

When Simon was staffing *The Simpsons*, he homed in on people whose comedic edges were still sharp and not completely dulled by network television. They were, for the most part, the kind of painfully clever kids who grew up in front of the TV. After high school, some of them went to Harvard. And at Harvard, they joined the *Harvard Lampoon*.

That's where they started their formal training. That's an eye-rollingly pompous way to describe what went on at the *Lampoon*, but the self-described "world's oldest continuously published humor magazine" really was a finishing school for comedy nerds.

Any decent history of *The Simpsons* will mention the *Lampoon*'s connection to the show and the long list of comedic talent it's produced. But what, exactly, is the nearly 150-year-old institution's influence? Most obviously, the magazine gave smart young people the chance to work with other smart young people.

"It was a place that imbued you with a desire for quality," says George Meyer, a Harvard alum. "And a desire to get that out of yourself."

Lampoon staffers spent college living and breathing comedy. That helped when it came time to find a job. "You had the framework," says Greg Daniels, a *Lampoon* vet who wrote for *The Simpsons* and had a hand in creating *King of the Hill*, the American version of *The Office*, and *Parks & Recreation*. "We'd been talking about it a lot and had been sitting around with other people who, if you made an easy joke, would give you shit. So it kind of raised your standards a bit. And it felt like, 'Alright, whoever's hiring us is getting somebody who's a little bit more experienced.'"

"It's also trial by fire in that nobody has any impetus to be nice to you," *Simpsons* writer and Harvard alum Bill Oakley says. "It's a job and you have to maintain a certain level of quorum. Sometimes we did rewrite stuff a little bit. That's part of it. But it's also the fact that it's very much like being in a writers' room that is extremely judgmental. You have to have a thick skin and have some sense of what's gonna work and what's not gonna work."

Competitive? Sure. Highbrow? Nah. Inside the *Lampoon* castle, which was once named the fifth most phallic building in the world, the soon-to-be professional comedy writers had important debates like: which late-night sketch show was better, *SCTV* or *Saturday Night Live*? It was the most interesting place on campus to procrastinate.

"Instead of reading the book you were supposed to read, you would watch a *Brady Bunch* episode for the fifth time and deconstruct the logic," Vitti says. "Which would've been so sad if we hadn't wound up with sitcom careers."

These were the kind of guys Sam Simon wanted to work with on *The Simpsons*. The first writers he sought out were a team of Harvard grads: Tom Gammill and Max Pross. Before spending time with Simon at *It's Garry Shandling's Show*, they'd been at *Saturday Night Live*, *SNL* creator Lorne Michaels's short-lived *The New Show*, and

Late Night with David Letterman. Gammill and Pross made cleverly absurdist short films at *Late Night*, like one about Letterman actually living inside his studio with his crew. It ends with him in his office on his couch turned bed, reading a magazine by flashlight.

The problem was, Gammill and Pross had already taken another job. So Simon looked elsewhere. But he kept their sense of humor in mind. "I said, 'I want Max and Tom to like the show,'" Simon told Marc Maron. "So they were our target audience." As ridiculously specific as that sounds, Simon meant it. "I just liked their sensibility," he added.

Simon ended up recruiting writers *like* Gammill and Pross. Like Al Jean and Mike Reiss, who worked for *The Tonight Show Starring Johnny Carson* and later on alien puppet sitcom *ALF* and *It's Garry Shandling's Show*. And Jeff Martin, who wrote for and occasionally performed on *Late Night with David Letterman* as Flunky, a chain-smoking clown who answered viewer letters. And George Meyer, who also ended up at *Late Night*, where he came up with highbrow gags like "Dave Crushes Things with a Steamroller." Eventually, Meyer ended up at *Saturday Night Live*. Fellow *Lampoon* alum Jon Vitti did, too. It was there that they met another future *Simpsons* writer.

His name was John Swartzwelder. And he was not a Harvard man. "There wasn't, like, a thunderclap that announced his appearance on *Saturday Night Live*," Meyer says. "But you knew he was the real deal."

At *SNL*, Meyer struggled to get his ideas on the air. His coworkers, he once said, found his sketches to be "fringey." In 1987, he quit the show. But he immediately missed comedy. So in 1988, without much else going on, he started to work on a project for the people who actually understood his humor: other writers. He had one simple objective: "To make something that had no agenda other than to make you laugh," Meyer said later.

And so *Army Man* was born. Touting itself as "America's Only Magazine," the self-published compendium of jokes was a 150-proof distillation of Meyer's sense of humor. His voice carries the black-and-white, hand-typed zine, which is sprinkled with editor's notes like this:

"Due to the tiny volume of mail we receive, we are able to acknowledge every submission with a heartfelt personal note, and occasionally even a gift."

"All 'errors' in *Army Man* are, of course, intentional and represent an artistic choice."

"SUBSCRIBE, YOU MAGGOTS!"

Army Man jokes could be anything—anti-authority, political, satirical, surreal, nihilistic, ironic, silly, stupid—as long as they were funny and short. Meyer could write lengthy comedic pieces, but he liked punchy stuff. That became his signature at *The Simpsons*. "He had the quick lines versus the longer performance pieces," Vitti says.

Reading *Army Man* now feels like perusing the world's funniest, best-organized bulletin board. Every page is covered in neatly typed bits. Meyer recruited some of America's best comedy writers to fill every issue. It was easy. That world was small and many of the contributors were his friends. Among many others, there was Vitti, Jack Handey of "Deep Thoughts" fame, Gammill and Pross, original *Letterman* head writer Merrill Markoe, *New Yorker* cartoonist Roz Chast, eventual *Fresh Prince of Bel-Air* creator Andy Borowitz, and future *Better Call Saul* star Bob Odenkirk. Swartzwelder was also in that group. In Meyer's opinion, Swartzwelder wrote the "quintessential" *Army Man* joke: "They can kill the Kennedys. Why can't they make a cup of coffee that tastes good?"

"It's a horrifying idea juxtaposed with something really banal—and yet there's a kind of logic to it," Meyer once told the *New Yorker*. "It's illuminating because it's kind of how Americans see things: Life's

a big jumble, but somehow it leads to something I can consume. I love that."

You can find Swartzweldian juxtapositions all over *The Simpsons*. Some are, well, bleaker than others. One I'll remember forever is in "You Only Move Twice," the episode about Homer briefly taking a new job at a shadowy tech giant. In a promotional film about the company's Pacific Northwest–like community, there's a montage of the town gentrifying. It starts pleasantly, with parking meters becoming trees and boarded-up storefronts morphing into coffee shops. Then an unhoused man turns into a mailbox.

Swartzwelder wrote jokes that escalated so methodically that it was hard to know how or when he was going to drop an anvil on your head. Like this one from *Army Man*: "Announcer: The first prize winner in our contest tonight will receive a beautiful vase. Second prize is a not-so-beautiful vase. Third prize is the world's worst vase. And fourth prize...death by vase."

It's a precursor to one of my favorite Swartzwelder *Simpsons* jokes. The time when Homer, who's temporarily filling in for Mr. Burns's toady Mr. Smithers, reads his boss's messages to him: "You have thirty minutes to move your car. You have ten minutes to move your car. Your car has been impounded. Your car has been crushed into a cube. You have thirty minutes to move your cube."

Army Man's run was like one of its best jokes: very short. It lasted three issues, but still managed to build a cult following. In the late '80s, comedy writers passed around fraying copies of the magazine like bands passed around VHS tapes of the guerrilla rock documentary *Heavy Metal Parking Lot*.

One of *Army Man*'s readers was Simon. He was a fan. So he mailed Meyer a cassette of the *Tracey Ullman* interstitials and asked if he wanted a staff job.

At first, Meyer turned the offer down. The show didn't seem promising.

"His line was 'I'm retired,'" says Vitti, who ended up marrying one of Meyer's sisters.

"Well," Meyer says, "I said a lot of stupid stuff."

Meyer suggested Simon pursue two *Army Man* contributors: Vitti and Swartzwelder. So that's what Simon did. But he didn't give up on Meyer. "Sam could be very persuasive, and he was obviously a brilliant writer, and just a brilliant guy in general," Meyer says. "I think he talked me into it."

Like the rest of the original crew of *Simpsons* writers, Meyer was relatively new to TV. Sam Simon stayed away from bitter sitcom veterans. Instead, he looked for people he thought were funny. It didn't matter if they had little experience—or the desire to write for a show based on a crudely drawn cartoon.

Swartzwelder, Vitti, and Meyer all worked in late-night comedy, as did Martin, who came aboard a bit later, but is considered part of the first crew of *Simpsons* writers. Jean and Reiss were writers on the fourth-wall-breaking *It's Garry Shandling's Show*, which was only nominally a sitcom. And Jay Kogen and Wallace Wolodarsky, who rounded out the eight-member original writers' room, came from *Tracey Ullman*. They went to state schools. Oh, the horror.

Vitti remembers asking his new boss if he'd just hired all of them because they came relatively cheap. They did. But that wasn't it.

"We said, 'Just admit it, Sam, you hired us because you couldn't afford your *Cheers* friends,'" Vitti recalls. "And he said, 'No, actually, I wanted people who didn't have a lot of experience in thirty-minute comedy. I figured I could teach you how to write thirty-minute comedy.' And he said, 'I didn't want people who had developed a lot of bad habits.'"

Simon had faith in his new recruits, who were still skeptical.

"I had my own biases against animation," Meyer says. "I loved what it could do. But just the fact that it had not succeeded in prime-time in a long time made me think that it wasn't the best career move."

Kogen recalled that his father, Arnie, an Emmy-winning comedy writer himself, advised his son against taking a job at *The Simpsons*. In the '80s, animation was considered a backwater. Cartoons were for kids, not aspiring sitcom writers.

"You just broke into show business, why would you work on a cartoon?" Kogen remembers his dad telling him. "It'll destroy you." Around that time, his father helped him set up a meeting with NBC chairman Grant Tinker. "And he said, 'Oh, don't do a cartoon,'" Kogen says. "So, the greatest people I respect were giving me really strong advice not to do it." But the warnings didn't faze him. "I knew that I was young enough that everything's recoverable," he adds. "If you're working on a crappy show, they'll give you a chance to work on another show pretty soon after that. You have to do a lot more really hard and damaging work to destroy your career. I didn't think I would do that."

And besides, Kogen wasn't in a position to be picky. Neither were the other young *Simpsons* writers. "We could have been on any show at all that would've offered us a job," Kogen says. "If it was *Webster*, I would've done *Webster*."

The first *Simpsons* writers were talented, but when it came to scripted television, they were greener than Krusty the Clown's hair. And they all knew it. Most sitcom staffs had more collective experience. So the writers took their cues from Simon.

"We didn't have those sitcom chops," Meyer says. "And frankly, we didn't really know how to tell a story, most of us. So we really learned from Sam. I had only worked on *Saturday Night Live* and *Letterman*. Nothing where you had, you know, a plot."

"It was important to him to make *The Simpsons* feel different than other half-hour shows, to have conceptual comedy elements like *SNL* and *Letterman* did," Vitti says. "That part of *The Simpsons* had everything to do with Sam's courage in hiring guys like us. And it wouldn't have worked if Sam hadn't known everything about writing half-hour comedy."

Simon's creativity felt effortless. Early *Simpsons* editor Brian Roberts used to watch his boss draw on whatever was in front of him. Even Simon's doodles were consequential. "I remember thinking, 'Damn, I should keep some of those napkins,'" Roberts says. "He would draw all this stuff. I remember going over to his house and he had the original drawing of Bleeding Gums Murphy behind his desk. And I said to him, 'Is that all you kept?' He goes, 'Yeah, I would just draw it,' and handed it over to the animation directors."

It was Simon, Vitti recalls, who came up with Mr. Burns's look. There's a reason why Homer's grotesquely skinny, almost beaked boss doesn't resemble all the other characters. "I saw Sam draw Mr. Burns for the first time and that's why he looks different," Vitti says. "Because he's drawn by Sam, not by Matt or one of the animators."

The way Vitti remembers it, Simon wasn't pulling a power move. He was just trying to speed up the editorial process. "Somebody sent him the boss for Episode 4, 'The Company Picnic,'" Vitti says. Originally Mr. Burns was a squat man, like Mr. Spacely from *The Jetsons*. "Sam turns to me like, 'No, no, no he should be very birdlike,'" Vitti says. "So he just went and drew, exactly, Mr. Burns. He didn't sneak it past Matt. Matt was probably off doing fifty other things at the same time."

In Vitti's first year at *The Simpsons*, he proofread and edited scripts for Simon. "One of the first things he said, early on—it was such a cool thing to say to story editors—was, 'Every *Simpsons* episode should be like no other *Simpsons* episode we've ever done,'" Vitti says. "And I just go, 'Oh, OK, cool. I'm in Hollywood now. I'm supposed to reinvent the show. The reason I arrived.' The last thing most showrunners want story editors to do is surprise them. But you not only could do it, it was part of your job description to surprise Sam and show him something he hadn't seen before. And it's amazing to write for somebody like that."

After a decade in TV, Simon knew the landscape well. He was tired of doing the same old thing. Sure, there were a few promising sitcoms—*Roseanne* was a slice of working-class life you didn't see much, *Murphy Brown* was a positive portrayal of a single career woman, and *Seinfeld* was a style of sentimentality-free comedy that had never been done before—but most weren't breaking new ground. In 1989, ABC introduced TGIF, its family-friendly block, and *America's Funniest Home Videos*, a crowdsourced clip show. Both were wildly popular and about as sharp-edged as a marshmallow. NBC was still drafting off of *The Cosby Show* and *Cheers*, and one of its biggest shows was *ALF*, which starred a furry puppet. CBS still had an eponymous hit sitcom from comedian Bob Newhart, but he'd been on TV since the '60s.

What united the newly assembled *Simpsons* writers wasn't necessarily dislike of specific network sitcoms, but rather the format itself. It was stale. And it felt small. "Most of us were a bit disdainful of the sitcom world," Meyer says. "It seemed to be stagebound." They'd been watching their whole lives. They were tired of being beholden to primetime TV's old traditions. They wanted to see if they could tinker with the formula.

In reality, Simon didn't set out to change America forever. What actually emboldened him was low expectations. He didn't think a

primetime cartoon would last long, so he had no interest in playing it safe. Armed with creative freedom and a group of similarly irreverent writers, he decided to play around with sitcom conventions and structure. That meant often starting an episode with a first act that was only tangentially related to the second and third. "That's from Sam," Kogen says. "And he says, 'Nobody's ever seen that. That's gonna be interesting to our audience. Because we're a cartoon, we can do it.' I think people were surprised that it wasn't as linear as a lot of stories are in half-hour comedy. You have a very limited time to tell a story. You don't really have time to tell two stories on most shows, but *The Simpsons* did because of the speed at which we were able to tell a story."

The writers packed every single episode with gags, large and small. "We don't have a laugh track, so we don't have to wait for audience laughs," Kogen says. "We can put a visual joke behind a verbal joke at the same time. And maybe it goes too fast for people to see it, but then they get it. And so at the time it was a little revolutionary." And more importantly, he added, "really kind of fun to see." The result was something that's almost endlessly sustainable.

"He thought he was building a show that was going to last thirteen episodes, but he was actually laying a really good foundation," Vitti says. "A lot of his work was to accommodate the weird writers who hadn't done a lot of thirty-minute comedy and give us a way to express ourselves. It had the unintended effect of helping the show run a really long time."

Whether he meant to or not, Simon provided a blueprint to follow when he was gone. His sensibility trickled down to the writers, who wanted to make the same kind of joke-packed, trope-busting show that he did.

Writer David M. Stern called Simon the best showrunner he's ever seen. "Because he was both the smartest guy in the room, but also he really understood how to set a table for competitive camaraderie."

Simon taught his protégés to fight for the biggest laugh, not public recognition. "It was intense, and you could sometimes have a bad idea mocked," Vitti says. "But it was really good about the best idea carrying the day."

And if Simon thought something you wrote was funny, it was a gift. Martin's first episode, Season 2's "Dead Putting Society," is about Bart and Todd Flanders squaring off in a miniature golf tournament. The writer included a scene featuring British broadcasters waxing poetic—like the boys are playing the eighteenth hole of St Andrews. "Soon, one man will emerge triumphant," one of the commentators says. "He will drink naught but champagne while his opponent tastes bitter defeat, in this oft-cruel game."

"We got to that and Sam Simon went like, 'Ah, this is really funny,'" says Martin, who was totally gobsmacked. "It's like, *What?* Every line goes through the same machine. And so things that *didn't* get rewritten stand out more to me."

Simon had legendarily high standards, which the writers desperately wanted to meet. "When you made Sam Simon laugh or smile, it would just light up your day," Stern says. "I mean, you wanted this guy to like you so much. Even though he scared the hell out of you, you lived for making Sam Simon laugh."

Stern's early *Simpsons* memories still make him cringe. Back then, he felt like an outsider. He'd landed a development deal with Gracie Films, but the pilot he wrote for Brooks's company never got made. Simon eventually asked him if he'd like to take a shot at writing an episode of his new animated series. "I jumped at the chance," Stern says. Before that, he'd gotten his hands on a few of the show's early scripts through his Gracie connections. He loved what he saw. "This thing was gonna be a monster," Stern says. But when it came time to work on *his* script with his new colleagues, he wondered if he'd made a mistake.

Stern called his episode "Blackboard Jungle." Simon said he hated the title, in front of all the other writers. "Before it's even cracked open, I'm like, 'Oh my God,'" Stern says. "My worst nightmare, you know? And I'm trying to get a handle on what I did wrong. And he goes, 'It just tries too hard. It's too conceptual. It's too clever by half.' Nobody knows me in there. It's a tense moment, you know? And I hear what he says and I'm like, 'What about "Bart Gets an 'F'"?' It was the simplest, stupidest thing I could think of. And the crocodile smile just creeped over his face, and he liked it."

As intimidated as Stern was, he appreciated his boss's directness. To the *Simpsons* writers, Simon's blunt criticism was often more helpful than his praise. Meyer recalled Simon slicing up his first script. "He just X'ed out a couple of pages," Meyer says. "I think it was a flashback that really wasn't necessary." The writer got so angry that he tried to argue the changes with his boss. But instead of fighting back harshly and putting Meyer in his place, Simon sent him off to do a mindless production task.

"That got me out of the room and allowed me to cool down," Meyer says. "He knew that's really all I needed. I mean, he could be prickly and difficult, but was a real savant when it came to human nature. And that's why his own writing was so good. And that's why he was able to bring out the best in us."

Simon was even funny when he didn't have to be. After he stopped working on the animated series on a daily basis, he was still punching up scripts. He always seemed to be able to pull great lines out of thin air. "He would think about it for a minute and then it would come out and it'd be hilarious," Roberts says.

In a script that Jeff Martin wrote, Ned Flanders calls his sons for dinner. One of the Flanders kids is so excited by what's on the menu, he shouts, "Oh boy, liver!" When Simon got his hands on an episode

outline, he scribbled in the margin, "Iron helps us play!" People *still* quote the line.

The writers looked up to Simon. But he wasn't the only boss they were trying to impress.

On his first day at *The Simpsons*, writer Jon Vitti met God. Sam Simon was giving Vitti a tour of the show's offices and Brooks walked by. "Hey Jim," Simon said, motioning toward his underling, "it's Jon Vitti."

Unsure who this Vitti guy was, Brooks stared straight ahead. "Like, *uh-huh*," Vitti recalls.

And then Simon clarified: "The author of 'Bart the Genius.'"

At that moment, Brooks's face lit up. "Hey, put 'er there," he said, shaking Vitti's hand.

Brooks's fondness for "Bart the Genius," an episode from the first season, made sense. It has both broad comedy—Bart enrages Homer while playing Scrabble by making up a word, "kwyjibo," that he defines as "a big, dumb, balding North American ape with no chin and a short temper"—and pathos: after swapping IQ tests with his brainy classmate Martin Prince, the fourth grader struggles to fit in at his new gifted school. In the final scene, Bart cops to cheating and expresses love and gratitude toward his father. It's the kind of genuine moment that Brooks loved. And it's also perfectly undercut by Homer getting hopping mad at Bart again. "I could have retired right there, and been completely happy with my writing career," Vitti says. "I had grown up loving *The Mary Tyler Moore Show*. If Jim Brooks had told me that I sucked as a writer, it just would've destroyed everything."

If Simon gave the show a brain, then Brooks gave it a heart. Take one away and the show wouldn't have felt so alive. "The combination of Jim Brooks's humanism and all these intelligent people not wanting

to settle for an easy joke is what makes *The Simpsons* what it is," writer Greg Daniels says.

After a tough childhood in North Jersey—his father left his family when his mother was pregnant with him—Brooks built his career on laugh-out-loud, emotional, grounded comedy. It was a combination not usually found in mainstream animation. He brought that humanistic formula to *The Simpsons*.

"Which became a tenet of the show," David M. Stern says. "That's the first thing he'd say. 'These aren't cartoons. These are humans.'"

Simpsons scripts even described scenes as if they were being filmed for a live-action series or a movie. From the start, the writers challenged the animators by paying homage to the classics.

"A lot of times scripts would say like, 'à la *Citizen Kane*,' so you could get an intention of what they were going for," animation director Rich Moore says. "And Jim Brooks really supported that."

From the start, Brooks wanted viewers to see that the Simpsons were, like every real family, flawed. "Jim Brooks actually had a really nice one-liner for the show at the beginning," Vitti says. "He called it, 'The American family in all its horror.'"

Bart and Lisa bickered like real siblings. And Marge and Homer fought like real adults. *Simpsons* writer Mike Scully remembers Brooks giving him a helpful tip about how to stage the couple's serious discussions. "He said, 'Put it in the bedroom, have them under the covers and ready for bed,'" says Scully, who got to the show in the mid-'90s. "And it just automatically makes it more intimate."

Even after going through hell, the Simpsons always managed to stick together. That was Brooks's doing. "The family does love one another," Moore says. "So you could have those moments of deep heart. And we understood that as directors. So we would lean into it

really hard in those moments, and then go broad in the comedy when it was appropriate."

While overseeing the first season of *The Simpsons*, for example, Brooks suggested an episode about Lisa feeling sad. In "Moaning Lisa," newly introduced jazzman Bleeding Gums Murphy advises the young saxophonist to play through her pain.

Yeardley Smith, who plays Lisa, once told me that Groening didn't think the idea would work at first. It was, after all, experimental for an animated series. "Matt Groening apparently says, 'You can't do that. It's a cartoon. This is a comedy,'" Smith said. "Jim Brooks was like, 'We're doing it.'"

At the time, Groening and Simon had given *Simpsons* staffers Al Jean and Mike Reiss three script ideas to choose from. They jumped on "Moaning Lisa."

"Mike Reiss and I say, 'Well, let's write this one because it's an emotional show and we had a chance to do it for Jim Brooks, which is a great opportunity,'" Jean once told me. But they didn't pick it just because it was Brooks's idea. They also picked it because it was a *Brooks idea*.

"It's one of the best episodes ever," Smith said. "I think part of the success of *The Simpsons*, and the enduring quality of it, is that despite all the slapstick, they never lost their heart, right? You had to have, for the most part, in every episode, one real moment where people went 'Huh?' and they recognized themselves."

Comedy writers can be deeply pessimistic, but Brooks's presence led the *Simpsons* crew to explore their feelings. Sometimes they even uncovered sentimentality they thought they'd long since buried. When Jeff Martin was working on "Lisa's First Word"—which is "Bart"—he wrote a line that melted one of his iciest coworkers. "Marge goes, 'Lisa's crazy about you. She thinks you hung the moon,'" Martin says.

"And George Meyer, who could be cranky, was like, 'Ah, that's so sweet. That's so touching.' I got him."

Even if the writers knew what Brooks liked, it was difficult coming up with stories, emotionally resonant or not, that he said yes to. The Emmy- and Oscar-winning producer was...discerning. Trying to sell ideas to him at the show's annual story retreats was intimidating.

"To pitch for two minutes to Jim Brooks is terrifying," Vitti says. He was a comedy kingmaker. His seal of approval was a big prize. A rejection from him was an ego blow. His non-confrontational nature made him even scarier to the writers, many of whom were used to the bluntness of the late-night TV world. "Even when Jim was going to completely not do what you say, it was always, 'That's great, buddy,'" Vitti says. "That was what you heard when Jim had no interest in doing what you had suggested."

When he *did* like your idea, he nurtured it. When Vitti turned in the first draft of an episode where Homer takes a miracle drug to grow his hair back and uses his newfound confidence to climb the nuclear power plant ladder, he got summoned to see Brooks. "It was totally being called to the principal's office," Vitti says. "It was like, 'Jim wants to see you, take your script.' I walked in and I was like, 'What is this?' He was really happy with my draft and wanted to give me notes for me to do a second draft on it by myself, rather than just immediately go into the group rewrite. I mean, just the fact that he read something that I wrote, and then thought it was *good*? Nothing could beat that."

By then, Brooks was deep into middle age. He had his own production company. He directed hit movies. He didn't hang out with the writers every day. But deep down, he still considered himself one of them.

Vitti still remembers something Polly Platt, Brooks's longtime collaborator, said about him: "I've never seen Jim happier than when he's with the *Simpsons* writers."

"That was like, 'Wow,'" Vitti says. "Because you're so desperate not to seem like a total loser in front of Jim Brooks. I mean, what more do you want as a writer? You want validation."

The writing staff looked up to Brooks and Simon. They also took after them. But they weren't just doing impressions of their heroes. Even early on, all of their individual personalities and comedic strengths showed up in the writers' room. And from the get-go, two members of the crew stood out from the rest. Without them, *The Simpsons* would not have become what it did.

CHAPTER FOUR
SO STUPID IT WAS KIND OF SMART

"MANY PEOPLE HAVE GONE INSANE TRYING TO SATISFY THEIR AUDIENCES. FORTUNATELY, IN MY CASE I HAD A HEALTHY DISDAIN FOR THE AUDIENCE ALL ALONG."

—GEORGE MEYER

The *Simpsons* writers were always searching for the perfect punch line. Sometimes, jokes came easy. Sometimes, the process was mentally exhausting. "Those were the longest hours of the show," Vitti says.

On this day, it was taking forever. The episode they were working on was about Homer banning Bart from seeing *Itchy & Scratchy: The Movie*. The fourth grader, whose awful behavior has led to the punishment, is devastated. His bad mood leads to a father-son chat.

Homer tells Bart that one day he'll thank him for this. Bart is incredulous. "No, it's true," Homer says. "You know, when I was a boy, I really wanted a catcher's mitt. But my dad wouldn't get it for me. So, I held my breath until I passed out and banged my head on the coffee table. Doctor thought I might have brain damage." At that point, Bart wonders, "Dad, what's the point of this story?"

This is where the writers got stuck. What was a surprisingly funny way for Homer to respond to Bart? No one could come up with anything. Everyone was silent. That is, until George Meyer said, "I *like* stories."

Everyone exploded in laughter.

In the *Simpsons* writers' room, this was a common occurrence. Jeff Martin, who told me the story, saw it happen over and over. "George would pitch these jokes where we'd just be like, 'That's perfect,'" he says. "'That's going on the air, and people will like that joke.'"

There are too many classic Meyer jokes to list here, but the example Martin often cites comes when Homer stumbles into a roadside honky-tonk. A quick exchange between two angry drunken rednecks follows:

"Hey you, let's fight!"

"Them's fightin' words!"

To explain Meyer's influence on the show, Martin turns to baseball's greatest modern thinker: statistical guru Bill James. "Bill James said that probably the leading skill that indicates you might be a big leaguer is the ability to hit home runs," Martin explains. "To be a TV writer, what's the skill? I would say the ability to write a fantastic joke. If people are still quoting it thirty years later, a joke is a home run."

In the '90s, *Simpsons* writers hit *a lot* of dingers. But the way Martin sees it, Meyer "hit the most." If the show's writers' room in those days was the 1927 Yankees, then Meyer was Babe Ruth.

And though he wrote several classic *Simpsons* episodes, Meyer was not at his funniest in front of a keyboard. He was at his funniest in front of other people.

"There's a difference to me in terms of script writing and room power," writer David M. Stern says. "Just strictly speaking in the room, George Meyer was the guru of the room. He's always coming at things with an angle that nobody else in the room is thinking of.

Everybody else is literally on the page. And George Meyer saw the big picture."

While working on the script about Bart entering a miniature golf tournament, Martin came up with the idea of his sister helping him prepare for it mentally. "I was like, 'I'm thinking maybe Lisa's teaching him Zen. *What's the sound of one hand clapping?*'" Martin says. As soon as he heard Martin repeat the koan, which is supposed to provoke thought and not a response, Meyer tried his best one-hand clap. Which is exactly what a wise-ass like Bart would've done—and ends up doing. "It's like, 'Oh, boy,'" Martin says. "It just seems like a joke someone *should've* thought of."

Meyer was always capable of making the other writers laugh when they least expected it. When they were trying to get jobs at *The Simpsons*, writers Bill Oakley and Josh Weinstein sent Meyer some of their best jokes and never heard back. Then in the mid-'90s, after Oakley and Weinstein had been working on the show for a few years, George found their sample packet in his office and gave it back to them—with a handwritten note: "Congratulations, you're hired."

It was important to have someone with the ability to bring up the mood of the writers, because making *The Simpsons* could be a real grind. They worked long hours, sometimes fixating on impossibly minute details. Greg Daniels coined a term for the type of microjoke that used to keep the writers at the office way too late into the night: a Gallipoli. It's a reference to an infamous World War I battle dramatized in director Peter Weir's 1981 film of the same name. "All these enthusiastic Australian volunteers were told to take some hill that didn't need to be taken," Daniels says. "And the other side was dug in with machine guns. The flower of Australian youth got mowed down trying to achieve this objective that didn't need to be achieved."

The metaphor is a wee bit hyperbolic. But I get Daniels's point: thinking too hard about ultimately inconsequential material could

suck the joy out of comedy writing. "We should've stopped and gone home at 10:15 or whatever," Daniels says. "Instead we went till midnight and killed our energies and enthusiasm."

Being stuck was soul-crushing. Solving the puzzle was exhilarating. Meyer seemed to be the best at finding an antidote to the drudgery. "Sometimes it was super fun. And often George was involved with what made it fun," Daniels says. "We would get into this jazzy sort of improvisational mood where the goofiness kept kind of escalating."

Meyer was always capable of nailing a walk-off joke. One that could save a script and send the writers home for the day. But that took a lot out of him.

"He was very hard on himself and sometimes he could get into a funk a bit where nothing seemed funny to him," Daniels says. "And I think it was related to having such high standards. Some people will pitch a bunch of things and they're OK if it's a half step toward the final idea. He never did that. He always pitched the final topper."

No one was a harsher critic of Meyer's comedy than Meyer. Even some of his jokes that are considered classics make him cringe. One of my favorite bits of his involves Bart feeding a disparaging line to Springfield Elementary's striking teachers, who play a literal game of telephone with it. "Skinner says the teachers will crack at any minute," the final person in the chain says to Mrs. Krabappel, before adding, "Purple monkey dishwasher."

"It's so silly," Meyer says. "At the time, I felt it was slightly hacky. It had the word 'purple' in it. But I don't know, let's not be pure."

In practice, Meyer's grand comedic vision was actually pretty myopic. To him, the only way to make a good sitcom was not to seek approval from anyone outside the writers' room. After all, he trusted its collective sense of humor more than the public's.

"Many people have gone insane trying to satisfy their audiences. Fortunately, in my case I had a healthy disdain for the audience all

along," Meyer says with a laugh. "I never, never particularly wanted to please them, honestly. We were just doing this stuff to make ourselves laugh. I mean, we say that a lot, but it's totally true."

While working on a successful TV show, comedy writers normally had to repress their gonzo urges. Networks didn't want to risk alienating the audience they'd built. But the *Simpsons* brass encouraged their staff to embrace what they found funny, no matter how oddly specific it was. It was the perfect place for someone like Meyer.

"He's the best comedy writer in the history of comedy writing," Oakley says.

With one possible rival.

He was middle-aged, towered over almost everyone he met, smoked cigarettes, and had looks that would've allowed him, if he'd so chosen, to pursue a career impersonating David Crosby. In a room of comedy nerds who, in Jay Kogen's words, enjoyed "acting like little goofy idiots," John Swartzwelder stuck out.

There wasn't anyone like him on staff—or in the world. "I recall just how singular he was," Meyer says.

If comedy writing has a Paul Bunyan, it's Swartzwelder. Except instead of a blue ox, he rode a beat-up Datsun B210. "It ran really hot," Vitti says. So hot, writer Mike Scully says, that there was always "smoke spewing out the back." Editor Brian Roberts described it as the kind of car Pig-Pen from *Peanuts* would've had if he were old enough to drive, full of papers and packs of cigarettes.

"He was like a character out of a '40s or '50s movie," says producer Joe Boucher, who worked closely with the creative staff in the early days of the show. One whose diverse comedic influences went all the way back to Preston Sturges films, radio plays, and the Algonquin Round Table, the famed New York literary society. He loved making

old-timey references that went back centuries. He was...an original. And unlike most of his younger colleagues, he'd lived a full life before becoming a TV writer. In the '70s, Swartzwelder was an adman. He knew how to churn out copy. And not just junk.

At *The Simpsons*, no one has ever been as prolific. Swartzwelder alone wrote fifty-nine episodes, still by far the most in the history of the series. Forty-four of those aired in the '90s. "People never properly appreciate how much of the creative development of the show in the early seasons consisted of John Swartzwelder writing a script that jumped way out in front of anything else that had been done," Vitti says.

Every *Simpsons* script got reworked by the writers communally. But Swartzwelder's scripts needed the least punching up. "It's just the pace runner in a race, and you're killing yourself trying to catch up," Vitti says.

Vitti still can't believe how much Swartzwelder squeezed into his scripts without pissing off their bosses. "Because you were sort of a bad person if you handed in more than fifty-four pages, he would just make the margins super wide and hand in fifty-five pages that would format out to sixty-one pages as soon as you hit the normal format," Vitti says. "He said, 'I'm actually a really slow writer, but when I'm on a script, I wake up, I work on my script, I eat, and I go to bed.' And so, at the end of those four weeks, when you looked at it, it was amazing how much stuff he had put in. When you would read the script, it was incredibly inspiring. And then you would finish the script and it was incredibly depressing. It was like your mood would plunge so fast when your brain turned to, 'How am I going to write a script that can be watched alongside this?'"

Swartzwelder was sui generis. But in the writers' room, he wasn't aloof. In fact, he was an open book. You could consult him, and he'd happily share his knowledge and wisdom. "I worked every day with

John Swartzwelder for four years," Vitti says. "And it was so good. You could watch him, you could talk to him, you could ask him questions."

Swartzwelder was more than willing to share his specific philosophies about how to make *The Simpsons* a good TV show. In his head, for example, Homer was a big talking dog. And that's how he'd write him.

"One moment he's the saddest man in the world, because he's just lost his job, or dropped his sandwich, or accidentally killed his family," Swartzwelder said in a 2021 *New Yorker* interview, the only substantive one he's ever given. "Then, the next moment, he's the happiest man in the world, because he's just found a penny—maybe under one of his dead family members."

Arguably Swartzwelder's most famous *Simpsons* joke comes in the Season 8 episode where Springfield brings back, then repeals, prohibition. Homer celebrates the reversal with a toast: "To alcohol! The cause of, and solution to, all of life's problems."

"His jokes have a whole other layer of satire and sometimes pathos that often speak volumes about American society," Oakley says.

Swartzwelder actually buried Homer's now legendary salute to booze in the middle of his script. When it came up in the writers' room, Scully remembers looking at Meyer and saying, "This is insane. This has to be the final line." It got moved to the end of the episode. After all, the joke couldn't be topped.

Without officially running the show, Meyer and Swartzwelder helped shape its comedic sensibility.

Back then, Meyer relished finally getting the chance to make fun of primetime TV tropes while working in primetime TV. On the small screen in those days, tidy endings were standard. Almost every sitcom episode had a clear resolution. Usually a lesson was learned,

and all the characters moved on to the next week with clear heads. One of Meyer's earliest *Simpsons* episodes laid waste to that approach. In "Blood Feud," Bart donates his blood to an ailing Mr. Burns, who tries to repay him with a thank-you note. Things wrap up without ever wrapping up. The family even openly struggles to figure out if there's any lesson to be learned. When Lisa theorizes that there's no moral to the story, Homer chimes in with, "Exactly! Just a bunch of stuff that happened."

Unsurprisingly, Meyer wrote some of the show's most subversive episodes. Arguably his best-known *Simpsons* classic, though, is about religion. It was series canon that the Simpsons went to church every week. "Missing one service was presented as a pretty serious breach," Meyer says. "And Marge wasn't happy about it." With the help of Mike Reiss and Al Jean, Meyer came up with the idea of Homer skipping church on a freezing cold morning and not regretting it. "The idea that it was the greatest day that Homer ever had, I think, was so fun and liberating," Meyer says.

In "Homer the Heretic," the titular character wraps himself up in bed like "a big, toasty cinnamon bun" while his family huddles in a church with a busted furnace. "There were literally icicles hanging on the walls," Meyer says. "It perfectly matched the kind of chilliness of the message." At the end of the episode, when the devout Ned Flanders saves him from a fire, Homer regains his faith. It wasn't a sign that Meyer's feelings about organized religion had changed. It was his and the writers' way of staying true to the ethos of *The Simpsons*.

"We all had our problems with authority growing up and with the culture—there were things that bugged us," Meyer says. "But if we didn't love those things too, the whole show would've just had a sour kind of ax-grinding quality that we didn't want. So even when we sent stuff up, it was done with love and appreciation."

As a result of that balance, the show was at heart good-natured despite its distrustful leanings. Maybe it wasn't totally optimistic about human nature, but it wasn't totally pessimistic either.

"I would say it kind of transcends those categories, because it is essentially saying that you have to throw yourself into the mainstream of life," Meyer says. "And you don't just want to be on the edges with slingshots and taking potshots. You have to be immersed in it and of it as well as observing it."

Swartzwelder's approach was slightly more...anarchic than Meyer's. Swartzwelder loved writing a joke that created so many logical problems that it was hard to pinpoint why the gag didn't make sense. The example Vitti used to explain this approach came in the third-season episode "Dog of Death," when the Simpsons are trying to win the lottery. Bart asks his father what he'd do if he hit the jackpot, and Homer starts daydreaming. Swartzwelder came up with the idea that Homer would imagine himself as a golden, jewel-encrusted giant. "I was like, 'How would having money make him *larger*?'" Vitti says. And yet seeing a gilded Homer towering over Springfield is funny. No matter how preposterous it was.

"It became an aspiration of everybody else to make something so stupid, it was kind of smart," Vitti adds. "You could create a moment that had five logical problems at once. But you just blow by it like it totally made sense."

Vitti also liked to ask Swartzwelder philosophical questions. No one in a writers' room full of sharp comedic minds thought about things quite like he did. His perspective was unique.

"Who do you write for?" Vitti once asked him. "Who do you picture watching the show?"

"I'm writing to what we like to think ourselves as having been," he replied. "I picture a smart kid."

Like usual, Swartzwelder was on to something. The *Simpsons*

writers, consciously or not, were making a series that their cleverly impressionable younger selves would've been obsessed with.

Meyer and Swartzwelder stood out from the rest, but everyone in the writers' room had a different comedic bag of tricks.

Wallace Wolodarsky and Jay Kogen, in editor Brian Roberts's words, were "off-the-wall funny." Kogen, after all, was the son of a comedy writer. "So he was very well versed in jokes," Meyer says.

One of Kogen's favorite writers' room bits was feigning death whenever there was a loud noise. "You would look outside and see what it was, and when you looked back Jay was lying limp with a pencil in his ear and a perfect glassy-eyed stare," Vitti says. "And you were free to do as much 'Oh my God, Jay's dead!' as you felt. Pre-dated Kenny on *South Park*."

Wolodarsky was the perfect partner for Kogen. Meyer says that he "brought an acerbic, streetwise quality to his episodes. He was also a fan of vintage movies and criminal argot from the gangland era, which made its way into the show."

The duo pushed the early development of a handful of iconic characters, especially Krusty the Clown and Mr. Burns. And they weren't afraid to stage elaborate set pieces like monster truck rallies. The Simpsons' world, after all, didn't *have* to be confined to Evergreen Terrace. "They painted in such bright primary colors," Vitti says. "They gave license to all of us to do the same thing."

Writing partners Mike Reiss and Al Jean were similarly in sync with each other. "I think Mike and Al were complementary," writer Bill Oakley says. "To vastly oversimplify it, Mike was kind of the joke guy, and Al was kind of the logic and story guy."

Jean took a scientific approach. "He has a very logical, methodical mind," Oakley says. "And I think he was able to run that complicated

system perfectly." And Reiss was as energetic as Jean was reserved. Vitti calls Reiss "one of the best joke writers of my generation."

After Simon, Reiss and Jean ended up running the show. They were fastidious about the animated series. "Sam was a bit more, 'Yeah, that's fun. That made me laugh. I like that. Didn't get a laugh at the table read but I like it,'" Martin says. "Mike and Al were very rigorous about, 'Let's have every train on this track, every car on this train is a solid "A" that got a good laugh in the room.'"

Vitti may have been the most versatile of the group. "Vitti has heart," Oakley says. "If you look back at those earliest seasons, many of the episodes that are the most emotional are his. Suffice to say, there were an ample number of guys on the show who were the zany guys."

Oh, and Vitti was funny. "He was really good at coming up with clever things," Meyer says. "One of the first I remember was Bart changing the spelling of 'COD PLATTER' to 'COLD PET RAT.'"

Martin was the music man. He wrote some of the best songs on *The Simpsons*. The first was a "New York, New York" send-up that Tony Bennett actually sang. "That one's special to me because I hadn't been working there long at all, just several weeks," says Martin, who'd also written songs on *Letterman*. "You're insecure."

He also came up with the music and lyrics for "Capital City," which is a cheerful tune about a borderline dystopia. "Everything's a little off about it," Martin says. "'People stop and scream hello.' 'It's against the law to frown.' That *sounds* happy, but, 'You'll caper like a stupid clown.' 'Once you get a whiff of it.' It's like, '*What?*'"

Martin also was able to nail family dynamics and sibling relationships in ways that the other writers sometimes couldn't. "Jon Vitti's mom paid me a nice compliment once," he says. "'You can tell from Jeff Martin's episodes that he has kids.'"

There was no shortage of individual brilliance at *The Simpsons*, but writing the show was a group effort. Collaboration, as much as

singular talent, made the series what it is. "Suddenly you're in a room with Swartzwelder, and Vitti, and Meyer, and Jay Kogen, and Wally Wolodarsky, and Jeff Martin. Reiss and Jean. Everybody's throwing in great stuff," Conan O'Brien, who came on board as a writer, once told me. "That's the part of that show that I think was so magical: everybody comes together in this very communal way...I always count myself very lucky that I was invited to play around in that world for a while."

CHAPTER FIVE
LIMITLESS, LIMITLESS, LIMITLESS

> "THERE'S A LOT OF, 'TAKE ME BACK TO THAT MAGICAL MOMENT.' WHAT YOU WANT TO SAY IS THAT MAGICAL MOMENT IS FRIED FOOD, A CRAPPY COMPUTER...A LOT OF FEAR, LONELINESS, AND SECOND-GUESSING."
>
> —CONAN O'BRIEN

Making a TV show from scratch was chaotic. That's why it was important to have Brooks around. While the creators of *The Simpsons* were tinkering with things, he helped shield the makers of the animated series from the powers that be. "It was the first time anybody tried to start a fourth network and so there's a lot of pressure," editor Brian Roberts says. "There were a lot of eyeballs on us, especially from up above."

But thanks to his status, Brooks was able to institute something that turned out to be extremely influential: the network brass would not be involved in the creative side of the show. "When you're begging someone to do a show, which is what we were mostly doing in those days, you let them do their thing," says Garth Ancier, Fox's head of programming. "He knew me well enough to know I was not about to cramp him."

That meant no notes on scripts.

"That was absolutely crucial to the success of *The Simpsons*," Jeff Martin says. He can still hear Brooks's euphemistic instructions on how to deliver each completed episode: "Put it in the mail slot." And then it's done. "That helped give the show a distinctive voice," Martin says, "an edge."

"The more people put their fingers in it, there's less of a chance you come up with something that's very interesting and unique," Jay Kogen says. "The more homogenized things become, the less interesting they become."

Back then, having that kind of freedom was almost unprecedented. "Very rare," Kogen adds. "You wouldn't get that on any other network." But Fox granted it. All because of Brooks.

The James L. Brooks no-notes rule became legendary. After all, he managed to do what most comedy writers couldn't: get the paper pushers off his back. "We truly never saw Fox executives," Martin says. "Didn't know what they looked like."

When I asked former Fox executive Sandy Grushow about the no-notes policy, he admitted having mixed feelings about it. "Because it really diminishes the role of network executives, which of course, all creatives love to do," he says with a big laugh. "We're just knuckleheads and obstructionists. And I know that's not true, because I worked on shows like *90210* and *Melrose Place*, and those shows wouldn't have lasted beyond the year had we not gotten in there and rolled up our sleeves."

But, Grushow adds, "In the case of *The Simpsons*? Yeah, there was virtually no network or studio involvement."

One note on the no-notes rule: it's often slightly misunderstood. First, not all feedback from the network was destructive. "You'd love to be self-flattering and say, 'We could do our great ideas and not have to do their stupid ideas,'" Martin says. "And I've gotten dumb notes.

But I've gotten smart notes, too." The problem was that notes, good or bad or somewhere in between, were a time suck. Not having to deal with them was a luxury.

"Just the simple procedure of it takes time," Martin says. "So, OK, we've addressed their notes, now we don't have quite as much time. We don't have quite as much energy."

The Simpsons was made in a bubble that burst long ago. George Meyer is still wistful about it. "I was just thinking the other day about how different the creative environment was when we were working on Season 1," he says. "We had very little feedback other than ratings numbers and some reviews in newspapers and magazines. No notes from the studio or network, no social media opinions, no blogs, no podcasts...you get the idea. It was glorious!"

Given full creative control, the writers filled the first season of *The Simpsons* with belly laughs, irreverent humor, and heartfelt moments. And thanks to Brooks and Simon, the show had funny guest stars—like Brooks's *Broadcast News* collaborator Albert Brooks, *Cheers* star Kelsey Grammer, and actor-director Penny Marshall.

Larina Adamson remembers being in the room when Albert Brooks recorded his lines as Jacques, the suave bowling teacher who woos Marge, unsuccessfully. Listening to him go off script with Julie Kavner made it hard for her to stay composed. "To watch Julie sit there and ad-lib with him without laughing, oh, it was very difficult," Adamson says. "You were in this open room with these mics. So you had to be quiet."

Even from the start, the lack of network notes wasn't the only reason that writing for *The Simpsons* was liberating. Kogen remembers working on an early script. He'd been writing sketches on *The Tracey Ullman Show*. For him, this was another world.

Kogen was used to pitching sketches set in a single location. There was only room for a handful of characters onscreen at once. And at

most, a scene went on for ten pages. But a half-hour cartoon was different from a variety show.

Springfield was populated by people from all sorts of backgrounds. And though the show was a cartoon, it was grounded in reality. Brooks insisted on it. "It wouldn't have cartoon logic," Kogen says. In other words, this wasn't *Looney Tunes*. If a character got hit in the head with a giant hammer or fell off a cliff, he got hurt. Beyond that basic rule, the possibilities were endless.

"Limitless sets, limitless effects, limitless characters," Kogen says. If you wanted to cut to a jet plane or a football game, you could. "And to just go there for like a quarter of a page," he says, "is a great luxury for a writer." There was, he added, only one limitation: "It had to be about the family."

The show was called *The Simpsons* for a reason. Homer, Marge, Bart, Lisa, and Maggie were its heart. "It's gotta have an emotional underpinning," Kogen remembers Brooks saying. "We've gotta care about these people, like they're human beings and not drawings. And every time we sort of veered off into the silliest, biggest parodies, we'd be pulled back into what's real."

In the Season 1 episode "Homer's Odyssey," credited to Kogen and Wolodarsky, the Simpsons patriarch's incompetence as a Springfield Nuclear Power Plant safety inspector leads to Mr. Burns firing him. Unemployed and feeling hopeless, he writes a suicide note, ties a boulder to himself, and walks to the closest bridge with plans of jumping off. He finally has a change of heart when his family rushes in to save him from an oncoming car. With his will to live back, Homer goes on a public safety crusade. He makes it his mission to solve the town's traffic problems. Then he takes on his former employer before Mr. Burns rehires him.

Kogen and Wolodarsky enjoyed filling the episode with physical comedy. They also managed to sneak in a tongue-in-cheek parody

of a 1960s nuclear energy propaganda film. "We couldn't have done that on *The Tracey Ullman Show*," Kogen says. "And we wrote about a three-eyed fish. That's not easy to do on any show. It can only be done in a cartoon. That's unfair to the nuclear power industry, but fuck it. We had a great time doing it, and it was very freeing."

The thing about Hollywood, though, is that creative freedom doesn't guarantee success. It may be hard to believe now, but *The Simpsons* was no sure thing. After all, there was no blueprint for what the show's writers, producers, and animators were building.

To Meyer, the animated series felt small-time. The idea that the people behind an adult cartoon were working in the same vicinity as, say, the producer of blockbuster movies *Die Hard* and *48 Hrs.* was funny. "There were other people in the building, and some of the people seemed to be much more on the ball than we did," Meyer says. "There just seemed to be a lot going on and we did not seem like the preeminent show on the lot."

It may not have felt that way to Meyer, but the show actually had a big presence at 20th Century Fox. The studio was on Pico Boulevard in Century City, a now mostly glass-and-chrome Los Angeles business district that served as Fox's backlot until it got sold off in the 1960s. The show's team was spread out across the lot. "*The Simpsons* wasn't under one roof," Brian Roberts says. "I would call it eight different outposts."

Gracie Films was originally headquartered centrally, in bungalows. Roberts remembers Brooks's office being filled with his Oscars and Emmys. Polly Platt and Richard Sakai had offices in there, too. "There was a kind of a conference room/screening room," Roberts says. "It wasn't huge." Near Gracie Films were makeshift offices where producers like Larina Adamson, Joe Boucher, and Mike Mendel spent their days. "Two double-wide trailers," Roberts says.

Roberts worked out of a space in what used to be Shirley Temple's bungalow. In a soundstage between Sixth and Seventh Streets, an orchestra recorded the show's music, including Danny Elfman's iconic theme song. "There was a live chorus singing 'The Simpsons' and an 80-piece orchestra performing the theme song in the larger adjacent scoring stage," Roberts recalls. "They did it to picture, and the first time we heard and saw it was magical. Kind of a Danny Elfman meets *The Flintstones* and *The Jetsons*. Utterly unique."

The cast recorded their dialogue in an adjacent building. Then there was the Stars Building, where Sam Simon and Matt Groening had offices. The original writing staff was small enough that it initially gathered for group rewrites in Simon's office.

The writers got a building of their own. It was a small, garden-style multi-unit complex. "It really did look like an apartment building," Roberts says. "And you always knew who was there because you knew everybody's car."

It was so strangely iconic that it's still known as the Simpsons Motel. "It's a two-level thing and all the offices are open to the outside," Vitti says. "So, on a rainy day, you would have to get rained on a little bit going back and forth between the rewrites. For a long time, it was clearly the worst offices on the Fox lot. They would renovate the offices when a show got canceled and then nobody would use it for a while. *The Simpsons* never got canceled and so it was not great when we got it, and it just got older and dirtier and dirtier."

The rewrite, or "writers'," room, where the group punched up scripts together, was on the second floor. "It was definitely a campus feel," Roberts says. In other words: it was like the frat house in *Revenge of the Nerds*, with less charm and fewer women. The writing staff piled in and didn't file out until their scripts were as funny as possible. There was nothing picturesque about it.

The furniture was old and cheap. The carpet was soaked in a slurry

of spilled soda and coffee. There was an old window-unit air conditioner that did a poor job of clearing out various...scents.

"It *was* cleaned regularly," Meyer says. "The surfaces weren't that sticky, but it did have kind of an odor of French fries and onions."

"I'm sure we've all documented its grossness for you," Vitti says.

"I wouldn't say it was gross," writer Bill Oakley says. OK, fine, he adds, "it was medium gross." He compared it to the common room in a college dorm, right down to the residents' habit of throwing stuff at the ceiling—including, Kogen recalls, a glob of mashed potatoes.

One Christmas, someone mailed the show's staff a gift basket stuffed with a panettone. Soon after the Italian fruitcake's arrival, the writers started using it as a volleyball. "We would bat it around the room," Oakley says. Before long the room needed to be vacuumed: it was filled with crumbled bits of pastry.

The writers' methods of procrastination were, well, rudimentary and juvenile. "We had a sticklike thing in the rewrite room, which was similar to one of those two-piece cue sticks that screws together," Meyer says. "And just because we were bored—and it was before fidget spinners—we used to screw that thing together, unscrew it, screw it together, unscrew it, and then hand it to the next guy. And that would go on. I think it mainly peaked in the Conan years. And when he got the job doing his own show, I sent him that stick because I thought it would remind him of home."

Some of the writers also went through a phase where they kept unlit cigarettes in their mouths. "I think I might've started it," Meyer says. "I used to buy these menthol cigarettes and I didn't want to smoke, but I liked having something in my mouth. And I especially was trying to perfect the idea of sticking it in the very corner and have it dangling like a French person. And I remember that kind of going around. And even sensible people like Mike Reiss were doing that for

a while. It's harmless. But it looked really stupid. We looked like a bunch of eleven-year-olds."

Writer John Swartzwelder was not one of those posers. He smoked cigarettes, Meyer says, "incessantly." He had a smokeless ashtray, Oakley adds, "But it didn't work that well." Kogen remembers him puffing away outside the writers' room and then poking his head in to suggest jokes and lines of dialogue.

"That room was dilapidated, but it didn't smell bad," Oakley says. "Except when people left their half-eaten lunches in the trash."

About lunch...

At *The Simpsons*, it wasn't just a break. It was a treat, an event, and a salve. Days in the writers' room sometimes felt like they lasted forever. "Just twelve hours in that room," Martin says. "That's what it was."

You couldn't get away from it, even if you tried. "This was before the days of cell phones, so you didn't have anything to distract yourself in the room," Oakley says. "There was nothing but work all day long. All day long. Food became your entertainment."

Writers obsessed over lunches, which often grew to be three-course meals. Hey, Fox was paying! "You wanted to order as much stuff as possible to take up your time," Oakley says. That meant gorging on an appetizer, an entrée, and a dessert. Occasionally, people would order whole pies from L.A. greasy spoon The Apple Pan, then nosh on them over multiple days...or just hours. They sampled all kinds of restaurants, from fast-food joints to sub shops, standard chains to upscale establishments.

As the show progressed, lunch—and if the workday went long, dinner—orders became more extravagant. "I would order extra shrimp cocktails and take them home to my family," Oakley says. "That was because we were like, 'This is such an arduous job and it's our only pleasure.'"

Eventually, Oakley adds, ordering became *aggressive*. "I remember there were several occasions where we would order the most expensive things on the menu just for fun. I know I ordered caviar one time. I think that story got out. I remember I heard that agents were talking about it."

In the early '90s, producer Larina Adamson handled everything from organizing cast recording sessions to making sure the show stayed on budget. She estimates that in those days, staff meals cost Fox more than $300,000 a year. That was a drop in the bucket for a network that was part of a massive studio, but Adamson still once felt the need to confront a writer for overindulging. "I said, 'Why are you ordering two lunches?'" Adamson says. "And he's like, 'Because I eat them and I want them.'"

Eating so many big lunches, combined with having access to a snack room filled with things like Doritos and Oreos, left Oakley feeling as bloated as the show's food budget. After he quit the animated series, he says he lost sixty-five pounds.

But Oakley still doesn't regret his gluttony. It helped the writers get through some tough stretches. Every afternoon, the sound of a production assistant coming up the stairs with lunch caused everyone in the room to salivate.

One day in the early '90s, Oakley remembers, he heard the unmistakable sound of crinkling wrappers. Then a loud scream. "And the sound of all that stuff rolling down the stairs," he says. "Oh my God. And we're like, 'Oh, shit. This guy's injured. And more importantly, our lunch is ruined.'"

The writers then sprinted out to the hallway. There was no wounded PA. It was just Conan O'Brien, who'd filled a cardboard box with garbage and thrown it down the steps. "Just to screw with us," Oakley says.

"That was such a devastatingly effective prank," Vitti says. O'Brien even went as far as making sure some of the trash he used was Styrofoam—to properly match the sound of real takeout containers.

"It's certainly the funniest thing that happened at *The Simpsons* when I was there," Oakley says.

A *slightly* less funny story from those days involves Vitti and the Simpsons Motel's most charming feature: its old outdoor fountain filled with live goldfish. "The goldfish were your friends," Vitti says. "When your table reading went badly, you would walk—I would, anyway—the perimeter of the fountain and look at the fish like, 'Oh, those fish are so happy.'"

One day, a facilities worker changed the water in the fountain. That weekend, Vitti drove to the Fox lot to cram. "I was behind on my script and deadline was approaching," he says. "I didn't trust myself to focus if I worked at home."

When Vitti reached the fountain, he came upon a grisly scene. All of his little friends had floated to the top. "Well-intentioned, but it turns out, I learned, you can't change too much of the water or all the fish die," Vitti says. What happened next, he adds, was even worse: "The studio cats started fishing the dead goldfish out of the water, half-eating them, and leaving their carcasses outside your door." In Vitti's words, it was "the ultimate Simpsons Motel experience."

There's no real moral to the story. But it's a reminder that creative work is rarely as fun as it sounds.

For the early *Simpsons* writers, this wasn't a nine-to-five job. They devoted their days to writing and rewriting scripts. That's really it. "Basically 100 percent," Jeff Martin says. "We would show up at 10 o'clock and we would work till 10 o'clock, usually."

Since most of them were in their twenties and thirties and few had children yet, the show was their life. And besides, this wasn't *ALF*. They wanted to make the animated series as funny as it possibly could be. That could take a frustrating amount of time.

Boucher remembers once watching Simon standing at the door for almost half an hour while trying to come up with a single short

exchange between Homer's friend Barney and Lisa. It was late at night and Boucher just wanted to go home. "We were going on twenty-five minutes of him just looking at some of the writers in the room," he says. "And I looked at him and I was like, 'Can you guys do this later?' And he looked at me like he wanted to punch me. And he was like, 'Joe, you have somewhere else you need to be?' And I'm like, 'Yeah, I do.'"

O'Brien used to drive his Ford Taurus into the Fox lot every day and on most weekends. He spent countless hours there agonizing over their scripts. "Jon Vitti had the office next to me," O'Brien once told me. "We would both click away for a couple of hours. Then the two of us would walk to a vending machine on the lot, which was deserted." It wasn't exactly a charmed existence.

"Something that happens a lot in this business, if you're lucky enough to have been part of an episode of TV that gets discussed or remembered fondly, is there's a lot of, 'Take me back to that magical moment,'" O'Brien said. "What you want to say is that magical moment is fried food, a crappy computer—or in my case, a legal pad because I was a technophobe—a lot of fear, loneliness, and second-guessing."

And sometimes dead fish.

As hard as the people behind the animated series worked, and much as they cared about their new show, not everything they did was very well thought out. To fans, *Simpsons* lore is sacred. But many of the earliest behind-the-scenes creative decisions were accidentally consequential.

The most famous one was Homer's iconic "D'oh!" It was originally written as "annoyed grunt." And Dan Castellaneta made it his own. It's the first example of a word from *The Simpsons* entering the lexicon. The thing is, the people making the show weren't trying to come up with catchphrases. They were, in fact, anti-catchphrase. In the '80s and '90s, sitcom writers leaned on them to the point of parody. By the

end of *Diff'rent Strokes*, for example, Gary Coleman had said "What you talkin' about, Willis?" so many times that he got sick of it.

And yet, in the early years of *The Simpsons*, young Bart Simpson spits out one-liners by the handful. "I'm Bart Simpson, who the hell are you?" pops up in the very first episode. "Don't have a cow, man," "Ay, caramba!," and "Eat my shorts" followed. So how did Bart become the king of early '90s catchphrases?

Well, those catchphrases weren't actually imagined as cheap gimmicks. It was Sam Simon's way of saying: *See, television influences kids!* "We're not going to make up taglines for Bart," Vitti recalls Simon saying. "Bart repeats taglines he's seen on TV."

Even if they were intended as social commentary, Bart's catchphrase phase didn't last. "We were very serious comedy writers," Vitti says. What he means is *self*-serious. "We were so quick to say we've done something too much."

Blissfully, Bart wasn't the Fonz or a Teenage Mutant Ninja Turtle. But like most kids his age, he *was* impressionable. "People said, 'Do you guys think that "Cowabunga!" is an original phrase?'" Vitti adds. "You'd have to explain to them: *This is what a kid would do.* Bart is not original. Bart doesn't come up with 'Got any cheese?' or 'Did I do that?' Bart repeats stuff he saw on TV." Other foundational aspects of the show can't be explained as sly satire. Vitti remembers when the writers decided that Homer needed a pal. "We were under orders to try to reuse designs as much as possible, because we had so little money and the animators were so stressed out," he says. "So it's like, 'Who can we make Homer's friend? Well, there's that drunk guy he had a fight with in the bar in the first episode.' I remember laughing. 'That's Homer's best friend?!'" And that's how Barney Gumble became Homer's best friend.

Homer's other buddies, Lenny and Carl, have a similarly boring origin story. "They're my fault," Vitti says. After falling behind while

writing "Homer's Night Out," Vitti tossed the duo into his script. They were just supposed to be in the background. "If you had told me that day that Lenny and Carl were going to go longer on TV than Frasier Crane, I just would've been sick to my stomach," Vitti says. "It's like, no thought. I think in later years, they actually started to get some quality jokes based on what terrible characters Lenny and Carl were."

The writers filled in the supporting cast with familiar characters. "Most shows, a classroom has three friends, one nerd, and one bully," Vitti says. "Bart has one friend, there's one nerd, and four bullies. Which kind of says something about where we're at." It made sense: for the writers, that's what childhood was like. They were brainy. They shared many of the same creative influences, pop culture references, and general point of view. Even the handful of writers who *didn't* go to Harvard felt a kinship with those who did.

"I went to UCLA and my writing partner went to UC Santa Cruz, so we weren't Harvard guys," Kogen says. "But these other guys who mostly came from Harvard were super smart, super funny, super nerdy. You know, our kind of people."

The *Simpsons* writers' room, where they spent hours upon hours punching up scripts, was nothing like a typical school. The balance of power flipped. The nerds were cool.

There were days when producer Joe Boucher, a college athlete, felt like he didn't fit in. "People probably always looked at me as kind of the jock," he says. "I was a lacrosse player. I was constantly playing lacrosse, pushing the sport. I was always judged, the way *they* were probably looked at as *Harvard Lampoon* writers."

Their braininess helped give *The Simpsons* its distinct voice. But it was only natural that the homogenous makeup of the writers led to some obvious creative blind spots. Back then, the people staffing writers' rooms weren't terribly concerned about diversity. And that sometimes showed.

For example, Kwik-E-Mart owner Apu was originally described in a first-season script as a "clerk." In his memoir *Springfield Confidential*, Mike Reiss, in hopes of avoiding cliché, wrote that he even added this bit of stage direction: "THE CLERK IS NOT INDIAN." But at a table read, Hank Azaria gave the character a stereotypically Indian accent. Everyone in the room laughed. He based the portrayal on the Indian and Pakistani store cashiers he interacted with growing up in New York. The white, Jewish actor has also admitted that his performance was partially inspired by *The Party*, a movie starring Peter Sellers in brownface. Azaria has said he didn't realize what he was doing was offensive. Neither did the writers. From their point of view, Apu was one of the smartest, most hardworking characters on *The Simpsons*. He was an immigrant who represented the American dream.

But over time, Apu transformed into a symbol for the need for proper representation in movies and television. There were, after all, very few people who looked like him on TV. Years later, comedian Hari Kondabolu made a documentary about how Apu became a stand-in for all South Asians. To him, Apu was a caricature whom bullies wielded as a weapon. The movie came from a place of love. Growing up in the '80s, Kondabolu was obsessed with the show. "You can criticize something you love because you expect more from it," he said in an interview, echoing something his mother once told him. For better or worse, that was the power of *The Simpsons*: it imprinted itself on American pop culture.

At the time, television *had* gradually become more creatively progressive, especially in its portrayal of women. *The Cosby Show* had Clair Huxtable, an attorney who balanced work and family life and refused to let chauvinism slide. She even caused what media critics dubbed the "Clair Huxtable Effect," which resulted in more characters like her being featured prominently on TV. Murphy Brown, a single career woman who chose to become a single mother, was the next step

in that evolution. It had been a long time coming. For decades, sitcom women were, like in real life, often relegated by men to subservient roles. As feminist Betty Friedan put it in 1964, "An American woman on TV is portrayed as a stupid, unattractive, insecure little household drudge who spends her martyred, mindless, boring days dreaming of love—and plotting nasty revenge against her husband."

James L. Brooks's most famous sitcom, *The Mary Tyler Moore Show*, was a reaction to that kind of midcentury sexism. Mary Richards was an independent career woman. His work, from *Rhoda* to *Broadcast News*, had strong female characters. With him around, *The Simpsons* was not going to have retrograde gender politics. (Fox's very own *Married...with Children* made fun of Al Bundy's piggish behavior and attitudes, but it also made a meal out of women being shrill and humorless. Al's nemesis was Marcy D'Arcy, a feminist who couldn't take a joke.) Marge was a homemaker who, sometimes singlehandedly, kept her family together. Unlike Clair Huxtable, she didn't make it look easy; she didn't have that luxury. Uncoincidentally, Lisa was the show's moral center. Even at her young age, she was a budding feminist who called out corruption and unfairness. The show ridiculed misogyny.

There was, then, some irony in the fact that the *Simpsons* writers' room was a boys' club. This is indisputable. In the first five seasons of the show, only two episode scripts were credited to women. The first woman on the writing staff, Jennifer Crittenden, got hired before Season 6. Mimi Pond, a cartoonist friend of Groening's, wrote what ended up being the series premiere. But she was never offered a full-time job. She's said in interviews that Sam Simon, who was going through a divorce at the time, didn't want a woman around.

"I feel like I was just as qualified as anyone else who came along and got hired on the show, and it was just because I was a woman that I was, you know, not allowed entry into that club," Pond said in

a 2017 interview with *Jezebel*. "I always wind up being the turd in the punchbowl because the show is so beloved and everything, and I'm sorry to burst bubbles but it wasn't a pleasant experience for me."

Looking back on that time wasn't fun for Pond, who understandably felt like she deserved a real shot to regularly contribute to the show. "Just in terms of being denied the opportunity to participate in something that became that big is kind of a drag," she added. "And then having to explain this over and over is the biggest drag of all."

Nell Scovell, who went on to have a long TV writing and producing career, had a slightly better experience with *The Simpsons*. She applied for a job on *Tracey Ullman* but didn't get it. But with the help of Jean and Reiss, who she'd met at *It's Garry Shandling's Show*, she was able to pitch ideas at *The Simpsons*.

"*The Simpsons* employs about twenty-eight writers now, but when I walked into Sam Simon's office in the spring of 1990, there were fewer than ten," Scovell wrote in her memoir, *Just the Funny Parts*. She inflated the size of the current writers' room a tad, but she was correct about the original one. There were only eight writers to start, which meant there was room for freelancers to throw out ideas. In those days, a typical TV season was twenty-two episodes long.

"I recognized Al and Mike, and was introduced to Jon Vitti, Wally Wolodarsky, Jay Kogen, and George Meyer. Sam Simon sat behind a desk while the rest sunk into sofas. I sat on a chair rolled in from the outer office. The all-male room was welcoming but intimidating."

One of the episodes Scovell pitched, about Homer's brush with death after he eats poison fugu at a sushi restaurant, got the green light. Brooks even chose the third act she suggested over one that Simon did. The episode aired in 1991 and is considered a classic, but she was never offered a staff gig.

"There are things about *The Simpsons*, they're totally indefensible," Vitti says. The fact that the series had a writing staff made up of all

white men didn't completely stifle it creatively, but it certainly made its point of view more myopic. There's a reason why Lisa starts off with one friend, Janie. And Marge has none. Vitti acknowledges the obvious: "A lot of it is a reflection of the fact that we didn't have any female writers."

In the early days, there were only a handful of women who worked on the creative side of the show. Daria Paris was Simon's assistant. She helped keep the writers' room on track. "Daria took incredible notes in the story meetings and rewrites," Roberts says. "In a room full of writers who threw 100-mile-per-hour fastballs all day every day, she had to write it all down at breakneck speed." Doris Grau was a script supervisor whose gravelly voice led to her being cast as Lunchlady Doris. "An amazing lady," Roberts adds. "I thought it was hilarious that they put her in the show."

The era's gender disparities never fazed producer Larina Adamson. She was used to being around the kind of guys who worked at *The Simpsons*. "They came from backgrounds, you know, where I don't think a lot of 'em had a lot of female interaction," she says with a laugh.

There was still a misguided sense that women couldn't hang in the male-dominated comedy world. Guys swore! They made off-color jokes! Women might have to shield their virgin ears in the writers' room! "I've been in a lot of them, sure," Adamson says. "They get kind of dirty and nasty." But she knew that was a bullshit excuse. "Of course, female comedians were all quite dirty back then," she says. "They could be gross, too." The fear among the men running all the shows, she adds, was pretty simple: "If you have a female in there that's uber-, uber-, uber-sensitive, you can get yourself into trouble." In other words, if there was a woman around, there's a risk that you'd get called out for being inappropriate. It also didn't help that in the late '80s and early '90s, women were still portrayed in pop culture as shrill and humorless.

That's the world Adamson came up in. She started labeling tapes at ABC, moved on to cutting promos for the network, and then became a producer on the short-lived *Max Headroom*—a science-fiction satire about a computer-generated TV host whom most of America knew from his appearances in commercials for New Coke. "Even at ABC when I was doing promos, if there was a guy who was competing with you," Adamson says, "they would figure out ways to discredit you." In the late '80s, Gracie Films hired her to work on *The Tracey Ullman Show*. And after that, she landed a job as a producer at *The Simpsons*.

Adamson wasn't famous—though her friend Cameron Crowe *did* cast her as a member of the divorced women's group in *Jerry Maguire*, a Gracie Films picture—but her contributions shouldn't be overlooked. Without any fanfare, she made sure the complicated series ran smoothly. She was a bridge between Gracie and Fox, managing script reads, voice recording sessions, and budgets. The kind of work that was both difficult and taken for granted. If Richard Sakai, Brooks's right-hand man, wasn't up for doing any logistical tasks, she'd pick up the slack. "I took all the dirty work, what he didn't want to do," she says. "You had to do what you had to do back then. You just had to figure it out."

"She has this delightful combination of vulnerability and toughness that I really like," Meyer says. "Which served [her] well on a show, I think."

Adamson helped the show run smoothly. But as one of the only women around, she says she got stuck with more than a few "bullshit jobs." Things she had to do when no one else wanted to do them. Things that the guys didn't have to do.

When Kelsey Grammer came in to record his lines as Sideshow Bob and decided to catch a few winks, Adamson had to deal with it, because no one else wanted to. "We're down there recording, and he falls asleep on the couch and starts to snore," she says. "Oh my

God. But who has to tell him to wake up and go sleep somewhere else? I did."

And when James L. Brooks wouldn't start a recording session because he didn't have a cup of coffee, Adamson had to find one. "I went through the whole building looking for coffee," she says. "And when I brought him coffee, he said to me, 'You'll go far in this business.'"

That kind of patronizing reaction annoyed Adamson, who worked for the show off and on until the late 2010s. "That whole coffee moment to me was like, 'Are you kidding me?'" she says. But when the boss needed some caffeine, she had to do something about it. "You know what? I was relieved," she says. "Because the minute I got him coffee, we could continue with our day."

It was the kind of thing she often did without having to be asked. Because if Adamson didn't do it, she knew no one else would. That's what life was like then for women working in Hollywood. Even if they didn't experience harassment or antagonism, they were often casually subjugated. "I'm sure if you talk to any women who were in the industry back then," Adamson says, "they *all* experienced different degrees of what I experienced."

Making the show was chaotic, the writers were green, and a primetime cartoon still seemed like a risky bet, but by the second half of 1989, the first season of *The Simpsons* was rounding into shape. But it was unclear what the finished product would actually look like.

The creative staff of the show was cramming to finish the thirteen episodes that Fox had ordered. The writers churned out the scripts, and the stateside animators at Klasky-Csupó storyboarded each one, provided instructions for color and camera positioning, and then sent the directions to AKOM Production Co. in South Korea. Outsourcing part of production was a common way for networks to keep costs

down since animators overseas made significantly less money than American animators. The first episode the company produced was "Some Enchanted Evening," revolving around a fugitive babysitter voiced by Penny Marshall. It was supposed to be the series premiere. When the tape arrived that fall, a group of Fox executives and the *Simpsons* brain trust gathered to screen it.

"We were all there with this amount of anticipation," Roberts says. "It was like fifty people."

But the episode was a disaster. AKOM hadn't mastered the show's style yet. The animation, color, and sound were off. Few jokes landed. Scenes were missing. There was also a sequence where Bart, Lisa, and Maggie are watching a cartoon called "The Happy Little Elves Meet the Curious Bear Cub." In hindsight, it sounds innocuous. Director Kent Butterworth and some animators, however, went rogue and added shots of a bear cub tearing off an elf's head and drinking his blood. "Not exactly a minor addition," Groening said back then.

When the show ended, Brooks was silent. Then he said this: "Can we thin the room out a little?" That instant, dozens of people left in a whoosh. "So fast it almost created a vacuum," says Roberts, who remembers either Simon or Brooks grabbing his arm and telling him to stay.

Producer Joe Boucher was among the handful of people who stuck around. "I was standing right by the door and I was like, 'You know what? I'm working too hard on the show, I'm not leaving,'" he says.

"Well, I made Joe stay with me in there," says Larina Adamson, who was also in the room that day. "Because I wasn't gonna be in there myself. I just looked at Joe and I say, 'You're staying in here because I can't do this on my own.'"

What happened next is the stuff of legend. "Everybody has their own way to remember it," Boucher says. "*I* remember Jim just kind of stammering, like, 'That was shit.'"

Rich Moore, who was also in the room, recalls that Gábor Csupó, the show's executive animation producer in America, got angry. In an attempt to defend what they'd just seen, he asked, "What do you mean, 'It's shit'?" Brooks's reply, at least in Moore's memory, went something like this: "By shit, I mean it is a substance that smells bad and is odorous and makes people unhappy."

An upset and embarrassed Csupó didn't back down.

Vitti recalls Csupó's reply, in slightly broken English: "Maybe your script shit."

"You have to remember, this is a man that escaped Communist Hungary to come to America to make animation," Moore says. "So, he would tell these stories of how harrowing it was to get out of the country. And it's like, well, once you've been through something like that, sitting in a room with a producer that's saying, 'This is shit,' it's kind of nothing."

The argument ended, but the problem remained. "It was like, 'What the fuck are we going to do now?'" Roberts says. "We can't show this to anybody. *Keep it under wraps. We've got to fix it.*"

The staff, reasonably, thought that *The Simpsons* was over before it started. "It really totally seemed like the show had failed," Vitti says. "And it's like, 'OK, well it was an unrealistic goal. You can't do a weekly animated show. We can't produce it. The show's dead.' We just knew that we had wasted our summer, and it was time for people like me to go back east and get a real job."

But Brooks was undaunted. "Jim thought creativity came out of adversity," Adamson says.

Brooks temporarily shelved the disastrous potential debut, the first and only episode that Butterworth ever directed. Miraculously, one of the next to arrive from South Korea was much better. "Simpsons Roasting on an Open Fire" was irreverent, warm, and funny. Bart gets a tattoo and its removal comes at the cost of the family's Christmas

budget. Homer works as a mall Santa to make up the deficit, and the story ends happily, with the adoption of greyhound track reject Santa's Little Helper. Thanks in part to director David Silverman, the festive installment actually looked polished. It felt like the perfect series premiere.

"David's style all the way going back to film school was to round out characters, make them a little smoother," says Roberts, Silverman's classmate at UCLA. "You can see the beginnings of really what *The Simpsons* would become."

Another episode, "Bart the Genius," also came back around that time. Vitti, Simon, Brooks, and Silverman, the director, spent a screening of it laughing. Vitti, who wrote it, could sense Brooks's relief. "Jim had so much money at stake and had accepted that the show was dead," Vitti says. "I remember Jim saying, 'It's like getting a reprieve from the governor.'"

With Brooks feeling like the show got a stay of execution, Fox finally gave *The Simpsons* a premiere date: December 17. In the late '80s, a Christmas TV special was an *event*. It'd be easier to promote than a regular episode. The holiday season was coming up fast, so there was no time to roll out a methodical marketing campaign. Sandy Grushow knew that he had to call an all-out blitz.

"One of the conversations I had with Barry and Jamie Kellner, who was the president of the network, was the need to get off our own air to buy advertising," Grushow says.

The network was building momentum, but it still only aired primetime programming on weekends. In-house ads, even if they appeared relentlessly, weren't going to be nearly enough to drum up nationwide interest. So Fox bought as many radio, print, and cable TV ads for *The Simpsons* as possible. "We spent a lot of network dollars," Grushow says.

At first, *The Simpsons* was a hard thing to sell. Al Ovadia was Fox's product licensing and marketing vice president. He was trying to create a merchandise line for a cartoon for adults that most adults hadn't heard of, for a network that carried little cachet. "People weren't all that knowledgeable about Fox or its line of programming," Ovadia says. "The challenge was pretty herculean."

By then, Hollywood studios had long since figured out that their movies and TV shows could sell merchandise. *Star Wars* and its toy line was only the beginning. From 1980 to 1989, sales of licensed products jumped from $10 billion a year to $64.6 billion annually. Before *The Simpsons*, *Teenage Mutant Ninja Turtles* and Tim Burton's *Batman* each sold more than half a billion dollars' worth of merch. Marketing execs at the time were like prospectors, mining the entertainment world for gold.

Ovadia, for one, didn't think *The Simpsons* would be the next red-hot property. When he started working to license it, he didn't even have finalized artwork to present to toy and T-shirt companies. The cheaply made *Tracey Ullman* shorts didn't look like something you could build a slick merchandising campaign around. There *were* a few *Simpsons* deals in place when Ovadia got his job. But he had to get rid of them. "There was a T-shirt licensee and there was a school supplies licensee," he says. "I fired them both, because they had produced and distributed merchandise without approval."

The first *Simpsons* licensing contract Ovadia signed, during the *Ullman Show* days, was with Butterfinger. Ferrara Candy Company made the crumbly peanut butter chocolate bars, which got stuck in my preteen teeth every single time I ate one. "It was a six-figure deal," Ovadia says. "Which was almost as much as that department had made the prior year." That was miraculous, considering the Simpson family didn't even have their own show yet. No one was more shocked by the deal than their creator. "Although he acknowledged

he was surprised that there was commercial interest in his work, Mr. Groening said he was pleased with the opportunity to do advertising," the *New York Times* reported. "The agency did put restrictions on his expressiveness, however." What did that mean? "We couldn't say carrots are boring," Groening said.

The first *Simpsons* Butterfinger commercial, featuring Bart holding one of the candy bars hostage from Lisa and Maggie, aired almost a year before the full-length animated series debuted. It ended with Bart delivering a catchphrase that helped sell tons of chocolate over the next decade and a half: "Nobody better lay a finger on my Butterfinger."

Before the series premiere, Ovadia's bosses tasked him with getting a *Simpsons* balloon into the Macy's Thanksgiving Day Parade. The holiday extravaganza, broadcast to millions of American homes every year, would be the perfect showcase for Fox's brand-new animated sitcom. A few weeks before the premiere, a five-story-tall inflatable Bart on a skateboard floating through Manhattan would surely drum up interest in *The Simpsons*.

The problem was, it was a complete Hail Mary, thrown by a network desperate for splashy promotion. No one involved in booking the department store chain's signature event had apparently ever seen *The Tracey Ullman Show*, let alone the animated bumpers buried inside of it. "They said, 'I don't know what *The Simpsons* are,'" Ovadia recalls. "'We appreciate the call. We're not biting.'"

Then Fox sent journalists *Simpsons* screeners, and around October, they started writing about the show. Feature stories understandably tended to focus on Groening, a subversive indie cartoonist who, against all odds, had landed a Hollywood TV deal.

"The press, God love 'em, love the story," says Brad Turell, then Fox's head of publicity. "David versus Goliath. It's this little cartoon. The characters are great. It's Jim Brooks. It's Barry Diller. It's *right*. And I won't say it writes itself, but you know, it's pretty fucking good."

In the days before the series premiere, dozens of newspapers printed their reviews. They were so overwhelmingly positive that Brooks called Grushow and asked him to create an in-house ad that was just a collection of raves. "His recent past was the movie business, and that's driven by reviews," Grushow says. "And I came from the movie business. And so there we sat trying to figure out which reviews we wanted in the spot. And the reviews were incredible. I mean, just one love letter after another."

Even after seeing one episode, critics picked up on what made the show great. "They're a bickering family of five lovable mutants with yellow skin, golf-ball eyes and absolutely no resemblance to *The Brady Bunch*," Howard Rosenberg wrote in the *L.A. Times*. "Weird...but wonderful."

"What the reviews started to point out, which became very much our rallying cry," Grushow says, "was that even though it was a cartoon, even though the characters were yellow and funny-looking, that it was somehow more realistic than a show like *The Cosby Show*, which was far and away the most successful show on television."

Eight days before Christmas, as the lead-in to a two-part *Married...with Children* episode guest-starring extremely caustic and extremely popular comedian Sam Kinison, *The Simpsons* premiered. More than thirteen million homes tuned in to the Christmas special. According to Nielsen, the company that's measured TV audience size since the '50s, it was the second-highest-rated program in Fox's short history.

"I remember getting those numbers and going, 'Holy shit,'" Grushow says. "From there, clearly we had great confidence that the show was going to be successful."

On the other hand, the writers, cast, and crew weren't so sure. In December, they gathered for a staff Christmas party at a bowling alley in Santa Monica. Everyone got a free "Barney's New Bowlarama"

bowling shirt—in the series, we learn that the old one burned down—and they watched the first episode on the TV monitors hanging above the lanes. It was a celebration, but no one there, including John Swartzwelder, knew what was coming next. "If you had said the show would still be on in 2024 we would have been surprised you said that," he said much later.

Unbeknownst to them, *The Simpsons* was about to become a phenomenon.

CHAPTER SIX
BART VS. COMMERCE

WOMAN 1: "IF I HEAR ONE MORE THING ABOUT THE SIMPSONS, I SWEAR I'M GOING TO SCREAM."
WOMAN 2: "AT FIRST THEY WERE CUTE AND FUNNY, BUT NOW THEY'RE ANNOYING."
— *TREEHOUSE OF HORROR II*

On January 14, 1990, Bart Simpson began to take over America. That night, Fox aired "Bart the Genius." The second *Simpsons* episode, which attracted nearly as many viewers as the premiere, was a star vehicle for the mouthy fourth grader. That night, the country heard him say "Eat my shorts" for the first time. He blatantly cheats on an intelligence test. And he blows up his chemistry experiment and turns green. In other words, he steals the show. He did that a lot back then.

We had seen plenty of adolescent boy stars on network TV. Before Bart, there was Opie, Dennis the Menace, the Beav, Arnold from *Diff'rent Strokes*, Alex P. Keaton, Webster, and Fox's own Bud Bundy. Precociousness was a reliable formula.

But Bart was a different kind of wise-ass. It wasn't only that he pulled pranks, cursed lightly, and disrespected authority—he was just so *confidently* irreverent. That attracted young viewers, who were

obsessed with everything about Bart. He was a more evolved version of every other charismatic kid they'd watched on TV. Children idolized him, even though he was a cartoon. "The whole whirlwind," Jeff Martin says. "I like how you look, I like how you sound, and I like what you're saying and doing."

Preteens didn't just like Bart. They wanted to *be* Bart. He was a funnier, bolder version of themselves. But most importantly, he was still a kid. Writer Jon Vitti remembers Groening saying that "a perfect Bart Simpson action is really smart and really stupid at the same time."

"A lot of Bart's ideas, they're clever," Vitti says, "if you don't play them out for forty-eight hours."

Growing up, the writers were more like the bookish Lisa than Bart. But it was the ten-year-old boy's pure snark that appealed to their base comedic instincts. "It's funny to remember just how much Bart was the engine initially," Martin says.

During the first season of the show, which spanned the first half of 1990, Bart gets a tattoo, becomes a general and mobilizes his forces against bully Nelson Muntz, cuts off the head of the statue of town founder Jebediah Springfield, goes to France as a foreign exchange student, and saves his hero Krusty the Clown from being framed for murder.

That was the year Bartmania took over America.

Bart was, in some ways, a product of what kids were watching on TV at the time. For the most part, programming aimed at them wasn't terribly educational. Popular cartoons like *Teenage Mutant Ninja Turtles* and *Transformers* were hyperviolent. Hell, there were animated series based on the *Rambo* and *RoboCop* movie franchises. And most family sitcoms, while wholesome, weren't very enriching. Or all that funny. In the real world, it's the kind of stuff little Bart would've watched and mimicked.

What the writers didn't expect is that kids would start repeating Bart's lines in *real life*.

"Showing kids corrupted by TV was part of the general goal," Vitti says. "Although we then would sometimes become part of the problem."

Even if it was the writers' attempt at satire, they realized that all those catchphrases had helped create one of the most commercial characters ever. There was more to their artistically rich show than that. So they gradually stopped feeding Bart one-liners. But they died hard. After all, "Eat my shorts" and "Don't have a cow, man!" sold a lot of T-shirts.

How many exactly? By the spring of 1990, stores had sold fifteen million *Simpsons* tees. That sounds absurd, but it was a sign of the show's explosive popularity. Between thirteen and fourteen million American homes on average were watching each episode of the first season. During that stretch, the cartoon finished in the top 10 in the Nielsen ratings seven times.

Fox had its biggest hit ever. The network wanted to capitalize. In the months following the premiere, dozens of officially licensed *Simpsons* products hit stores. But no single item was more of a sensation than the Bart Simpson T-shirt.

At the time, writer Jeff Martin had a Disneyland annual pass. While walking his toddler around the theme park, he noticed that Bart seemed to be more popular than Mickey Mouse. "We'd go on the weekend instead of going to a playground," he says. "Man, just *Simpsons* T-shirts *everywhere*."

The graphic T-shirt had long been an American wardrobe staple. But in the '80s, as the country veered away from dressing formally on a daily basis, sales of tees skyrocketed. Stores like The Gap, restaurant chains like the Hard Rock Cafe, and dozens of touring bands sold millions of them. *The Simpsons* shirts supercharged that craze.

The humble T-shirt was the perfect *Simpsons* product: cheaply made, affordable, and wearable by all. Al Ovadia had never seen product move as fast as Bart Simpson tees. "They were getting the most volume and we were generating the most licensing revenue from T-shirts," he says. That first year, Fox essentially built a T-shirt cannon with unlimited range. It sprayed *Simpsons* tees across the world.

Ovadia thought that making deals with two screen printers to produce the first batch of officially licensed *Simpsons* T-shirts, which were heavily Bart-centric, would be enough to meet public demand. Shirt Shed Inc. made cotton-polyester-blend tees that sold in mass-market stores like Walmart. Changes made 100 percent cotton tees that sold at higher-end retail locations like Macy's. The printers were facing high-six-figure orders by March 1990, but couldn't keep up. Stores across the country sold out of *Simpsons* shirts on the day they arrived.

"That's how intense it was in the early months and probably the first year or so," Ovadia says. "It just went nuts." At one point, a manager at Macy's in San Francisco phoned him in a total panic. "Begging me, *begging* me to get more T-shirt licensees," he says. "Because Changes could not fill the orders fast enough."

Ovadia tried to be reassuring. He said that more *Simpsons* tees were on the way. "You don't understand," the exasperated Macy's rep replied. "We're pulling the boxes onto the sales floor." Customers didn't even wait for the Bart Simpson "Cool Your Jets, Man" shirts to hit the racks. They just grabbed them out of the boxes by the fistful as fast as they could.

As those shirts were selling by the millions, schools began banning them. Well, one style specifically: "'Underachiever' and Proud of It, Man!" "To be proud of being an incompetent is a contradiction of what we stand for," one small-town elementary school principal said back then. "We strive for excellence and to instill good values in kids."

Bart's T-shirt slogans seem almost quaint now—the National Museum of American History has an "Underachiever" tee in its collection—but back then they shocked adults. "It was so unbelievably edgy to say 'hell' and 'damn' on TV, and *the kid* was saying it," says Helen Boehm, then Fox's vice president of public service and children's programming. "Everybody wanted to have him on their T-shirt."

The "Underachiever" shirt is the one piece of *Simpsons* clothing that my academically minded, liberal parents banned me from wearing. Groening didn't buy the backlash. "Whenever kids have too much fun at something, somebody finds it's not good for them," he said. "If you'll read the T-shirt, it says, Bart Simpson, quote, underachiever, unquote. He has been labeled an underachiever and his response to that is, he's proud of it. He didn't call himself an underachiever, he does not aspire to be an underachiever." It seemed a *tad* far-fetched that an elementary schooler wearing the shirt would understand that distinction.

When I relayed my story to Martin, he replied, "You tell your mama she's got a point." To the writer, the "Underachiever" tee just felt wrong. "Matt had a convoluted justification for that, that didn't quite hold water," Martin says. "And I thought, 'Uh, I don't think we should tell kids it's good to underachieve.'"

Newspapers and local TV stations around the country covered the controversy. Naturally, Ovadia told me, this led to the already wildly popular T-shirts selling at an even faster clip. Debbie Siegel, understandably, still never bought me one.

With T-shirts flying off the shelves, corporations now wanted to be associated with Groening's little cartoon. Ovadia recalls being at the Hilton in midtown Manhattan for the annual Licensing International Expo in 1990. Not long after the event started, a swarm descended upon the Fox

booth. "There must have been—I swear to God—forty people screaming at me, wanting to make a license agreement," Ovadia says. He no longer had to beg big brands to take his calls about *The Simpsons*. "It was insane. This was a relatively new gig for me. I'm not completely unaware of what's going on, but it was overwhelming."

That day, Ovadia was the pied piper. "They were following him everywhere, it was nuts," says Steve Peña, an attorney who worked on merchandising and licensing for Fox. "It was weird because Fox had never had a property like that. At least since *Star Wars*, I think."

"People wanted to put the Simpsons on virtually anything," Ovadia says. The way he remembers it, a conversation he had with one manufacturer went something like this:

"I want to license toilet paper."

"We're not gonna do that."

"Come on. Why wouldn't you license toilet paper?"

The off-kilter ideas didn't stop at bathroom tissue. Someone else pitched *Simpsons* condoms. "All these other sort of weird things that you would never do for the sake of the show," Ovadia says. But he couldn't blame anyone for trying.

The thing is, no one involved in making *The Simpsons* expected it to be this *huge*. The show screamed cult following, not cultural phenomenon. It was a cartoon for adults created by an independent artist on a fledgling network. When *Los Angeles Times* critic Howard Rosenberg lovingly called the series "a guerrilla attack on mainstream TV," it felt like he was describing a program that aired on a cable-access station at 1 a.m. on Friday nights.

But bomb throwers, it turned out, *could* appeal to a broad audience. They just had to be really funny. Which *The Simpsons* was. Groening's motto, he once said, was "entertainment and subversion, in that order."

Yet that sensibility alone didn't make the show ubiquitous. As soon as the series premiered to high ratings and sparkling reviews,

Fox's marketing efforts went into overdrive. Executives were eager to shill the best series in Fox's short history. The story of *The Simpsons* isn't only about what happens when some of the smartest people on earth are given creative freedom. It's also a tale of hyper-aggressive commercialism.

The show became *the* consumer phenomenon of the early '90s. Which is more than a little ironic, considering how mercilessly it mocked America's many capitalistic excesses. Bart's hero Krusty the Clown would endorse any product, no matter how crappy, and sucked every penny out of his young fans' pockets. (Er, their parents' pockets.) Mr. Burns is a miserly billionaire who hoards his wealth. And in almost every episode, there's at least one commercial for a fictional product that over the years has become less far-fetched. The "Good Morning Burger" that Homer once lusts over—eighteen ounces of ground beef soaked in butter, bacon, ham, and a fried egg—now sounds like an item that Guy Fieri would try on *Diners, Drive-Ins and Dives.*

And yet, more than any other sitcom in the history of television, the animated series had a tight hold on American consumers—and their kids. The contradiction of a corporate marketing machine pushing TV's most subversive show is obvious. Then again, it's not the first time art and commerce have joined forces to make many people rich. Though that wasn't necessarily the intention of the people making *The Simpsons.* "We weren't aiming at commerce," Jay Kogen says. "We just fell into commerce."

There was clothing, toys, video games, beach towels, bedsheets, coffee mugs, lunchboxes, candy, fast-food promotions, and even an album—which went double platinum. Not every product was well made, but there was a measure of quality control. After all, Groening had approval over all merchandise.

"Matt was the overarching heartbeat of the program because he knew instinctively what made sense and what didn't make sense

for each character," Ovadia says. "There were probably things that I would like to have done that he said no to. And there were things that I hadn't thought of that he suggested. We had, I felt, a really good relationship."

The arrangement was mutually beneficial. Long before anyone at Fox realized that his show was going to be a hit, Groening had negotiated for a high percentage of merch sales. He had no clue the series would succeed, but it was his creation, and he wanted to make sure he received a fair share of any potential profits. It was a coup for the underground cartoonist, whose signature appeared on just about every *Simpsons* item on the market.

For the writers, watching the show they'd helped bring to life become a monster in 1990, during its first season, was surreal. *The Simpsons* wasn't just on their TVs. It was on T-shirts worn by millions of kids across America. And the rank and file wasn't getting a cut.

"Merchandising, that's when the rain really fell. It was like, the pinball machines, the T-shirts," editor Brian Roberts says. "Everywhere I went, it was like I couldn't get away from it."

Thirty years later, Jon Vitti is happy he still gets *Simpsons* episode residual checks. But back then, the merch made him salty. "Because we were penniless, we would get bitchy if a T-shirt came out with a line on it that we wrote," Vitti says.

Kogen tried not to let the effects of the craze faze him. "I mean, if I had a piece of the merchandising money, I would've cared a lot about it," he says with a laugh. But as the show took off that first season, he understood why some of his colleagues felt a bit more shortchanged.

"I remember George [Meyer] kind of trying to lead a revolution," Kogen says. "*They're making billions off our work and they're paying us peanuts.* That kinda thing. Like, we have to fight the man."

Kogen felt that there was no other choice but to make peace with what *The Simpsons* was turning into: a cash cow. "That's the bargain

we made," Kogen says. "If it becomes a giant hit for 20th Century Fox, then they get all that money. And so does Jim Brooks, and so does Sam Simon, and so does Matt Groening. We're just gonna make this really funny TV show."

Kogen and company may have been focused on making a really funny TV show, but it was hard to ignore that, not even a season in, *The Simpsons* was no longer just a TV show. It was inescapable. And that was bewildering. "*The Simpsons* was an important cultural thing," Kogen says. "And it was so much fun to be there on the inside."

The Simpsons was now culturally important enough to be made fun of on *The Simpsons*. The writers were smart and self-aware enough to realize that. They relished addressing the phenomenon in the most meta way possible. The first segment of the show's second Halloween special was a parody of W. W. Jacobs's horror short story "The Monkey's Paw." The tale concerns the titular object, which grants its owner's wishes. And is also cursed.

Early on in the episode, Bart wishes for his family to be rich and famous. Moments later, while the suddenly wealthy clan is having dinner at the Gilded Truffle, two well-dressed women are talking about them. "If I hear one more thing about the Simpsons," one says, "I swear I'm going to scream." "At first they were cute and funny," the other replies, "but now they're annoying."

Soon a nerdy guy is complaining about the high price of a Bart T-shirt. While listening to the calypso song the Simpsons cut at a record store, Otto the bus driver recoils and says, "Man, this thing's really getting out of hand." When Helen Lovejoy comes across a billboard featuring Bart saying, "Get a mammogram, man!" she self-righteously whines, "Is there anything they won't do?" And when Lisa's wish for world peace results in aliens Kang and Kodos invading Earth and taking over, a man blames the Simpsons for it. "Before I

was just bored with their antics and their merchandise," he says. "Now I wish they were dead."

As Fox was trying to keep up with the official *Simpsons* merch craze, bootleggers launched an *unofficial* merch craze. "People were selling *Simpsons* T-shirts on the side of a freeway," Kogen says. "They were counterfeited. *Simpsons* stuff was everywhere."

In the early '90s, Bootleg Bart Simpson was as iconic as the real Bart Simpson. Enterprising T-shirt makers dropped him into all sorts of designs, which ranged from clever, to stupid, to silly, to transgressive, to offensive. There was Air Simpson, Teenage Mutant Ninja Simpson, Safe Sex Bart, Bart Sanchez, Frat Bart, Local Sports Franchise Bart, Pro–Gulf War Bart, Sexy Bart, Gay Bart, Homophobic Bart, Deadhead Bart, Stoner Bart, and Anti-Drug Bart.

There's one pornographic design that Vitti still can't get out of his head. "The word balloon was, 'Don't have a cow, man. Mom, she lost her pacifier,'" he says. "You can figure out the cartoon from that. It was all these weird iterations of stuff."

There were even Bootleg Bart subgenres, most notably Black Bart. Early Def Jam Recordings president Bill Stephney, who both signed and produced the rap group Public Enemy, was a *Simpsons* fanatic. He still remembers seeing Black Bart shirts pop up all over New York City.

"There's this entire aesthetic that develops in the early '90s of Afrocentricity," says Stephney, who spent the '80s and '90s marketing and publicizing hip-hop acts. The ideology, which peaked in popularity at that time, centered African culture and its influence on the world. In America, Afrocentric iconography made its way into music, TV, movies, and fashion.

"There would be—on 125th Street or on Fulton Avenue in

Brooklyn or Jamaica Avenue in Queens—these T-shirts of an Afrocentric Bart Simpson," Stephney says. Today, he wonders if an African American Bart making a Black Power fist—even if created by a Black artist—might be considered too silly for the modern racial justice movement. "Fast forward to today in a post-BLM, post–George Floyd world, that stuff would not fly," he adds. "But thirty years ago, when perhaps the sensitivities were not as precise as they are today? Everybody in the community loved Bart Simpson. I didn't place too much importance on whether it was rebellious or provocative politically. I think it was just a very funny show."

The day that anti-apartheid activist and future South African president Nelson Mandela addressed the crowd at Yankee Stadium in June 1990, vendors in Harlem were selling tees emblazoned with a version of Bart Simpson with brown skin, Nikes, a chain with an Africa pendant, and a hi-top fade. "Mandela," Bart says on the shirt, "The Dude's My Hero." Stephney still has his. "Somewhere in my attic," he says.

Bart cut across the racial divide. Groening approved. "Bart looks cool no matter what skin color," he said at the time. "He lends himself to any color treatment." (Fox never approved an officially licensed Black Bart shirt.)

Bootleg Bart was not affiliated with *The Simpsons*, but he carried the rebellious spirit of the show. He was transgressing against TV's most transgressive sitcom. That was something its creators could appreciate.

"Rampant copyright infringement is the sincerest form of flattery," Groening joked back then, before getting a little more serious. "Actually, some of them are funny and some of them are just pure theft."

The *Simpsons* creator even collected the fake merch. "What was interesting is that I was under orders to always send examples of interesting T-shirts to Matt," says Steve Peña.

"There was nobody who loved a crudely done Bootleg Bart T-shirt more than Matt Groening," Vitti says. But that love, he adds, came with a caveat: "Matt often loved what you did, but you would get a cease-and-desist notice. He now had a second career policing *Simpsons* bootleg merchandise."

That game of Whac-A-Mole actually fell to Fox's legal department. On Monday mornings, Peña would listen to phone messages from colleagues who saw fake *Simpsons* gear for sale all over L.A. "I was the receptacle for all that kind of stuff," he says.

The network and its lawyers teamed up with law enforcement to root out unlicensed products. They started with small-time busts at swap meets and flea markets, a strategy they hoped would discourage wannabe unauthorized sellers. That progressed to full-on raids.

One day in 1990, federal authorities seized more than a thousand bogus Bart shirts from Florida Classic Impressions, a screen printer that did not, in fact, have a license to make *Simpsons* tees. Most featured an image of beer-keg-holding Bart saying, "Party till you puke, dude!"

Attorney Tom DeWolf, who in the '60s helped Disney buy the land it needed to build its Orlando-area theme park empire, had, on behalf of Fox, filed a temporary restraining order against Florida Classic Impressions. FCI didn't comply, leading to an operation that a United Press International reporter clearly had a hell of a lot of fun describing:

"Dudes from the U.S. Marshals office came looking for signs of a skateboarding underachiever with spiky blond hair and bulging eyes who spends most of his time in trouble. And man, did they ever have a cow, as Bart himself might say."

Even federal agents were doing *Simpsons* shtick.

"Instead of cooling their jets, we cooled their presses," U.S. marshal Pete Nagurny told reporters. "This is just another case where Bart the bad boy ended up in hot water."

Later that month, a six-week investigation, dubbed "Operation Dizzy Fox," culminated in eighteen hours' worth of raids in Washington, D.C., that yielded $2 million in counterfeit clothing. The load included thousands of Bootleg Bart T-shirts that vendors were selling on the National Mall. "*The Simpsons* was a collateral find," says attorney Robert Baum, who worked on the case. At the time, he was also representing the *Washington Post* syndicate for the comic strip *Bloom County* and the World Wrestling Federation.

After the sting, U.S. attorney Jay Stephens claimed that the feds weren't targeting sellers, but rather the large-scale distributors of the T-shirts and "the nature of the enterprise."

The problem was that the enterprise was too widespread to control. It wasn't really hurting the *Simpsons* brand—merch was still selling and the show was a phenomenon—but the network viewed it as a financial drain. It's hard to pinpoint how much money fake *Simpsons* merch cost Fox, but it's helpful to know that a Bootleg Bart shirt usually cost between $6 and $8 and an official one retailed for more. Each piece of counterfeit clothing cut into the bottom line.

By the summer of 1990, authorities had seized more than sixty thousand counterfeit *Simpsons* items. And Fox was investigating over five hundred bootleg operations. "It got to the point where, quite honestly, we just couldn't even control it," Ovadia says. "I think we might have spent a million dollars in the first year or so trying to squash this thing. And it just didn't even make a *dent*."

And eventually, Ovadia adds, "You had to give up."

The irony of Fox zealously going after bootleg T-shirt operations is that all that fake merch didn't seem to hurt *The Simpsons*. Oversaturation didn't seem to be a worry among fans—or corporations. When Mattel announced that it had signed an exclusive agreement to produce *Simpsons*

action figures, the stock of the maker of Hot Wheels and Barbie rose to its highest level in eight years.

In the summer of 1990, after the first season ended, Burger King kicked off a multimillion-dollar TV ad campaign featuring collectible *Simpsons* drink cups and Homer, Marge, Bart, Lisa, and Maggie dolls. ABC, CBS, and NBC, which usually barred commercials promoting competing programs and their characters, had to scramble to react to the arrival of the coat hanger network's biggest hit. They each responded to the ads differently.

CBS aired them but made the fast-food chain remove mentions of the name of the series. ABC allowed versions that only included images of the licensed merch, not any animated footage. And NBC, apparently too threatened by the presence of America's new favorite family during episodes of *Cheers* and *The Cosby Show*, refused to run them at all.

"At this point we're not going to run any ads in which the Simpsons appear in any form of their on-camera persona," an NBC spokesperson said at the time. "A doll is an on-camera persona representation."

Fox happily ran the spots, but purposely not during *Simpsons* episodes. "In terms of ethical marketing to kids, which I oversaw at Fox," says Helen Boehm, who helped build the network's new children's division, "the theory was that commercials that showcased a character in an ad *within* a show that featured that character might take advantage of a child's affection for that character."

The decision, Boehm says, was made by network president Jamie Kellner. "He knew Bart would become the most effective kid influencer of all time," she says.

For the people running the TV network, it was a savvy move. But it wasn't done out of the kindness of their hearts. Fox wanted to protect *The Simpsons*, its most highly rated, heavily merchandised show. No matter how good the animated series was, there was still a

chance that its ubiquity would, as the writers later pointed out in the show, eventually breed resentment. The goal was to delay that as long as possible.

Sandy Grushow, the marketing exec, remembers being in a meeting in which Barry Diller loudly told his underlings to stop licensing so many *Simpsons* products. "He was screaming at the guys who oversaw merchandising," Grushow says. "It just sort of felt like too much."

Ovadia remembers his bosses giving him mixed signals: "*We're overexposed. We need to make more revenue. You're licensing too much. You're not licensing enough.* There was this constant pulling back and forth."

Late in 1990, less than a year after the initial marketing push, the network did indeed stop authorizing new *Simpsons* products. "The powers that be decided that we had overlicensed," Peña says. "Too many deals. There was too much stuff out there. And so the word came down to get out of as many deals as you can without getting sued." He calls the process "torture."

In the end, Peña recalls, Fox only pulled out of about a dozen potential licensing agreements. "It wasn't huge," he says. But it had the intended effect of soothing management's nerves. And most importantly, Peña says, "We didn't get sued."

As Fox was scaling back, cracks were finally starting to show. Burger King had stocked up on *Simpsons* dolls for a promotional campaign. Yet customers, who likely had their fill of Bart gear, weren't buying them. Sales were so poor that the toys' manufacturer bought them back en masse and then flipped them to traveling carnivals to use for prizes. Less than a year after signing an exclusive contract with the show, Mattel got out of the *Simpsons* business. And stores stopped ordering T-shirts by the thousands.

It turned out that there was a limit to America's desire for *Simpsons* merchandise. In the end, oversaturation comes for all merch crazes.

But this one burned brighter than a comet before fading out. People bought $750 million worth of *Simpsons* merchandise and products in 1990 alone.

This wasn't Cabbage Patch Kids or New Kids on the Block. The merch craze flamed out, but the animated series had staying power. Even after parents stopped storming the mall for Bart Simpson tees, the public never turned against the show. The only thing viewers complained about was the long gap between the end of the first season in May 1990 and the beginning of the second season that October.

Eventually, Al Ovadia called Macy's back about a *Simpsons* balloon. This time, there was absolutely no need for a hard sell. During the second season of the show, Bart Simpson made his Macy's Thanksgiving Day Parade debut. By then, the spiky-haired boy wasn't just towering over New York City. He was towering over the whole country.

CHAPTER SEVEN

BART VS. BILL

"THE ONLY THING MORE PAINFUL IN HOLLYWOOD THAN FAILURE IS SUCCESS."
— SANDY GRUSHOW

Long before decades of documented sexual abuse allegations finally caused the public to turn against him, Bill Cosby was the nation's favorite TV dad. By early 1990, the top-rated *Cosby Show* was in the middle of its sixth season. The comedian routinely sold out theaters across North America, cranking out marathon sets that were heavy on PG-rated jokes and light on blue material.

During one performance, Cosby turned his attention to a boy in the audience. The kid was wearing a T-shirt with an image of a spiky-haired character on it. It was only natural that Bart Simpson caught the comedian's eye. Soon after *The Simpsons* premiered, everyone seemed to be comparing it to his sitcom. Both were about tight nuclear families, though those families' lives couldn't have been more different.

The Huxtables were Black and affluent, the Simpsons were white (well, technically yellow) and lower middle class. Cliff was an excellent physician whose kids mostly respected their elders and did well in school. Homer was a lazy power plant employee whose son gets

a tattoo and curses at adults. The media branded *The Cosby Show* as aspirationally wholesome, and *The Simpsons* as cleverly cynical. *Tonight Show* host Johnny Carson, whose long-running program, like *Cosby*, appeared on NBC, went as far as quipping that the cartoon clan actually sounded more realistic than the live-action one.

"*The Cosby Show* was an example of what an American sitcom family should be, versus a complete example of exactly what an American family shouldn't be," *Simpsons* writer David M. Stern says.

"People were like, 'Oh my God, this thing is going to destroy Western civilization and it's the anti–*Cosby Show*,'" animation director Rich Moore says. "It's amazing. It's like, 'Do you watch it? Do you guys actually watch the show?'"

Due in part to this near-constant comparison, a rivalry started to develop. And Cosby didn't mind playing it up. So when he saw a *Simpsons* shirt, he chose to turn it into a bit. Cosby asked the kid to borrow the tee. Then he put it on himself. For the veteran showman, the move was slickly magnanimous. "Cosby got to proclaim his appreciation for his competitor—and make friends and big bucks while doing so," Tim Appelo wrote in *Entertainment Weekly*. That year alone, *Forbes* claimed that Cosby was projected to pull in an estimated $55 million, making him the top-earning entertainer in the world. America's dad didn't seem worried about the competition.

Back at *The Simpsons*, the staff didn't fret much over it, either. They didn't really have the time. Work was beginning on the second season of the show and they had episodes to make. "I don't remember thinking too much about it," says producer Joe Boucher. "I was still probably so in the weeds and just trying to get the show produced."

What the writers of *The Simpsons* didn't realize was that Fox was turning a press-driven talking point into a true head-to-head matchup. After the first season, the network decided to move its phenomenally

popular new series to Thursdays at 8 p.m.—opposite *The Cosby Show*. The fall of 1990 would be all about Bart vs. Bill.

"It was sort of being hyped as good versus evil," Stern says. "Which is incredibly ironic at this point. Bart Simpson is bad for American families. And the angel was Bill Cosby."

The decision to move *The Simpsons* from its original time slot was made, metaphorically at least, far, far away from the writers' room. In a meeting to plan out Fox's expanded 1990–91 programming schedule, 20th Century Fox owner Rupert Murdoch suggested to his studio chief Barry Diller that their TV network should pit the animated series against *The Cosby Show*.

"Barry says, 'We're going on Thursday night,'" recounts Fox head of publicity Brad Turell, who was in the boardroom that afternoon. "So, we're already like, 'Gulp.'"

Taking on America's top-rated sitcom was...aggressive. "Rupert wasn't happy with success," says marketing exec Sandy Grushow. "He had to kill somebody in the process."

At best, the shift seemed hubristic. At worst, flat-out stupid. Before NBC coined "Must See TV," its Thursday night lineup included megahits *Cosby*, *Cheers*, and *L.A. Law*, in addition to a sitcom still finding its footing: *Seinfeld*. "They had a fucking juggernaut on Thursday night," Turell says. "Everybody else gave up on Thursday night against NBC. It was killing it. I mean, killing it." Fox was gaining viewers—in 1990, it started airing two hit series aimed at young people: teen drama *Beverly Hills, 90210* and primetime sketch show *In Living Color*—but until that fall, Fox didn't even *have* a Thursday night lineup.

Brooks, who had to fight to get *The Simpsons* on the air, was angry about the move. He couldn't believe his bosses were messing with the

show. "The only thing more painful in Hollywood than failure is success," Grushow says. "And in some respects that's what *The Simpsons* felt like. We were dealing with the crown jewels."

Around that time, Turell remembers having lunch at the studio's commissary with Diller, network president Jamie Kellner, and Fox Entertainment President Peter Chernin. ("A bunch of guys that are gonna end up worth hundreds of millions," Turell says. "And I lived in the Valley.") Brooks walked up to the table and kneeled to face Diller at eye level.

"I'm begging you, don't move *The Simpsons* to Thursday night," Brooks said.

"Literally says that," Turell recalls. "'I'm begging you.' And Barry said, 'It'll be fine, Jim. Trust me. It'll be fine.' [Brooks] goes, 'Barry, you don't understand. We haven't done anything yet. We're still figuring out the animation and the music. This is a very fragile thing. Don't move it.'"

"It goes on and on," Turell says. "And I'm thinking, 'This is Jim fucking Brooks. He's gonna cave now because this is one of the most important producers in the world.'"

But Diller didn't budge. "Jim, it'll be fine," he said. "You have to trust me on this."

"Barry was insanely confident," Turell says. "For whatever reason, this was going to work."

The move led to strange rumors. "Conspiracy theory number one was: perhaps they think we've gotten too big for our britches, so they're going to put us up in the suicide slot against *Cosby*, and they're finally going to be done with us," editor Brian Roberts says. "We're going to be canceled, then we're off the air. They want to kill us and this is how they're going to do it. And then the other one was: somebody has smoked so much crack that they actually thought we could take *Cosby* down."

Simon, adversarial by nature, may have believed the first theory. "Sam came down to the editing room a bit depressed and said, 'They want to kill us,'" Roberts recalls.

Writer Jay Kogen wasn't concerned about the show's survival, but he *was* slightly confused. "I wasn't worried, because to remain on Fox, you didn't have to be as big as you were at NBC," he says. "I also thought it was dumb. I don't understand network demos and advertising money, but I don't know why you would take your very best show and put it against one of the other biggest shows."

The Simpsons vs. *The Cosby Show* became a national story. Fox execs did their best to explain what felt like an inexplicable decision. "Because of *Cosby*, the other networks have not been as competitive as they should be against it," Chernin told the *Los Angeles Times*. "The heart of our schedule is counter-programming, and we felt this was the best place to counter-program. Our feeling is that if we could get past *Cosby* and survive it, we have great opportunities at 8:30 and 9."

Brooks continued to be so bothered by *The Simpsons'* move to Thursdays that he openly complained to the press about it. "There have been two weeks in my life when a show I was associated with was number one in the ratings, and on Sunday night, we had a chance to be the number one show in the country," he told the *Washington Post*. "I don't think we have a chance on Thursday night."

Cosby shared none of Brooks's pathos, at least outwardly. After all, he was the king of TV comedy. There was nothing to be worried about. Right? In August 1990, he appeared on the cover of *Entertainment Weekly*, smiling, reclining, and wearing a Bart Simpson T-shirt. The headline? "Can Bill Beat Bart?"

In an interview with *EW*, Cosby declared that he would not be tinkering with his show as a reaction to *The Simpsons*. "There's really nothing wrong with Bart... But we've got a job to do," Cosby said.

"This series goes into syndication and I've got to maintain my standards. I can't force things in to compete."

That year, the series did add a teenage girl to the cast: Pam, Clair's cousin. The move proved that the sitcom wasn't above tweaking its formula to try to pick up new viewers. The *Simpsons* audience, unsurprisingly, skewed younger than the *Cosby* audience.

Cosby claimed the addition was a coincidence. "All of the changes were made B.B.—before Bart," he quipped. He was careful not to bash his new ratings rival. The only thing he said that came close to an anti-*Simpsons* dig was about the rise of what he considered to be transgressive programming: "The mean-spirited and cruel think this is 'the edge,' and their excuse is, 'That's the way people are today.' But why should we be entertained by that?" He wasn't specific, but it's easy to imagine which up-and-coming network's shows he was talking about.

In reality, many viewers likely watched Fox *and* NBC. People liked *The Cosby Show* and *The Simpsons*, no matter how different they were. There was room for both. "I didn't really think that our audience and the Huxtable audience would be fighting each other," Kogen says. "I thought that there's probably a lot of crossover. A lot of the same people watch the same shows and maybe they'll flip channels." (Or, since it was the '90s, record one on a VCR and watch later.)

Kogen and the writers knew that there was only one way to productively respond to the schedule shift: by cleverly alluding to it on the show. "We would've joked about Cosby anyway, 'cause it was the number one show," Kogen says. "We usually take whatever the culture is and put it in our show. I didn't see *The Cosby Show* as our enemy that we must destroy. It's just another big show that's part of the culture."

In a second-season episode, Kogen and Wallace Wolodarsky wrote in a character named Dr. Julia Hibbert. After Simon and the writers heard about the shift to Thursdays, she became Julius Hibbert. He was an African American doctor who looked and even sounded a little bit

like Cliff Huxtable. He was smart, gregarious, and a family man who laughed at his own jokes. "Dr. Hibbert sort of became our version of Cosby," Kogen says. But not a *direct* copy.

"We're not going to hit people over the head, we're going to do it in passing," Simon told Roberts.

The Simpsons, to be clear, was not above hitting people over the head. At one point, Homer's having trouble bonding with Bart. To get help, Homer visits the National Fatherhood Institute. A friendly employee there gives him a copy of Cosby's 1986 parenting memoir *Fatherhood*. The book teaches Homer reverse psychology—he reads a real line from it out loud: "No matter what you tell your child to do, he will always do the opposite"—which he uses to at least *try* to connect with his son. "Thank you, Bill Cosby," Homer says. "You've saved the Simpsons."

In a later episode, you can see the book burning in the Simpson family's fireplace.

On October 11, 1990, Fox aired the second-season premiere of *The Simpsons* against *The Cosby Show*. In "Bart Gets an 'F'," the titular character agonizes over his repeated failures at school. A snow day saves him from having to take a big test, and eventually, at the very last second, right before his teacher Mrs. Krabappel is about to fail him, he proves to her that he actually studied a *little*. Then he celebrates his miracle. "Part of this D-minus belongs to God," he says to Homer.

Tom Shales, America's best-known TV critic, wrote that the episode "is not only funny, it's touching. You really find yourself rooting for this bratty little drawing." The praise was satisfying, even to a cynical group of writers. *The Cosby Show*, it turned out, didn't have a monopoly on feel-good family TV. "It was reviewed in every publication, and so we really got a chance to see what people thought of it,"

says David M. Stern, who wrote the Season 2 opener. "And the reviews were pretty good!"

But what felt like a gift from a higher power were the Nielsen ratings. Overall, 33.6 million people watched the episode. That night, *Cosby* edged *The Simpsons* by a tenth of a point, but both season premieres were watched by 29 percent of the TV audience. "Bart Gets an 'F'" was the highest-rated program in Fox history. It reigned until early 1995, when a little underdog called... an NFL Wild Card playoff game finally topped it.

Bart may not have beat Bill, but he definitely could hang with him. For the staff of *The Simpsons*, it was somewhat of a relief. As Roberts put it, they went up against a heavyweight champ and "didn't get knocked out." That alone was a victory. But the show not only held its own, it put up a fight. "The sheer numbers of it and the fact that it was Thursday night, which was *the* night at the time," Stern says. "I mean, fantastic."

The day after "Bart Gets an 'F'" aired, *Entertainment Tonight* led with a story about the *Cosby–Simpsons* battle. "When it comes to TV ratings, Bart Simpson is no longer an underachiever. And he's proud of it," said host John Tesh. (The Grammy-winning pianist and composer of the iconic *NBA on NBC* theme song also moonlighted at the Hollywood news magazine.) "Nobody ever thought we could even do what we did last night," Sam Simon said on *ET*. "It was beyond anyone's wildest expectations."

Today, it'd be hard to imagine *Entertainment Tonight* opening with a story about a ratings battle between two sitcoms. But back then, viewers *really* cared about their favorite TV shows. On most nights, families had to pick one thing to watch together. Screens were at a premium. If you didn't like what was on in your house, you couldn't just go in the other room and peruse Netflix on your iPad. And if you missed something when it first aired? Forget it. You were out of

luck until reruns. This made every single episode appointment viewing. Now, if you don't have time for the new *House of the Dragon* on a Sunday night, you can just catch up later.

Entertainment Tonight also interviewed Shales. He didn't declare Bart the winner or condemn Bill to TV hell, but he did point out something that was becoming very obvious: "*The Simpsons* somehow seems a much more '90s show. *The Cosbys* we associate with the '80s." The fact that *Cosby* wasn't absolutely crushing its competition anymore, Shales added, was "kind of a way of saying goodbye, I guess."

The Huxtables were perfect for the Ronald Reagan era: an idealized family that distracted viewers from the social and economic hardships that most middle-class people dealt with at the time. By the time the Berlin Wall fell, the show felt unrealistically hopeful. In 1990, two years after George H. W. Bush was elected president after using "no new taxes" as his campaign pledge, America entered a recession. Over the next few years, millions of Americans lost their jobs. Viewers clearly were ready for a more realistic look at everyday life in this country. That's what shows like *Roseanne*, *Married...with Children*, and *The Simpsons* gave them. Homer, Marge, Bart, Lisa, and Maggie bickered, let each other down, and sometimes couldn't make ends meet. In other words, they were a real American family.

The first season of *The Simpsons* was revelatory. After such a spectacular start, a sophomore slump would've been understandable. Or at least forgivable. The writers weren't about to let that happen. The show was their pride and joy; they were obsessed with making it even better than it already was.

"When you're twentysomething and proving yourself on being funny, that's your power," Kogen says. "When you're a comedy nerd,

your swagger is, 'How funny are you?' So we were just trying to up the funny. Every time."

Even the best comedy writers, however, are prone to self-doubt. It was hard to up the funny every time. And so the anxiety of high expectations led to long days filled with deflating moments. "In the rewrite room, you always felt like a failure," Jon Vitti says. "Because the instant you come up with something that makes the room laugh and move on to the next problem, the next line the showrunner doesn't think is good enough. And then there's like, fifteen minutes to an hour where the rewrite room is stuck on that line. And every minute you feel your personal failure to come up with a line that will make the room laugh and let us move on."

But as they were sweating through making the second season of the show, the writers began to realize that they'd developed the most expansive world on TV. With free rein, they started to play around with the sitcom format, in ways that traditional sitcoms like *Cosby* could never dream of. *The Simpsons* was not stagebound, and that helped set it apart.

Jay Kogen and Wallace Wolodarsky, for example, pushed for *Treehouse of Horror*, a three-part Halloween special. At first the idea of a self-contained anthology seemed too experimental to work, even for an animated series. "They beat that drum until the resistance crumbled," Vitti says. The spooky anthology was radically different from everything the show had ever done—and it proved that *The Simpsons* could make shows that felt like events. *Treehouse of Horror* was its annual version of a popular TV trope: The Very Special Episode.

"The first *Treehouse of Horror* got us excited because it had really cool animation," writer George Meyer says. The episode had dozens of visual references, from *Poltergeist*, to *The Amityville Horror*, to *Tales from the Crypt*. Each segment felt nothing like a typical installment

of *The Simpsons*. The animators treated the vignettes like mini–horror flicks, and that's what they looked and felt like.

The first segment is a send-up of haunted house movies. The second is a parody of the classic *Twilight Zone* episode "To Serve Man." And the third is a faithful adaptation of Edgar Allan Poe's "The Raven," with Homer as the tortured narrator and Bart as the title character. To build suspense at the start of the episode—and play with the audience—the writers also included a dead-serious-sounding disclaimer read by Marge. "If you have sensitive children," she says, "maybe you should tuck them into bed early tonight."

"What it showed us is that we could do whatever the hell we wanted to," Meyer says. "If we thought it was fun to do three segments of a Halloween show, we could do it. I used to get very intoxicated by the shows that could never have been performed on a sitcom stage."

One of those episodes, "Bart the Daredevil," features Bart planning to jump Springfield Gorge on his skateboard, like a pint-sized Evel Knievel. Wanting to protect his son, Homer convinces Bart not to do it—then accidentally attempts the stunt himself. But instead of making it all the way across the gorge, he falls way short.

As Homer's being airlifted to safety, his head repeatedly smashes into one of the gorge's walls. Then the ambulance he's loaded into hits a tree, shooting him out the back doors and down into the gorge again. The sequence is brutally hilarious.

"That was really funny when we watched because the original had him quite bloody," Meyer says. "It was violent. That's the kind of thing that could never have been done on *Seinfeld* or any other sitcom, you know? And it really showed us the possibilities of the medium."

Animation created an almost infinite amount of room for sight gags. When the writers figured this out, they filled the open space to the brim. Writer Greg Daniels remembers many late nights spent helping come up with stuff that most viewers couldn't even catch.

"Bart would be walking through a mall or something and they'd say, 'We're going to pan down the mall, we need eleven hilarious store names,'" Daniels says. "And we're like, 'But it's a whip pan.' And they're like, 'Yes, but people will be able to tape it and go frame by frame.'"

The writers' habit of packing jokes on top of jokes and their deep well of pop culture knowledge pushed forward the show's visual style, which became more and more complex with every episode. "It was like we were storyboarding for a live-action piece," Rich Moore says. "We all loved old movies. We really brought a lot of cinematic language to it."

Homages and parodies appear in various forms throughout *The Simpsons*. The writers referenced TV classics, schlock, blockbusters, and even obscure films. When Vitti was outlining the episode "Mr. Plow," for example, Sam Simon suggested he write a sequence where Homer drives his snow-removal truck over a rickety drawbridge. It was a shot-for-shot remake of a scene in director William Friedkin's *Sorcerer*, a painfully tense 1977 action-adventure flick about a group of outlaws tasked with driving loads of unstable dynamite across the jungle. Homer's misadventure even has a Tangerine Dream–like electronic score similar to the one in the cult classic, which *Star Wars* buried at the box office.

"It was one of those ideas you're happy to run with," Vitti says. "I'd always been fond of the movie, and I watched the original it was based on, *Wages of Fear*. *Sorcerer* is better and was the starting point for the sequence."

The Simpsons was unafraid to reference a movie—or TV show, or historical figure, or play, or mathematical theorem—that its audiences might not know. "This is why I think the show was successful in a lot of ways," producer Larina Adamson says. "Because you have these writers from different backgrounds that knew a lot of stuff nobody

wanted to know about. That's why adults, I think, liked it. Because there were things in there that you'd go, 'Really?'"

This was a new stage in the evolution of TV. There *had* been other shows and movies that were highly referential. For example, in Barry Levinson's *Diner*, a Baltimore-set film about a group of twentysomething guys in 1959 that came out 1982, the characters obsess over the Colts and their favorite music. But nothing had ever mined pop culture quite like *The Simpsons*.

Not all of the references were broad. Some felt like inside jokes. And that's a big reason why Gen Xers and elder Millennials loved the show when we were growing up. We inhaled TV, music, and movies. We could do what previous generations couldn't: rent whatever we wanted at the video store, see movies at giant multiplexes, scroll through hundreds of cable channels, and hang out for hours in mall record and comic book shops. Two generations of latchkey kids spent hours upon hours in their rooms, devouring what they'd just discovered. Inadvertently, we invented modern nerd culture. It became our shared language.

By the '90s, geeking out over *Star Wars* or Dungeons & Dragons or Rush had gone mainstream. Comedian and pop culture junkie Patton Oswalt, who grew up in the '80s, saw it coming. "Pretty soon, being the only person who was into something didn't make you an outcast," he once wrote. "It made you ahead of the curve and someone people were quicker to befriend than shun. Ironically, surface dwellers began repurposing the symbols and phrases and tokens of the erstwhile outcast underground."

The Simpsons was, very often, into things that no one else was. The show was basically our older brother. Its sense of humor made us curious about every reference it made, no matter how niche it was.

Sorcerer wasn't in the zeitgeist in the early '90s, but that didn't stop the show from parodying it. "We'd say, 'It's a one-percenter,' like one

percent of the audience might know what this is," Rich Moore says. "But that one percent is going to love it."

Unlike a lot of dumbed-down sitcoms, *The Simpsons* trusted us to be curious. So, if we didn't get that the show was evoking a John Huston movie from 1948, that was fine. We could look it up—or just enjoy the surface-level comedy.

In Season 2's "Three Men and a Comic Book," Bart, Milhouse, and Martin pitch in to buy the first issue of *Radioactive Man*—and then turn on each other. The plot is a parody of *The Treasure of the Sierra Madre*. While working on the episode, the writers gathered to watch an old print of the classic western. "Sam would do this," Adamson says. "He would get Fox to screen a movie just for the *Simpsons* guys."

Long before the internet made searching for old images easy, finding visual references for the show was a truly laborious process. The animators used to make a weekly list of movie stills they needed for inspiration and a production assistant would then take that list to the Warner Bros. research archive. "They would pull out what they had, make color Xeroxes," Moore says. "And the PA would bring them back. He'd be like, 'OK, here they are. You have one week and I need to take these back.' You couldn't keep it."

And it wasn't always that straightforward. Moore remembers an episode's mention of "the later work" of photographer Diane Arbus sending everyone scrambling. Where could they find examples of her photos? "You'd have to like, pore through books," Moore says.

When books, traditional archives, and run-of-the-mill stores failed, Moore and his colleagues headed to a store called Saturday Matinee. The North Hollywood emporium had a library of more than eighty thousand videos, including rare, out-of-print, and pirated films. The L.A. institution was owned by former comedy writer, performer, and animator Eddie Brandt.

"He knew all these people that independently would videotape stuff off TV," Moore says with a laugh. "And then he'd make these bootleg copies. You could go like, 'Hey, Eddie, do you have *blank*?' And he'd be like, 'Oh, yeah.' And it was great."

In hindsight, Moore can't believe what it took to make an episode of *The Simpsons* back then. Just thinking about the way it was done in the early '90s makes him anxious. "Just 24/7, eating, breathing, sleeping *Simpsons*, where I would dream about it," Moore says. "People will ask, 'Wow, you guys must have been riding high to be working on something so cool?' It's like, I barely left the studio. We would say it was our Vietnam or something. It was just absolutely like a meat grinder. And I probably erased years from my life, you know?"

The grind was only worth it, Moore adds, for one reason: "I loved it."

By the second season of *The Simpsons*, the first hit primetime cartoon since the '60s was no longer a Hollywood underdog. There was no more illustratively ridiculous example of the show's explosive popularity than its crossover into pop music. Hey, it was the early '90s. Studios were aggressively trying to make as much money as they could off their biggest properties. Warner Bros., for example, had just enlisted Prince to do the *Batman* soundtrack, which turned into a smash hit. Squeezing a best-selling record out of a red-hot television show actually seemed possible. This was, however, different from a standard movie or TV soundtrack. It was more like a Weird Al Yankovic concept album, with real musicians and comedy writers collaborating on funny songs.

Given its peculiarity, the *Simpsons* record needed a very particular shepherd. His name was John Boylan. And he was, despite what the project required, a serious producer. He'd managed Linda Ronstadt and helped form the Eagles.

One day, Boylan got a call from music mogul David Geffen. "We need to make an album out of the *Simpsons* characters," he recalls the now multibillionaire telling him. "And we need to do it immediately."

Boylan quickly agreed to come on board. "I think David hired me just because I had a reputation for getting shit done," he says. The first thing the record's brain trust had to figure out was what a *Simpsons* concept album would look like. "We decided to go get really ridiculous and call it *The Simpsons Sing the Blues*," says Boylan, who had worked with James L. Brooks as a consultant on *Terms of Endearment*. "'Cause they really have no reason to sing the blues."

Before kicking around song ideas, Boylan had to find out if the show's cast could actually sing. To his excitement, they all could. But one stood apart. "To my delight," he says, "by far the best singer was Yeardley."

The Simpsons Sing the Blues was maybe the most gimmicky, high-profile thing associated with the animated series to that point, but Boylan still wanted to ensure that it was no ordinary novelty record. So he recruited both famous guest artists and the show's creative team. Groening, Brooks, Simon, and the writers were enlisted to coauthor songs. Four of the ten tracks were partially credited to them.

Keeping all of this a surprise, naturally, was impossible. Not with the media attention that *The Simpsons* attracted. "They hired Pat Kingsley, arguably the number one publicist in the world at that point, to filter and keep the lid on everything," says Boylan, who in his fifty-plus-year career has worked with artists like Boston, Little River Band, and Carly Simon. "I mean, there were people hanging around trying to get at us all day long. People turned me down for various reasons. I wanted Rod Stewart to come and sing one, but his manager turned me down."

As laughable as it sounds, there probably wasn't another album in production that year under more scrutiny. In September 1990, news

broke about the record: Michael Jackson would duet with Bart Simpson on a song called "Do the Bart, Man." (It ended up being called "Do the Bartman.")

This was long before news broke that the Los Angeles Police Department was investigating molestation allegations several young boys made against Jackson. But even though the tabloids were already branding the ultra-famous, elusive musician as "Wacko Jacko," he was still the biggest pop star in the world. At the time, he was recording the follow-up to *Bad*, an album that sold thirty-five million copies worldwide. Unsurprisingly, a man who lived in an estate he called Neverland Ranch and had his own attraction at Disney World also happened to be a fan of the animated series.

According to the report, Jackson reached out to Brooks and asked to collaborate. "This is the beginning of a beautiful friendship," Groening said. "They're sort of like a Batman and the Joker team-up, with Bart in the Joker role. They're going to take over the world."

A week later, however, Brooks issued a press release claiming that the song was written not by the artist but by his friend and contributor Bryan Loren. Groening also walked back his comments. "It's so frustrating," he told the Associated Press. "I said to a reporter a while ago that I would like to have this happen and it was printed as if it was true."

The thing is, it *was* true. Sort of. During the making of *The Simpsons Sing the Blues*, Boylan met with the pop star. "He said he had an idea to do kind of a hip-hop song," says Boylan, who had worked with Jackson at Sony's Epic Records in the '80s. It was "Do the Bartman." Jackson even came up with an accompanying dance. "I brought my video camera," Boylan says. "He had this guy, a dancer. They worked out a dance. I videoed that so the animators could come up with something."

But when it came time to make "Do the Bartman," Jackson backed off—beyond quietly only providing vocals. "It was clear from

the beginning Michael was not at all interested in having any actual credit," Boylan says. "He didn't want anyone to know that he sang all those background vocals. I think it may have been contractual."

Jackson, you see, was about to sign a massive new deal with Epic. Officially appearing on a Geffen Records release likely would've been a no-no. Loren is the one who ended up receiving writing credit.

The week of Thanksgiving in 1990, "Do the Bartman" hit the airwaves. The New Jack Swing–infused track, which features Nancy Cartwright as Bart rapping lyrics like, "If you can do the Bart, you're bad like Michael Jackson," and "Homer was yellin', Mom was too, because I put mothballs in the beef stew." It felt like an even sillier version of a song like DJ Jazzy Jeff & the Fresh Prince's "Parents Just Don't Understand."

"Mothballs? That's like an eighty-year-old's prank," says Jeff Martin, who cowrote a song on the album that Harry Shearer sang (more like *spoke*) as Mr. Burns called "Look at All These Idiots."

In the music video for "Do the Bartman," which soon premiered on Fox, the titular character leads Springfield in a choreographed dance through town. Despite never getting an *official* release as a single in the United States, it still hit number 24 on the *Billboard* radio chart.

The Simpsons Sing the Blues, with a lineup of contributors that included B.B. King, DJ Jazzy Jeff, and Joe Walsh, was released in December 1990. The album shot all the way to number 3 on the *Billboard* chart, behind only Madonna's *The Immaculate Collection* and Vanilla Ice's *To the Extreme*.

"I kind of had a feeling we would do well," Boylan says. "I mean, when David Geffen puts his mind to something, shit happens, you know?" No one was happier about the album's success than Boylan's daughter. "That's the first time I ever became a hero," he says with a laugh. "I mean, what does she care about Boston or Little River Band? She was eight years old."

That a record based on *The Simpsons* was a smash hit was a feat. The project seemed ambitious, even for the minds behind the animated series. But with their creative input, they struck gold again. "Do the Bartman" may have had jokes about mothballs, and the *New York Times* may have stuck the record on its worst pop music of the year list, but the success of *The Simpsons Sing the Blues* was yet another sign that the show was a true phenomenon.

Like all *Simpsons* products, the album was, to some, a gateway to the show. When I told Martin that it was one of the first CDs I ever bought, he laughed and said, "Sorry about that."

For the people behind the animated series, all the recognition felt a little jarring. "When you work on a TV show, most of the time you have to tell people you know what you're doing and what the show is," Kogen says. "And then eventually, when we worked with *The Simpsons*, we didn't have to do that. Everybody kind of knew."

David M. Stern admitted that he liked telling people that he wrote for *The Simpsons*. "I would drop that any chance I got, at any party," he says with a laugh.

The writers may not have become national celebrities, but they *did* become famous in one place: the comedy world. Hell, there was once even a *Mad* magazine parody of the creative process at the show. "A Mad Peek Behind the Scenes at 'The Simpsons' Studio" was an incredibly intricate two-page spread that included illustrated versions of Groening, Brooks, Simon, their underlings, and the animators. The cartoon makes fun of Fox's low status, the ridiculous amount of merchandise the show produced, and its supposed similarities to other hit primetime animated series.

To the writers, there was no greater honor than being the butt of jokes in *Mad*. Other comedy writers didn't just revere *The Simpsons*.

They would've done anything to work for the show. In that world, there was no more coveted gig. David Mandel, who went on to become a writer-producer on *Seinfeld*, *Curb Your Enthusiasm*, and *Veep*, remembers those days well. To him, *The Simpsons* was appointment viewing. And anyone who treated it as anything *but* that was suspect. "I can distinctly remember getting a phone call from a writer who had sent me their spec script and wanted notes," Mandel says. "And the fact that they were calling at 8:10 on a Thursday night while *The Simpsons* was on—I never looked at that writer the same way again. Honestly, I hate to say it, I dismissed them out of hand."

Admiration from their peers was nice, but the *Simpsons* writers couldn't really bask in the glory. They had a show to make.

"We didn't have a lot of time to relish it," Meyer says. "We were busy. I think most writers, they suffer a little bit from paranoia. And none of us really trusted that the success was going to last. Because there had been a bunch of other things that were huge phenomena, including *Batman*, and it only lasted three seasons. So, I guess we just felt like we had to keep our shoulders to the wheel."

The writers weren't the only ones hidden behind the scenes. At first, Fox kept the *Simpsons* cast under wraps. "They specifically didn't do any publicity with us as the actors," Yeardley Smith once told the *Washington Post*. "They wanted the characters to exist as much as possible in their own right, as separate entities."

It sounds silly, but viewers couldn't see the cast of *The Simpsons* on TV every week. They didn't necessarily associate Yeardley Smith with Lisa or Nancy Cartwright with Bart. They were just names in the credits.

"*The Simpsons* doesn't have a live-action cast for people to glom onto," writer Bill Oakley says. "People don't talk about the writers of *Friends*. They talk about Matthew Perry and Courteney Cox. And those are just actors. They're *good* actors, but the writers made that

show up. They don't talk about [creators] David Crane and Marta Kauffman. They talk about Chandler. *The Simpsons* didn't have actors that are known to the public, so the writers get more credit than they would otherwise."

When *The Simpsons* took off and the audience realized there were real human beings bringing those iconic characters to life, the network started to encourage the actors to do more interviews.

"They had to pivot and go, 'Oh, alright, now we're going to lean into, *these are the people*,'" Smith once told me. "But at first they didn't want people to know that Bart was done by a woman." Fox didn't keep that fact a secret. But it didn't play it up either. "When it came out, people were kind of like, 'What?'" Smith said. "It shattered this cone of silence around the thing."

At the beginning, the press gravitated toward Brooks, the Oscar winner, and Groening, the underground cartoonist. Despite his outsized influence on their show, Simon received less media attention than his creative partners. He started to feel slighted, particularly by the exaltation of Groening, who wasn't doing much writing for the show.

Not long after the series had become a phenomenon, Roberts attended a staff Christmas party. That night, Roberts says he remembers Simon feeling down. "He had a few cocktails and we went to smoke a cigarette, and I just said, 'Sam, what's wrong? You're the king of the hill?' And he goes, 'It's just fucked.'" Roberts tried to reason with him. "I go, 'What makes a better story? A local cartoonist who struggles in his garage for twenty years and then gets a hit TV show? Or a slick industry insider who knows how to make a TV show makes another great TV show?'"

The message didn't sink in. As Groening's fame grew, so did Simon's resentment toward him. The feeling was mutual. Roberts felt like a kid stuck between parents who didn't get along. "I was editing

shows and it was me, Matt, and Sam," Roberts says. Simon would say, "Well, you tell that fat fuck that that's a shitty idea," and then Groening would say, "You tell that asshole..." "And I'm in the middle of it," Roberts says. "Those were the hard times."

Larina Adamson, the producer, worked closely with both. She remembers there being constant tension. "Their offices were down the hall from each other," she says. "So, I'd have to do a creative meeting with Matt, and then I'd have to go into a creative meeting with Sam and show him what Matt wanted to do. And he would never want to do what Matt wanted to do. So, then I would have to go to Matt and say, 'These are the changes.' There was always animosity between those two."

Their mutual hostility occasionally spilled into public view. In one 1990 interview with Howard Rosenberg of the *L.A. Times*, they took turns sniping at each other.

Simon admitted that Groening's newfound status as a media darling upset him. "It bothers me a little bit," he said. "But I knew going in that Matt, the underground cartoonist who gets a series, was a compelling story. He did create the characters." In the article, he went on to describe Groening as "the show's ambassador."

When Rosenberg told Groening what Simon called him, he replied, "That's a little bit condescending." He did, however, acknowledge the obvious. "There's definitely a power struggle here. There's a scramble to claim credit for the show now that it's become successful."

After the story was published, Adamson remembers Brooks mediating. "Jim sat the both of 'em down," she says. "It was sort of like Jim was the father. Bringing in the sons. You know, brothers and sisters don't get along all the time."

All the backbiting and bickering never surprised Adamson. It was the kind of dynamic that Brooks liked to explore in his work,

especially *The Simpsons*. "I think that's kind of how Jim approached comedy," she says. "You fight. And then you come around and realize how much you love your family." To her, that's what making the show often felt like. "I don't know if he was conscious of it, but he would want to see how we worked it out amongst ourselves," she says. "And then he would step in if it got really wild. And it did get really wild at one point."

The Simpsons seemed to prove Sandy Grushow's point: success could be more painful than failure. "I mean, no one sets out to make something that fails. And certainly, when things fail, there's tension because of what went wrong," producer Joe Boucher says. "But being successful has its own problems. Who deserves the most credit? Who *really* created it and did the most work to make it successful? Those are kind of the ongoing issues. If you're lucky enough to have hit shows, there's stuff that comes along that needs to be managed."

No amount of managing could've saved Simon and Groening's working relationship. And yet both continued to make the show. The beef didn't poison the writers' room, which continued to churn out funny scripts. In the end, that's what mattered most. "When it all came together, if you could kind of muscle through all the friction, it was beautiful," Moore says. "At the end of the day, it's like, 'My God, look what we did.'"

The biggest challenge the makers of *The Simpsons* had after its breakthrough was keeping the explosively popular show fresh. And with Simon pushing them, they did it. "Even after we had gotten into the top 20 and onto the cover of *Time* magazine, Sam made it clear that we were going to stay creative and keep developing the show," Vitti says.

That required more than just sharp scripts. When the writers came up with new supporting characters, they needed voices. And those voices made the show even better.

During the 1986–87 season of *Saturday Night Live*, the one year Jon Vitti worked there, word came down from executive producer Lorne Michaels to the writers: stop putting Phil Hartman in every sketch. The comedic actor, then new to the cast, was so reliably hilarious that he became a crutch. "He was somebody who could be the dad or be the president and be funny," Vitti says. "There was always something you wanted to do with Phil. He was always good."

Hartman played dozens of famous people on *SNL* in the late '80s and early '90s, including Frank Sinatra, Ed McMahon, Charlton Heston, Ronald Reagan, *and* Bill Clinton. He also starred as dozens of memorable original characters, like Unfrozen Caveman Lawyer and the Anal Retentive Chef. His nickname was "Glue" for the way he always managed to help the cast stick together.

The Simpsons needed someone like Hartman. Someone who could do *anything*. Like play Lionel Hutz, the ambulance chaser who first appears, naturally, in the second-season episode "Bart Gets Hit by a Car."

The producers figured, correctly, that Hartman would be perfect for the sleazy lawyer. It was supposed to be a one-off part. But like usual, he was too good *not* to bring back. And when it came time to cast the washed-up but cocksure movie star Troy McClure, Hartman was the obvious choice.

"One of the things that he did particularly well was bravado and confidence," Conan O'Brien once told me. "I remember when I'd see him at *SNL*, if he walked into a room and he saw me sitting with Greg Daniels and Robert Smigel and Bob Odenkirk, he'd say, 'Hiya, fellas.' We'd say, 'Hi, Phil.' He'd go, 'Keep them flying, boys. Keep them flying,' and keep walking. It was a breezy, self-assured, slick, confident guy."

Hartman brought that persona to every role he played. It didn't change much from character to character, but it never stopped being funny. "What's the difference between Troy McClure and Lionel Hutz?" Vitti says. "It was a weird thing. He worked a fairly narrow range, but you never got tired of it. You never heard Phil and thought, 'This is getting old.'"

There was nothing the staff enjoyed doing more than coming up with the titles of McClure's B-movies, public service announcements, and telethons. "Of course, the writers got super into that," Vitti says. They loved minutiae. And they loved hearing Hartman's line reads. They were *always* hilarious. (Vitti's favorite McClure vehicle: *Here Comes the Coast Guard*.)

The *SNL* star became *The Simpsons*' skeleton key. He could unlock any narrative problem. "When something had to work and you didn't know how we were going to make it work," Vitti says, "the way we made it work was we called Phil Hartman."

When Tom Cruise turned down a guest spot as a manly mentor assigned to Bart by the Big Brothers program, no one at *The Simpsons* scrambled to find a famous fill-in. "We immediately skipped to, 'Let's just call Phil,'" Vitti says.

Hartman wasn't the only one they called. The second season of *The Simpsons* is filled with memorable appearances by interesting people, including *The Godfather*'s Alex Rocco as Itchy & Scratchy Studios chairman Roger Meyers Jr., EGOT James Earl Jones as the narrator of Edgar Allan Poe's "The Raven" (and more) in *Treehouse of Horror*, *SNL*'s Jon Lovitz as both Marge's greasy high school prom date and her art teacher, actor-director Danny DeVito as Homer's long-lost brother Herb, Broadway star Harvey Fierstein as Homer's secretary/personal guru Karl, high-ranking *Star Trek* crew member George Takei as sushi chef Akira, *Honeymooners* star Audrey Meadows as Grampa's girlfriend Bea, and Tony Bennett and Larry King as themselves.

It got to the point where the show's producers started to successfully recruit mega-celebrities. Brian Roberts has one *Simpsons* writing credit, Season 2's "Brush with Greatness." In the script, a teenage Marge paints a portrait of Ringo Starr and mails it to the Beatle. Decades later, he finally discovers the work of art, hangs it on his wall, and responds with a grateful letter. The idea was, at best, speculative.

"Nobody knew whether Ringo would do it—or would ever consider it," Roberts says. "They sent that script off to the south of France, which is where Ringo was. And lo and behold, Ringo is like, 'Hey, I'm going to be in L.A. in October. Sounds like fun.' Everybody's like, 'Wow.'"

With Starr on board, the writers smartly beefed up his part. "Because, oh my God, we got Ringo. Remember, this is the early days," Roberts says. "Getting a Beatle was a big fucking thing. We had Tony Bennett, but *we got a Beatle*."

The day of the recording session, a limousine pulled up to the recording studio and Starr got out. "Everybody else was late, so it was just Ringo and I smoking Marlboros and shooting the shit for twenty minutes," says Roberts, who accidentally committed a faux pas—he asked for an autograph. (He'd missed a memo instructing Fox employees not to ask Ringo to sign anything.)

The drummer happily obliged. "I'm the only guy who got Ringo's autograph that day," Roberts says. After that, Starr's recording session got off to a rocky start. The drummer was surprised by how big his role had become. "He stumbles over a few lines," Roberts says. "And then he says, 'Jesus, when you sent me the script, I only had four lines.'"

Starr eventually got the hang of it and delivered a funny performance. "In answer to your question, yes we do have hamburgers and fries in England," he tells Marge in a letter, "but we call French fries 'chips.'"

When Ringo was done recording his lines, he got back into the limo. Before the car left, Roberts noticed one of the back windows opening just a crack. "This hand comes out with his little ring," says Roberts, who happily shook it. "He goes, 'Thank you very much, had a great time.' Then he's off."

If Roberts has one regret from that day, it's that he couldn't convince Simon to feed Starr a few unscripted lines about meeting the other surviving Beatles for a beer. His thought was that if *The Simpsons* eventually landed Paul McCartney and George Harrison, they could cut together a gag about a "reunion" at Moe's Tavern.

"Sam had this great way of putting you down and being deadpan at the same time," Roberts said. "He turned to me and he goes, 'Brian, no other Beatle's ever going to do this show.'"

It was a rare occurrence at *The Simpsons*. Simon was wrong.

Yeardley Smith was petrified.

After all, she'd never shared a scene with an Academy Award winner before. While making Season 2, *The Simpsons* had landed by far its biggest guest star yet: Dustin Hoffman. He agreed to play Lisa's wise substitute teacher Mr. Bergstrom. Hoffman was fresh off winning his second Oscar, for *Rain Man*. He was a huge movie star. Today, A-listers dominate animation. Hell, Chris Pratt is the voice of Super Mario *and* Garfield. But back then, the medium was still considered second-rate. But Hoffman's kids liked the show—so he said yes.

Smith took a flight to New York City to record with the actor in a studio. "It was unbelievable," she once told me. "I was so nervous that day. It was just me, Jim Brooks, Dustin Hoffman, and Sam Simon."

Brooks had cooked up the idea for the episode. "Before a page of it was written, Jim announced that this was an important story he had

come up with," Vitti says. "And Dustin Hoffman was going to be the guest star."

Brooks already had the basic story beats: A sub fills in for Lisa's teacher Ms. Hoover, Lisa connects with him intellectually in ways she can't with other adults (especially her dad) in her life, then he leaves town—but not before a bittersweet farewell.

"My immediate thought was, 'I feel sorry for whoever has to write that,'" Vitti says. Trying to write a dramatic comedy good enough to satisfy a master of the form sounded like an impossible task.

Simon tried to assign the script to David M. Stern, who'd been nominated for an Emmy while working on the coming-of-age drama *The Wonder Years*. But Stern turned it down. Then Simon asked Vitti if he wanted to do it.

At that moment, Vitti's confidence happened to be shot. The table read for another one of his episodes, "Bart's Dog Gets an 'F,'" had just gone horribly. "I was so down," he says. "The only thing that could have made the day worse was being assigned the substitute teacher story. And I was." Vitti said yes, reluctantly: "I found that to be the most terrifying episode of my career."

After thinking about it for a few days, Vitti realized he couldn't set out to make a funny episode. At least by *Simpsons* standards. "The only thing to do is to try to make this story work," he says. "Which was really terrifying. With an episode with a lot of jokes, there's less at stake. Because if you don't like this joke, there's another one coming in fifteen seconds. When you totally commit to a story, the story either works or it doesn't. In which case the episode has nothing going for it. It's the worst episode of *The Simpsons* ever."

So Vitti did his best Brooks impression. "I really tried to write the episode the way Jim would if he had time to do it," he says. "Instead of winning more Oscars." His script for "Lisa's Substitute," which references *The Graduate* and has a subplot about Bart running for class

president, *was* funny. But more memorably, it was, and still is, the most touching episode in the history of the show. While saying goodbye to his favorite student, Mr. Bergstrom gives her a note reminding her that she's special. It reads, "You are Lisa Simpson."

The four-word sentence would've been even *more* uplifting if it had, as Vitti intended it to, ended with an exclamation point. But while watching an early version of the episode, he didn't catch the error. "It haunts me to this day," Vitti once admitted.

Omission be damned, it was the most emotional moment *The Simpsons* had ever produced. "Those tears that you hear in that episode when he leaves," Smith said, "I was bawling." She called recording with Hoffman "one of the highlights" of her career. "There was so much ad-libbing," she said. "It's really a shame you couldn't do a documentary on the recording of that episode, because he was so game."

Working with Hoffman showed Smith how far her character had evolved since the days of the *Tracey Ullman* shorts. "Where I was just basically just a foil for Bart," she said. "Now I've just really become this fleshed-out little person."

Neither Fox nor Hoffman's representatives ever publicly announced or promoted his role. There was never a formal reveal. For a live-action show, the network would've been running promos about his appearance nonstop. But again, movie stars didn't really do TV—let alone cartoons, even one as critically acclaimed as *The Simpsons*. To get Hoffman to agree, the producers allowed him to pick a pseudonym. So he did. "I told them to put down Sam Etic," the actor, who's Jewish, explained years later. "In other words, Semitic. My attempt at humor."

The episode aired on April 25, 1991, late in the second season. *The Simpsons* was already a mix of madcap comedy and emotional resonance, but this was different. It was so different that it initially didn't exactly go over well with Groening. "Matt was sitting there watching it shell-shocked, saying, 'I wanted aliens living in the backyard. I never thought

my show would be this,'" Vitti says. "It's like he was so disturbed. You always want to do new things with the show and get it to do things it's never done before. When you step over that line, and the creator dislikes who you are and what you've done, it's really disappointing."

To Vitti's relief, Groening eventually came around to the episode. It elevated the animated series in a way that even the writers didn't think was possible.

Meyer recalls "Lisa's Substitute" feeling like a milestone. "Because it was a very successful, emotional episode that also had great jokes," he says. "It was a bit of a departure from all the sillier things that we were doing."

Vitti never intended the episode as a creative counterrevolution. Neither he nor any of the other writers wanted to remake *The Simpsons* into a dramedy. "We were just realizing we could get way more comedy into a half hour than we'd thought," Vitti says. "I always saw it as a one-time thing, but people were understandably nervous. Maybe they were wondering if their next assignment would be something similar."

It turned out that the writers had nothing to worry about. No one was threatening to snuff out their collective sense of humor. But "Lisa's Substitute" showed every snarky teenager who loved the animated series that it could be as earnest as *The Cosby Show* without losing its edge. It was the kind of episode that proved that Bart *could* hang with Bill. It was also the kind of episode that could convince the most skeptical Baby Boomer that the primetime cartoon was more than just "Eat my shorts!" And most importantly, it was the kind of episode that convinced the writers that they didn't have to throw in a joke every fifteen seconds to make a memorable episode of *The Simpsons*.

CHAPTER EIGHT

BUSH V. BART

"MY DEAR GIRL, THERE ARE SOME THINGS THAT JUST AREN'T DONE, SUCH AS DRINKING DOM PERIGNON '53 ABOVE THE TEMPERATURE OF 38 DEGREES FAHRENHEIT. THAT'S JUST AS BAD AS LISTENING TO THE BEATLES WITHOUT EARMUFFS!"

—JAMES BOND, 1964

"WE NEED A NATION CLOSER TO *THE WALTONS* THAN *THE SIMPSONS*—AN AMERICA THAT REJECTS...THE TIDE OF INCIVILITY AND THE TIDE OF INTOLERANCE."

—PRESIDENT GEORGE H. W. BUSH, 1992

The year that *The Simpsons* premiered, Curt Smith joined President George H. W. Bush's staff. The speechwriter didn't watch much television, but he'd seen the animated series. It was, after all, one of the best-known shows on earth.

"Part of our job was to be up to date in terms of what's popular and what's not," Smith says. He wasn't really a fan of the show. He

found its portrayal of a typical nuclear family to be insulting: "They struck me as uncivil, divisive, and intolerant of Middle America."

Smith preferred his TV to be more...idealized. He grew up in the '50s and '60s in a small upstate New York town that reminded him of the (mostly) strife-free one in *The Andy Griffith Show*. "Front porches, greenery, and no traffic lights," he once said in an interview. "Mayberry without the accent." His all-time favorite show was even more earnest: *The Waltons*.

The historical drama, based on creator Earl Hamner Jr.'s novel, told the story of a family in a fictional Virginia mountain community during the Great Depression and World War II. The year before, CBS had started to replace its down-home comedies like *The Beverly Hillbillies*, *Green Acres*, and *Andy Griffith* spinoff *Mayberry R.F.D.* with fresh programming that often depicted city life and explored current hot-button issues. *The Waltons* did neither. But it still found a home at the network in a socially conscious, racially diverse lineup that by the mid-'70s grew to include James L. Brooks's *The Mary Tyler Moore Show*, *All in the Family*, *Maude*, *M*A*S*H*, *The Jeffersons*, and *Good Times*.

The Waltons spent the decade giving viewers a weekly hourlong break from the Vietnam War, Watergate, and the energy crisis. Richard Thomas played teenager John Jr., whom everyone knew as "John-Boy." He was the oldest of seven siblings and the show's moral center. At the end of every episode, the hardworking blue-collar clan verbally tucked each other in. That's where the series' signature line—"Good night, John-Boy!"—comes from.

In Smith's eyes, *The Waltons* spoke directly to "millions of ordinary Americans." These were the folks that the Republican incumbent was desperately trying to reach in the early '90s when he was running for reelection against fortysomething Democratic candidate Bill Clinton. "There was an affinity with a broad section of people in

Middle America," Smith says. "And Middle America is where the election would be decided in 1992. Or at least we felt it was."

Throughout the campaign, the speechwriter and the president discussed the theme of tolerance. "We wanted to prove that you could be conservative and tolerant at the same time," Smith says. To Smith, there was one family that embodied that kind of decency: the Waltons. And there was one family that was the antithesis of it: the Simpsons. "You had the two cultures at war in this country. And I say that sadly," he says. "*The Waltons* with Red America and *The Simpsons* with Blue America."

So Smith decided Bush should draw a red line between the two. "Irrespective of what speech you're working on, you want to make it zing," Smith says. "You want it to be understood. You want it to be relevant." And nothing on TV was more relevant in 1992 than *The Simpsons*. The merch craze may have died down, but the show, then in its third season, was hitting its creative stride. Ratings remained sky high.

There was nothing new about a presidential candidate using current pop culture to try to appeal to his base. Richard Nixon had made an awkward appearance on the sketch show *Laugh-In* when he was running in 1968. His opponent, Hubert Humphrey, turned down the invitation, and allegedly said later that the decision may have cost him the election. Gerald Ford got onstage with his *SNL* alter ego Chevy Chase at the White House Correspondents' Dinner, proving that he did indeed have a sense of humor. The longest interview Jimmy Carter, a Southern Baptist, gave during his 1976 campaign wasn't with the *New York Times* or the *Washington Post*. It was with *Playboy*.

And at a campaign rally in New Jersey in 1984, President Ronald Reagan brought up the state's favorite rock star. "America's future rests in a thousand dreams inside your hearts," he said. "It rests in the message of hope in songs of a man so many young Americans admire—New Jersey's own Bruce Springsteen." The Republican

incumbent probably didn't know this, but at the time Springsteen was singing a lot about how tough life had become for the middle class in Reagan's America. Alas, Reagan ended up winning reelection in a landslide.

Bush, Reagan's vice president, knew a *little* bit about pop culture. He eventually even had Dana Carvey, who played him on *SNL*, as a guest at the White House. But Smith knew that asking a sixty-seven-year-old man to reference a hip cartoon on the stump might take him out of his comfort zone. As popular as it was, *The Simpsons* didn't exactly match Bush's sense of humor.

"I would give him different cultural references, many of which, as I recall, he simply didn't use," Smith says. "Particularly if they were connected to current humor. I would give him something that might have been referenced on one of the late-night shows. And he basically would say, 'Unclear on meaning. Find another.'"

But the president, it turns out, was comfortable mentioning *The Simpsons*. His administration and the Simpson family had a history that dated back to May 1990, when Bush's drug czar William Bennett noticed a Bart Simpson poster at a rehabilitation center and reportedly told the residents, "You guys aren't watching *The Simpsons*, are you? That's not going to help you any."

Bennett apologized, said he was kidding, then "joked" that he'd "sit down with the little spike head" Bart and "there's nothing that a Catholic school, a paper route, and a couple soap sandwiches wouldn't straighten out." The show's producers responded to Bennett with this appropriately snarky statement to the press: "If our drug czar thinks he can sit down and talk this over with a cartoon character, he must be on something."

Four months later, there was *another* minor run-in. This one involved *Barbara* Bush. In a *People* magazine interview, the First Lady said she was a fan of *America's Funniest Home Videos*. She also expressed

disdain for *The Simpsons*. "It was the dumbest thing I had ever seen," she said, "but it's a family thing, and I guess it's clean."

This time, the show decided to kill its high-profile detractor with kindness. In a letter released to the press, Marge Simpson—who sounded suspiciously like James L. Brooks—earnestly expressed her disappointment. "I try to teach my children Bart, Lisa, and even little Maggie, always to give somebody the benefit of the doubt and not talk badly about them, even if they're rich. It's hard to get them to understand this advice when the First Lady in the country calls us not only 'dumb,' but 'the dumbest thing' she ever saw. Ma'am, if we're the dumbest thing you ever saw, Washington must be a good deal different than what they teach me at the current events group at the church." Before signing off "with great respect," Marge said she and Barbara had a lot in common. "Each of us," she wrote, is "living our lives to serve an exceptional man."

The correspondence seemed to mortify the First Lady, who replied publicly with a short note of her own. In it, she thanked Marge for speaking her mind, admitting, "I foolishly didn't know you had one." Then she spent a paragraph describing the art on a plastic collectible Burger King Simpsons cup that she apparently had on hand. "Lisa, Homer, Bart, and Maggie...are camping out. It is a nice family scene." Before apologizing for her "loose tongue" and signing off, Barbara gave the Simpsons a compliment. "Clearly you are setting a good example for the rest of the country," she wrote in the reply, which news stories warmly quoted.

After the exchange, the Bushes and the Simpsons engaged in a brief détente. At the Environmental Youth Awards in late 1990, the president warmed up the students gathered at the Old Executive Office Building by referencing the show.

"So many people, in so many ways, are getting involved—even the Simpsons," said Bush, who in the same speech mentioned the Teenage

Mutant Ninja Turtles. "You know, Bart Simpson dropped me a line the other day when I told him you were coming—true story—and he wrote me saying: 'When I mess up my bedroom, my mom comes in and yells, but eventually she cleans it up and everything's cool. But when we mess up the environment, we're the ones who are going to be yelling, and it definitely won't be cool.' Well, this is one of those rare moments when Bart makes sense. Wise beyond his years, just as all of you are wise beyond yours."

Bringing up Bart, especially to a group of kids, was a guaranteed crowd-pleaser. So when Smith dropped a line about the Simpson family into the speech to be delivered at the National Religious Broadcasters convention, Bush approved.

On January 27, 1992, the president stepped to the podium at the Sheraton Washington Hotel and addressed a crowd that included his "two good, respected friends," the Reverend Billy Graham and Focus on the Family founder James Dobson. In his remarks, Bush vowed to reverse "the decline of the American family," emphasized his commitment to "winning the war on drugs," and called for the allowance of voluntary school prayer. But his splashiest sound bite of the day was this:

"The next value I speak of must be forever cast in stone. I speak of decency, the moral courage to say what is right and condemn what is wrong. And we need a nation closer to *The Waltons* than *The Simpsons*—an America that rejects the incivility, the tide of incivility, and the tide of intolerance."

The next morning, the quote appeared in major newspapers across the United States. Andrew Rosenthal, who was covering the event for the *New York Times*, even ended his article with it. Smith was happy. "I felt deeply that the line was germane. I thought it was true. And it would help us politically," he says. "So, we had quite a three-fer."

Still, Smith knew that making something beloved by young people a wedge issue in 1992, while facing a saxophone-playing Baby Boomer, was a big risk. But, Curt Smith says, "He did it because he believed it."

Smith was convinced that the *Waltons/Simpsons* comparison would fire up his boss's base, but said that his White House colleagues were not so sure. "There were other writers who might've come from more privileged backgrounds," he says. "They didn't have the confidence that I did that the line would resonate in Middle America."

In truth, Smith was responsible for only half the line. "After I had written 'We need a nation closer to *The Waltons* than *The Simpsons*,' Bush added a dash and then said, 'an America that rejects the tide of incivility, and the tide of intolerance.'" The speechwriter called the addition "pure Bush. It reflects the kind of moderation and decency that he would bring even to a discussion as partisan as both sides were in this case."

When *Simpsons* writer Jeff Martin heard what President Bush said about the show, he came to a much different conclusion. All he remembers thinking is, *This isn't going to go well for you.*

Today, the idea of *The Simpsons* as a culture war target seems strange. The animated series has been around so long and is so beloved by so many people that even the squarest reactionaries have forgotten that it once was considered shockingly subversive. Now *The Simpsons* is an American institution. As far as pop culture phenomena go, it's in rarefied air.

"All disclaimers in place," Martin says, "but if the Beatles are the world's favorite thing, *The Simpsons* is a contender for second." At this point in our conversation, Martin, a Beatles fanatic, reminds me that it took a while for the establishment to embrace the mop-haired Fab Four. The president's zinger, Martin says, brought to mind *Goldfinger*, a movie released back in 1964. In one scene, Sean Connery's

James Bond says that drinking Dom Perignon '53 warm is "as bad as listening to the Beatles without earmuffs!"

Unlike that exquisite champagne, 007's line did not age well. Neither did Bush's. But the latter highlights the fact that there was indeed a time when some grown-ups still considered *The Simpsons* dangerous. The day after he said it, Bush's provocative line ended up in headlines in newspapers across the country. He did, after all, take a shot at one of the most popular shows on TV.

A few days later, Pulitzer Prize winner Ellen Goodman made the quip the centerpiece of her syndicated column bashing the president for trying to use nostalgia to score cheap points with middle-class voters hurt by the recession. The headline was "Good Night, George-Boy."

One famous comedian used the occasion to make fun of the president's plea. "The trouble with America is that we have too many families like the Waltons," he said in an interview. "They've got no jobs. They live in broken-down shacks with no health care. At least Homer Simpson has a job and his own home." That was Jay Leno, who was at the time preparing to take over for Johnny Carson as host of *The Tonight Show*.

It's hard to know exactly what the average voter thought of the *Waltons/Simpsons* incident, but some left-leaning folks seemed to find it a tad misguided. "Someone should remind our Republican president, however, that the Waltons were 'New Deal Democrats,' as were most of their neighbors on the show," read one letter to the editor in the *Daily Item*, a paper in Lynn, Massachusetts. "Perhaps Mr. Bush is indirectly telling us whom to vote for in November!"

To the people who worked on the show, Bush's insult induced a mix of anger, bemusement, and validation.

"I do remember being really furious, and outraged, and disappointed," Yeardley Smith once told me. "Like, you so missed it. You missed the point. You don't get that these people really love each other."

"I mean, it didn't really affect us one way or the other," writer George Meyer says. "But we thought it was cool that, you know, the show had invaded the sensibility of the commander in chief."

"Most of us were happy that we were notorious," writer Jon Vitti adds. "The Republican president of the United States was unhappy with us. It kind of showed that we were doing what we were trying to do: show parts of growing up that weren't being shown on TV."

For the writers, that meant sympathizing with the show's lower-middle-class protagonists but refusing to sugarcoat their lives. The president desperately sold potential voters on his vision of the world: one where people could, through hard work and decency, become the Waltons. But by the '90s, that wasn't a widely achievable dream. Most blue-collar American families were more like the Simpsons.

Bart was an underachiever. Lisa's intelligence was not being nurtured. Homer was a lazy father. Marge was a put-upon mother. Money was always tight. Springfield's institutions were failing. Authority figures were greedy and corrupt. The Simpsons' world was just like the real world. That was on purpose.

"It was the first show with the Baby Boomers writing about their messed-up upbringings," Vitti says. "It was a gigantic topic." (*The Simpsons* may have been built for Generation X, but its earliest writers were born at the tail end of the Baby Boom.)

The powers that be disliked *The Simpsons*' snarky honesty. But what *really* bothered them was the show's anti-authoritarian streak. It's one thing to feature a ten-year-old boy swearing and disrespecting his elders. But to *celebrate* him? Well, that was scary.

James Dobson himself—whose 1978 book *The Strong-Willed Child* argued that a kid must "yield to the loving authority" of his parents so that he can learn "to submit to other forms of authority which will confront him later in his life"; who later accused the makers of *SpongeBob SquarePants* of enlisting the character for a "pro-homosexual"

video about tolerance—made a point to condemn the wildly popular "'Underachiever' and Proud of It, Man!" T-shirts. "If there were a simple, single solution to the pervasive problem of underachievement, I'd put it in a bottle and sell it by the millions," Dobson once wrote. "It sure couldn't be any less helpful than those Bart Simpson T-shirts."

The religious right's misreading of the show, willful or not, was deeply ironic. Bart may have been a hellion, but the Simpson family went to church every week. Brooks made sure of it. "He didn't grow up Christian, but it was really important that the Simpsons go to church and pray," Vitti says. "And *The Simpsons* actually explicitly states that God exists on multiple shows."

In the Simpsons' universe, however, religious devotion isn't nearly as important as devotion to each other. "They would go to the mat for each other," Yeardley Smith told me. "They would stand in front of a train for each other. But they're not perfect." The family, as flawed as it was, usually *tried* to do the right thing. Anyone who tuned in regularly, regardless of politics or beliefs or age, had to agree. "Look, this show's good," says the Houston-raised Martin, whose high school graduation speaker was George H. W. Bush. "It's essentially moral. It's for everybody."

In those days, pushback to *The Simpsons* was common. And not just from conservatives and angry parents. Sometimes it came from the show's biggest fans, some of whom were, well, nerds. And one thing nerds are good at is adopting new technology. In the early '90s, that meant the internet, which back then was still a fairly obscure invention. Several *Simpsons* staffers knew about it. After all, they were eggheads, too. One of them was Bill Oakley, who along with his writing partner Josh Weinstein started at the show in 1992. As a teenager in Washington, D.C., in the late '70s and early '80s, Oakley used a modem and his family's Apple II computer to

post messages on electronic bulletin board systems. BBSs eventually gave way to Usenet, a pre–World Wide Web network of newsgroups dedicated to different topics. Basically, it was a proto-Reddit. Newsgroups were split into hierarchies. *Comp.* covered computers, *sci.* covered science, and *soc.* covered social issues. Then there was *alt.*, which encompassed "alternative" subjects, including TV programs like cult classic *Star Trek*. And what exactly went on in a Usenet newsgroup? Here's how the computer scientist Gene Spafford once described it: "Usenet is like a herd of performing elephants with diarrhea: massive, difficult to redirect, awe-inspiring, entertaining, and a source of mind-boggling amounts of excrement when you least expect it."

Spafford didn't know it at the time, but he'd successfully summed up what the internet would become. He also inadvertently characterized alt.tv.simpsons, the Usenet group University of Delaware computer science student and *Simpsons* fan Gary Duzan created in March 1990. On its first day of existence, three months after *The Simpsons*' series premiere, about a hundred posts poured in. "People found the thing right away," Duzan once told me.

This was relatively remarkable, considering that internet access was still so limited. Early alt.tv.simpsons occupants tended to be college kids and unusually tech-savvy *Simpsons* obsessives. Some posters discovered a.t.s. only after logging on to the internet through university-provided Unix shell accounts. (Unix was a completely text-based operating system.) The web browser hadn't even been invented yet. That meant no GIFs or memes or TikToks or Reels or Snaps to look at. There were just words on a screen.

Alt.tv.simpsons wasn't just a breezy message board. It was brimming with recaps, reviews, and minutiae. The contents ranged from meticulous (a list of the show's introductory blackboard and couch gags) to overcritical (in the middle of an early season, somebody started the thread "Simpsons in decline?") to offensive (e.g.,

"Lisa has a proto-dyke Marxist Jew agenda"). As a tutorial posted in alt.tv.simpsons wisely explained, "These are called trolls, and even alt.tv.simpsons isn't immune to them."

One day early in his time at the show, Oakley made a strange discovery. Hiding in a cluttered corner of the *Simpsons* writers' room, "under a whole bunch of crap," he told me, was a five-inch-thick stack of dot matrix printer paper. (Hey, this was the early '90s.) The perforated pile contained thousands of neatly typed comments. Oakley recalls sifting through the bundle and thinking, *What the hell is this?*

The copious notes were posts the writers had culled from alt.tv.simpsons. To Oakley, a computer nerd, this was a revelation. At the time, public feedback consisted of little else but Nielsen ratings. "Literally, you got zero feedback," Oakley once told me. "And the ratings never had anything to do with the quality of the episode. They had to do with what was on opposite it, or what the weather was like, or whatever. It was very weird, certainly compared to today."

Another *Simpsons* writer, David X. Cohen, couldn't quite wrap his head around the lengths the online community went to express its intense obsession with OFF (that's alt.tv.simpsons shorthand for Our Favorite Family, a.k.a. the Simpsons). "It was stunning to see people willing to devote so much of their lives to a half-hour TV show," Cohen once told me. "I made the discovery in those early days that people only post to the internet when they have an extreme point of view."

Matt Groening even once admitted to the *Philadelphia Inquirer* that he frequented alt.tv.simpsons. "I lurk," he told the paper. And occasionally, Groening said of the message board's users, "I feel like knocking their electronic noggins together." Always deeply protective of his characters, he seemed annoyed by the fact that people were providing the world with an unauthorized (and sometimes critical) guide

to the show. "Sure, I'm bugged by the copyright violations," he said. "But *The Simpsons* has been violated so often that I don't lose any sleep over it. I don't really know what could be done about it."

In the case of *The Simpsons*, the conversation wasn't just among fans. When he started working on the show, Oakley joined in. After trying and failing to get dial-up internet access from UCLA, he found a now defunct provider called Netcom. At his request, Fox installed an office phone line that was compatible with a modem.

Unlike his boss, Oakley didn't just lurk on alt.tv.simpsons. He posted in it under his own name. For example, he once posted detailed episode information for an upcoming season. For fans of the show, it's an amazing time capsule.

In hindsight, there's something quaint about a writer from a hit TV series happily feeding inside information to people on a message board. But Oakley shared their love of *The Simpsons*. Had he not ended up writing for the show, he said, "I would've been one of them."

The forum's seemingly high collective IQ also intrigued Cohen, who has a master's degree in computer science from Berkeley. He enjoyed hiding geeky Easter eggs in episodes just to see what kind of reaction he'd get. There's little doubt that the denizens of alt.tv.simpsons were smart. "You had to have a degree in computer science or you had to have access to a mainframe to post these things," Oakley said. "That selects a certain crop of people who were usually pretty intelligent." But that didn't guarantee civility. After all, this was still the internet.

Naturally, the show's staff responded to the sniping with its most powerful weapon: military-grade snark. On *The Simpsons*, the internet came to be known as a place occupied by the blissfully unhinged. For the writers, the ponytailed Comic Book Guy was the perfect

embodiment of the kind of internet troll who took himself and his opinions far too seriously.

Back in the early '90s, the web was a much more intimate place. But the toxic feedback loop was slowly building. Oakley and Weinstein saw its construction firsthand on alt.tv.simpsons. Mixed in with valid criticism and good-humored insight was a sense of entitlement.

"They hated everything," Oakley says. "And also because they knew who I was, they became very presumptuous. They would tell me how to run the show. And I was like, 'Who the fuck are you?' But they didn't stop. They're the kind of weird internet nerds who think they probably know better than me."

For Oakley, the constant critical feedback became tough to handle. He began to take negative comments personally. "If there are ninety-nine pieces of praise and one criticism, I will obsess on the criticism," he told me. "It's a personality quirk that a lot of people have, especially creative people and writers. They can't stand it. They want everything to be just so."

At his office, Oakley started getting angry phone calls about the show. From who, he's not sure. Soon after that, he ripped the cord connecting his modem out of the wall. He told me that he didn't look at internet comments again until he left *The Simpsons*.

Internet cranks were annoying. But they could be ignored. The network could not. Fox executives didn't give creative feedback, but its censor did. Back then, Avery Cobern was the manager of broadcast standards. Her job was to read every single script and flag potentially objectionable material. She was meticulous. After all, it was on her to make sure the show didn't do anything that would get the network in trouble. But in hindsight, the notes she sent to the producers were almost as funny as any *Simpsons* episode.

Some were obvious. Like these: "This *Itchy & Scratchy* cartoon goes too far. Please do not show a cat coughing up blood." "Caution that the 'large-breasted woman' in the picture is adequately covered." "Obviously we do not want to show the intimate details of a bris."

Some were thematic. When Bart becomes mobster Fat Tony's errand boy, Cobern was worried. "I am concerned that this script makes it seem that Bart is attracted by the criminal lifestyle, willingly joins a gang, and commits illegal acts for the money they give him, and also that Marge and Homer don't even mind," she wrote. "The only way for Bart not to be compromised in this episode is if it is believable to the viewer that he was completely fooled by Fat Tony."

And some were about language. When the *Treehouse of Horror II* script came in, Cobern wasn't pleased with the way Mr. Burns described his lazy employees. "Please substitute for Burns' 'their days of suckling at my teat are numbered.' It is our policy not to accept this word, since many viewers will merely be offended by it without grasping an implied metaphor. Something like 'sucking at the bosom of my generosity...' would be acceptable." The word "teat" ended up staying in the episode. As did Bart's stated desire, despite Cobern's initial objection, to rename the United States "Bonerland."

Simpsons humor was never as blue as Marge's hair, but there *was* light cursing and slightly dirty jokes. Like in "Brush with Greatness." When commissioned to create a portrait of Mr. Burns, Marge depicts the power plant owner as he really is underneath his malevolent exterior: naked, shriveled, and frail. The script ends with the billionaire complimenting the artist. "Your painting is bold but beautiful," he tells Marge. "And, uh, incidentally, thanks for not making fun of my genitalia." In response, she says, "I thought I did." Before the episode aired, Cobern wrote a memo that demanded, um, cutting the word "genitalia." "As constituted, the moral point and a very human moment with Mr. Burns is lost in the shock of the specific body part reference,"

she wrote. "Calling specific attention to a man's sex organs in this way would be certain to offend and anger many viewers, especially parents who are watching this show with their children. Although in previous discussions I requested a very general word such as 'body' in this scene, the substitution of your original term, 'equipment,' would be preferable and would satisfy our concerns in this context."

Instead of relenting, ten *Simpsons* staffers, including Simon, Brooks, and Groening, signed their names to a letter explaining their refusal to replace the word to Fox's vice president of broadcast standards Don Bay. Even Barry Diller was CC'ed.

"Although we will always fight for our right to use adult language and reject any attempt to turn *The Simpsons* into a children's show, there are some particular aspects of this 'genitalia' controversy that have moved us to take this strong action," the letter reads. "In the original draft of this script we used the word 'equipment,' and it was rejected. Traditionally, a solution to this type of language problem is to select a more clinical term. Therefore, we chose 'genitalia.'"

The memo asserts that at one point, Cobern *did* approve the word. "At any rate, it is currently disapproved and you are now proposing 'equipment,' which your department had earlier rejected, as the only approved substitute," the letter continues. "...We hope you will not bleep or edit the word, because we cannot help but see such an action as a creative assault on the integrity of our show. We also think that there are no winners or losers in these arguments. Unless we work together, we all lose."

"When somebody showed me this memo, which I was unaware of, it read like a fucking declaration of independence," Roberts says, "and it was signed by not one, but ten John Hancocks in my world." To his delight, Fox dropped the objection and the reference to

Mr. Burns's genitalia—which is visually covered by a hat feather, Marge's hand, and champagne flutes—stayed in. Roberts wasn't surprised that Brooks, Simon, and Groening and the writers held their ground over a small detail. This was *their* show, not the network's.

The Mr. Burns bit was transgressive. But *The Simpsons* was rarely as offensive as parents thought, even when it wanted to be. The writers knew that having creative control didn't give them license to violate broadcast standards. Remember "Homer's Night Out," when Homer is caught on camera canoodling with a belly dancer? Vitti, who wrote it, calls it a "problem episode." It was a problem because the writers knew the photograph of Princess Kashmir couldn't be lewd enough to be scandalous. They understood that there were lines they couldn't cross.

"George said something really smart when I was sadly trying to figure out what lessons could be learned," Vitti says. "He said that *The Simpsons*' tone just didn't let us create a photo that was offensive enough to justify how shocked the characters get. It was just a story we shouldn't have done on *The Simpsons*."

Vitti felt bad for pitching the idea, but he was reassured when neither Brooks nor Simon—or anyone else—could help make the story work better. "It's the only time in my career I sought a do-over," Vitti says.

When he started writing for *The Larry Sanders Show*, a sitcom starring Garry Shandling as a late-night host, Vitti noticed a story idea on a bulletin board. The premise? The show-within-a-show's writers discover and circulate Larry's sidekick Hank Kingsley's sex tape. "I immediately recognized it as my chance to write a non-crappy version of 'Homer's Night Out,'" says Vitti, who indeed went on to write one of the best *Larry Sanders* episodes: "Hank's Sex Tape."

"George was right," Vitti adds. "The story wanted to have an

R-rated HBO reality. It was much happier in that world and was never worth troubling parents and children with on an animated show." (To be fair to Vitti: there was no real backlash to "Homer's Night Out.")

That's not to say that *The Simpsons* couldn't do "adult" episodes. Though they rarely set out to come up with material that had a message, when it was called for, they managed to do it well.

The writers' room was, of course, filled with very smart people. But as erudite as those people were, they were above all dedicated to producing huge laughs. This meant that commenting on any serious issue was always done with a degree of silliness. Here's where one of John Swartzwelder's rules comes in. He used to call *The Simpsons* "a drama done by stupid people."

At one story meeting for Season 2, Brooks pitched an idea involving Marge crusading against cartoon violence. Afterward, Simon asked the group who wanted to write the episode. Vitti didn't want to do it. "It sounded difficult and *Oh, it's going to get preachy*," he says. But Swartzwelder, Vitti remembers, immediately volunteered.

"I totally didn't get it," says Vitti, who was confused by Swartzwelder's eagerness. "I didn't want to say anything in front of Sam, but when we went back to our office, I said, 'Why do you want to write the Marge versus cartoon violence episode?' And he just smiled and said, 'You can't show someone crusading against the problem unless you show the problem.'" At that moment, Vitti had an epiphany. "And as soon as he said it, it was like, 'Ah, you magnificent bastard,'" he says. "It's like you could just see it. It gave him license to write all the cartoon violence he wanted to write."

At the beginning of "Itchy & Scratchy & Marge," Maggie hits Homer on the head with a mallet. (The scene is an extended homage to *Psycho*.) It doesn't take long for Marge to figure out where her infant

daughter learned such behavior: the hyper-violent show-within-a-show *Itchy & Scratchy*. In the first act alone, Itchy and Scratchy repeatedly hit each other with meat-tenderizing mallets, Itchy blows up Scratchy with a football bomb, Itchy stabs Scratchy with a butcher knife, Itchy torches Scratchy's head with a bazooka, and Itchy knocks Scratchy's eyeballs out with a sledgehammer, then replaces them with cherry bombs, which explode.

The gratuitous mayhem leads Marge to organize Springfieldians for Nonviolence, Understanding and Helping (S.N.U.H.), lead a picket of Itchy & Scratchy International, and piss off company chairman Roger Meyers Jr. and the cartoon's writers, who respond by having the cat and mouse team up to attack a shrill squirrel with a familiar blue beehive.

Basically, Marge transformed into an animated version of Terry Rakolta, who'd led an advertising boycott of Fox's *Married... with Children*. By the Reagan era, reactionaries unhappy with what they perceived as the increasingly harmful influence of pop culture were sprouting up around the country. The Parents Music Resource Center, co-founded by future second lady Tipper Gore, attempted to clamp down on music that was allegedly obscene. Artists banded together to fight the organization, which did succeed in getting Parental Advisory stickers slapped onto explicit albums. Like Marge, Gore was also the subject of ridicule by the voices she was trying to suppress. A genre-spanning lineup of musicians took shots at her on their records.

Around that time, Satanic Panic was sweeping America. What started with a discredited book featuring claims that a woman suffered horrific ritual abuse—that never happened—caused a media-fueled frenzy. In the '80s, there were reportedly twelve thousand unsubstantiated accusations of satanic ritual abuse. Local news stations reported

on the supposed problem. Talk shows were obsessed with it. And lurid accusations made against the employees of a preschool in Southern California spawned a nearly decade-long, heavily covered case that ended with all the charges being dropped. The SRA epidemic, it turned out, wasn't real.

That didn't stop the scare tactics. Heavy metal bands were accused of promoting the occult. And a group known as Bothered About Dungeons and Dragons (B.A.D.D.) claimed that the role-playing game helped lure kids into devil-worshipping cults. The fear was, needless to say, unfounded.

In 1987, the Federal Communications Commission repealed the Fairness Doctrine, a nearly forty-year-old law that required broadcasters to present opposing viewpoints while covering controversial issues. A year later, uncoincidentally, stations across the country began airing right-wing broadcaster Rush Limbaugh's radio show. The gay-bashing, racist, misogynistic host aired his grievances daily for an audience of millions. He scoffed at the supposedly liberal invention of political correctness, which he equated to censorship. At the same time, he took pleasure in bullying everyone who disagreed with him.

This was the world *The Simpsons* drew from. In the face of ridicule, Marge's persistence leads to change: the studio begrudgingly sanitizes *Itchy & Scratchy*. But bored by seeing Scratchy do uncharacteristically sweet things like offer Itchy lemonade, Springfield's hardened children collectively turn off the idiot box and play outside. Alas, the TV-free utopia doesn't last long. When concerned mothers recruit Marge to protest a local exhibition of Michelangelo's *David*, she rebuffs them and is promptly labeled "soft on full-frontal nudity."

Realizing that censorship isn't the best way to shield her family from negative influences, Marge backs down. And soon, Itchy and Scratchy are once again doing things like engaging in a duel that ends with the former using a planet-enveloping gun to shoot the latter into

the sun. As absurdist as it often is, the episode *does* have a lot to say about parenting and free speech. If adults disliked *The Simpsons*, they could change the channel. Or turn off the TV.

What no one who worked on the show ever expected to see was the ending of "Itchy & Scratchy & Marge" unfolding in real life. In 2023, a Florida school board reportedly forced a principal to resign after three parents objected to an art teacher showing their sixth graders a photograph of Michelangelo's *David*. That reality was way too dumb to imagine.

"John Swartzwelder must be really happy," Vitti wrote back when I emailed him an article about the controversy. "I don't remember anyone even wondering if we needed to explain why Marge was against censoring *David*. And to a fault we would explain anything that might confuse anybody. There was zero concern that anybody out there would be rooting for Marge to get *David* banned. So we predicted the event, but we really can't say we influenced society at all this time, since America went in exactly the wrong direction."

To Vitti, "Itchy & Scratchy & Marge" was "a breakthrough for us, in terms of the level John took it to." From then on, if he was struggling with a more dramatic script, Vitti reminded himself of Swartzwelder's "drama done by stupid people" rule. It always made him feel better.

As the landscape of the U.S. presidential race rapidly shifted in 1992, Bush continued to double down on the *Simpsons* bashing on the campaign trail. In August, during his arrival speech at the Republican National Convention in Houston, he trotted out a new version of speechwriter Curt Smith's line. "We are going to keep on trying to strengthen the American family... to make American families a lot more like the Waltons and a lot less like the Simpsons." That year, I should note, Vice President Dan

Quayle had also started a feud with the creators and star of the sitcom *Murphy Brown* over the main character's choice to have a child as a single woman.

As writer Jeff Martin predicted when he first heard the president's dig, things didn't go well for George H. W. Bush. "Virtually anyone that I knew that worked for Bush in '92 would call 1992 the worst year of his life," Smith says. "Because it was so gruesome."

For the sitting president, it was a stunning reversal of fortune. After the perceived success of the Gulf War, he seemed invulnerable. Then came the L.A. riots, criticism of his broken "read my lips: no new taxes" promise, and a worsening recession. Not to mention a challenge from the Republican Party's hard-right wing. In the New Hampshire primary, Bush only defeated the deeply reactionary Pat Buchanan by about 16 percentage points. For a sitting president, it was a terrible result.

In the general election, the president ceded swaths of the United States to Clinton. The underdog won, among others, Louisiana, Arkansas, Missouri, Illinois, Kentucky, Tennessee, Pennsylvania, and Ohio—all states that Bush took in 1988. Clinton, boosted by independent Ross Perot siphoning off almost 20 million votes, cruised to victory. "The problems actually arose in Middle America," Smith says. "We didn't talk enough to Middle America."

The *Simpsons* dig was one more example of Bush being out of touch. Some of those instances, like when people made fun of him for being baffled by a newfangled grocery store barcode scanner and when he couldn't cite the price of a gallon of milk when asked, were cheap gotcha moments. The *Simpsons* attack, on the other hand, deserved to be questioned.

While Clinton was jamming on *The Arsenio Hall Show*, Bush was trashing one of the most popular shows in America. He'd taken on the

animated series at a moment of extreme political weakness, at a time when *The Simpsons*' standing could not have been higher. His base may have agreed with his stance on the show, but he didn't account for the fact that Middle America loved *The Simpsons*, too. It was a silly fight to pick.

The Simpsons didn't dump on working-class people. The show may not have *exalted* them either, but it often portrayed them sympathetically, flaws and all. America appreciated that honesty. It took the passage of time for Smith to come to realize that he'd mistaken the series' irreverence for condescension. It was far more wholesome than he originally thought. "Having watched it later with some frequency," he says, "I would agree with that."

For a while, Smith says that the *Waltons/Simpsons* quip was displayed on a wall at the George H. W. Bush Library and Museum. To his camp, the line was iconic. If anything, it's proof that being immortalized and being a punch line are not mutually exclusive. Which side it falls on just depends on who's doing the remembering.

In the Bill Clinton years, *The Simpsons*' status as a culture war target began to fade. Its approach to comedy stayed the same, but the series mostly stopped being considered dangerous. "We were trying to make good TV," Brian Roberts says. "Nobody was trying to start a revolution." The American public, even once-irked adults, had seemingly begun to accept the show's sensibility. And the ones that didn't moved on to some other outrage.

To the writers of *The Simpsons*, the Bush vs. Bart controversy ended up being an eye-rolling blip. "It was a sideshow," George Meyer says. "Kind of a goof. And then we just got back to work."

But before moving on, they responded to Bush. In a scene opening a rerun on January 30, 1992, the Simpsons gather around the TV and watch a clip of Bush insulting them. Homer says, "Huh?" Then

ten-year-old Bart fires off a satisfyingly, age-defyingly sharp barb: "Hey, we're just like the Waltons. We're praying for an end to the Depression, too."

And when Bush brought up *The Simpsons* again at the Republican National Convention, the series had Bart repeat his burn. As much as the writers hated making the same joke twice, this one was just too funny not to.

CHAPTER NINE

BEYOND BART

> "I WAS THINKING, 'YOU DOPES. DON'T YOU KNOW BART'S THE KING? BART'S WHERE THE FUTURE OF THE SHOW IS.' WELL, THE SHOW BECAME SO MUCH BIGGER THAN BART."
>
> —JEFF MARTIN

Homer was getting stupider. It's hard to pinpoint exactly when it happened, but around the third season of *The Simpsons*, he started to lose IQ points every week. Before long, he'd gone from a mediocre slob to a bumbling idiot. The decline wasn't his fault. The writers did it to him.

"If you watch the early *Simpsons*, when Dan Castellaneta is still finding the voice, Homer is a very imperfect, flawed man," Conan O'Brien once told me. "But then he is on this trajectory and we were all just galloping. We loved it. How dumb can we make him?"

The writers didn't just love to make Homer dumb. "We loved making him *really* dumb," O'Brien said. "It got to the point where Homer's brain gets mad at Homer for being so stupid and walks out on him."

Even when *The Simpsons* was at its peak, painting Homer as a dimwit did become a crutch. "There were times where, you know, I felt like we were counting too much on making Homer too stupid,"

producer Joe Boucher says. "Like, what was funny in the moment is just Homer being as stupid as possible."

There *was* a reason for Homer's de-evolution. "It was mainly because we started to see the enormous comic possibilities of the character," George Meyer says. "In my opinion, Homer Simpson is the greatest comic character ever to appear on television. All the writers on the show loved writing for him, loved Dan Castellaneta's performance. He was just an endless, bottomless vessel of creative joy for us."

When the show began, Homer was basically Oscar Madison. But he got even funnier when his gruffness gave way to foolishness. "Homer became a more appealing character, I thought, after Dan switched from the Walter Matthau voice," Jeff Martin says. The change, which Castellaneta made because of vocal strain, effectively lightened Homer up. Philosophically *and* intellectually. Over time he ceased having the ability to stop and think. That led to painfully hilarious situations that appealed to viewers' base instincts.

"We thought America was responding to our really smart jokes, and then Fox gave us research that said that the audience likes the pretty colors and they like it when Homer hits his head," Jay Kogen says. "We had to sort of forget that and then just continue doing what we were doing."

When Homer occasionally fell too far down the hole of idiocy, the writers liked to yank him out and send him in the opposite direction. "We loved making him stupid, but we also loved giving him great knowledge and eloquence out of nowhere when it suited us," O'Brien said. Like when Springfield Elementary's teachers go on strike and Lisa laments that she'll fall so far behind in school that she won't even get into *Vassar*. Homer then scolds his daughter. "I've had just enough of your Vassar bashing, young lady!"

"You're like, 'Wait a minute. Is he the stupidest man in the world? But he knows what Vassar is?' I don't know," O'Brien said. "It really delights me."

O'Brien was tickled by Homer's short bursts of dumbed-down but profound lucidity. Like at the end of "Mr. Plow," when Homer and Barney reconcile and the former says that "when two best friends work together, not even God himself can stop them."

"He's very eloquent in a Charlton Heston *Ten Commandments* way at times," O'Brien said. "He is also so stupid that he's in danger of dying from forgetting to breathe."

Though the writers enjoyed breaking *Simpsons* rules and making Homer smart, they knew that he was at his funniest when he was blissfully ignorant. John Swartzwelder was on to something when he said he liked to imagine Homer as a big talking dog.

"He reacts really passionately to everything in the moment, which is actually a really healthy way to live," says Jon Vitti, who points to a Wallace Wolodarsky joke that appeared in Season 2. Homer steps on the bathroom scale, which starts spinning back and forth like a wacky roulette wheel. Every number the dial temporarily lands on causes him to cheer, scream, groan, and, when it settles on 260 pounds, cry. "In an instant he's really happy," Vitti says, "and then really sad, in a half second."

Bart's cleverness, irreverence, and devilish streak made him fun to write for, but he was a child. That was inherently limiting. His world was just smaller than Homer's.

"I fully admit, I was slow on the uptake," Jeff Martin says. "When I started working on [the show], it was a lot of Homer. Lots and lots of Homer. I was thinking, 'You dopes. Don't you know Bart's the king? Bart's where the future of the show is.' Well, the show became so much bigger than Bart."

As the world of *The Simpsons* was growing, Sam Simon decided it was time to start his long goodbye to the series he'd help create. In the midst of disagreements with Brooks and Groening about credit and money, he decided to stop running the show on a day-to-day basis. Before stepping back into an advisory role, he put Mike Reiss and Al Jean in charge. They had a tough job: making sure the animated series continued to be the funniest thing on TV. They were the first in a line of showrunners determined not to screw up *The Simpsons*.

"We all respected them and they were very good at keeping the trains running and also coming up with brilliant stuff," Meyer says.

Jean and Reiss faced the same dilemma that their successors did: How do you take the show in new directions while staying true to what made it great in the first place? Well, they figured out that the show didn't *only* have to be about a wise-ass little boy. As funny as Bart could and continued to be, there was a great big world beyond the four walls of 742 Evergreen Terrace. By the third season, the animated series' universe was expanding. And sometimes surreality even crept in.

Like the time Michael Jackson decided that his shadowy contribution to the *Simpsons* album wasn't enough for him. He wanted to be *on* the show. So he called Groening and asked to make a cameo. Once Groening said yes, Al Jean and Mike Reiss wrote an episode specifically for the artist, who instead of appearing as himself would play a hefty mental hospital patient named Leon Kompowsky who claims to be (and sounds *just* like) Michael Jackson.

Before agreeing to the role, Jackson requested a script table read at his manager Sandy Gallin's house. That day, MJ was nowhere to be found. "We waited for like an hour for him to come down the stairs," says Larina Adamson. During the read-through, Jackson was

supposed to sing a song that he wrote for the episode: "Happy Birthday Lisa." But he refused. "He wouldn't sing," Adamson says—not even at Brooks's urging. "Jim kept on saying, 'Come on buddy, sing.' And he finally sang a little bit 'cause I guess he was embarrassed to sing in front of us."

Days later at the Fox lot, there was a second table read. Adamson was tasked with getting the room ready for Jackson's arrival. Her bosses gave her strange instructions. "I had to turn up the heat in order for it to be 80 degrees in there," she says. "With a bunch of Evian water. And I'm thinking to myself, 'What the fuck? You're gonna go up there, drink water, and sweat.' But I did it."

That day, Roberts was running late. When he got to the table read, he took one of the two remaining seats. Jackson showed up wearing his signature sequined jacket with epaulets. "I prayed that he wouldn't take the seat next to me," Roberts says. Sure enough, he sat down right next to Roberts. "Literally elbow to elbow and knee to knee, because we're squished in and we're reading the script and he's doing his thing, and it's going well, and it's very funny," Roberts says. And then there's a place in the script where he sings, 'Man in the Mirror.' And I said, 'OK, how often in your life are you touching the guy's knee and elbow who wrote and sang "Man in the Mirror"?' So I'm going to fucking look, OK? So I look over and there was a white guy sitting next to him who was singing the song."

The white guy was Kipp Lennon, a Michael Jackson–approved Michael Jackson impersonator. MJ was providing Leon Kompowsky's voice, but Lennon was singing for the character. That's what Jackson wanted. He claimed he thought his brothers would find it funny. And more importantly, having someone sing for him would ensure he wouldn't run afoul of Epic Records.

Jackson ended up recording his part at his house, in private. In the Season 3 premiere "Stark Raving Dad," he plays Kompowsky and

Lennon belts out the songs. Fox never even officially announced the star's appearance, which was standard for A-list celebrities. The exception was *The Simpsons*. Even so, Jackson was notoriously press shy. In the episode's closing credits, he's listed as John Jay Smith. Like many of his other disguises, this one didn't work. Even when coming from the mouth of a burly bald guy, the voice was unmistakably Michael Jackson's.

By the time the King of Pop made his appearance, guest stars were becoming a huge part of *The Simpsons*. Celebrities wanted to join in on the fun. Actors even started using their real names in the credits!

On Christmas 1990, *The Godfather Part III* hit theaters. The third installment of Francis Ford Coppola's mafia epic wasn't close to as critically praised or financially successful as the first two, but it was a breakout moment for one member of the cast: Joe Mantegna. The Tony Award–winning character actor had a meaty part: noisy mobster Joey Zasa.

Maybe more than any other performance in the movie, Mantegna's popped. "At that particular moment in time, I was probably the most well-known movie gangster on the radar," he says with a laugh.

Not long after *Godfather III* opened, Mantegna got a phone call from someone at *The Simpsons*. They wanted to know if he'd be interested in guest-starring as an animated mafioso named Fat Tony. "I'd heard of it, but I hadn't really watched an episode of it," Mantegna says. "I really didn't know anything about it."

For research, Mantegna watched a few episodes. "I checked it out and I thought, 'OK, this is not just a cartoon,'" he says. "It's not *Bugs Bunny*. This is its own thing."

Among famous people, that reaction was common. After actually finding out what it was, they wanted to be associated with *The Simpsons*. Which said a lot about its prestige. Hollywood was and still

is a very image-conscious place. An actor like Mantegna didn't want to risk his career on any old animated series. Mantegna only had one concern. He didn't want his role as a cartoon heavy to undermine his role as a live-action heavy. Choosing to be a made guy on *The Simpsons* so soon after his turn as Joey Zasa made him uneasy. He thought it'd be like if Marlon Brando played a comic don in satire *The Freshman* a few months—rather than two decades—after starring as Vito Corleone in *The Godfather*.

"For sixteen years people were waiting for this new *Godfather*, and here I am playing the bad guy," Mantegna says. "I don't know if it's a smart idea to all of a sudden be doing that same voice, that same guy, in the cartoon."

In the end, the offer was one Mantegna couldn't refuse. He agreed to become *The Simpsons*' resident mob boss and eventually headed into the Fox lot to record his lines. "In a basement," he says. "And there was just a Ping-Pong table and a semicircle of microphones. I mean, it was almost like being in the dungeon."

When it came time to be Fat Tony, Mantegna didn't try to speak like Joey Zasa. Instead, he imitated his uncle Willie. "Who *actually* sounds like that," the actor says. "And I thought, 'Let's just see if this flies. And so when I get to my first lines and I do them with *this kind of a voice*," he continues, dropping into Fat Tony's deliberate speech pattern, "I'm thinking, well if they say, 'Stop, what are you doing?,' then we're gonna have a discussion. But nobody said anything. There were a few giggles. And I thought, 'Oh, maybe they like it.' So I did it."

In "Bart the Murderer"—a third-season episode with themes that the Fox censor was very concerned about—the fourth grader becomes Fat Tony's loyal errand boy and crack bartender. Mantegna liked the episode. But he thought he was done with Fat Tony. "I got a call a few months later saying, 'We really like that character, let's consider doing

it again,'" he says. "Not knowing it was going to take me over the next thirty-plus years."

Since 1991, Mantegna has played Fat Tony dozens of times. The actor is still surprised that it's become his longest-running role. "Did the Beatles know they were gonna be the Beatles?" he says. "I dunno. You put it out there and hope for the best. I'm thrilled that it's resonated with the fans."

By the time Fat Tony's Legitimate Businessman's Social Club opened in Springfield, being part of *The Simpsons* was a badge of honor. Making a cameo on the show was a sign you'd entered the pop culture pantheon, even if you weren't in the entertainment business.

For the John Swartzwelder–conceived "Homer at the Bat," about Springfield Nuclear's championship softball team, casting director Bonnie Pietila recruited nine bona fide Major League Baseball players. The All Star–studded lineup features Wade Boggs, Roger Clemens, José Canseco, Ken Griffey Jr., Don Mattingly, Steve Sax, Mike Scioscia, Ozzie Smith, and Darryl Strawberry. The episode, which Swartzwelder filled with references to old-timey players like two-time World Series champion Mordecai "Three Finger" Brown, was, well, a five-hundred-foot grand slam. The week it debuted in February 1992, it beat *The Cosby Show* in the ratings. For *The Simpsons*, that was a first.

The players involved had no idea that a significant segment of the population would remember them for their appearance on a cartoon more than for their on-field exploits. I once asked Smith if his fans ask about "Homer at the Bat." The answer was yes. The only question the Hall of Fame shortstop gets more, he told me, is if he can still do his signature backflip.

Three seasons in, under the leadership of Jean and Reiss, *The Simpsons* was getting even better. The guest stars piled up, the story lines grew

more complex, and even if Homer was dumber, the comedy became more sophisticated.

In Season 3, Lisa takes down a corrupt politician and becomes a beauty queen. German tycoons buy the power plant. Bart falls down a well. Homer's adventures also... intensify. He accidentally saves the world from a nuclear meltdown, manages a beautiful country singer, and develops a tasty new cough-syrup-fortified cocktail that Moe steals for his bar without credit.

Also, Krusty the Clown gets a proper origin story: his real name is Herschel Krustofsky and his father is a rabbi played by comedian (and former rabbi) Jackie Mason. Kogen and Wolodarsky's "Like Father, Like Clown," a parody of *The Jazz Singer*, was something new for the show: a story told from the perspective of a side character. In his 2018 memoir, *Springfield Confidential*, Reiss cited it as one of the show's most groundbreaking episodes.

The animated series seemed to deepen every single week. "The characters were getting more fleshed out," Nancy Cartwright once told me. "They were becoming more real. That's what kept us on the air. The more the writers emphasized that, the more the public loved the show. They could relate to it."

Homer and Lisa's relationship, already one of the show's most interestingly fraught, became even more complicated. Like in Season 3's "Lisa the Greek," when they bond over the titular character's damn near supernatural ability to pick NFL winners.

The writers mined the idea from their own existence: in the fall, the writers' room practically became a sports book. There was a weekly Gracie Films pick 'em pool. "Which I spent way too many hours worrying about on Sundays when I should have been out riding my bike or taking a walk," Vitti once told me. And Simon even introduced the writers to his bookie, "Broadway Harry."

The plot of "Lisa the Greek" revolved around betting on the NFL.

But it wasn't *really* about that. "Honestly, the show isn't about football," Kogen said. "The show is about a father and daughter."

Homer and Lisa couldn't be more different, but that contrast is what makes their connection so touching. Lisa was smarter than her dad, but she still pined for his affection. And as stupid as Homer was, he still adored his kids. "Homer the clueless dad really doesn't get his daughter," Smith once told me. "But it doesn't mean he doesn't love her."

When Homer and Lisa were together, Castellaneta and Smith's performances became even more affecting. "To watch Dan Castellaneta play those moments where his heart is broken open, for me, it never gets old," Smith told me. "When he gets behind that microphone, he absolutely blossoms."

Smith's touching performance in that episode earned her an Emmy Award. Her character had never felt more real. "If you had to ask Meryl Streep to play an eight-year-old girl, I don't know if Meryl Streep could do it," Kogen said. "Yeardley Smith can do it."

By the end of the third season, *The Simpsons* had become a pop culture phenomenon, beaten *The Cosby Show*, and taken on the president. Before the fourth season, Fox announced a big change behind the scenes: it was dumping Klasky-Csupó. The independent animation studio had made the show from the beginning, but squabbles over the chaotic production schedule and the budget led to bad blood.

According to Gábor Csupó, Gracie Films demanded that Klasky-Csupó fire a producer incorrectly alleged to be inappropriately double-billing. "They told me to fire the producer, and I said no," he says. Csupó was confident that this would not be a problem since, he says, "we were doing everything just fine."

He was wrong. "And so basically it was like a yearly $10 million

contract just went out the window," Csupó says. "When you're part of a Hollywood machine, you just never know what will happen." He was crushed. But fortunately for him, kids' network Nickelodeon had recently hired his company to make animated shows. Their first Nicktoon was *Rugrats*. It was a huge hit and, like *The Simpsons*, spawned merchandise and a movie.

"And why did they call us?" Csupó says. "Because they saw our work on *The Simpsons*. They basically gave us a green light to create our own shows. And you know, as we say, the rest is history."

Meanwhile, Fox hired Film Roman, another independent animation studio. The small shop, which made *Garfield* cartoons, brought on most of the Klasky-Csupó *Simpsons* team. "They kind of just got out of the way and they just kind of watched us like, 'What are they doing?'" Rich Moore says. "You know, because they were kind of a mom-and-pop place that suddenly inherited like this juggernaut."

At that point, Moore was still somewhat shocked that *The Simpsons* had become a juggernaut at all. A successful primetime animated show had just seemed so unlikely. "We always worried like, 'How much longer will this go on?'" Moore says. His friend, fellow *Simpsons* animation director Jim Reardon, used to wonder aloud if one day the audience was going to realize it's watching a cartoon and finally tune out. "And it will end," Moore says.

The way *The Simpsons* stayed successful was figuring out unexpected ways to evolve. The staff seemed to take Sam Simon's early advice to heart. As he used to say, every episode should be like no other episode. The writers tried to make that happen. Sometimes, they did it by finding ideas in strange places.

Back then, Conan O'Brien was still one of the new guys. In 1991, he'd left *Saturday Night Live* for *The Simpsons*. Even for him, the environment was daunting.

"Mike Reiss and Al Jean heard that I was available, and they said,

'Look, would you want to come work in the *Simpsons* writing room?' Pretty much it was the original crew," O'Brien said. "I was intimidated because that's being asked to play on the Dream Team. I had never worked in that format before. I'd only been pretty much exclusively a sketch writer. I was nervous."

Vitti understood O'Brien's early anxiety. Everyone at *The Simpsons* had high comedic standards. It was a lot to live up to. "You have moments like, 'Oh my God, I work with such brilliant people,'" Vitti says. "Some of your great jokes you owe to other writers. I can totally admit." And contributing to another writer's script? Well, O'Brien said, that was "sometimes the most fun I would have." The moment in Vitti's "Mr. Plow" when Homer nonsensically turns his radio dial to the right to rebalance his truck and stop it from falling off a cliff? That was from O'Brien.

And nothing was more satisfying than shoehorning in a joke that didn't have anything to do with an episode's plot. "I don't know why, but for a week the idea of someone throwing out perfectly good food and saying, 'Wasting food is fun,' was making me laugh," O'Brien said. His throwaway line became the Simpsons watching a news report about "a new fad that's sweeping the nation: wasting food." Then a guy dumps a perfectly golden-brown turkey into the trash. "You're in the writers' room and it's like a burp," O'Brien said. "You say it and then suddenly it's in." That's also how Marge's sister Selma's pet iguana got its name. "They're like, 'We need a name for the iguana,'" O'Brien recalled. "I just said, 'Jub-Jub.' They were like, 'Jub-Jub it is.' Is that funny? I can't say."

O'Brien loved working at *The Simpsons*. But he was still getting used to Los Angeles. Like everyone else in his new city, he hated the traffic. There's no punch line about living in Southern California that's more hackneyed. Or enduring. Probably because no one's been able to fix the century-old problem. Though people have tried. In the late '80s, decades before Google Maps, *Simpsons* editor Brian Roberts

co-wrote *L.A. Shortcuts: A Guidebook for Drivers Who Hate to Wait*. "We gathered up our best shortcuts from friends and drivers," he says. "Even Harry Shearer gave us a great shortcut."

Around that time, the Los Angeles County Transportation Commission set out to expand a public transit system that would, in theory, ease San Fernando Valley congestion. By the early '90s, several options initially emerged. One was an elevated monorail that ran above the Ventura Freeway.

That's right: a genuine, bona fide electrified monorail. And boy, was it expensive. "As proposed, the $2.6 billion, 16.2-mile monorail line would be built on 20-foot-tall columns in the freeway median," the *Los Angeles Times* reported. "It would connect Universal City to Warner Center with about 14 stops in between."

O'Brien knew nothing about this. But one afternoon, while driving home from the Fox lot in his Ford Taurus SHO, he looked up and noticed a billboard featuring a rendering of a sleek train. MONORAIL, it read in block letters, THE RIGHT CHOICE FOR L.A.

For some reason, the message on the giant advertisement caused O'Brien to crack up. "I remember 'monorail' just made me laugh," he once told me. "Monorails were always funny to me because they're a phony promise of the future. It really is just a trolley, right?"

The word, O'Brien added, "stuck in my head." And to his delight, it didn't leave. "So much of a career, whether it's in comedy or music, is you exploiting your own obsessions," O'Brien said.

O'Brien is a man of many obsessions. Growing up, he loved *The Music Man*. The 1962 film, based on the hit Broadway musical, centers on a con man named Harold Hill. As soon as he heard star Robert Preston sing the showstopper "Ya Got Trouble," O'Brien wanted to play the role himself.

One of his other childhood obsessions was the work of Irwin Allen, who produced disaster movies like *The Poseidon Adventure* and *The*

Towering Inferno. "It always had this very specific structure," O'Brien said. "The beginning is always great promise. 'We built this wonderful skyscraper!' There's a lot of talk about the skyscraper, and then there's always a dire warning: 'You should worry about the electrical system and the smoke alarms.' Don't you worry about that! Then there always comes the moment where all the celebrities are being brought in for the big grand opening. Then there's the moment it all goes to shit."

As he was coming up with ideas for *Simpsons* episodes, he couldn't stop thinking about *The Music Man*, *The Towering Inferno*, and the monorail. "Somehow all those things are swimming around in my head," he said.

To his own delight, O'Brien came up with a concept combining all three. Charismatic scammer Lyle Lanley would show up in Springfield and convince its citizens to pay for a monorail. As ridiculous as it sounds on paper, he believed that the premise was *just* grounded enough to work. The town's decision makers, after all, were gullible enough to fall for a phony promise of the future. "It unfolds really naturally because once you have the idea of a music man selling you a monorail, you know Homer's for it. The town's for it," O'Brien said. "Well, who's going to be against it? It's either Marge or Lisa, because they're sensible. For me, it was Marge. She'll be the voice of reason who senses this isn't wise. The first part is *Music Man*. The second act is an Irwin Allen disaster movie."

O'Brien loved the idea, but didn't think his *Simpsons* coworkers would feel the same way. Eventually, he ran it by Mike Reiss and Al Jean. They thought it was funny. But he still had to present it to James L. Brooks, who preferred human stories to high-concept ones.

When it was O'Brien's turn to pitch at the staff's annual story retreat, he was anxious. If Brooks liked your idea, someone in the room would bang a little gong. "I pitch an idea. James L. Brooks has a very distinctive laugh. He starts laughing, we all talk about it. People

throw out different ways to flesh it out. Gong," O'Brien said. "Then, I pitched the second idea that went well, and that got gonged. There was part of me that thought, 'Get out while you're ahead.'"

Then O'Brien remembers Jean saying, "Tell him about the monorail." In the moment, O'Brien wasn't all that excited about having to explain it. "I was thinking, 'Eh,'" he said. If the pitch fell flat, it would've ruined his great day. But he couldn't resist.

"I thought, 'Well, you've got two, so why not?' The pressure's off. I'm glad it wasn't my first pitch, but I pitch it and James L. Brooks started laughing, and then it gets gonged. From that moment on, that was the one I wanted to write. I just wanted to write the monorail."

O'Brien tried not to get too attached to his ideas, but he couldn't help imagining what an animated monorail would look like. He saw the episode as an extension of his personality. "I felt like, 'Oh, this is such a *me* kind of idea," he said.

Until that point, *The Simpsons* had never done anything as narratively ambitious. For the epic episode, O'Brien finally got his wish: he got to write his own version of "Ya Got Trouble."

"The Monorail Song," which Lanley uses to sell Springfield on a shoddy new public transit system, scratched O'Brien's performative itch. He was stuck behind the scenes in the early '90s, but he'd long seemed destined to be onstage. Jeff Martin, his buddy from Harvard, remembers shooting a video film review with O'Brien back in college. "We did a *Siskel & Ebert* type thing talking about the movie we just saw," Martin says. "We'd put it on and look at it and I thought—this is when we're twenty and eighteen—'Hmm. Conan's funnier on camera than me.' I don't feel so bad about it now."

Martin was around when O'Brien was cobbling together what became a classic *Simpsons* anthem. He'd stop by Martin's office and throw out lyrics like:

"Were you sent here by the devil?"

"No, good sir, I'm on the level."

"He just knew he had something good," Martin says. "It's like he had a thread of something that he wanted to keep on unspooling. He was just coming in and sharing it."

Martin, who'd already written a handful of classic *Simpsons* songs, was there to help. "That was my little niche on the show," he says. O'Brien had the words, and Martin helped him come up with the tune, a propulsive march. "It's like boom, boom, boom, done," Martin says. It was simple, but it worked. "Elton John needs Bernie Taupin," Martin deadpans. Listening to Hartman sing the song made O'Brien think his friend could've had a huge Broadway career. "You realize, yeah, Phil could have been the star of *The Music Man*," he said, "and he would've killed it." The way that Phil Hartman, who plays Lanley with his typically perfect amount of self-assuredness, belts out the song is hilariously hypnotic.

O'Brien wanted to enlist George Takei, who played Officer Sulu on the original *Star Trek*, as a guest star for the futuristic transport-related episode, but he said no. He'd appeared in a previous *Simpsons* episode, so O'Brien said that the writers were shocked he didn't want to return. "It came back to us that George Takei was somehow affiliated with the San Francisco Board of Transportation. He thought that this was maybe making fun of public transportation."

O'Brien was heartbroken. But the next day, he walked by Jean's office and got some good news. "He says, 'Leonard Nimoy said he'd do it.' I said, 'What? That's better. He *outranked Sulu*. This is great.'" O'Brien was in the studio when Spock himself recorded his lines. "Lying on the floor in my parents' living room, watching endless reruns in the dreary Boston '70s, and here he is," he said. "That was electric. He didn't have many lines, but I got to be in the studio when he did it, which was one of the joys of my life. I don't care how many famous people you get to meet in this life, it's seeing the people you grew up with on television in real life that trumps everything."

Thinking about what went into bringing O'Brien's disaster parody to life makes animator Rich Moore simultaneously laugh and wince. "I had to get really creative to actually pull it off because we had not done shows like that before," Moore says. Hell, it begins with a Sam Simon–suggested parody of the *Flintstones* theme song; a sequence that has absolutely nothing to do with the plot. "Zero," Moore says.

From there, the episode gets more and more visually intricate. Among other things, the animators had to come up with an entire new town. By then, Springfield was fully imagined. The animators didn't have to re-create it for every episode. But now they had to build North Haverbrook, one of the run-down places that Lanley had scammed, from scratch. It was like constructing a new set in the middle of making a movie. Moore didn't have time to oversee the planning of a whole new cityscape, so he grabbed a Polaroid camera and drove to North Hollywood.

"I would just kind of quickly take some pictures and compose them how I would imagine what the shot would look like," Moore says. "And then just skip the whole design process." Instead he went right to animator Nancy Kruse, who at the time was in charge of background layouts. "I was just going around taking photos and just having Nancy translate them directly into backgrounds," Moore says. "For the third act, with the monorail, it's a lot of action. It's a lot of quick cutting. So we had a finite amount of days to actually set up shots."

The animators ended up creating the episode's thrilling, action-movie-like climax practically on the fly. But what a climax it is. Homer, who despite being Homer is hired as the monorail conductor, ends up saving the day. When the train's brakes fail, he uses a donut shop sign as an anchor. "Donuts," he says. "Is there anything they can't do?"

"Marge vs. the Monorail" aired on January 14, 1993, midway through the show's fourth season. In Los Angeles, it turned out that the monorail was indeed a phony promise of the future. It was never built.

From the start, the animated series was a funhouse mirror reflection of America. But as its scope expanded, the primetime cartoon also began to see where the country was headed. Lyle Lanley wasn't real, but public-bilking con men like him were out there. And he's now a stand-in for a depressingly common archetype.

"I get a kick out of the cultural reach of *The Simpsons*," Martin says. "If there's some shorthand for a dishonest salesman, a flimflam man, it's a monorail salesman."

Not long after making his musical extravaganza, O'Brien left *The Simpsons*. He moved to New York City and started building his own future as an NBC late-night host. Yet even as he was struggling to settle in as the guy who took over for David Letterman, that cloud-smooth monorail was still following O'Brien around. "I remember an early fan who would hang around Rockefeller Center wore a handmade jacket that had the monorail on it," he said. "That gave me some solace. No one else in America knows who I am. They're not too happy with me, I don't think at this moment, as David Letterman's replacement. But here's a fan who's maybe only checking out the *Late Night* show because they like the monorail episode."

Looking back on it when we spoke in 2023, O'Brien couldn't help but laugh at the monorail episode's outsized imprint on pop culture. When he was visiting his parents in Brookline, Massachusetts, a few years ago, he dug through some boxes that he'd had shipped there long ago. Inside one, he found one of the legal pads that he used back in his *Simpsons* days. On the first page there was a single scribbled word: "Monorail!"

CHAPTER TEN

HOW NOT TO SCREW UP THE SIMPSONS

"I CAN TELL YOU, THERE WAS A *SIMPSONS* WRITER PESSIMIST CLUB."

—JON VITTI

Late in his time at *The Simpsons*, Sam Simon organized a field trip. Martin Scorsese's remake of *Cape Fear* had just come out. The producer was so excited to see the movie that he invited the writers to join him. "The only time we did that," Vitti says.

When they left the theater, Vitti remembers, Simon immediately said, "Hey, let's do *Cape Fear*." By that, he meant that the show should send up the film. The idea sounds obvious now. But back then it was far bolder than it seemed.

"Sam's the only one who could have successfully pitched something that weird," Vitti says. "You aren't supposed to rest an *entire* episode on a single parody like that; you ruin the episode for anyone who doesn't like that."

Vitti once again landed an assignment no one else wanted. In the script, Sideshow Bob plays a version of Robert De Niro's version of Max Cady—a parolee seeking revenge on the person who he thinks put him behind bars.

The creatively titled "Cape Feare"—hey, it was just different enough to separate it from the movie—features the Simpsons going into the witness protection program and becoming the Thompsons. The climax involves Sideshow Bob singing the score of Gilbert and Sullivan's *H.M.S. Pinafore*. "Sam was always great at those show-finishing set pieces," Vitti says. "Sideshow Bob's Gilbert and Sullivan performance was Sam's."

The episode also contains a classic gag: Sideshow Bob accidentally stomping on the head of a rake, sending the wooden handle back into his face. The step-and-smack doesn't just happen once. It happens nine times in thirty seconds. The goal of the drawn-out bit was to lengthen a story that was slightly too short for broadcast. Instead it became one of the best-known jokes in the show's history.

The episode is absurd, but it's also very faithful to the source material. Director Rich Moore started to work on it before the thriller went to home video. Without source material handy, he had to go see the film several times.

"There were *direct* satires of scenes from the movie," Moore says. "I am militant. If I'm satirizing something, it really has to feel like the real thing. We can't just half-ass this. We would go and take a sketchpad just to get the composition of the shot. Not to copy it exactly, but to get the feeling of it."

"Cape Feare" aired in October 1993, at the beginning of Season 5 of *The Simpsons*. But it was made during the production of Season 4. "It's the last time the original staff was in the room together," Vitti says.

By then, Simon had already long since stepped back from running the series on a daily basis. Jaded and convinced that his cut of the show's profits was too low, Simon negotiated his departure from the animated series after Season 4. Greg Daniels, who briefly overlapped with him at *The Simpsons*, remembers that the producer had started to

adopt dogs. En masse. "He'd come in with all these cuts on his hands from his puppies biting him," Daniels says. Simon dedicated the next several decades of his life to animal rights activism. Oh, and he also received yearly royalty checks for millions of dollars.

The year Simon left, Jean and Reiss exited to make their own animated series for Gracie Films and ABC: *The Critic*. Many of the original writers—Jeff Martin, Jay Kogen, Wallace Wolodarsky, and Jon Vitti—followed them out the door. The job was burning them out. Working on *The Simpsons* wasn't just exhausting. It was all-consuming. Especially to people deeply invested in making it as funny as possible.

"It was 97 percent sitting in that room rewriting," Martin says. "But I was the only guy on the writing staff who had a kid. After three years, I was like, 'I just can't do this anymore.'"

Jon Vitti recalls that before Martin left, he wisely asked for two days off a week. "And so all of a sudden one of us didn't have to come in," Vitti says. "Part of it, you admired his brilliance. But part of it was you just thought about the fact that you had to come in five days a week, and Jeff had to come in only three days a week."

Having a single rewrite room may have helped hone *The Simpsons*' comedic voice, but didn't allow for any breaks. "It's a grind, because in live action you'll get like a two-and-a-half- to three-month hiatus period," Mike Scully says. "Animation is just year-round. There's always animation coming in, so there has to be people there."

When the show began, those vacations were few and far between. "It wasn't until years later that they started rotating writers out for vacation," Vitti says. "It was brutal. I mean, that's a big part of why the staff turned over so much after four seasons. We didn't physically maintain ourselves, and the show had not really thought about trying not to kill the writers. We all just had to stop."

Working on *The Simpsons* in the early years had also created impossibly high expectations. And that gave the writers anxiety. After nearly half a decade of making a cutting-edge show, they were scared that it was going to hell. "I can tell you, there was a *Simpsons* Writer Pessimist Club," Vitti says.

The club had three members: Vitti, Swartzwelder, and Meyer. When they were feeling down about the direction of the animated series, they'd stand on the balcony of the Simpsons Motel and run through the episodes of whatever season they were on. Inevitably, Vitti says, "this season was not as good as the season before."

It was ludicrous. But that's how high their standards were: when *The Simpsons* was the best it ever was, the writers were still worried that it wasn't funny enough.

When Greg Daniels got to *The Simpsons* in 1993, he was worried he was too late. Almost all of the original writing staff had left, except for Meyer and Swartzwelder. And at that point, Swartzwelder had started working from home. Rumor had it that his colleagues were tired of his smoking. But as is often the case with Swartzwelder, it's damn near impossible to separate the man from the myth. According to him, he renegotiated his contract simply because he didn't feel like driving to the Fox lot every day. "Getting old, I guess," he told the *New Yorker*.

"When he got the chance to leave the writers' room and just write shows, I completely understood," Kogen says. "Because who wants to sit with those idiot kids all day long? He withstood the slings and arrows with all of us, including the volatile Sam Simon, who could be a weirdo. And he was good. I think he withstood it pretty well. I don't think he loved it. I don't think it was his great joy." Swartzwelder continued to write, from diner booths he installed in his home.

The writing staff of *The Simpsons* in the early '90s. "The occasion was Jay and Wally's last week," Jon Vitti says. "The script we're holding is 'Mr. Plow.'"
Front row (L to R): Conan O'Brien, John Swartzwelder, Al Jean, Mike Reiss, Jay Kogen, Matt Groening, George Meyer, Wallace Wolodarsky
Back row (L to R): Sam Simon, Daria Paris (Simon's assistant), Jeff Martin, Jon Vitti *(credit: Jon Vitti)*

"The photo that gets used the most," Vitti says. "It appeared on the History in Pictures Twitter account. Because something inside me discerned that Conan would become the most famous of us." *(credit: Jon Vitti)*

Jay Kogen (playing dead, left) next to Mike Reiss. A typical day in the *Simpsons* writers' room in the early '90s: takeout, little sunlight, long hours—like a frat house, but funnier. *(credit: Jon Vitti)*

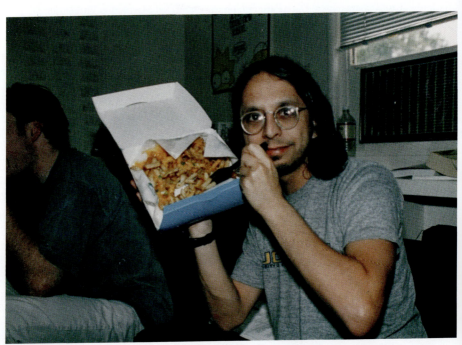

"The infinitely cool Wally Wolodarsky," Vitti says. "It looks like an Islands Burgers day. So Swartzwelder didn't choose lunch, or it would be Apple Pan burgers. We were always proud of eating burgers and candy, and then we wondered why we felt so awful at the end of the season." *(credit: Jon Vitti)*

THE NEXT VALUE I SPEAK OF MUST BE FOREVER CAST IN STONE. // I SPEAK OF <u>DECENCY</u> -- THE MORAL COURAGE TO SAY WHAT IS RIGHT, AND CONDEMN WHAT'S WRONG. // WE NEED A NATION CLOSER TO <u>THE WALTONS</u> THAN <u>THE SIMPSONS</u> -- AN AMERICA THAT <u>REJECTS</u> THE RISING TIDE OF INCIVILITY AND INTOLERANCE. //

WE SEE THIS TIDE IN THE NAKED EPITHET -- AND IN THE CODE WORDS -- THAT PLAY TO OUR WORST PREJUDICES. / WE SEE IT WHEN PEOPLE RIDICULE RELIGION AND RELIGIOUS LEADERS -- LIKE THE GROUP WHICH DESECRATED COMMUNION HOSTS ON THE STEPS OF ST. PATRICK'S CATHEDRAL. / WE SEE THIS TIDE OF INCIVILITY AND INTOLERANCE IN BIGOTRY, DISCRIMINATION, AND ANTI-SEMITISM. / HAVE THEY NO DECENCY -- HAVE THEY NO HONOR -- HAVE THEY NO RESPECT FOR THE RIGHTS OF OTHERS? // <u>I WILL CONTINUE TO SPEAK OUT AGAINST THESE APOSTLES OF HATE WHO POISON OUR KIDS' MINDS AND DEBASE THEIR SOULS.</u> //

The first time President George H. W. Bush publicly criticized the show was in 1992 at the National Religious Broadcasters convention. This is a page from the fateful speech that he gave that day.

THE SIMPSONS™

September 28, 1990

Mrs. Barbara Bush
The First Lady
The White House
1600 Pennsylvania Avenue
Washington, D.C.

Dear First Lady:

I recently read your criticism of my family. I was deeply hurt. Heaven knows we're far from perfect and, if truth be known, maybe just a wee bit short of normal; but as Dr. Seuss says, "a person is a person".

I try to teach my children Bart, Lisa, and even little Maggie, always to give somebody the benefit of the doubt and not talk badly about them, even if they're rich. It's hard to get them to understand this advice when the very First Lady in the country calls us not only dumb, but "the dumbest thing" she ever saw. Ma'am, if we're the dumbest thing you ever saw, Washington must be a good deal different than what they teach me at the current events group at the church.

I always believed in my heart that we had a great deal in common. Each of us living our lives to serve an exceptional man. I hope there is some way out of this controversy. I thought, perhaps, it would be a good start to just speak my mind.

With great respect,

Marge Simpson
Marge Simpson

Bush Library Photocopy
Preservation

10201 West Pico Blvd., Los Angeles, California 90035 *Telephone:* 213.203.3993 *Fax* 213.203.3852

In a 1990 interview with *People*, First Lady Barbara Bush said *The Simpsons* was "the dumbest thing I had ever seen." That led to this exchange.

BARBARA BUSH

Anne
Improve &
Typo - Lil sys

Oct. 5—

Dear Marge —

How kind of you to write — I'm glad you spoke your mind — & foolishly didn't ~~know~~ you had me. I am looking at a pickup of you ... depicted on a plastic cup... with your blue hair filled with pink birds peeking out all over. Evidently you and your charming family ... Lisa, Homer, and Maggie & Bart are camping out. It is a nice family scene. Clearly you

BARBARA BUSH

are setting a good example for the rest of the country. Please forgive a loose tongue —

Warmly —

Barbara Bush

P.S. Homer looks like a handsome fella!

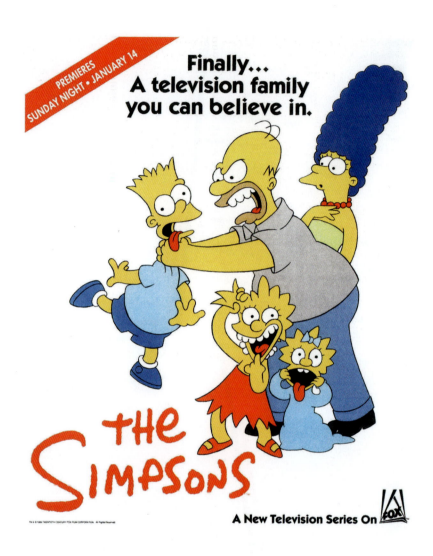

Early advertisements for *The Simpsons* captured an iconic James Brooks–ism about the show: "The American family in all its horror." *(credit: Alamy)*

James L. Brooks and Matt Groening in 2009, at the unveiling of the United States Postal Service's *Simpsons* stamps. By then, the show had long since transformed from a subversive phenomenon to an American institution. *(credit: Shutterstock)*

Dan Castellaneta, the voice of Homer Simpson, at the premiere of *The Simpsons Movie* in 2007. Writer George Meyer called Homer "the greatest comic character ever to appear on television." *(credit: Shutterstock)*

"I missed the boat," Daniels recalls thinking to himself. "I was like, 'Huh, the fourth-season crew, a lot of them are leaving now.'"

Daniels tried to stay open-minded. After all, this was *The Simpsons*. It was a comedy writer's dream. Before he got there, his college buddy Conan O'Brien had told him what to expect: a challenging but extremely rewarding work environment.

"I remember him telling me, 'OK, here's the culture here,'" Daniels says. "'After work, we stay. We are trying to make our episodes the best possible, and we probably need three weeks to write an episode. But we don't get three weeks. We only get two weeks. So everybody works on weekends and we can't let the team down. And we've got to show off how great these episodes are when we turn our draft in. And people were just incredibly driven by how good the show was.'"

That last part remained true. But the animated series *was* entering a new era. It had long since become a multimillion-dollar property that Fox protected fiercely. When Tracey Ullman sued the company for a share of the series' profits in the early '90s, the network successfully fought off the suit. And in 1993, it sold *Simpsons* syndication rights to affiliates for between an estimated $1 and $2 million an episode. Those local stations began airing reruns twice a day, five days a week. (In 1994, under new president Sandy Grushow, who'd started in the marketing department, Fox also moved *The Simpsons* back to its original Sunday night time slot.) Needless to say, *The Simpsons* was no longer an upstart. It was part of the TV establishment.

So to replace Jean and Reiss, Brooks hired a TV veteran: David Mirkin. For the first time, *The Simpsons* had a showrunner who wasn't involved in the series' creation. He'd worked on *Three's Company* and *The Larry Sanders Show*. He'd also run *Newhart* and created *Get a Life*, a surreal Fox series that lasted only two seasons but became a

cult classic. When Mirkin took over, he moved the writers out of the Simpsons Motel.

"When Mirkin came, he had the office that used to be Richard Sakai's office in the Gracie Bungalow. It was a giant office," Oakley says. "He could sit at his desk while all the writers sat around it." Some of them didn't love the new arrangement. "It was a spacious room, so it was no problem," Oakley says, "but it certainly lost all that kind of shabby charm that we had in the old room."

But Mirkin was new, and he did things his own way. He had a difficult task ahead of him. "The two showrunners that had it the toughest were, well, obviously, Sam Simon, because you're creating this and you're figuring out what the show is on a weekly basis," Mike Scully says. "And Dave. Dave is the only showrunner who ran the show without ever being on staff first. Dave kind of had to hit the ground running and learn the show and run it at the same time."

The new showrunner brought an absurdist streak to *The Simpsons*. The animated series was already offbeat by TV standards. Mirkin made it even more unconventional than it already was.

"I love the timing on the Mirkin episodes," Vitti says. "Whatever the musical term for it is, it's like, the cut's not on the beat. He really pushed the comedy."

"Dave has a darker comedic sensibility," Scully says. "He also had a great, funny visual sense."

Mirkin was an experienced live-action director, so he had an eye for unique shots and sight gags that he knew would pop. He was the one who came up with the now famous, often-memed image of Homer magically emerging from and then disappearing back into a hedge. It was also Mirkin who decided to make Homer an astronaut. He wrote "Deep Space Homer," an eclectic half hour that features real drama (a dimwitted everyman grapples with a death-defying challenge), pop culture references (a David Silverman–directed *2001: A Space*

Odyssey–inspired sequence showcasing Homer floating through the air eating potato chips), and iconic jokes (news anchor Kent Brockman, mistaking footage of a broken ant farm on the space shuttle for an alien invasion, saying, "I, for one, welcome our new insect overlords").

The Season 5 episode is considered a classic. But back then, some people at *The Simpsons* wondered if the show was becoming too ridiculous. Groening has said that, at least at first, he found the idea of sending Homer to space to be preposterous. "You're catching us thirty years later and it's, 'Oh, yeah, that's right. Homer went into space. Ha-ha,'" Vitti says. "But that was really controversial. There were real fights over whether the show had crossed a line. And it's kind of inescapable with good comedy writers. They care a great deal about what they're doing."

The writers gradually came around to the shift. "I think we all understood that each showrunner could only do it the way he wanted, the way his taste led him," Meyer says. "So you could win little skirmishes if you argued about tone, but overall, it was going to be the way it was going to be. So eventually you tried to fall into line and just do the best version of that."

The staff also realized that *The Simpsons* could only stay pure for so long. In the early '90s, the show was a revelation because it gave Americans something that they didn't know they wanted: an animated series that was mostly grounded in reality. As the series snowballed into a long-running franchise, the realism gradually began to chip away. After all, there are only so many intimate family stories you can tell.

Vitti likes to cite something Mike Reiss said about sitcoms: "You can either evolve or you can repeat yourself." To avoid stagnation, *The Simpsons* chose the former.

In the first episode Daniels wrote for Mirkin, for example, Homer travels to India with Apu. Logically, it didn't make sense. "I was just

like, 'How's he going to get to India?'" Daniels says. "'We've established he makes $240 a week.'"

Viewers, save for the most vocally hardcore fans, didn't seem to mind that plotlines were becoming more outlandish in the mid-'90s. Maybe it was because their world was also leaning that way.

By the Mirkin years, *The Simpsons* quite obviously realized this. The sense of promise sold to us in the early part of the decade was beginning to crack and fade. And the show reflected that curdling optimism, in that it started to get more and more (realistically) absurd.

In "Bart's Inner Child," Albert Brooks plays a self-help master named Brad Goodman, the kind of guy who now would make a killing as a podcaster. He tells citizens of Springfield to channel their much younger, more immature selves. "There's no trick to it," the guru says. "It's a simple trick." Then he directly implores them to act like Bart, repeating, "Be like the boy."

When everyone starts relying on vibes alone, the town collapses, then recovers after realizing that self-improvement isn't as easy as acting like a wise-ass ten-year-old. "It's a long, arduous journey of personal and spiritual discovery," Lisa says. To which Homer responds, "That's what I've been saying! We're all fine the way we are!"

But things were definitely not fine. Not at home, and not in America. *The Simpsons* knew that. "Bart Gets Famous" calls out the fleeting emptiness of modern celebrity. Even back then, the show picked up on the fact that people were starting to become famous for increasingly ridiculous and dubious things. Years after the show became a national phenomenon, the fourth grader becomes one himself—for a catchphrase that's no less silly than Haley Welch's: "I didn't do it." Bart likes his new status at first, but then he starts to feel like he's being exploited. When he appears on *Late Night with Conan O'Brien*, he tries to show off his knowledge of Amazon deforestation. But the host and former *Simpsons* writer, who makes his return to the show via

a voice cameo, interrupts, flatly saying, "Just do the line." The public eventually tires of Bart's one-note shtick and casts him aside. The episode ends with a sweet touch: Marge telling her son that he "can go back to just being you."

When it was at its peak, *The Simpsons* was never afraid of portraying American ugliness. Take, for example, Greg Daniels's creatively titled episode "Homer Badman." ("I had a Word doc that was just called 'Homer bad man' and I made it as stupid and rudimentary sounding as possible," he says. "And I called the episode that to be like, 'Don't be precious about your episode titles.'") The story revolves around a babysitter accusing Homer of grabbing her butt. It's a true misunderstanding: he's actually snagging a gummy Venus de Milo he'd acquired from the candy convention that's stuck to her pants.

Springfield's tabloids, news magazines, and late-night shows pile on Homer, painting him as a chauvinist pig. Though in hindsight it feels like a slightly misguided way to make a point—it wasn't intended to shame actual victims who speak out against sexual misconduct, but the episode centers on a discredited allegation—the show's critique of the media is righteous. The crushing amount of coverage, sometimes based on little or distorted evidence, is harmful. And it's only gotten worse. "Clearly the show is powerless to change anything there," Daniels says.

In the late '90s, *The Simpsons* wasn't just prescient about American cultural trends. It also understood the kind of public figures who ended up running the country better than most political analysts did. In 2000, the show made a throwaway joke that inadvertently predicted the Trump presidency. But before we get there, let's start with the episode that best captured Trump's essence. It actually aired in 1994. In "Sideshow Bob Roberts"—named after Tim Robbins's similarly over-the-top political satire *Bob Roberts*—the big-haired, murderous

Republican gets out of jail and runs for mayor as a right-wing populist. He's funny, entertaining, and an absolute ghoul. About a year before Trump defeated Hillary Clinton in the 2016 presidential election, I remember speaking to Bill Oakley, who cowrote "Sideshow Bob Roberts" with Josh Weinstein. All of a sudden, the idea of a charismatic ex–TV host winning a high political office didn't seem so crazy. "It's certainly hard to make it any more outrageous than real life," Oakley said.

Sideshow Bob is eventually arrested for election fraud, but not before he starts recklessly monologuing. He's far more eloquent than Trump, but they have the same God complex. And neither is afraid of letting the world know how they see themselves.

"You need me, Springfield," Sideshow Bob says. "Your guilty conscience may force you to vote Democratic, but deep down inside you secretly long for a coldhearted Republican to lower taxes, brutalize criminals, and rule you like a king. That's why I did this: to protect you from yourselves." It's the kind of thing that most political candidates used to be afraid to say in public. As Krusty the Clown once put it, Bob "said the quiet part loud." Now the fear of doing that is gone.

"The political discourse now is way more fucked up than the one depicted in the show," Oakley told me. "The masses now behave a little bit more like the population of Springfield than they did back then."

The Simpsons has, quite obviously, always leaned left. "The show is unabashedly liberal," Oakley said. "I think it's super clear." But a distrust of authority had been baked into the series. And it didn't go away during the scandal-plagued, promise-breaking Clinton presidency. After campaigning as a progressive, Clinton pushed policies that increased mass incarceration, cut social programs, and boosted financial deregulation.

STUPID TV, BE MORE FUNNY

In the writers' eyes, neither party was doing enough to help ordinary citizens. Mayor Quimby, one of Springfield's most corrupt characters, is a Kennedy-inspired Democrat. There's a moment in 1994's "Bart Gets an Elephant," when said pachyderm, Stampy, runs past the Republican and Democratic conventions. A banner in the former reads, "We Want What Is Worst for Everyone." A banner in the latter reads, "We Can't Govern!"

"We always tried to be evenhanded," Scully says. "*If* it seemed like a funny joke." Back then, attempting political humor just felt so much less... fraught.

"Politics was so much less crazy," Vitti says. "I mean, it's weird to talk about it that way because it felt very crazy at the time. But it was so much less polarized. George H. W. Bush would be thrown out of the Republican Party now. But it was different. There wasn't this feeling that you were fighting evil. You could totally take shots at the Democrats because they're *politicians*."

That they are. Which is why good TV writers will always have a lot to work with: "The nature of the universe is that there can't really be any competent public officials of any political party," Oakley said, "or there would not be any comedy."

It's a pessimistic outlook. Though in the Mirkin years, that felt warranted. During the Clinton era, the twenty-four-hour news cycle brought in a massive tidal wave of sensationalism. Cable TV was no longer just a place for *Brady Bunch* reruns, old movies, and Australian rules football. CNN was about to have competition: the soon-to-be-launched Fox News, a channel that rode the coattails of its parent network's biggest success: *The Simpsons*.

Tabloid shows like *Inside Edition*, *Hard Copy*, and *A Current Affair* rolled out nonstop coverage of things like the Menendez brothers case, the Lorena and John Bobbitt incident, the Tonya Harding–Nancy Kerrigan story, and the O. J. Simpson trial. The media surge also washed

in a new age of hysteria, emboldening America's high-profile grifters, hollow self-help experts, extreme right-wing pundits, the fame-hungry, and overinvolved sports parents. It was crazy out there. And the show reflected that. Though *The Simpsons* rarely let its nihilism get in the way of a good time. Sometimes, the writers still just liked to have fun.

For the Season 6 finale, Mirkin and the writers planned a cliffhanger. In the two-part episode, which picks up with the Season 7 premiere, someone tries to assassinate Homer's boss. "Who Shot Mr. Burns?" was a tongue-in-cheek version of what the primetime soap opera *Dallas* did with "Who shot J.R.?" back in the '80s. For Fox and *The Simpsons*, it was a bona fide *event*. There was a tongue-in-cheek *America's Most Wanted*–style promotional special, a summer tie-in with convenience store chain 7-Eleven, and a sweepstakes sponsored by 1-800-COLLECT, a popular service for making collect calls. (If you're young enough to never have used a pay phone, google that last thing.)

After the first installment aired, Mirkin called local TV stations and claimed he knew the attempted killer's identity. He hoped someone would pass along bogus info to *Entertainment Tonight*. But nobody did—everyone loved the show too much to spill the beans.

"It was the only time in Hollywood where I really needed dishonest people and I couldn't find any," Mirkin once told me. "Generally they're all over you like a cheap suit. It was very sad. Otherwise the evil is just pouring out of this city."

There also were plenty of emotional, grounded moments in Mirkin's tenure. Homer and Marge's relationship is put to the test, a looming deadly comet leads to lessons in self-sacrifice, Lisa becomes a vegetarian and befriends Paul McCartney—the third living Beatle to appear on *The Simpsons* after George Harrison joined for an episode where Homer joins a barbershop quartet—and the story of Maggie's birth is touchingly told. "With Mirkin, the comedy is fantastic and

you can see the fact that he was a real director," Vitti says. "I would say as great as the actors are, the voice performances are the best in Mirkin's years."

Mercifully, Mirkin didn't screw up *The Simpsons*. Under his watch, it evolved into something slightly different but still funny. It was the first, but certainly not the last, time that's happened.

CHAPTER ELEVEN

WORST EPISODE EVER

"THEY'RE GIVING YOU THOUSANDS OF HOURS OF ENTERTAINMENT FOR FREE. WHAT COULD THEY POSSIBLY OWE YOU? IF ANYTHING, YOU OWE THEM."

—BART SIMPSON

Working on *The Simpsons* in the early years was challenging. But actually running things was downright punishing. *The Simpsons* burned through showrunners every two years, going from Sam Simon, to Al Jean and Mike Reiss, to David Mirkin, to Bill Oakley and Josh Weinstein.

"I remember distinctly wishing that I was the guy out valet-parking the cars and not being the guy writing this script," Oakley says. "'Cause I'm so sick of sitting here writing these scripts. I remember wanting to do *anything* that involved not sitting with the script at night."

If there was one consolation for them, it was this: they were making *The Simpsons*. They were proud to be part of the best show on TV. "It was worth all the discomfort and stress because look what we left behind," animator Rich Moore says.

When they started at *The Simpsons* in the early '90s, Oakley and Weinstein were in awe. The old friends, who went to high school

together, were the first two hardcore *Simpsons* fans to actually work for *The Simpsons*. At first, they didn't believe that they were up to the task. "We were extremely intimidated," Oakley says. "We didn't know the first thing about working on a TV show like that. We worked on a couple of really low-rent shows, but previous to this, we'd been employed for a year and a half. So we were like, 'Oh my God, this is the most amazing thing that's ever happened. This is the best.' It wasn't like working on one of those other shows. This is the best-written show in the history of television. And getting to work with these guys, every one of them is a god. It's incredible."

But even then, they felt like the perception of the show was changing. At least among *Simpsons* obsessives. You know, the ones who seemed to spend every waking hour dissecting the intricate show online. "The internet seemed to be created for people at university campuses to trade their responses to the *Simpsons* episode last night," Greg Daniels says.

When the sitcom began in 1989, its creators had no clue that their baby would be poked and prodded by strangers online. The internet wasn't yet ubiquitous; it was an untapped tool mostly available to academics, high-level government employees, and eggheaded hobbyists.

"It was ham radio, you know?" Oakley says. I once asked him whether he ever could've imagined that the planet eventually might have billions of internet users. He laughed and replied, "The question was as ludicrous as saying, 'Everybody's gonna have a ham radio.' I never thought we'd get to the point where the average person would be able to handle the complicated computer issues necessary to go online."

But as *The Simpsons* grew into an institution, so did the internet. Their respective rises ran parallel, occasionally intersecting enough to rub off on each other. One wouldn't be quite the same without the other.

Amateur online critics had been out there since *The Simpsons* started, but back then praise drowned out all the anger. "Once the show took off, we just felt that the country—and the world—was rooting for us," George Meyer says. "They wanted us to succeed. They were like Jack Kerouac in those jazz clubs with Neal Cassady, going like, 'Go man, go.' Or the guys at the beginning of *Faster, Pussycat!* who were cheering on the go-go dancers. There was nothing but just 'farther, longer, faster,' you know? That is a hard feeling to get these days. Because anytime you want to be deflated or taken down a peg, just check out the comments on whatever you're doing on the internet."

Oakley and Weinstein understood that reality before their colleagues, most of whom weren't on the internet yet. Early in their time as showrunners, they tried to stop paying attention to what the most vocal *Simpsons* fans were saying. "We finally decided it wasn't worth it," Oakley says. "Because we just weren't gonna get what you're hoping for. People shouldn't look at the internet for the show that they're working on then. It's not gonna help you. No. It's gonna make you crazy."

Now that they were in charge, Oakley and Weinstein did their best to shut out the noise. They'd worked there for a half decade and had earned the trust of the staff. "We just said, 'I don't care what anybody else thinks, including the people at the table read," Oakley says. "We're doing it this way because we want to do it this way. We're *Simpsons* fans.' And so it paid off down the road. I think history has borne us out."

Oakley and Weinstein wanted to bring back the feeling of their first few years at *The Simpsons*. So when Mirkin left, they reopened the old writers' room. "Part of the fun, in my opinion, was that this was an extremely prestigious show, and an award-winning show, that everybody knew made a lot of money, but it was still kind of all done in a garbage dorm room setting," Oakley says.

The new old writers' room set the tone for Oakley and Weinstein's version of *The Simpsons*, which embraced the humanism of the show's early days while also mixing in the avant-garde. "They wanted it to be more grounded and to recapture some of the emotional stuff," Vitti says. "I don't think there's a version of *The Simpsons* that's the perfect version of *The Simpsons* and all other versions are lesser. If I had to say it, I *would* say the closest thing to *The Simpsons* being done perfectly is Bill and Josh because they were the first guys who had never been showrunners before to run the show. They had just been the staff writers who worked their way up. They were so determined to not be the guys who screwed up *The Simpsons*."

Oakley and Weinstein's determination led to some of the show's boldest creative moments, which were inspired by mid-'90s pop culture. The Gen X showrunners shepherded "Homerpalooza," in which the title character joins a music festival as a carnival freak who takes a cannonball to his stomach during every tour stop. The episode is a clever take on the generation gap and features the voices of Smashing Pumpkins, Sonic Youth, and Cypress Hill. In typical *Simpsons* fashion, though, the real star of the show is the most surprising one: Peter Frampton, the aging British '70s rock god whom casting director Bonnie Pietila recruited to join the far younger lineup.

"Well, things weren't that great for me in my career," Frampton says. "So I said, 'Are you sure you've got the right number?' And she said, 'Yes.' So I said, 'Wow, I would be honored to be on a show.'" Then Pietila explained the premise. "You would be headlining a Lollapalooza concert," she told him. For a minute, it didn't make sense to Frampton. He was in his fifties. "I said, 'I wouldn't be,'" he recalls. Then it hit him. "I said, 'Wait a second. I think I have it. You want me to be the old, crusty rock star that's been there, done it and I don't really want to be there.' And she said, 'Oh my God, you've got it perfectly.'"

Self-deprecation, it turned out, was one of Frampton's specialties. At one point in the episode, he complains that Homer has wrecked the inflatable pig he bought at Pink Floyd's yard sale, Cypress Hill has stolen his orchestra, and Sonic Youth is raiding his cooler. "Get out of here, you kids!" he says. For Frampton, taking the piss out of himself was a blast. Plus, for one night at least, he got to be hip again!

As perfect as he was for the role, Frampton was not the producers' first choice. "Bob Dylan was first," Frampton says. "And let me just tell you, as much as I love Bob Dylan, I know I did a better job."

"Homerpalooza" instantly became a fan favorite. And it was only one example of Oakley and Weinstein's eclectic tastes. Take, for example, "22 Short Films About Springfield." The Season 7 episode was composed of a bunch of vignettes and was inspired by a sequence in *another* episode, "The Front," which had included a short segment called "The Adventures of Ned Flanders." Oakley and Weinstein figured it'd be fun to showcase other minor characters. *Pulp Fiction* had also recently been released and the pair wanted to attempt non-linear storytelling. To decide assignments, the writers picked character names out of a hat. Oakley drew Superintendent Chalmers.

The finished product indeed felt a little like Quentin Tarantino's opus. (There's even a sequence starring Chief Wiggum that's a send-up of Vincent and Jules talking about the differences between American and French McDonald's.) Oakley admitted to me that it was an overcomplicated concept that probably shouldn't have been green-lit. In the earliest days of the show, it may not have been. "We didn't have to answer to anybody," he says. "That was the only way that idea got through."

The most memorable part of the episode is when Principal Skinner attempts to cook Superintendent Chalmers dinner, burns the roast, and then covertly serves his boss Krusty Burgers. Panicked and not

wanting to admit that he's serving fast food, Skinner inexplicably calls the burgers "steamed hams." The strange euphemism leads to a bizarro "Who's on First?" routine between the two men that ends with Chalmers saying, "Well, Seymour, you are an odd fellow, but I must say, you steam a good ham." Oakley came up with the phrase, which his fellow writers treated with indifference at best. "I don't think anybody really liked it but me," he says. "It was one of those things where we just kind of put it on the air. I remember when I gave it to Greg Daniels, who was kind of compiling everything. I sat there and watched him read it and he didn't laugh once. And I was like, 'Ah, fuck it. I'm his boss. It's going on.' That's what happened. And it took on this life of its own."

"Steamed hams" has become the thing that Oakley is known for. "That's gonna be on my tombstone," he once told me. Oakley still doesn't quite understand how the weird joke has endured, but he's not complaining. "I'm glad that it's my thing and not someone else's," he says. "Because I would be very jealous if it were someone else's. I don't know that it deserves the acclaim that it's gotten, but it's become a template."

What Oakley means is memes: there's no scene in *Simpsons* history that's the basis of more of them. "Probably the best one I've seen was with a German expressionist film," he says. "People express their own creativity by remixing it."

In 2022, Oakley founded the Steamed Hams Society, a subscription "food discovery club." With livestreams and videos, he covers restaurant news, samples new and exotic snacks, and tries, you guessed it, all kinds of interesting steamed hams, er, burgers. "I'm flattered that I've been able to use my minimal notoriety from that," Oakley says.

His part in "22 Short Films About Springfield" may be Oakley's most famous contribution to *The Simpsons*, but it's one of several offbeat classics from his and Weinstein's time running the series. To keep

the show going, they felt like they needed to get weirder. Simple storytelling alone wouldn't cut it.

"I can certainly say that I thought we were running out of ideas and the show would be gone," Oakley says. "Every show gets canceled. So we were assuming the show was going to be canceled soon, and it was time to have all the fun we wanted to have in the sandbox."

Oakley and Weinstein, like the showrunners before them, tried to push the boundaries of traditional sitcom writing and structure. During their tenure, Homer goes on a Carlos Castaneda–inspired, "Guatemalan insanity pepper"–induced, Johnny Cash–voiced, talking-coyote-guided psychedelic trip. Old friends of the show George H. W. Bush and Barbara Bush move to Evergreen Terrace (sadly, the former president and First Lady didn't actually lend their voices). And Milhouse's parents split up and actually divorce. Post-split, Kirk Van Houten brags about sleeping in a race car bed, to which Homer replies, "I sleep in a big bed with my wife." (When I was single, I named my Wi-Fi network after Kirk's apartment complex: the Bachelor Arms.)

Then there's the John Swartzwelder–penned tale of Frank Grimes, a self-made new power plant employee who reacts to an incompetent like Homer like a real person would: with utter disgust. "If you lived in any other country in the world," Grimes tells him, "you'd have starved to death long ago." In a fit of reactive anger, old Grimey accidentally electrocutes himself to death. Homer snores through his funeral. It's the bleakest half hour in series history. Some fans still consider it to be too harsh to be funny. When Mike Sacks of the *New Yorker* pointed out to Swartzwelder that the episode didn't have a James L. Brooks–approved level of heart, he replied with this: "Grimey was asking for it the whole episode. He didn't approve of our Homer. He was asking for it, and he got it. Now what was this you were saying about heart?"

Frank Grimes wasn't a harbinger of *The Simpsons* taking a dark turn, but he was a fun experiment. Swartzwelder had leeway, for one

week at least, to send the show down a miserable rabbit hole. In real life, Homer *would* be a nightmarish coworker. But we'd still love him.

At the time, Oakley felt like he and Weinstein pushed "Homer's Enemy" out into a void. "Many episodes that people consider classics now were not classics then," he says. "They just kind of vanished into oblivion. And nobody talked about them. They were no more popular and some of them were less popular than the average episode. Frank Grimes was not popular, George Bush not popular, '22 Short Films' not popular. All these ones were not popular at the time. They weren't even popular *at the show.*"

By then, *The Simpsons* just wasn't as explosively popular as it was in its earliest years. Ratings had dipped. But that was inevitable. The show was once a phenomenon. Then it became an institution. Still, the powers that be decided that *The Simpsons* needed freshening up. Before Season 8, Oakley and Weinstein received a troubling request.

Oakley wouldn't reveal who exactly made the request, but it came from someone with influence. "Someone very, very high up in *The Simpsons*, who shall remain nameless, was like, 'You gotta add a teenager to this cast,'" he once told me. "And I'm not gonna say who it was. But I think there was a certain number of people being appalled by that notion."

At the time, Oakley and Weinstein didn't want to tamper with the show's tried-and-true formula. So they dismissed the idea. But then they hatched another one. Why not temporarily add a character to the ultra-violent show-within-a-show *Itchy & Scratchy*? That way, *The Simpsons* at least could try to explain how hard it is to keep a long-running series fresh—without getting desperate. It would give the writers a chance to strike back at their loudest critics. Not the ones who wrote for mainstream publications. For the most part, *they* still liked the animated series. I'm talking about their online critics.

So David X. Cohen was assigned to write "The Itchy & Scratchy & Poochie Show." The premise of the episode is this: *The Krusty the Clown Show*'s ratings are down because the quality of its most popular asset, *The Itchy & Scratchy Show*, has plummeted. Krusty demands that slimy Itchy & Scratchy Studios head Roger Meyers Jr.—who's again voiced brilliantly by the late character actor Alex Rocco—fix the problem. This leads to a meeting in which Meyers proposes that Itchy (a mouse) and Scratchy (a cat) would be joined by another four-legged friend: a dog. Krusty's writers, who are all modeled after *Simpsons* staffers, try pushing back. But a marketing executive keeps shutting them down, demanding "a dog with attitude" who's "in your face," who "gets biz-zay. Consistently and thoroughly." When Krusty asks if this dog is "proactive," the exec responds, "Oh God yes. We're talking about a totally outrageous paradigm."

This, naturally, raises the hackles of the writer who looks like George Meyer. "Excuse me, but 'proactive' and 'paradigm'? Aren't these just buzzwords that dumb people use to sound important? Not that I'm accusing you of anything like that. I'm fired, aren't I?"

Roger Meyers says, "Oh yes," then asks the writers to come up with a name for this funky dog, "something along the lines of, say, 'Poochie.'" The writers then shrug and agree to just stick with Poochie. It's one of the most realistic scenes in the history of the show, a true distillation of what it's usually like to work in network TV. Everyone always seemed to be resigned to disappointment and compromise. "An episode like that is very cathartic for the writers," Mike Scully says. "You get a lot off your chest under the guise of entertainment."

The makers of *The Simpsons*, of course, had mostly been immune to network interference. But that doesn't mean they didn't feel any bureaucratic pressure, especially after they'd spent almost a decade working on the series. They wanted to tell a story that illustrated the dangers of caving to misguided feedback. If you do, you might end up with Poochie.

The rockin' dog deserved to be made fun of. But he was still just a TV character. He wasn't worthy of hatred. While working on "Itchy & Scratchy & Poochie," the writers also decided to take on the kind of fans who took *The Simpsons* a little too seriously. You know, the ones spewing vitriol online. "They hated everything starting in Season 4," Oakley says. "Or at least a fair number of them. It irritated the shit out of everybody."

In the episode, Homer hears that there's an open casting call for Poochie. He's not a voice actor, but auditions anyway and gets the job. (Hey, he likes attention.) Even before making his debut on *Itchy & Scratchy*, the supposedly cool, goateed, surfing, skateboarding, neon-dipped, fanny-packing, backwards-hat-wearing, environmentally conscious new character is the toast of Springfield. But when Poochie finally appears on *Itchy & Scratchy*, the show-within-a-show's casual *and* hardcore fans brutally pan the overhyped character. Audiences can always tell when a show is trying too hard. If a "jump the shark" moment is when a TV series does something desperate and loses people (it's a reference to the Fonz's death-defying leap over a great white in a fifth-season episode of *Happy Days*), a "Poochie" moment is when it futilely attempts to win them back.

"A really good expression of what you worry about as comedy writers is Poochie," Vitti says. "If you start worrying that something you're doing is Poochie, it's a real incentive to stop what you're doing."

The day after Poochie's introduction, Bart feels compelled to defend *Itchy & Scratchy* to Comic Book Guy. Here's how the exchange goes:

> **COMIC BOOK GUY:** Last night's *Itchy & Scratchy* was, without a doubt, the worst episode ever. Rest assured that I was on the internet within

> minutes, registering my disgust throughout the world.
>
> **BART:** Hey, I know it wasn't great, but what right do you have to complain?
>
> **COMIC BOOK GUY:** As a loyal viewer, I feel they owe me.
>
> **BART:** What? They're giving you thousands of hours of entertainment for free. What could they possibly owe you? If anything, you owe them.
>
> **COMIC BOOK GUY:** Worst. Episode. Ever.

Unsurprisingly, Cohen plucked the oft-quoted "worst episode ever" from a 1992 alt.tv.simpsons post. Its author was expressing his displeasure with the episode "Itchy and Scratchy the Movie"—a classic. In an old post about the origins of the phrase, *Simpsons* fan site Dead Homer Society came to the logical conclusion that "despite the vast technical changes in the interceding 20 years, internet arguments really aren't all that different in 2012 than they were in 1992."

And "Worst. Episode. Ever." is no longer just a *Simpsons* joke. It's come to represent the comically hyperbolic way that some fans assess what they perceive to be subpar pieces of pop culture. When I interviewed him a decade ago, even Cohen couldn't help but break out his near-perfect impression of Comic Book Guy petulantly uttering the line. Cohen referred to "Itchy & Scratchy & Poochie" as "the ultimate homage to alt.tv.simpsons."

And at least a section of the message board, it seemed, took it in that spirit. Seriously, who wouldn't like being referenced on their favorite TV show?

"A good episode that wouldn't be nearly as relevant to viewers unfamiliar with the fan community," one reviewer wrote. "Grade: A, because the writers would mock me if I gave it anything else."

"Whoa! This slams on the more pessimistic and nitpicky of us on a.t.s," added another, "this episode, frankly, rocked."

Others, well, acted a lot like Comic Book Guy.

"They've been paid handsomely for their work—work that many people would kill to get a chance to do, and they use their creativity to insult their biggest fans," a poster wrote of the *Simpsons* writers. "You owe them squat."

"The episode was an outrage," someone wrote. "It was very inconsiderate to the fans who aren't even on the internet. If you stripped it of its bitter flames, it would be an empty 10 minutes of nothingness."

Loyal fans, Oakley acknowledges, *are* "justified in taking some ownership of a show." But, he adds, "On the other hand, the people who make it should have at least as much ownership. And sometimes there's a tug-of-war." In the episode, the *Simpsons* writers *did* mockingly add a Fonzie-for-the-'90s teenager named Roy, who shows up for a few scenes. He calls Homer "Mr. S" and then disappears. Forever.

Toward the end of "Itchy & Scratchy & Poochie," when Homer is recording his lines as Poochie, he goes rogue and gives an impassioned speech begging the audience for acceptance. "I know I can come off a little proactive, and for that I'm sorry," Homer says. "But if everyone could find a place in their hearts for the little dog that nobody wanted I know we can make them laugh and cry until we grow old together."

The defense goes over well in the room. The writers even give Homer a round of applause. But it's not enough to save his character. During the next episode of the show, Poochie's impassioned speech is replaced by Meyers saying, "I have to go now. My planet needs me," and a title card informing viewers that "Poochie died on the way back to his home planet."

Poochie's death was as hilariously, embarrassingly abrupt as his life. But then again, he was never going to get a dignified send-off. In

Hollywood, that's how things usually end: without any fanfare. You rarely get to go out on your own terms.

While watching the now Poochie-free show-within-a-show at the conclusion of "Itchy & Scratchy & Poochie," Lisa looks at her brother and says, "We should thank our lucky stars they're still putting on a program of this caliber after so many years." She is, of course, really talking about the cartoon that the *audience* is watching. Unfazed, Bart responds, "What else is on?" Then their TV cuts to static.

The episode was a pointed kiss-off to its worst critics, a laugh-out-loud meta-commentary on the show by the people who made it, and a bittersweet celebration of a series that refused to rely on cheap gimmicks to be funny. It would've been the perfect series finale. But *The Simpsons* didn't end there. And it still hasn't.

One of the last episodes that Oakley and Weinstein worked on during their two-year run as *Simpsons* showrunners seemed, to them at least, innocuous. It was Principal Skinner's true origin story: His real name was Armin Tamzarian. While serving in the Army, his mentor, Sergeant Seymour Skinner, went missing. When Armin returned to Springfield to break the bad news to his friend's mother, she mistook him for her MIA son. That's how Armin became Seymour.

The premise wasn't meant to be a radical narrative choice. A decade before *Mad Men*, writer Ken Keeler wanted to tell an impostor tale. He was interested in the Tichborne case, a nineteenth-century scandal involving a man claiming to be the heir to an English baronetcy. Oakley also recalls someone in the writers' room mentioning a newspaper article about a Vietnamese soldier who had assumed another man's identity.

"We were like, 'That's perfect for Skinner,'" Oakley says. "Oh my

God. Skinner has a long history of being a Vietnam veteran. It fits with him excellently."

The episode was also a parody of *The Return of Martin Guerre*, a 1982 movie based on the story of a sixteenth-century Frenchman who posed as a missing man. *And* it sent up *Sommersby*, a 1993 *Guerre*-inspired film starring Richard Gere as a Civil War–era impostor. "*The Return of Martin Guerre* was a very famous movie," Oakley says. "And it's also a story that's been around since the 1500s. A guy comes back from war and takes over someone else's life. We did not think it was going to ruffle anyone's feathers."

"The Principal and the Pauper" aired early in Season 9. At the time, it wasn't controversial. At least to a lot of viewers. The week of its broadcast in late September 1997, it was even Fox's second-highest-rated program. "People didn't really notice," Oakley says. But over on alt.tv.simpsons, the Usenet newsgroup that Oakley and Weinstein had long since given up on, hardcore fans raged.

"Ken Keeler, I hate you," one user seethed. "This episode is certainly a waste of tape. Abandoning all continuity and destroying a great supporting character in exchange for a few cheap laughs? I'm sorry, that might've worked on *The Critic*, but if you haven't noticed, this ain't *The Critic*. The only solace is that this appears to be Keeler's final episode. (F)"

"This episode is extremely unnecessary, and to me, proves the writers are running out of fresh ideas," another wrote. "I'm sick of these 'revelations' with characters."

"One of the distinguishing things about the show has (had?) always been the feeling that the writers had really lively minds; and that no matter what excesses they went to, they were applying a wide base of amusing thoughts & information," added a third reviewer. "This was virtually absent here, and the really worrying bit was that no one even seemed to be TRYING!"

As the years passed, and intricate online breakdowns of pop culture became common, those opinions started trickling out of message boards and into the mainstream. "The Principal and the Pauper" was, to a lot of *Simpsons* fans, the moment the show began to lose some of its blindingly bright luster.

Jon Hein, the man who coined the phrase "jump the shark," wrote in 2003 that "we finally spotted a fin at the start of the ninth season when Principal Skinner's true identity was revealed as Armin Tamzarian." And prolific TV critic Alan Sepinwall, a former alt.tv.simpsons poster himself, later deemed the story line "so implausible that even the characters were disavowing it by the end of the episode." Harry Shearer, who voices Skinner, even went as far as complaining about it in the press. "That's *so* wrong," he said in a 2001 interview. "You're taking something that an audience has built eight years or nine years of investment in and just tossed it in the trash can for no good reason, for a story we've done before with other characters. It's so arbitrary and gratuitous, and it's disrespectful to the audience." Five years later, he addressed the issue in *another* interview. This time, he said that the writers "refuse to talk about it" and "they realize it was a horrible mistake."

Even Matt Groening piled on. In a 2002 Q&A with *Rolling Stone*, he said this about "The Principal and the Pauper": "We make some missteps, but we acknowledge it on the show. We had an episode where it was revealed that Principal Skinner was an impostor. By the time we finished the episode, we realized it was a mistake, and we had a judge say, 'We'll never speak of this matter again.' And we never did."

These days, the subject is not verboten. Oakley's happy to talk about it. He understands why fans don't love "The Principal and the Pauper." "People don't like when you mess with the underpinnings of the characters," he says, even though that's not what the writers

thought they were doing. The episode, he points out, "essentially resets everything at the end. We didn't really think it was tampering with the underpinnings of the characters to the extent that everybody would care."

If he could do it over, Oakley would run the episode midseason and slap on the kind of "this might be too scary for your kids" disclaimer that used to appear before every *Treehouse of Horror*. "That says, 'This was an episode of fantasy,'" Oakley says. "So that people wouldn't get so stuck on it."

The *Simpsons* writers weren't trying to insult the audience. They simply wanted to play around with the stolen identity trope. "To us it was just another version of that story," Oakley says. "But to people who had not heard those stories before, they were like, 'Something's broken about this.'" They thought, he adds, "that we made a horrible mistake rather than doing it intentionally."

Oakley cared about *The Simpsons* just as much as its hardcore fans did. But there were times, he admits, when he just wanted to tell them not to take the show so damn *seriously*. In the end, he says, "It's a cartoon."

Although *The Simpsons* never again scolded its hardcore fans as harshly as it did in "Itchy & Scratchy & Poochie," the internet remained in the writers' crosshairs. When the children of Springfield attempt to get back at their parents in an episode that aired in 1999, Milhouse suggests putting rumors about the town's adults on the web. "No!" Bart responds. "We have to reach people whose opinions actually matter!"

In reality, Bart turned out to be wrong. It's true that the world never used to care about the opinions of nerds. Now, emboldened by the explosion of the internet and their own purchasing power, they've gained leverage. Making fun of them these days is actually an act of

punching up, not punching down. "You're not really picking on the weak anymore," Vitti once told me.

Before Season 9, Mike Scully became showrunner of *The Simpsons*. Shortly after he got the job, a fan site asked him for an interview. He agreed on one condition. "I said, 'I'll trust you to screen the questions and not go super obsessive on it,'" he says. "If it's genuine curiosity about how the show works, that sort of thing, I'm happy to do it." What he didn't want was a reenactment of the scene in "Itchy & Scratchy & Poochie" when an *Itchy & Scratchy* fan panel devolves into the nerds in attendance asking things like this: "In episode 2F09, when Itchy plays Scratchy's skeleton like a xylophone, he strikes the same rib twice in succession. Yet he produces two clearly different tones. Are we to believe this is some sort of magic xylophone or something? Boy, I really hope somebody got fired for that blunder."

Scully remembers being sent a list of about a hundred questions. "And the first question is, 'What brand of saxophone does Lisa play?' And I told the guy, 'This is exactly the kind of shit I don't have time for.' And it was not long afterward that somebody told me there was an offshoot group called, like, 'Kill Mike Scully and His Family.'"

As he was telling the story, Scully laughed. He understands when hyperbole is being used for comedic effect. He didn't actually fear for his life. But the extreme fan reaction did irk him. He points to an interview *Simpsons* writer Ian Maxtone-Graham gave to *The Independent* in which he admitted that he didn't really watch the show before working on it. "We were pitching new names for characters and I pitched the names of all three members of the Flanders family: Ned, Rod, and Todd," he said. Maxtone-Graham also mentioned "the beetle-browed people on the internet" who "see everything as part of a vast plan, but boy, is there ever no vast plan!" Scully says that hardcore fans didn't take that well: "Suddenly they turned their wrath on him."

To them, Maxtone-Graham sounded like he thought that the show they revered was just a silly cartoon.

"Ian just proved why he's the least liked writer around here, anyway," one alt.tv.simpsons poster wrote. "Fans of the series grew to appreciate the series for the same reason the forefather writers explained. It was a series that was funny and had human characters whose adventures, while sometimes distorted slightly for comedy effect, never strayed miles away from reality."

The wrath was excessive. But some of the *reasonable* fans did have a point: *The Simpsons* was changing. In the late '80s and early '90s, the show was a revelation because it gave Americans something that they didn't know they wanted: a realistic animated series. But to avoid stagnation, *The Simpsons* chose to evolve. "We started to lean into the fact that we're a cartoon," Yeardley Smith once told me. "So you really can drive off a cliff, and everybody survives." Homer got painfully dumb, the story lines got zanier, the jokes got broader, and celebrity guest stars multiplied.

By the late '90s, the animation also got crisper. The bright colors of the show's earliest days gave way to more naturalistic shades. When Vitti first noticed the change, he liked it. "*The Simpsons* has grown up now," he recalls thinking. "But now when I look at it, I miss the purples and yellows." The original palette was so aggressively out there that it provided cover for the writers, who could focus on storytelling. "The look of the show would get you credit for being edgy and different," Vitti says. "And you could actually just think about the fundamentals."

As the '90s wound down, the show's influence on the world had begun to wane. After all, you can only stay on the cutting edge for so long. As much as its biggest fans didn't want to believe it, it was inevitable. The early version of the show was so smart, so multilayered, and so damn good that they held it to an impossibly high standard.

But unlike dramas like *Breaking Bad*, *The Sopranos*, *The Wire*, *White Lotus*, or *Succession*, *The Simpsons* isn't limited to a relatively short run.

A funny thing happened after Sam Simon declared "thirteen and out." He built a show that was made to last. The characters don't age. Animation makes almost any idea possible. And thus *The Simpsons* isn't just a show. It's a billion-dollar franchise. When it will end is anyone's guess.

But it's damn near impossible to sustain greatness for around eight hundred episodes. As often frustrating as it's been for people who loved the show in its glory years, it only makes sense that the series began to decline in quality after a decade on the air. "TV comedies don't go eight, nine, ten years," Cohen once told me. "That's the extreme outside edge of where TV comedies go. Except *The Simpsons*." He's right.

Megahits *All in the Family*, *Seinfeld*, and *The Office* all ran for nine seasons. *Friends* went on for ten. *Cheers* lasted for eleven. *The Big Bang Theory* ended after twelve.

In reality, the series is a victim of its own success. The legacy the show's golden age created has made cancellation practically impossible. The fact that *The Simpsons* continues to air is a testament to how funny the show was in the first place. Even if it's not as good as it used to be.

CHAPTER TWELVE

THE SIMPSONS DIASPORA

"THAT'S HOW SHOWBIZ WORKS, DOESN'T IT? THEY LIKED IT ONCE. THEY'LL LOVE IT TWICE."
—JEFF MARTIN

In the wake of *The Simpsons*, Hollywood followed the blueprint that had always served it well. As Jeff Martin put it to me: "Give people what they want." Or in this case, what the entertainment industry *thought* people wanted.

"That's how showbiz works, doesn't it?" Martin says. "They liked it once. They'll love it twice. *Animal House* came out when I was in high school, and the next year, there were three fraternity sitcoms that all came and went quickly."

Naturally, the early '90s were littered with primetime animated series green-lit by major networks trying to capitalize on the success of *The Simpsons*. Some were good, some were bad. And almost all of them failed.

The Simpsons seemed to trick the studios into thinking that the magic was all in the format. David M. Stern, a veteran *Simpsons* writer, recalls being shocked to learn that several new primetime cartoons looking to hire him were run by the animation department, not a writers' room.

"It was only later that I was known as an animation writer and went out into the world of animation," Stern says. "I realized that animation shows were storyboard-driven. And so people say, 'Oh, I want a *Simpsons* show.' And I now know to ask, 'Is it board-driven or room-driven?' Because *The Simpsons* was run really as a sitcom. It was a sitcom model. It wasn't run like an animated show. And that's why it was so different. That was Jim's influence. And even though Sam had animation experience, Sam was a trained sitcom writer."

Viewers tuned in to *The Simpsons* because it was much more than just a cartoon. That should've been obvious to the people in charge of network programming. It wasn't.

"People realized it's not just animation," *Simpsons* writer Jay Kogen says. "You gotta make it good. You gotta make it compelling. You gotta make it interesting. And it's really hard."

The thing is, as laughably lousy as they seem in hindsight, many of the knockoffs weren't low-budget productions. *Family Dog*, created for CBS by *Simpsons* alum and future star animation director Brad Bird, was executive produced by Tim Burton and Steven Spielberg. The sitcom, which was like *The Simpsons* if every story on the show was told from the perspective of Santa's Little Helper, lasted ten episodes. *Capitol Critters*, co-created by *Hill Street Blues* and *L.A. Law* honcho Steven Bochco, was a political satire centering on anthropomorphic vermin living in the basement of the White House. ABC canceled the show after thirteen episodes but stayed in the Bochco business; he went on to make *NYPD Blue*. Then there was Hanna-Barbera's *Fish Police*, a comic-book adaptation starring former sitcom star John Ritter as a hard-boiled underwater detective who looked like Dick Tracy with fins. Only six episodes of the film-noir-style cartoon aired before CBS pulled the plug.

Despite the talent behind them, those three shows, among other deficiencies, lacked the simple premise of *The Simpsons*. That was a big

reason why the series attracted viewers. The family is what drew them in, and its mix of irreverence, emotional resonance, and unique sense of humor hooked them forever.

"You gotta start with something that's understandable," Kogen says. "And *then* be weird from there. Don't start from weird. *Fish Police* was weird. Too weird to buy into. Make a family. You can do a sitcom about a family and then make a cartoon cartoony. Something very understandable, something very grounded. Start from grounded and then go weird."

When it started, the adult animation push caused *Simpsons* writers to collectively scoff. They suspected that rival networks' executives weren't exactly approaching the medium with much originality. "They just kind of wanted their version of *The Simpsons*," Vitti says. "That's what we perceived, and we were correct in that way."

What wannabe imitators didn't understand was that *The Simpsons* was one of a kind. Groening, Brooks, Simon, and that group of writers, animators, and actors could never be assembled again. "You couldn't duplicate *The Simpsons*," Vitti says. "It was unreproducible."

Still, it didn't stop competitors from trying again and again. Al Jean and Mike Reiss's *The Critic*, a Gracie Films production that starred Jon Lovitz as a prominent New York film reviewer, was laugh-out-loud funny. But not even a *Simpsons* crossover episode could save it and its relatively esoteric premise from the chopping block. It debuted on ABC in 1994, then moved to Fox, and then got canceled after only twenty-three episodes.

"There was a brief period around that time when everybody, four networks, were open to considering animation," Bill Oakley says. "And they all did a terrible job with it, except for Fox. And then everybody turned against animation again." At least at the major networks.

On cable, there was a mini-primetime animation boom. Unconstrained by stricter network standards and the need to appeal to the

broadest of audiences, it became the place to find unconventional cartoons. In 1991, *The Ren & Stimpy Show* premiered on Nickelodeon. Despite the fact that it appeared on a channel for kids, the series was almost shockingly, chaotically weird. It starred a neurotic Chihuahua and a dumb Manx cat and was full of anti-consumerist messages, body horror, sexual innuendo, and gross-out humor.

There were episodes that made *The Simpsons* look tame. There's one moment from the show that I'll never forget: When the two main characters are at the Lincoln Memorial during a visit to Washington, D.C., Stimpy finds a sign that says "See the President Pick His Nose"—hey, this wasn't Algonquin Round Table–level comedy—licks a nickel, puts it in the coin slot, and watches the statue of our sixteenth president stick his finger in one of his nostrils, pluck a stuck Ren out, and wipe him under his giant chair. It was pretty depraved. And most notably: different.

"Fur ball for fur ball, *Ren & Stimpy* is the funniest cartoon on TV," Matt Groening told the *Washington Post* back then. "With almost all animation on TV, you can tell what the boundaries are, and Ren and Stimpy repeatedly step over those boundaries. Other than *The Simpsons*, it's the only good cartoon on TV since *Rocky and Bullwinkle*."

Ren & Stimpy set the stage for another outrageous cartoon, one that was directly aimed at an older audience. In 1991, MTV started airing *Liquid Television*, a weekly anthology featuring animated music videos and shorts. The show introduced America to two profoundly idiotic characters that a writer named Mike Judge had both dreamed up and voiced: Beavis and Butt-Head. Their first television appearance was a clip called "Frog Baseball." It was gory and stupid. And also hilarious.

The teenagers soon got their own show. The way Judge saw it, that wouldn't have happened without Nickelodeon's transgressive hit. Viacom, you see, owned both Nick and MTV. "*Ren & Stimpy* played on

MTV for a while and was a big success," Judge said at the time. "They used that as a justification to pay for this."

Beavis and Butt-Head both cleverly riffed while watching a wide range of music videos *and* did incredibly dumb things. It'd be wrong to call them latchkey kids; they don't even seem to have parents. Their antics made Bart's feel painfully innocent. They were obsessed with fire. And they loved talking about "scoring," though they never did. The destructive cartoon teens were blamed, often incorrectly, for real kids around the country becoming pyromaniacs. *Beavis and Butt-Head* was nowhere near as big as *The Simpsons*, but it was popular enough to cause a national shit storm.

At a 1993 congressional hearing on violence in television, seventy-one-year-old South Carolina senator Ernest "Fritz" Hollings referred to the series as "Buffcoat and Beaver," seemingly not on purpose. The controversies led MTV to put a "don't try this at home" disclaimer in front of every episode. The network eventually moved the show to a late-night time slot. And after four seasons and a modest hit spin-off movie, *Beavis and Butt-Head Do America*, Judge said goodbye to his two favorite dumbasses.

"I actually wanted to stop a little sooner," he told the *Los Angeles Times* in 1997. "We've done over 200 episodes. After the second season, I thought, 'How are we gonna do this anymore?' I was completely burnt out...You do it as fast as you can, get it on the air as fast as you can, and there's never a break. I felt, like, 'Why not retire before it gets too stale?'"

By then, Greg Daniels was trying to figure out what was next for him. He'd pitched Fox on running *The Simpsons* after David Mirkin in the mid-'90s, but he didn't get the job. He did, however, have a development

deal with the network. He was also working on potential shows elsewhere. "I had a number of projects," he says. "Some were live-action."

In the early '90s, the New York City native had sold a story to Larry David about two cars fighting for the same parking spot. It became the basis for a *Seinfeld* episode. "That was just something that happened to my dad," he says. "And so I had this idea of doing a *Seinfeld*-y type show, but a family version of it. And I put a lot of personal energy and anecdotes into it." He turned that concept into a pilot for NBC.

Around that time, Daniels went to the Aspen Comedy Festival. "I was in this new deal and I was like, 'I need to go see who's out there,'" he says. "And Mike Judge was also there, probably doing the same thing. And our managers were friends who set us up to meet each other. And we got along well. Judge was developing a new show called *King of the Hill*.

"I thought it was just brilliant," Daniels says. "Amazing. And so different from *The Simpsons*."

Hank Hill, whom Judge voiced himself, was a slightly angrier version of Sheriff Andy Taylor from *The Andy Griffith Show*: competent, stoic, and ultimately good-hearted. He was as iconic as Homer Simpson, but not much like him. Hank had three eccentric friends: deeply loyal schlub Bill Dauterive, conspiracy theorist Dale Gribble, and unintelligible ladies' man Jeff Boomhauer. (Bill became the repository for the kind of bits *Simpsons* writers wrote for Homer. "I knew from being in the *Simpsons* writers' room how attractive it is to pitch jokes for the sort of fat dumb guy," Daniels says.) And they lived in the fictional but realistic Dallas–Fort Worth-ish suburb of Arlen, not the increasingly zany world of Springfield.

"The tradition of the dad knowing what the score was and being surrounded by crazies was a throwback to the *Andy Griffith* days,"

Daniels says. "I really thought that was important. It would be different from *The Simpsons*. It would be some fresh snow."

Daniels liked that Judge's pilot didn't have any *Simpsons*-like rapid cutaways to sight gags. It lingered in the world of Arlen, on purpose. But it needed some rejiggering. "They had been developing it and it had kind of run into a dead end," Daniels says. "People were kind of like, 'There's *something* there.'"

That's where Daniels came in. But even after making some changes, he wasn't sure whether *King of the Hill* would become a series. His live-action project was in limbo, too. "Basically, whichever one got picked up first, I was going to do," he says.

Fox ended up picking up *King of the Hill*. Daniels's previous gig had prepared him for his new job. Early in his time working at *The Simpsons*, he'd picked up on the heavy tension between Groening and Simon. Daniels didn't want his working relationship with Judge to be similarly strained.

"When I got to be working with Mike, I was like, 'I'm the Sam of this situation,'" Daniels says. "But I don't want to get into a horrible situation with Mike. I want this to be a fun collaboration."

Joe Boucher, the *Simpsons* producer who later moved on to *King of the Hill*, remembers having conversations with Daniels about his partnership with Judge. "How this show goes is going to have a lot to do with how you and Mike get along," Boucher recalls telling him.

The media was always going to make Judge, a longtime Texan and the creator of *Beavis and Butt-Head*, the face of the show. Just like it made Groening, an underground cartoonist, the face of *The Simpsons*. "Matt was a more interesting story than Sam," Boucher says. "And I said to Greg, 'You know, Mike's kind of always gonna be a more interesting story.' When things came up, I was always there to kind

of remind Greg of how much fun we have on this show. Because we knew it was good."

Daniels was dedicated—and smart—enough to try to make *King of the Hill* as great as his former show, but in a different way. He also realized something extremely important: at *The Simpsons*, the vast majority of things *did* work. He helped recruit a talented cast of interesting voice actors who weren't all A-list celebrities. He brought over some of his old show's key contributors, including animation director Wes Archer, writer-producer Richard Appel—who became the showrunner of *King of the Hill*—and Vitti.

Creatively, Daniels hoped that on a week-to-week basis, *King of the Hill* would be as resonant as one of his favorite *Simpsons* installments: "Lisa's Substitute." "I was really concerned that the audience have a tightly prescribed emotional experience with every episode," Daniels says. But he realized that wasn't *always* necessary. Every so often, it was OK to devolve into ludicrousness.

Sometimes viewers just want to have fun. Just ask *Simpsons* fans. "I remember when the monorail episode came out and some people were a little nervous," Daniels says. "It's too zany. It's a little bit more comedy-forward." Yet it's remembered as one of the best *Simpsons* episodes of all time. "People have different takes," Daniels says.

The opening of the first episode of *King of the Hill*, which aired in January 1997, doesn't resemble anything that would've ever appeared on *The Simpsons*. It's glacially slow. Hank and his buddies are drinking beer silently, staring into a broken-down pickup truck's engine. The dialogue starts with this exuberant exchange:

"Yup."

"Yup."

"Yep."

"Mmm...hmm."

According to Daniels, Fox had an issue with the unhurried

opening. "There was a lot of pressure not to start that slow," he says. "And I really resisted it." The network did, thankfully, back off its increase-the-pace request.

The very deliberate introduction emphasized to viewers, Daniels says, that "we are not Season 9 of *The Simpsons*."

Judge was especially wary of this. He didn't want his show to be written by Ivy League types only. And he wasn't afraid of saying so. After leaving *The Simpsons*, Vitti worked on *King of the Hill*. He recalls Judge's script notes being, well, pointed. "PAs, they would just hand you Mike's notes uncensored," Vitti says. "So you would get Act 2, 2:30—in caps—'THIS IS WHY I DON'T LIKE HARVARD LAMPOON WRITERS FROM *THE SIMPSONS* WORKING ON THE SHOW.' It would feel so horrible."

Yet Vitti understood. "Mike really didn't want the show to be like *The Simpsons*," he says. Not because Judge hated *The Simpsons*. But because he had no interest in trying to copy *The Simpsons*. "It's why the show stands on its own," Vitti says.

Daniels did not want *King of the Hill* to be a copy of *The Simpsons*, either. But the latter's influence on the former is undeniable. It was *the* blueprint for a primetime animated series. The way Daniels saw it, the greatest strength of *The Simpsons* was a principle that James L. Brooks had brought to the animated series: these weren't cartoons, they were real people.

"One thing I feel like I'm very attracted to with Jim Brooks is the humanism of his work," Daniels says. "And people are people and they all have their own stories, and they're not objectified or turned into types or anything. A lot about *King of the Hill* was just trying to avoid stereotypes and make everybody a human being."

Daniels's approach paid off. From the night it premiered, *King of the Hill* was a success, occasionally even earning better ratings than its Sunday night lead-in: *The Simpsons*. It had taken years, but the

Simpsons diaspora had shepherded a huge hit. Which led to *another* adult animation boom.

Around that time, two college buddies from Colorado were developing a series based on a crudely animated short they'd created and passed around to their friends called *The Spirit of Christmas: Jesus vs. Santa*. Fox liked the idea of a show about a group of foulmouthed kids in a suburban mountain town, but eventually passed on it. The network didn't think the show was as family-oriented as *The Simpsons*. (It wasn't.) It also deemed a cartoon that featured a talking turd named Mr. Hankey too crude, even for a channel that aired *World's Wildest Police Videos*. So Trey Parker and Matt Stone took their pitch to Viacom. And that's how *South Park* ended up on Comedy Central. It debuted in August 1997, and became a sensation.

South Park ended up on magazine covers. T-shirts featuring its irreverent characters sold by the bale. It was the hottest animated series since *The Simpsons*, though the two were very different. Parker and Stone's sense of humor was hyper-topical, political, and vulgar. Like Bart Simpson, Eric Cartman was a wise-ass. The show was smart, but Cartman wasn't. He took his pranks too far. He was a proud little bigot. And underneath his mischievousness he had no heart. He was the perfect icon for the late '90s, when music, movies, and TV aimed at young people were getting edgier. The sensibility naturally sucked in young viewers.

"They've been around for years and years and years because they cracked the code," Jay Kogen says. "They did something different. They made it funny in different ways. They have a different look, a different feel, a different style."

As *South Park* was taking off and *King of the Hill* was becoming one of the best shows on TV, Fox took a chance on another upstart

animated series. Created by Rhode Island School of Design alum Seth MacFarlane, *Family Guy* revolved around a man named Peter Griffin, who was Homer Simpson with a New England accent.

"At the time, it was where I wanted to be," MacFarlane said in 2003. "I loved *The Simpsons*. It had laid the groundwork, sort of paved the way for subsequent animated shows. They sort of established the new method of doing primetime animation. I was very excited about pitching to Fox, and everyone that I dealt with there just seemed really cool."

The crass cartoon, which debuted after the Super Bowl in January 1999, also featured an evil-genius toddler and a talking dog. And it was overflowing with the kind of cutaway jokes and pop culture references that *The Simpsons* made famous. They could be funny—but often seemed to take the place of character development.

"*Family Guy* is of course much more heartless than *The Simpsons* was," Jeff Martin says. As harsh as that sounds, he doesn't mean it as an insult. A good show didn't need to be warm and fuzzy. After all, there was nothing heartwarming about *Seinfeld*. "Nobody hugs, nobody learns anything," Martin says, repeating the sitcom's mantra. "Just bucking the conventional wisdom of 'OK, let's try to make it funny. And also they learn a lesson and everyone loves each other.'"

After *The Simpsons*, Martin went to Disney, which at the time was producing ABC's *Home Improvement*. The people he met there, he says, were "a bit smug" about competitor *Seinfeld*'s long-term prospects because it didn't have an emotional component. "Once *Seinfeld* really got going, it was 50 percent more popular than any other show on TV," Martin says. "And it'd be crazy to say in spite of the lack of emotion. No, *because of it*."

The Simpsons made fun of schmaltzy tropes while retaining some traditional sitcom warmth. *Family Guy* and *South Park* stripped that away, often completely. That level of detachment helped them stand

apart from their predecessor. Which wasn't necessarily a bad thing. "Not better, not worse," Martin says. "But different and valid."

In the late '90s, Matt Groening was hard at work making something much different from his first TV project. His first post-*Simpsons* series was *Futurama*, which follows Fry, a cryogenically frozen late-twentieth-century pizza delivery man who wakes up in 2999 and has to adjust to his strange new existence. Groening, a fan of science fiction, developed the series with *Simpsons* writer David X. Cohen, a man with degrees in physics and computer science—and the former president of the *Harvard Lampoon*.

"He was excited and had a lot to do with the thrust of the show and the direction, so he and I developed this thing together, and took it to Fox," Groening once told *Mother Jones*. "They'd been begging me for years for another show, and in the meeting—which lasted about three hours because there was so much to talk about, we just knew the show inside and out—they jumped up and down and ordered 13 episodes on the spot."

The new series was brainier than *The Simpsons*. By then, *Fish Police* was a distant memory. Fox assumed TV viewers could handle high-concept cartoons, especially from someone with Groening's track record. While managing not to overwhelm the audience with headiness, *Futurama* introduced plotlines revolving around time travel, physics, and mathematical theorems.

Writer Lewis Morton, a Harvard guy himself, felt out of his depth at first while working on *Futurama*. One day, he listened to Cohen and executive producer Ken Keeler, another *Simpsons* alum who had a Harvard PhD in applied mathematics, argue about the moons of Mars. Were they in geosynchronous orbit with the planet? "The two of them were really going at it, whether or not this was true," Morton says. "And just trying to derive it with math. It's like being in a graduate student seminar where you didn't have the prerequisites."

There was nothing on TV like *Futurama*. But for Groening, making the series for Fox was miserable. "The second they ordered it, they completely freaked out and were afraid the show was too dark and mean-spirited," he said at one point, "and thought they had made a huge mistake and that the only way they could address their anxieties was to try to make me as crazy as possible with their frustrations."

Groening expected Fox to give him the same creative freedom he'd once had. The network famously left the creative side of *The Simpsons* alone. But that, likely because of Brooks, was a one-time deal. "It has been by far the worst experience of my grown-up life," Groening said. "Just as far as business, and I guess I shouldn't have been surprised because this is how everyone is treated. But I thought I would have a little bit more leeway since I made Fox so much money with *The Simpsons*."

Groening didn't want to have to address network feedback. It was something he just didn't have to deal with on *The Simpsons*. "When creativity becomes a matter of giving notes to other people rather than doing actual drawing and writing myself," he said. "That's not as much fun."

The cartoonist had an excellent track record. He believed that Fox should trust him to make another megahit. His feeling about *Futurama*, Morton recalls, was, "Of *course* it's going to be as big as *The Simpsons*. Oh my God, why wouldn't it be?' Well, I'll say it *was* great."

Futurama premiered in March 1999 and *was* great. But its original run was bumpy. Low ratings led Fox to shift it around to different time slots, including, starting midway through the second season, 7 p.m. on Sundays. Which meant that NFL broadcasts often prevented episodes from airing. "We were preempted by football four weeks in a row and it was like, 'We're in trouble,'" Morton says.

The series initially lasted until 2003, when Fox stopped ordering new episodes. Like seemingly every other cult favorite of the last

several decades, *Futurama* was eventually revived. (By Comedy Central, not Fox.) But there are two lessons to be learned from its first run. One is that a cartoon set in the thirtieth century might not be destined to rule the ratings. And two is that no matter how hard anyone tried, it was impossible to fully recapture the atmosphere that led to *The Simpsons*.

But thanks to the success of the show, creators were given license to make funny and interesting animated series. Groening's first show legitimized primetime cartoons, which was a boon for funny people. "*The Simpsons* made it so it's not like you're going into a career in animation," Morton says. "It's just part of comedy."

The primetime cartoon stigma had been tough to shake. "People were still saying, 'I don't watch cartoons. Cartoons are for kids,'" Bill Oakley says. "And they would say this to you even though they knew you worked on *The Simpsons*. And it was only after both *King of the Hill* and *South Park* became huge hits that it started to crumble a little bit."

Just like earlier in the decade, the late '90s saw a rise in adult-oriented animated series. Most were short-lived. After *The Simpsons*, Oakley and his show-running partner Josh Weinstein created a show of their own: *Mission Hill*. The premise of theirs, which they sold to the nascent WB network, was unlike other primetime cartoons at the time. It was about twentysomethings living in a city.

"The whole reason that this came to be was because we realized there's no characters at all between the ages of twelve and thirty-five on *The Simpsons* except for Otto," Oakley says with a laugh. "He was not exactly fun to write. And so we wanted a show where most of the characters were that age."

But as the premiere of *Mission Hill* approached in the fall of 1999, the WB had started to focus on a slightly younger demographic. *Buffy*

the Vampire Slayer, Dawson's Creek, Roswell, and *Angel,* all shows about high school kids, were huge hits. "They'd suddenly discovered that they were the teenage girl network," Oakley says. "And we had no place."

The WB only aired six episodes of *Mission Hill,* which got a brief second life on Cartoon Network's Adult Swim. It did eventually become a cult favorite, but not before being unceremoniously canceled. For a while, the major networks continued to struggle to make animation work. Remember British import *Stressed Eric?* Or *God, the Devil and Bob?* Or the David Spade vehicle *Sammy?* I didn't think so. NBC canceled all three in the middle of their respective first seasons.

But adult animation died hard. In the late 2000s, it surged back. Since then, Fox has made primetime cartoons a cornerstone. *Family Guy* is still going. *Bob's Burgers* is now in its second decade. And series like *Archer, Rick and Morty, BoJack Horseman, Big Mouth,* and a new version of *Beavis and Butt-Head* have all been hits on streaming platforms and cable. When Daniels and I spoke in late 2023, he was in the middle of rebooting *King of the Hill.*

It's obvious by now, but none of this would've happened without *The Simpsons.* "I mean, *The Simpsons* is a huge influence," Lisa Hanawalt, the artist who came up with the distinct look of all the anthropomorphic characters on *BoJack,* once told me. "Just the sense of humor and the little details that would make me laugh. I wanted to capture that same kind of energy. I come from a cartoonist background similar to Matt Groening. So that's definitely in the DNA."

The show casts a long shadow. Trey Parker and Matt Stone even addressed it on *South Park.* In "Simpsons Already Did It," goody two-shoes Butters breaks down when he realizes that every creative idea he thinks of has already been done by *The Simpsons.* He only recovers when he begins to understand that almost *every* story is derivative.

"They've been on the air for like, thirteen years," his pal Stan tells him. "Of course they've done everything."

That episode aired in 2002. The show Stan is referencing has now been on the air for like, thirty-six years. But Parker and Stone's point still stands. There's no use trying to match *The Simpsons*. It'll drive you mad.

CHAPTER THIRTEEN

SIMPSONS WORLD

"WE'RE COMMUNICATING TO PEOPLE THAT WE HAVE NEVER MET IN OUR LIVES. AND SHARING SOMETHING THAT WE THINK IS FUNNY OR PROFOUND. OTHER PEOPLE, NO MATTER WHERE THEY ARE OR WHAT THEIR SITUATION IS, CAN GO, 'I FELT LIKE THAT TOO.'"

—RICH MOORE

Sixteen years after *The Simpsons* premiered, the last member of the original writers' room said goodbye to the show. That was George Meyer. By the mid-aughts, he knew it was time to go.

"A very tough decision," he says. "I knew I would never get that kind of salary again. And I liked many aspects of the job. I loved the people who worked there. I just felt that it was getting harder to keep the show fresh. That was just my own assessment of it. I was still having fun doing it, but I knew that if I stayed a few more years, I would start to resent it, and I didn't want to get to that point."

Meyer had almost quit in the mid-'90s. Greg Daniels remembers what was supposed to be Meyer's last day. Daniels wrote about it in the journal he kept while working on the show.

"I was talking about his going-away party and how we went to this table read, which was supposed to be his last table read," Daniels says. "And I just happened to notice him in a contemplative moment. I was sitting next to him, and I said, 'Are you feeling nostalgic?' And he turned to me and he had tears in his eyes."

Meyer came back the next season. That's how much the show meant to him. His decision probably helped extend *The Simpsons*' golden age for a few more years. "George is among the most cynical of us, and I would say, occasionally the angriest of us," Jay Kogen says with a laugh. "And oddly enough, he's one of the two people who stayed the longest."

After leaving *The Simpsons*, Meyer moved to Colorado. He expected his post-show existence to be relatively carefree. But like pro athletes who retire and realize that they have nothing to fill the ultra-competitive void, he struggled with the transition. "I think it's always wise when you've worked on something for a long time to ease out of it if you can," Meyer says, "or at least to stay busy doing something as opposed to, 'OK, now I'm just going to have fun and live in Aspen,' which is what I did."

Meyer enjoyed toting his young daughter around town in a Burley behind his bicycle, working out, and skiing. But something was missing: the everyday challenge of making something as funny as possible. "I didn't reckon on the jolt to my system that would represent," he says. "It gets back to what I was saying about the complexity and nuance of life. Whatever you're telling yourself is going to be a gross oversimplification. Always. Because there's always so much more to it. I didn't have the respect that I do now for my own emotional requirements."

At this point in our conversation, Meyer starts telling me a story about being on a train and noticing that the door to the control room was open. "I just thought, 'Well, I'll just walk in and look at it,'" he

says. "And so I walked up there and I saw this guy sitting there and he had a throttle control and he had a brake. And I was like, 'What happened to the steering wheel? Where's the steering wheel?' But of course, the train doesn't have a steering wheel. It just goes forward and backward."

For a few moments, I felt like Bart when his father was telling him the story about really wanting a catcher's mitt. But I quickly realized that the anecdote, unlike Homer's, had a point. For years, Meyer says, he believed that he could only move in one direction at one speed: "I just saw myself more of a machine that occasionally needed to be revved up a little bit, but didn't have a steering wheel."

Meyer thought that making good comedy required going full speed ahead at all times. He later began to understand that the extreme pressure he felt was often self-imposed. And often unnecessary.

"The years since *The Simpsons* for me have been about my own emotional growth and trying to become a better, kinder, more loving person and enjoy life more, frankly," Meyer says. "Because at the time, I was having fun and I was certainly in an enviable situation, but I also got depressed a lot. I had anxiety and stress, and I'm just a lot happier these days."

It's impossible to get into his head, but another legendary *Simpsons* writer also seems to be thriving deep into his post-show life. The last episode credited to John Swartzwelder aired in 2003. These days, he writes detective novels. "His stuff is so funny and he still can do that in his books," Meyer says. "They're brilliantly funny." And undeniably Swartzweldian. "As my exciting story opens, I am being punched in the stomach. But I guess a lot of stories start that way," he wrote in *The Time Machine Did It*, the first title in the Detective Frank Burly series. In 2023, he published the fourteenth installment, *Dead Detective Mountain*. He promotes them all on Twitter, er, X. There's no Baby Boomer on earth with a better account. "If you read one

spy-without-pants book this year, make it 'The Spy With No Pants' by John Swartzwelder," Swartzwelder wrote in January 2021.

According to his friends, you can find Swartzwelder at his San Fernando Valley ranch. According to Meyer, Swartzwelder quit smoking about a decade ago. "I think that's fantastic," he says. Swartzwelder also hasn't hung up his spikes for good yet—and he's still ruggedly handsome. "I went and played baseball with him and his brother," Martin adds. "He looks like Clark Gable."

Both Meyer and Swartzwelder contributed to the script for 2007's *The Simpsons Movie*, but, unlike some of their colleagues, they haven't come back to the show that they helped shape. At one point or another, David M. Stern, Jon Vitti, Jeff Martin, Mike Reiss, and Al Jean all returned to write or produce. Today, Jean is still an executive producer of the animated series.

Meyer and Swartzwelder have both moved on, for good. And so did the animated series that they loved. But without them, *The Simpsons* is no longer connected to its golden era.

In the early days of the pandemic, Meyer planned to visit Swartzwelder over the holidays. "He discouraged me from doing that," Meyer says with a laugh. "That was COVID-related. OK, fair. Got it." The next year, Meyer tried once more. Swartzwelder said no again. And more emphatically. "George, don't come," he told his friend.

Before thinking better of it, Meyer still considered surprising Swartzwelder at his house. "I really wanted to just show up outside and start batting on his windows like a zombie. Oh my God," he says. "It was just too far to drive for a joke."

It's difficult to succinctly summarize the effect Meyer, Swartzwelder, and the rest of the *Simpsons* writers have had on American culture. But to do that, I'll start with a story about an absurdly silly joke and the people

who love it. On October 2, 1994, Fox aired "Itchy & Scratchy Land," a *Simpsons* episode that lampoons the Disney World experience. At one point, Bart and Lisa stop in the fictional park's gift shop. Intrigued by a display of novelty license plates, the former searches in vain for a souvenir featuring his name.

> **BART:** Look at all this great stuff, Lis. Cool! Personalized plates! "Barclay," "Barry," "Bert," "Bort"? Aw, come on. "Bort"?
> **CHILD:** Mommy, Mommy! Buy me a license plate.
> **MOTHER:** No. Come along, Bort.
> **MAN:** Are you talking to me?
> **MOTHER:** No, my son is also named Bort.

The throwaway gag returns later, when an employee manning Itchy & Scratchy Land's underground control room says, "We need more 'Bort' license plates in the gift shop. I repeat, we are sold out of 'Bort' license plates." The joke is so inconsequential that the episode's DVD commentary panel—which includes Matt Groening, David Mirkin, and director Wes Archer—doesn't bother to mention it.

"I always liked the joke," Bill Oakley once told me, "but I am surprised it took on this legendary status." Three decades later, just uttering the word "Bort" unlocks joy in even the show's most discerning fans. Why, two decades later, do people continue to reference "Bort"?

Because it's the kind of joke that only *The Simpsons* could've made. At its peak, the show had the ability to take something utterly inane and render it endlessly quotable.

If you believe this theory is bunk, visit the website of your state's Department of Motor Vehicles and try to order a "Bort" vanity license plate. Chances are some other *Simpsons* obsessive has beaten you to the punch line.

Still, I'd never seen a "Bort" tag in the wild. Even though there was evidence that they existed, I didn't quite believe it. So back in the fall of 2014, I set out to find the lucky few who'd managed to snag one. After all, I envied members of the "Bort" license plate club. It's one of America's most exclusive, eccentric, and geekiest fraternities. I had to learn more about it.

The problem was that I wasn't quite sure where to look. After calls to a dozen DMVs around the country yielded nothing, I resorted to searching Google. Within five minutes, I'd found a thread on Reddit. Sure enough, a handful of Redditors had shared photographs of their real-life "Bort" license plates. Several responded to my messages. All were happy to talk to me over the phone.

John Orr of Austin told me that he had to wait a year before a "Bort" Texas plate became available. But as soon as it was, the musician plunked down the cash. "That's the kind of thing I spend my money on," he told me with a laugh. Soon after he attached the new plate to his Ford, he began noticing people in nearby cars laughing and taking pictures. "I think people could appreciate that somebody like me could actually take the time and pay the money to put something like that on my vehicle," Orr said. And, he added, "not just on a bicycle."

For Link Lowe, finding a premade novelty plate with his name on it has been a lifelong quest. "Of course I'm never going to," he told me. Instead of continuing his search, the Oklahoma City middle school teacher decided to order a "Bort" plate. When it arrived in the mail, he went straight to his old Volvo. "I live in the arts district, so I am surrounded by *Simpsons* fans," Lowe said. "I'm putting it on and a crowd of people basically formed. They were just, like, drooling over it." He became so worried someone would steal the tag that he reinforced it with security screws. (For a while, rather than risk theft, he displayed it inside his car.) Lowe also claimed that a *Simpsons*-loving

police officer once flashed his lights and approached him in a parking lot. "That is the greatest plate I've ever seen," the cop said, and then let Lowe drive away.

When his company transferred him to Montana, Stuart Hocking decided to splurge on a "Bort" vanity plate. He was living in one of the least densely populated states in America, yet motorists regularly pulled up next to his truck and asked about "Bort."

The show's minutiae still turns full-grown adults into nerdy children. Fox's marketing machine has long since learned how to capitalize on fans' obsessiveness—at Universal Studios, the "Springfield" area's *Simpsons* gift shop peddles personalized "Bort" merch. And it routinely sells out.

Looking back on the golden age of *The Simpsons*, it's hard not to say that the show had a huge hand in the commodification of modern fandom. The animated series helped make pop culture merch a multibillion-dollar business. These days, every last corner of every movie and TV franchise is licensed and sold. Knowing an obscure *Simpsons* reference used to be a secret handshake. Now it's something you can buy and show off.

Even if the studio is shamelessly capitalizing on a throwaway joke, there's no denying that a four-letter word on a license plate has forged moments of genuine bonding. "Occasionally you're gonna come across those hardcore fans," Lowe told me. "And it does awkwardly bring you together."

By now, *The Simpsons* has permeated our culture to the point where words the writers made up during the show's first decade are entering the *official* lexicon. In March 2018, Merriam-Webster announced that it was adding "embiggen" to the dictionary, defined as "to make bigger or more expansive." Writer Dan Greaney made it up for the 1996 episode "Lisa the

Iconoclast." We first hear it in an educational film about town founder Jebediah Springfield.

> **JEBEDIAH SPRINGFIELD:** A noble spirit embiggens the smallest man.
> **MRS. KRABAPPEL:** Embiggens? I never heard that word before I moved to Springfield.
> **MISS HOOVER:** I don't know why. It's a perfectly cromulent word.

In 2023, Merriam-Webster added "cromulent" to the dictionary. It means "acceptable, satisfactory." David X. Cohen coined the term—which also pops up in "Lisa the Iconoclast"—after Oakley and Josh Weinstein challenged the writers to invent fake words that sounded real. "There are plenty of TV catchphrases that have seeped into our lexical consciousness, but none of them has been as sly as *cromulent*," reads the Merriam-Webster entry. "The joke was so sly and subtle that as 'It's a perfectly cromulent word' was repeated, it wasn't necessarily clear to the hearer that it was a joke." The thing is, it wasn't even really a catchphrase at all. In fact, *The Simpsons* wouldn't be caught dead trying to come up with catchphrases, which by the late '90s had started to disappear from TV. Classifying the word that way undercuts how funny it was.

"It was a joke and now it's a real word," Oakley says. "So there's no joke there anymore." Like "embiggen," "cromulent" has appeared in the *New York Times* crossword puzzle. "It seems like there's *a lot* of people who spend their time communicating in *Simpsons* references or phrases from the show," Oakley adds. "Then there's also something more specialized, which is all the remixing."

What Oakley is talking about is *Simpsons* shitposting. If you don't spend much time online, this probably sounds bizarre. The purveyors

of the phenomenon, which despite its name is not scatological in nature, have created countless Photoshopped collages that mix images from *The Simpsons* with other bits of pop culture and/or blend together some of the show's funniest, most obscure jokes. In *Wired*, Brian Raftery defined shitposting as "a catchall term for aggressively sloppy, oft-brilliant inside jokes, visual gags, and trollish mashups."

Oakley will never get tired of "Steamed Hams" mashups. To him, they represent the best of the internet: joyful, brainy, and delightfully deranged. Sometimes you have to dig through piles of manure to find treasure, but it's usually buried down there if you look hard enough.

In February 2018, for example, at the National Portrait Gallery in Washington, D.C., Kehinde Wiley's official portrait of Barack Obama was unveiled. The painting, which features the forty-fourth U.S. president sitting in front of lush green vines and colorful flowers, wasn't universally beloved. Crusty art critics and right-wing trolls joined together to bash the work for not looking exactly like every other lifeless oil-on-canvas depiction of a U.S. president.

Simpsons fans, on the other hand, adored the painting. They celebrated it in the only way they knew how: by posting photos of the leafy portrait side by side with images of Homer walking through Ned Flanders's bright green hedges. Both are works of art. The meme was the perfect companion to a one-of-a-kind creation. The former is a tool used to help understand the latter. This is why *The Simpsons*' heyday is relevant today. It shaped the way an entire generation of smart people processes the world.

We've now even reached a point where a large swath of the country believes that *The Simpsons* can tell the future. There are many ways to generate easy internet traffic. One of the easiest is to cobble together a *"Simpsons* predicted" listicle. Over the last decade, high- and lowbrow publications of all sizes have pumped out curated—and

exhaustive—collections of all the things that the animated series supposedly got right about the future. A quick Google search yields dozens of results.

"20 Predictions from *The Simpsons* That Came True"
—*Collider*

"*The Simpsons*: 31 Times the Fox Comedy Successfully Predicted the Future" —*Hollywood Reporter*

"*The Simpsons*: 15 of the Series' Most Uncanny Predictions" —*The Independent*

"21 Times *The Simpsons* Accurately Predicted the Future" —*Business Insider*

"16 Times *The Simpsons* Predicted the Future"
—*Entertainment Weekly*

"Everything *The Simpsons* Has Predicted in 2022 and Beyond" —*Esquire*

It's true: *The Simpsons* has predicted a lot, from Washington beating Buffalo in Super Bowl XXVI, to the proliferation of video phones, to Siegfried & Roy's tigers attacking their masters, to the Walt Disney Company buying 20th Century Fox. In a Season 11 flash-forward episode that aired in 2000, Lisa is the president of the United States. While sitting in the Oval Office, she mentions inheriting "a budget crunch from President Trump."

"It was just kind of a fill-in-the-blank joke," says then-showrunner Mike Scully. "We'd left Lisa saying, 'I've been left a big budget deficit

by President blank.' Mike Reiss says, 'Who would be the dumbest person we could have?' There were other names thrown out, but Trump, around that time had thrown out the possibility that he might run for president someday. So it was in the air. We didn't just, you know, pull it out of nowhere."

The writers certainly didn't think they were making an actual prediction. And in hindsight, they don't see themselves as soothsayers. "It's just a matter of smart people being behind desks," *Simpsons* editor Brian Roberts says. "I don't think there's any precognitive thing in there at all."

To Kogen, the show's predictive power is a matter of sheer volume. "We've been making fun of *everything*," he says. "If you make fun of everything and make impossibly silly jokes about everything, it turns out thirty years later, some of them turn out to be true."

The Simpsons has been around for so long and has covered so much ground that it's become one of the world's richest texts. Watch almost any episode from the '90s and you'll be able to identify a broad plot point or a specific sight gag that's prophetic. The series has become a twenty-first-century animated Bible: it's dense enough to be interpreted in many ways. Whatever your worldview, though, you can easily find something that seems to match your beliefs. Even if your read is completely wrong. Or at best warped.

As funny and satisfying as "*Simpsons* predicted" moments often are, the phenomenon is often far less meaningful than fans make it out to be. Treating the series like a mere fortune-teller cheapens its actual vision. *The Simpsons* didn't just accidentally predict singular events, it understood the world in a way that most other shows didn't.

It's true: a show that was considered transgressive has now become a sacred American text. In 2009, the U.S. Postal Service honored *The Simpsons* with stamps featuring portraits of Homer, Marge, Bart, Lisa,

and Maggie. And in the 2010s, Universal opened *Simpsons*-themed areas of their parks in California and Florida.

In 2017, the National Baseball Hall of Fame, one of America's stodgiest organizations, celebrated the twenty-fifth anniversary of "Homer at the Bat," the episode guest-starring Major League Baseball All-Stars. I was in Cooperstown that sunny Memorial Day Weekend morning. Hundreds of fans made the trip to the almost unnervingly picturesque village in upstate New York to see Homer Simpson get pretend-inducted into the Hall of Fame. It was not a typical Hall of Fame occasion. I remember hearing from a source that more than a few of the older members of the Hall's brass didn't understand why a seemingly frivolous event was generating so much attention.

Thankfully, then–Hall of Fame president Jeff Idelson embraced the idea of a *Simpsons* celebration. In the early '90s, when "Homer at the Bat" was being made, he was working in the New York Yankees' media relations department. When the team was in Southern California to play the Angels, he drove Steve Sax and Don Mattingly to the Fox lot to record their lines. "Sax made a lot of sense to me because he's just naturally a cutup," Idelson told me. "Donnie I was a little worried about. But he had fun with it." (Mattingly later said that he still hasn't seen the episode. But he still gets minuscule royalty checks.) It was only natural that the Hall would toast an episode starring Ken Griffey Jr., Wade Boggs, and Ozzie Smith. "As a museum it's our responsibility to embrace American history and how it relates to baseball," Idelson said. "It shows baseball's inextricable link with American culture."

When the actual ceremony began, Al Jean walked to the podium set up on the marble steps leading to the Hall of Fame's library, took the microphone, and said, "I must be on drugs." Three decades into the life of the subversive series, he still couldn't believe that it had become so...accepted. "The pope endorsed the show, OK?" Mike Reiss told me that day. "What more do you need?" Reiss brought the

show's trademark brand of irreverence to the proceedings. "This is a beautiful museum," he said from the dais, "of something I have no interest in whatsoever."

Jeff Martin, a huge sports fan who penned a new version of Terry Cashman's nostalgic ode "Talkin' Baseball" for the episode, naturally compared working on *The Simpsons* to being around the biggest band of the twentieth century. "It's like if you ever had anything to do with the Beatles," he said after Homer gave an animated induction speech. "People still care."

He's right. I talked to about a dozen fans who had driven hours to be there. Scott and Jack Williams, a father and son, wore bootleg versions of the Springfield Nuclear Power Plant softball team jerseys seen in "Homer at the Bat." About every other person in attendance was wearing some kind of *Simpsons* paraphernalia. By my count, there were as many Homer T-shirts as there were Derek Jeter tees. It was stunning. Like baseball, *The Simpsons* has become a national pastime. It brings people together.

The connection among *Simpsons* fans didn't form by accident. Like the series' creators, I spent my childhood in front of a television. Thanks to syndication, Gen Xers and elder Millennials like me could tune in to their favorite show every single night.

"If you were a kid and it was 7:30, what are you gonna watch?" Oakley says. "You're gonna watch *The Simpsons*. Obviously you're not gonna watch *Wheel of Fortune* or *Jeopardy!* So that's how it happened. The fact that it became impossible to avoid and influenced people while they were growing up is what's caused this."

We eventually got older but stayed loyal. We quoted the show through college, bought the DVD box sets, and as young adults went to see *The Simpsons Movie*. Thanks to some of the original writers

brought on to work on the script, the 2007 film did capture some of the magic of the '90s. By then, many of us had stopped watching the still-running animated series. "Prestige" series like *The Sopranos* and *Mad Men* became TV's gold standard.

Then, in 2014, Fox rolled out Simpsons World. The exhaustive website and accompanying mobile app housed every single episode in the history of the show. Instead of relying on dusty DVDs and unwieldy VHS recordings of old episodes (to '80s and '90s kids those were like dog-eared paperbacks), I used the single all-encompassing hub for a while. For me, *The Simpsons* has always been a religion. It's surprising that it took so long for someone to build it a proper house of worship.

The problem was, that house of worship was more exclusive than it seemed. You needed a cable subscription to access Simpsons World. And the only other place you could watch old episodes was on Fox affiliate FXX. By then, streaming services were on the rise. And young people had started cutting the cord. All of a sudden, new generations stopped discovering the show. "There was a period between like, 2010 and 2020, where that didn't happen," Oakley says. "Because *The Simpsons* was relegated to Simpsons World. My own kids, because they had Netflix, watched every episode of *Futurama* a hundred times and every episode of *Bob's Burgers* a hundred times. Never saw a single *Simpsons*. So what I have found is that people who are probably within the ages of ten and twenty don't know *The Simpsons* at all."

Then in 2017, the Walt Disney Company acquired 20th Century Fox. The deal ended up being worth $71.3 billion in cash and stock. The most important by-product of the massive merger was that *The Simpsons* was going to be available on the mega-conglomerate's new streaming service. (To me at least.)

When Disney+ launched in November 2019, the entire *Simpsons* catalog was available at the push of a button. It finally gave fans an

easy way to binge on classic episodes. And it gave *new* fans an easy way in. With their thirty-, forty-, and fiftysomething parents encouraging them, children are getting into *The Simpsons*. "It's happening again," Oakley says. Greg Daniels has a young cousin who just discovered the show. "Now that's all he wants," he says. "He just had a birthday and we had to get him a *Simpsons* calendar. All he wants is *Simpsons*."

Times have changed. When I was growing up, *The Simpsons* was often the one TV show that parents didn't allow their kids to watch. These days it's often the one TV show that parents bond with their kids over.

The love for the animated series is now intergenerational. Rich Moore, who went on to become the Oscar-winning director of *Zootopia* and *Wreck-It Ralph*, once met a woman whose late father was a big *Simpsons* fan. When she found out that Moore had worked on the show, she shared a story about her dad.

"Before he died, he went through all the chemotherapy. Just these brutal treatments that were so uncomfortable," Moore remembers her telling him. "And he was in so much pain. It was so hard to watch him suffering. But every day, *The Simpsons* was on for an hour. And in that hour, he would watch it and laugh. It was my dad again. He forgot about the pain, and he forgot about just the existential dread of what was going to happen so soon. And for an hour, he had a good time just enjoying a funny show. It was about a family. And I could sit there with him and laugh and we talk about it. So on behalf of him, I really want to thank you for those hours you provided."

At the time, Moore was feeling down about his life and his career. But the anecdote shook him out of his funk. "It just right-sized me in an instant," he says. "Like, 'This is why I do it.' We're communicating to people that we have never met in our lives. And sharing something that we think is funny or profound. Other people, no matter where they are or what their situation is, can go, 'I felt like that too.'"

The first time Jeff Martin visited the theme park version of Springfield at Universal Studios Hollywood, it all felt very familiar. The moment he spotted Cletus' Chicken Shack, a restaurant named for *The Simpsons*' resident redneck, he understood why. He'd helped build the place.

"Cletus was a Little League coach of mine," Martin says. "Not a hillbilly. A plumber. But I just always thought that was a real country name." So when the writers were naming the character, Martin suggested Cletus. It stuck.

Behind Cletus' Chicken Shack is the faux brick facade of Springfield's most famous movie house, the Aztec Theater. When Martin was there, the marquee read, "Troy McClure in *Here Comes the Coast Guard*." The title briefly sent him back in time. "It's like, 'Oh yeah, that was my joke,'" Martin says.

Even after Martin left faux Springfield, that feeling never left. In fact, it follows him around everywhere. "Earlier this year, I'm driving through South Dakota. I'd never seen that part of the country," he says. "And just listening to a sports podcast, they reference, 'Nobody rocks like Springfield.'" That's what Spinal Tap bassist Derek Smalls—who has to remind himself which city his band is playing in every night by writing it down on a piece of tape on the back of his guitar—perfunctorily says to charge up the Springfield Coliseum crowd.

"It was analogizing it to college coaches who have to pretend to be enthusiastic about the local rooting traditions of whatever college just hired them," Martin says. "Just going through the motions. *Nobody rocks like Springfield*. And it's like, 'Oh, yeah. I was in the room for that one.' It happens all the time. And then every now and then it's like, 'Oh, that's my joke.' People still remember it thirty years later."

Even now, Martin can't get over how much *The Simpsons* has seeped into American pop culture. "After the initial splash," he says,

"the ripples are still visible." For "Homer's Barbershop Quartet," which Martin wrote, he enlisted the Dapper Dans, who perform at the Disney parks. In the episode, the group provides vocals for Homer's quartet, the Be Sharps. "Nice guys, great barbershop singers," Martin says. At Disneyland, he once asked the group if they perform the Be Sharps' number one hit, "Baby on Board." No, they told him, because of a copyright issue. Martin then asked if people request the song. "They said, 'Every day.' It just shows the show's reach."

Strangers still approach Conan O'Brien and shout, "Monorail!" Not that he minds. He still can't believe he was a part of something that people love so much. His younger self couldn't have predicted it.

"You're driving a Ford Taurus, and it's really cold in your office on the Fox lot, and it's raining out, and you're here on a Saturday, and then you drive to a Chinese restaurant on the way home and eat alone at a table and continue to scratch away at your legal pad," he told me. "And someday you'll be performing a piece of this episode at the Hollywood Bowl? As I'm saying this to you, my mind can't contain those two things. The whole thing has been a very nice happening. I'm very grateful to *The Simpsons*."

Collectively, the early *Simpsons* writers were a product of television. They may have all been disillusioned with the medium, but their obsession with it never faded. The Simpson family was, in fact, shaped by that obsession. It's no coincidence that many of the memories Homer seems to retain are from old sitcoms. Before one high school reunion, he says that "it will be great to see the old gang again: Potsie, Ralph Malph, the Fonz..." At which point Marge replies, "That's *Happy Days*."

By the early '90s, *The Simpsons* had become as formative to comedy writers as a show like *Happy Days*. To the people that created it, that was bizarre. "We would say, 'Man, maybe three years,' 'Oh, maybe five years.' 'I bet we could get ten years out of this,'" Moore says. "It's hard for me to even fathom that it's still going on, you know?"

You can see the golden era of the show's influence every time you turn on any good sitcom episode made over the last thirty years. There are strands of *Simpsons* DNA in all of them. If there's one series that feels most like a live-action version of the animated series, it's *30 Rock*.

"Tina Fey said when she and Robert Carlock were creating the show, a basic decision they made is that they wanted to be like *The Simpsons*," Vitti says. "They wanted to be really smart as much as they could, but they never wanted to stop themselves from being really stupid when they felt like it. And that was a real core belief to us."

From the beginning, that cleverly anarchic approach is something that Matt Groening, James L. Brooks, and Sam Simon teamed up to instill in their writers.

In 2015, Simon died of colon cancer at fifty-nine. In his final years, he donated much of his multimillion-dollar fortune to charity. He hadn't worked on *The Simpsons* in more than two decades, but his involvement in its creation was in the first line of his obituary.

The success of *The Simpsons* was, after all, in large part due to his sensibility. Even if he seemed to be baffled by the show's staying power. "I thought some people would like some aspects of it, but I wasn't sure how many would come along for the full ride," he said in 2009. "It turned out I was incredibly wrong. Homer is now the prototype for every male lead on a comedy show. In some ways, it's the greatest job in the world. You make a product that's given away, and all it does is make people smile."

The days were too long, the lunches were greasy, and all the fish died, but working on *The Simpsons* could feel magical. Revisiting old episodes with his wife sometimes brings Vitti right back to the Simpsons Motel. "We were watching an old *Treehouse of Horror*, the one where they're passing around the witch's eyes and the witch's face, and Homer eats the face—it was an evil game," he says. "I can still

remember John Swartzwelder sitting in his chair pitching that in the rewrite room. It was fun."

To this day, *The Simpsons* produces moments of surreality that even its writers couldn't have conjured themselves. George Meyer was once in Brussels and noticed a giant mural featuring the Simpsons having sex... with each other. "I thought, 'Gee, that's something I never thought would happen when I was working there in the early days,'" he says. "It comes up in all kinds of strange places. That's rewarding." When I pressed Meyer about whether the explicit masterpiece showcased Homer and Marge, he laughed. "Sadly, no," he says. "It involved the kids."

Most of the time, thankfully, real-world *Simpsons* encounters are much more wholesome than that. But still surreal. Once, during a vacation to Cairo, Meyer and his family visited the part of Manshiyat Nasser known as "Garbage City," where the Egyptian capital's trash and recycled items are collected. Their tour guide was a big *Simpsons* fan.

"He really knew a lot more about the show than I did at that point," Meyer says. "And I just thought, 'How could your mind possibly imagine such a thing?'" Just thinking about that exchange makes him laugh. "If you let it affect you the wrong way, it will turn you into an egotist. But if you have the proper humility, it will make you feel like the whole thing is sort of divinely inspired. That it comes from the great beyond."

ACKNOWLEDGMENTS

Let's be honest: I've been writing this book in my head since I was in elementary school. But if you told me back in the '90s that I'd be able to turn my childhood obsession into a *career*, I wouldn't have believed it. This truly has been a true dream come true. Watching old *Simpsons* episodes and talking to the funny people who helped make them? It's the best job I'll ever have.

And I couldn't have done it alone. This all began, really, with a Google search. Back in 2016, I was a freelancer. I knew I wanted to write for *The Ringer*, but I didn't know how to break in. At the time, I had an idea for a *Simpsons* story. I wasn't sure if Sean Fennessey, the editor I'd been told to pitch, even liked *The Simpsons*. So, I typed in "Sean Fennessey" and "Simpsons," and sure enough, one of his old *Spin* magazine album reviews that referenced the show popped up. (Thank goodness he's also an elder millennial.) A few minutes later, I fired off a pitch to him about Homer's tech billionaire boss Hank Scorpio. He liked it, I wrote the story, and over the next several years, I got to treat the golden age of the animated series like my beat. Sean hired me full-time in 2019, and three years later he championed this book. All this to say: thank you.

I'll also be forever grateful to *another* Sean: Sean Desmond, my first editor at Grand Central, for understanding the power of *The Simpsons*.

ACKNOWLEDGMENTS

Suzanne O'Neill and Jacqueline Young may have inherited the project, but they believed in it from the start and treated it with great care. Thank you, Suzanne and Jacqui, for enthusiastically approving of me using a *Simpsons* quote as the title.

Speaking of enthusiasm... My agent Louise Fury deserves credit for being my most vocal advocate, even if there have been times when you've probably wanted to channel Troy McClure and say to me, "Get confident, stupid!"

Over the years, I've worked with an amazing group of editors, who, whether they knew it or not, were helping me prepare for this moment. The late Mike Muldoon taught me to care about what I cover, no matter what. Jason Schwartz taught me how to write a magazine story. Paula Mashore taught me the importance of getting even the smallest details right. Emma Span taught me to embrace my weirdest ideas. And Tommy Craggs taught me to stop being scared of my own voice. (One last time, Tommy: I'm sorry.) I've had many journalism rabbis over the years, but none is wiser than Josh Levin at *Slate*. There's no smarter writer and editor in the business. I owe you, man.

I don't have room for everyone I want to thank at *The Ringer*. Reading Bill Simmons made me want to be a writer. I'll never work at a more creatively fulfilling place. Andrew Gruttadaro hates tooting his own horn, so I'll do it for him: he's a true idea man. Katie Baker is one of the best writers I've ever met, and an even better friend. Claire McNear is an amazing reporter and always knows how to cut through the bullshit—thanks for the counsel and kindness. I wouldn't be where I am without the great Bryan Curtis, who I've been trying to emulate for the last decade. Thanks for being such a great sounding board, buddy. If only I could be as hypnotically soothing and funny on the mic as Rob Harvilla. Or as prolific as Miles Surrey. Cory McConnell is one of the most refreshingly level-headed, talented, loyal

ACKNOWLEDGMENTS

people I've ever met. Thank you for indulging all my long-winded Hollywood anecdotes over beers at Tee Gee.

Ever since I met Justin Sayles in July 2021—that day, he made sure to take me to a coffee shop in Los Angeles near where a scene in *Reservoir Dogs* was filmed—he's been a relentlessly positive force in my life. I've never met anyone who cares more. That's rubbed off on me, unlike your spectacular Rhode Island accent.

Moving to Los Angeles three years ago was a Springfield Gorge–level leap, and I only made it across thanks to friends like Jeremy Stahl, Alyssa Bereznak, Alison Herman, Shaker Samman, Phil Stark, Sarah Sprague, Nicole Ohanessian, Carolina McConnell, and Lisa Filpi. If only all L.A. film bros were like Cory Everett and Brian Raftery, two of the nicest, most supportive, and clever guys in this city.

And talk about clever: I wouldn't have been able to write this book without the help of several *Simpsons* staffers, who remain some of the funniest people on the planet. Larina Adamson, Joe Boucher, Greg Daniels, Jay Kogen, Jeff Martin, Bill Oakley, Brian Roberts, Mike Scully, David M. Stern, and Rich Moore all happily went down memory lane with me and didn't seem to mind that while talking to them, I often sounded like the host of *The Chris Farley Show*. Thanks to you all. And special thanks to Jon Vitti and George Meyer. Every single thing you said made me either laugh or think.

The media world can be miserably gloomy, but I've been lucky to get to know writers who haven't let cynicism crush their passion. That includes the whole crew at PhotoAssist, Cassie Good, Kjerstin Johnson, Julie Kliegman, Justin Sink, Brian Wolly, Luke O'Brien, Blake Harris, Brian Nathanson, Pete Croatto, Andrew Buss, Ryan Lambert, Nate Rogers, Kate Knibbs, Melissa Maerz, Aaron Gordon, Ryan Holeywell, Jake Kring-Schreifels, Scott Price, David Roth, and Torie Bosch. (Fun fact: Torie is one of at least two people I've mentioned with a *Simpsons* tattoo.)

I can't say this enough: this book was really decades in the making. At

ACKNOWLEDGMENTS

overnight camp, I used to rehash the golden age of *The Simpsons* late into the night, one quote at a time, with Andrew Nathanson, Jay Goldberg, Dan Frankel, Eric Weisbrod, and the late Todd Schwartz. I've known Instagram's favorite fitness guru Steve Lutsk since those days, too, and not a single one of our lunches in L.A. goes by without us talking about the show. He couldn't stop smiling when I told him about this book. Same goes for Andy Ostroff. Paul Cooley and I still communicate, pretty much exclusively, in references from the show. (Remember Paul, "Leaves of four, eat some more.") In high school, my buddies Steve Gasper, Dave Mancinelli, Alex Nunez, Jimmy Sucharewicz, and Jason Viger quoted *The Simpsons* incessantly. And in college, me and my roommates, Steve Johnston, David Root, Angus Chambers, and Cody Brumfield, watched two episodes a day.

I wouldn't have become a writer without my A.P. English teacher Rob Maloney, whose one-paper-a-week schedule helped me learn how to string sentences together. My *GW Hatchet* buddies Janice Wolly and Jeff Nelson showed me the journalism ropes. To this day, I go to both of them for sanity checks. At *The Eagle-Tribune*, Hector Longo, Jim Giarrusso, and Dave Willis showed me how to survive in this business. Hey, we occasionally got paid in Dunkin' Donuts gift cards, but we laughed *a lot*.

It makes sense that I was drawn to a show about a tight-knit family that watched a ton of TV. That was my childhood, too. My mother had three boys in four years, so there were times when we were at each other's throats. But when *The Simpsons* was on, we were little angels. At least that's how I remember it. As we got older, all the bickering fell away. Ethan, I've cherished all of our talks. Even when things look bleak, you can always make me laugh. If you and Nicole ever want to introduce the kids to *The Simpsons*, I'll happily watch some episodes with them. Brian, thank you for being an impeccable listener and style

ACKNOWLEDGMENTS

consultant. You and Susannah have always been there for me when I've needed you most.

Jeff Frost, my oldest friend, isn't technically a Siegel brother. But at this point, you pretty much are. Thank you for being the funniest person I know. As much as it pains me to say it, you *are* usually right. I'm proud that you and Kayla are raising a *Simpsons* fan.

My parents, Debbie and Stuart, are by far my biggest fans. Mom, thanks for passing down your creativity and love of pop culture. Dad, thanks for passing down your organizational skills and work ethic. It's all come in handy my whole life, especially while writing this book. I love you both.

And finally, to my wife, Julie: thank you, for everything. You're the best confidante, editor, booster, and partner anyone could ever have. Somehow, you've never grown tired of me quoting *The Simpsons*. Or you've somehow held off from telling me. Either way, I love you more than I love a cold beer on a hot Christmas morning.

NOTES

INTRODUCTION

Author interviews: Jon Vitti, Jeff Martin.

Yeardley Smith's quotes are from an interview conducted by the author for "Life as Lisa Simpson," published in *The Ringer* on September 22, 2022.

1 **"Who would have guessed reading and writing would pay off?":** From *The Simpsons* episode "Mr. Lisa Goes to Washington," airdate September 26, 1991.

2 **"coat hanger network":** NBC Entertainment president Brandon Tartikoff quoted in "Old NBC Shows Never Die, They Spin Off," by Andee Beck, *Tacoma News Tribune*, March 11, 1987.

3 **"meh":** "A History of *Meh*, from Leo Rosten to Auden to *The Simpsons*," by Ben Zimmer, *Slate*, September 6, 2013.

CHAPTER ONE: SMASHING THE SNOW GLOBE

Author interviews: George Meyer, Jon Vitti, Jay Kogen, Rich Moore.

Conan O'Brien's quotes are from an interview conducted by the author for "Throw Up Your Hands and Raise Your Voice! Monorail! Monorail! Monorail!," published in *The Ringer* on January 17, 2023.

7 **"The American people don't believe anything's real":** Richard Nixon quoted in "Nixon on Clinton," by Roger Stone, *New York Times*, April 28, 1994.

7 **"I watched so much and from such an early age":** George Meyer quoted in "Taking Humor Seriously," by David Owen, *New Yorker*, March 13, 2000.

9 **"The function of network TV is to make people feel that everything is OK":** David Chase quoted—as told by Terence Winter—in "Two Assholes Lost in the Woods: An Oral History of 'Pine Barrens,'" by the author, *The Ringer*, May 5, 2021.

NOTES

14 **"Stupid TV...be more funny!"**: From *The Simpsons* episode "Marge on the Lam," airdate November 4, 1993.

CHAPTER TWO: BREAKING THROUGH THE CLOUDS

Author interviews: Jay Kogen, Garth Ancier, George Meyer, Rich Moore, Jon Vitti, Gábor Csupó, Sandy Grushow, Larina Adamson.

Yeardley Smith's quotes are from an interview conducted by the author for "Life as Lisa Simpson," published in *The Ringer* on September 22, 2022.

17 **"It may be on a lousy channel, but the Simpsons are on TV"**: From *The Simpsons* episode "Mr. Plow," airdate November 19, 1992.

17 **Cable Franchise Policy and Communications Act**: "The Cable TV Law Hurts the Public," by Eric Schmuckler and Sidney W. Dean Jr., *New York Times*, November 14, 1984; "The '80s Were Big for TV," by Ron Miller, *Washington Post*, December 24, 1989.

18 **"To the risk-taker, as always, comes the spoils"**: Barry Diller quoted in "Fox's Barry Diller Gambles on a Fourth TV Network," by Aljean Harmetz, *New York Times*, October 5, 1986.

18 **"Television is today's new mass communication media"**: Rupert Murdoch quoted in Harmetz, "Fox's Barry Diller Gambles on a Fourth TV Network."

18 **"a family like you've never seen"**: From a 1987 Fox ad that can be found here: commercialmaster1, "Fox Launch and Married with Children Promo," YouTube, www.youtube.com/watch?v=GfjL8P23PM0.

19 **filmmaker James L. Brooks had signed**: "20th Century-Fox Advances in Box-Office War," by Aljean Harmetz, *New York Times*, September 29, 1988.

21 **In 1977, Groening moved**: "Bart Simpson's Real Father," by Joe Morgenstern, *Los Angeles Times*, April 29, 1990.

21 **gravitated toward L.A.'s braided punk rock and art scenes; encouragement of his friend Gary Panter**: "Comics Creators Recall How Punk-Era L.A. Drew Them Out," by Ben Schwartz, *Los Angeles Times*, July 25, 2010.

21 **"crude...full of alienation, angst, fear, and grief"**: Matt Groening quoted in "The Groening of America," by Paul Andrews, *Seattle Times*, August 19, 1990.

21 **First he self-published the strip; The first professional publication**: Morgenstern, "Bart Simpson's Real Father."

21 **"the magazine of gourmet bathing"**: "'Gourmet Bathing' Magazine May Make a Big Splash," by Jessica Frazier, Associated Press, June 28, 1977.

21 *Life in Hell* **started appearing; moved the comic to the rival** *L.A. Weekly*: Andrews, "The Groening of America."

22 **Polly Platt...gifted him..."The Los Angeles Way of Death"**: *The Simpsons: An Uncensored, Unauthorized History*, by John Ortved, 2009.

NOTES

22 all the ways Binky can die in L.A.: From "The Los Angeles Way of Death," by Matt Groening, *Life in Hell*, 1982.

22 Groening has said that Brooks called him in 1985: From several sources, including an online chat Matt Groening conducted with the Prodigy internet service in 1993 and "'The Simpsons' at 500: Untold Stories," by Stacey Wilson Hunt, *Hollywood Reporter*, February 8, 2012.

22 Richard Sakai had given Estin; fill the time between sketches: Ortved, *The Simpsons*.

22 Brooks liked the idea; didn't want to sign over merchandising rights: Hunt, "'The Simpsons' at 500."

23 Inspired by…the aggro antihero Jimbo: "Gary Panter's Jagged, Shape-Shifting Antihero Was Made for Our Moment," by Ed Park, *New York Times*, April 5, 2021.

26 They got the assignment; "It took three weeks to do one segment": David Silverman quoted in "'Simpsons' David Silverman Speaks," by Russell Bekins, Animation World Network, December 19, 2007.

27 "mutant-'50s-Father-Knows-Best Family in Hell": "An Alternative Cartoonist Who Draws the Line," by Beth Ann Krier, *Los Angeles Times*, August 23, 1987.

27 "angst-ridden Simpson family": "Matt Groening Draws from Kids' Fears and Pain," by D'Arcy Fallon, *San Francisco Examiner*, November 16, 1988.

28 "FBC Swallows Whopping $99 Mil Year-End Loss": *Variety*, September 1988.

28 Many of its affiliates were broadcast backwaters: "Fox Cleared to Expand Its Schedule," by Richard W. Stevenson, *New York Times*, May 5, 1990.

28 it only aired original programming on weekends: "Fox TV Plans 5 Nights of Programming," by Rick Du Brow, *Los Angeles Times*, January 20, 1990.

29 "We are reminded several times": "'Cops' Camera Shows the Real Thing," by John J. O'Connor, *New York Times*, January 7, 1989.

30 Her name was Terry Rakolta: "A Mother Is Heard as Sponsors Abandon a TV Hit," *New York Times*, March 2, 1989.

31 Jamie Kellner had called Ullman "a real star"; "It's true that it's harder to discover": "Queen of the Skitcom," by Howard Rosenberg, *Los Angeles Times*, April 17, 1988.

31 only 14 percent of Americans; Ullman later sued Fox; "Maybe I shouldn't have been so cavalier": "Ullman Has a Cow over 'Simpsons,'" by Dennis McDougal and Daniel Cerone, *Los Angeles Times*, April 19, 1991.

31 Unsuccessfully: "Ullman Loses 'Simpsons' Suit," Associated Press, October 22, 1992.

32 "The *Simpsons* series began like many things begin": "'The Simpsons' at 500: Untold Stories," by Stacey Wilson Hunt, *Hollywood Reporter*, February 8, 2012.

NOTES

32 **Groening and Brooks then began pushing; Brooks...had no interest; ordering thirteen episodes:** *The Simpsons: An Uncensored, Unauthorized History*, by John Ortved, 2009.

32 **"I used to say, 'We're thirteen and out'":** Sam Simon quoted on *WTF with Marc Maron*, May 16, 2013.

CHAPTER THREE: THE AMERICAN FAMILY IN ALL ITS HORROR

Author interviews: Jeff Martin, Jon Vitti, George Meyer, Greg Daniels, Bill Oakley, David M. Stern, Rich Moore, Mike Scully.

Yeardley Smith's quotes are from an interview conducted by the author for "Life as Lisa Simpson," published in *The Ringer* on September 22, 2022.

37 **"the fifth most phallic building in the world":** "The 10 Most Ridiculous Phallic Buildings in the World," by Nick Schonberger, *Complex*, November 12, 2012.

38 **"I said, 'I want Max and Tom to like the show'":** Sam Simon quoted on *WTF with Marc Maron*, May 16, 2013.

38 **"To make something that had no agenda":** George Meyer quoted in "An Interview with George Meyer," by Eric Spitznagel, *The Believer*, September 1, 2004.

39 **"America's Only Magazine":** Page 1, issue #1, *Army Man*, 1988.

39 **"Due to the tiny volume of mail":** Page 3, issue #1, *Army Man*, 1988.

39 **"All 'errors' in *Army Man*":** Page 6, issue #1, *Army Man*, 1988.

39 **"SUBSCRIBE, YOU MAGGOTS!":** Page 12, issue #3, *Army Man*, 1989.

39 **"They can kill the Kennedys":** John Swartzwelder, page 6, issue #2, *Army Man*, 1988.

39 **"It's a horrifying idea juxtaposed with something really banal":** George Meyer quoted in "Taking Humor Seriously," by David Owen, *New Yorker*, March 13, 2000.

40 **"The first prize winner":** John Swartzwelder, page 6, issue #2, *Army Man*, 1988.

40 **he mailed Meyer a cassette:** From an interview with George Meyer conducted by the author.

46 **"Soon, one man will emerge triumphant":** From *The Simpsons* episode "Dead Putting Society," airdate November 15, 1990.

47 **"Oh boy, liver!"; "Iron helps us play!":** From *The Simpsons* episode "Lisa's First Word," airdate December 3, 1992.

48 **"kwyjibo...a big, dumb, balding North American ape":** From *The Simpsons* episode "Bart the Genius," airdate January 14, 1990.

50 **"Mike Reiss and I say, 'Well, let's write this one'":** Al Jean quoted in an interview conducted by the author for "Life as Lisa Simpson."

50 **"Marge goes, 'Lisa's crazy about you'":** From *The Simpsons* episode "Lisa's First Word."

NOTES

CHAPTER FOUR: SO STUPID IT WAS KIND OF SMART

Author interviews: George Meyer, Jon Vitti, Jeff Martin, David M. Stern, Bill Oakley, Greg Daniels, Jay Kogen, Mike Scully, Joe Boucher.

Conan O'Brien's quotes are from an interview conducted by the author for "Throw Up Your Hands and Raise Your Voice! Monorail! Monorail! Monorail!," published in *The Ringer* on January 17, 2023.

53 "No, it's true"; "I *like* stories": From *The Simpsons* episode "Itchy & Scratchy: The Movie," airdate November 3, 1992.

54 "Hey you, let's fight!"; "Them's fightin' words!": From *The Simpsons* episode "Colonel Homer," airdate March 26, 1992.

55 "*What's the sound of one hand clapping?*": From *The Simpsons* episode "Dead Putting Society," airdate November 15, 1990.

56 "Purple monkey dishwasher": From *The Simpsons* episode "The P.T.A. Disbands," airdate April 16, 1995.

57 **a beat-up Datsun B210:** From an interview with Jon Vitti conducted by the author.

59 "One moment he's the saddest man in the world": John Swartzwelder quoted in "John Swartzwelder, Sage of 'The Simpsons,'" by Mike Sacks, *New Yorker*, May 2, 2021.

59 "To alcohol! The cause of, and solution to, all of life's problems": From *The Simpsons* episode "Homer vs. the Eighteenth Amendment," airdate March 16, 1997.

60 "**Exactly! Just a bunch of stuff that happened**": From *The Simpsons* episode "Blood Feud," airdate July 11, 1991.

60 "**A big, toasty cinnamon bun**": From *The Simpsons* episode "Homer the Heretic," airdate October 8, 1992.

63 "'COD PLATTER' to 'COLD PET RAT'": From *The Simpsons* episode "Homer's Night Out," airdate March 25, 1990.

63 "Capital City"; "caper like a stupid clown": Lyrics to "Capital City" from *The Simpsons* episode "Dancin' Homer," airdate November 8, 1990.

CHAPTER FIVE: LIMITLESS, LIMITLESS, LIMITLESS

Author interviews: Brian Roberts, Garth Ancier, Jeff Martin, Sandy Grushow, Larina Adamson, Bill Oakley, Jon Vitti, George Meyer, Joe Boucher, Al Ovadia, Brad Turell.

Conan O'Brien's quotes are from an interview conducted by the author for "Throw Up Your Hands and Raise Your Voice! Monorail! Monorail! Monorail!," published in *The Ringer* on January 17, 2023.

75 **Homer's iconic "D'oh!":** "Dan Castellaneta explains Homer Simpson's 'D'oh!,'" Television Academy video interview, September 28, 2010.

NOTES

76 **"I'm Bart Simpson, who the hell are you?":** From *The Simpsons* episode "Simpsons Roasting on an Open Fire," airdate December 17, 1989.

76 **"Don't have a cow, man!":** From *The Simpsons* episode "The Call of the Simpsons," airdate February 18, 1990.

76 **"Eat my shorts":** From *The Simpsons* episode "Bart the Genius," airdate January 14, 1990.

78 **Kwik-E-Mart owner Apu was originally described:** *Springfield Confidential*, by Mike Reiss with Mathew Klickstein, 2018.

78 **But at a table read:** "Bingeing is bad and Apu wasn't meant to be Indian: 'The Simpsons' co-creator Mike Reiss," by Ankita Chawla, Scroll.In, May 2, 2016.

78 **The white, Jewish actor has also admitted:** "Why Hank Azaria Won't Play Apu on 'The Simpsons' Anymore," by Dave Itzkoff, *New York Times*, February 25, 2020.

78 **"You can criticize something you love because you expect more from it":** Hari Kondabolu quoted in "'Simpsons' Doc 'The Problem with Apu' Confronts South Asian Stereotypes," by Elias Leight, *Rolling Stone*, September 28, 2017.

78 **"Clair Huxtable Effect":** "'The Cosby Show' Turns 40 with a Tangled Legacy," by Verne Gay, *Newsday*, September 22, 2024.

79 **"An American woman on TV":** "Television and the Feminine Mystique," by Betty Friedan, *TV Guide*, February 1, 1964.

79 **Mimi Pond; "was just because I was a woman":** Mimi Pond quoted in "A Chat with Mimi Pond on the Service Industry, Cocaine, and Writing the First Episode of *The Simpsons*," by Anna Fitzpatrick, *Jezebel*, August 8, 2017.

80 **Nell Scovell...had a slightly better experience:** Nell Scovell's quotes and anecdotes from *Just the Funny Parts*, by Nell Scovell, 2018.

83 **AKOM Production Co.; significantly less money:** "'The Simpsons' rides on the Seoul train," Reuters, March 2, 2005.

84 **"When the tape arrived; But the episode was a disaster:** The descriptions of this screening are from interviews conducted by the author.

84 **Director Kent Butterworth; "Not exactly a minor addition":** "Cashing in on a Hot New Brand Name," by N. R. Kleinfeld, *New York Times*, April 29, 1990.

87 **From 1980 to 1989, sales of licensed products;** *Teenage Mutant Ninja Turtles* **and Tim Burton's** *Batman*: Kleinfeld, "Cashing in on a Hot New Brand Name."

87 **"Although he acknowledged he was surprised"; "We couldn't say carrots are boring"; aired almost a year before:** "Television Ad for Cartoonist," by Randall Rothenberg, *New York Times*, December 23, 1988.

89 **"They're a bickering family of five":** "'The Simpsons' Get a Show of Their Own for Christmas," by Howard Rosenberg, *Los Angeles Times*, December 16, 1989.

NOTES

89 More than thirteen million homes; it was the second-highest-rated program in Fox's short history: "'Married' and 'Simpsons' Boost Fox," by Jeff Kaye, *Los Angeles Times*, December 20, 1989.

90 "If you had said the show would still be on": John Swartzwelder post on X, December 17, 2024.

CHAPTER SIX: BART VS. COMMERCE

Author interviews: Jeff Martin, Jon Vitti, Al Ovadia, Helen Boehm, Steve Peña, Jay Kogen, Brian Roberts, Robert Baum, Sandy Grushow.

91 Woman 1: "If I hear one more thing about the Simpsons": From *The Simpsons* episode "Treehouse of Horror II," airdate October 31, 1991.

93 stores had sold: "Eat My Shirts! Pesky Bart Simpson Tees Off a California Principal—and Gets Kicked Out of School for Swearing," *People*, May 21, 1990.

93 Between thirteen and fourteen million American homes on average: "NBC Wins Week, but Top Three Networks Nearly Even," by Scott Williams, Associated Press, July 19, 1990.

93 finished in the top 10: "Bill Cosby vs. Bart Simpson," Tim Appelo, *Entertainment Weekly*, August 31, 1990.

94 Shirt Shed Inc.; Changes: From an interview with Al Ovadia conducted by the author.

94 were facing high-six-figure orders: "Look Out Batman—Here's Bartman and the Next Big Marketing Bonanza," by Ray Richmond, *Orange County Register*, March 11, 1990.

94 "To be proud of being an incompetent": Elementary school principal Bill Krumnow quoted in "Simpson: A Cultural Icon or Rebel Without a Clue?," by Scott Williams, Associated Press, May 23, 1990.

95 "Whenever kids have too much fun": Matt Groening quoted in "Wow Man! Bart a Surprising Draw," by Robert Bianco, Scripps Howard News Service, July 22, 1990.

96 "a guerrilla attack on mainstream TV"; "entertainment and subversion": "Smart, Vulgar, Subversive, Quirky, Hilarious—and a Hit," by Howard Rosenberg, *Los Angeles Times*, February 23, 1990.

97 eighteen ounces of ground beef: From *The Simpsons* episode "Bart's Friend Falls in Love," airdate May 7, 1992.

98 Groening had negotiated: "'Simpsons Sales': Halving a Cow," by Marla Matzer, *Los Angeles Times*, September 25, 1997.

99 "Man, this thing's really getting out of hand": Quotes from *The Simpsons* episode "Treehouse of Horror II," airdate October 31, 1991.

NOTES

101 "Bart looks cool no matter what skin color": Matt Groening quoted in "'The Simpsons': Cartoon Rip-offs Turn Nasty," by Deborah Hastings, Associated Press, October 30, 1990.

101 "Rampant copyright infringement": Matt Groening quoted in "No Kid Stuff: New TV Tie-in Products," by Peter Smith, Cox News Service, September 16, 1990.

102 in 1990, federal authorities seized: "T-shirts Seized by Federal Dudes," by John Donnelly, *Miami Herald*, June 14, 1990.

102 Attorney Tom DeWolf; "Dudes from the U.S. Marshals office"; "Instead of cooling their jets": "Federal Dudes Seize Fake Simpson Shirts," United Press International, June 14, 1990.

103 a six-week investigation; "the nature of the enterprise": "Phony 'Bart Simpson' T-Shirts, Other Goods Seized in Crackdown," by Ian Wagreich, Associated Press, June 30, 1990.

103 an official one [Bart shirt] retailed: "Bootleg Black Bart Simpson, the Hip-Hop T-Shirt Star," by David Mills, *Washington Post*, June 27, 1990.

103 By the summer of 1990, authorities had seized: "Federal Dudes Seize Fake Simpson Shirts."

103 Mattel announced that it had signed: "Mattel Profits up 95%; Firm Snags Simpsons," Associated Press, May 11, 1990.

104 In the summer of 1990: "Burger King, Simpsons Team Up, Could Face Trouble from Networks," by Joan Chrissos, *Miami Herald*, August 20, 1990.

105 Sales were so poor; Less than a year after signing an exclusive contract: Matzer, "'Simpsons Sales': Halving a Cow."

106 People bought $750 million worth of *Simpsons* merchandise: "Ullman Has a Cow over 'Simpsons,'" by Dennis McDougal and Daniel Cerone, *Los Angeles Times*, April 19, 1991.

CHAPTER SEVEN: BART VS. BILL

Author interviews: Sandy Grushow, David M. Stern, Rich Moore, Joe Boucher, Brad Turell, Brian Roberts, Jay Kogen, Jon Vitti, George Meyer, Larina Adamson, John Boylan, David Mandel.

Yeardley Smith's quotes are from an interview conducted by the author for "Life as Lisa Simpson," published in *The Ringer* on September 22, 2022.

107 Cosby turned his attention to a boy in the audience: "Bill Cosby vs. Bart Simpson," by Tim Appelo, *Entertainment Weekly*, August 31, 1990.

108 *Tonight Show* host Johnny Carson: "The Simpsons: They're Scrapping Again—But This Time It's a Ratings Fight," by Tom Shales, *Washington Post*, October 10, 1990.

NOTES

108 Cosby asked the kid to borrow the tee; "Cosby got to proclaim his appreciation": Appelo, "Bill Cosby vs. Bart Simpson."

108 *Forbes* claimed that Cosby was projected to pull in: "Cosby Tops List of Money-Makers," Associated Press, September 17, 1990.

109 In a meeting to plan out Fox's expanded 1990–91 programming schedule: *The Simpsons: An Uncensored, Unauthorized History*, by John Ortved, 2009.

110 Brooks walked up to the table: The Fox commissary anecdote was recounted by Brad Turell in an interview conducted by the author.

111 "Because of *Cosby*, the other networks": Peter Chernin quoted in "Fall TV Schedules Aim at the Young and Restless: Fox Upstart Network to Pit Its Champ, 'The Simpsons' Against 'Cosby,'" by Rick Du Brow, *Los Angeles Times*, May 30, 1990.

111 "There have been two weeks": James L. Brooks quoted in Shales, "The Simpsons: They're Scrapping Again—But This Time It's a Ratings Fight."

111 "Can Bill Beat Bart?"; "There's really nothing wrong with Bart"; "All of the changes were made B.B.": Appelo, "Bill Cosby vs. Bart Simpson."

112 The *Simpsons* audience...skewed younger: "A 'Simpsons' Demographics Lesson," *Los Angeles Times*, October 16, 1990.

113 "Thank you, Bill Cosby": From *The Simpsons* episode "Saturdays of Thunder," airdate November 14, 1991; Homer is quoting Bill Cosby from his book *Fatherhood*, 1986.

113 In a later episode, you can see the book burning: From *The Simpsons* episode "Dog of Death," airdate March 12, 1992.

113 "Part of this D-minus belongs to God": From *The Simpsons* episode "Bart Gets an 'F,'" airdate October 11, 1990.

113 Tom Shales...wrote that the episode: Shales, "The Simpsons: They're Scrapping Again—But This Time It's a Ratings Fight."

114 Overall, 33.6 million people watched: "Battle of 'Cosby' vs. 'Simpsons' Not Over yet," by Robert Strauss, *Asbury Park* Press, October 24, 1990.

114 a tenth of a point [behind Cosby]: "'Cosby' over 'Simpsons' in Thursday's Ratings," *New York Times*, October 13, 1990

114 "Bart Gets an 'F'"...the most watched program in Fox history: "'Cosby' Slips by 'Simpsons,'" Associated Press, October 17, 1990.

114 It reigned until early 1995: "Fox Hits NFL Playoff Paydirt," Associated Press, January 7, 1995

114 "When it comes to TV ratings"; "Nobody ever thought": From the October 12, 1990, broadcast of *Entertainment Tonight*.

115 "*The Simpsons* somehow seems": From the October 12, 1990, broadcast of *Entertainment Tonight*.

115 "no new taxes": George Bush quoted in "Bush: 'I Mean to Win,'" by Nancy Schwerzler, *Baltimore Sun*, August 19, 1988.

NOTES

115 America entered a recession: "Jobless Ranks at 6.8 percent," Associated Press, April 6, 1991.

117 "If you have sensitive children": From *The Simpsons* episode "Treehouse of Horror," airdate October 25, 1990.

119 "Pretty soon, being the only person": "Wake Up, Geek Culture. Time to Die," by Patton Oswalt, *Wired*, December 27, 1990.

122 In September 1990, news broke: "Michael Jackson, Bart Simpson to Record Together," by Ryan Murphy, Knight-Ridder Newspapers, September 23, 1990.

123 "This is the beginning of a beautiful friendship": Matt Groening quoted in Murphy, "Michael Jackson, Bart Simpson to Record Together."

123 Brooks issued a press release: "'Simpsons' Sing the Blues," by Deborah Hastings, Associated Press, September 27, 1990.

123 "It's so frustrating": Matt Groening quoted in Hastings, "'Simpsons' Sing the Blues."

124 "If you can do the Bart"; "Homer was yellin'": Lyrics from "Do the Bartman," by Bryan Loren, released on November 20, 1990.

124 hit number 24 on the *Billboard* radio chart: From Billboard.com, week of December 22, 1990.

124 The album shot all the way to number 3: From Billboard.com, week of January 26, 1991.

125 the *New York Times* may have stuck the record: "POP MUSIC/1990; The Best Show? In the Court, Not the Concert Hall," by Jon Pareles, *New York Times*, December 30, 1990.

125 a *Mad* magazine parody: "A Mad Peek Behind the Scenes at 'The Simpsons' Studio," *Mad* magazine, December 1990.

126 "They specifically didn't do any publicity": Yeardley Smith quoted in "Yeardley Smith: First Person, Plural," by Patricia Brennan, *Washington Post*, October 31, 1992.

128 In one 1990 interview: James L. Brooks, Sam Simon, and Matt Groening quoted in "Smart, Vulgar, Subversive, Quirky, Hilarious—and a Hit," by Howard Rosenberg, *Los Angeles Times*, February 23, 1990.

130 His nickname was "Glue": "The Glue: Remember That Old 'Saturday Night Live' Sketch? You Know, the One with Phil Hartman?," by Bryan Curtis, *Grantland*, August 27, 2014.

130 "One of the things that he did particularly well": Conan O'Brien quoted in an interview conducted by the author for "Throw Up Your Hands and Raise Your Voice! Monorail! Monorail! Monorail!," published in *The Ringer* on January 17, 2023.

131 *Here Comes the Coast Guard*: From *The Simpsons* episode "Homer vs. Lisa and the 8th Commandment," airdate February 7, 1991.

NOTES

132 "In answer to your question": From *The Simpsons* episode "Brush with Greatness," airdate April 11, 1991.

135 "It haunts me to this day": Jon Vitti post on X, August 21, 2014.

135 "I told them to put down Sam Etic": Dustin Hoffman quoted in "An Interview with Dustin Hoffman," by Stephanie Radvan, *Maxim*, February 7, 2012.

CHAPTER EIGHT: BART V. BUSH

Author interviews: Curt Smith, Jeff Martin, George Meyer, Jon Vitti, Bill Oakley, Brian Roberts.

137 "My dear girl": Sean Connery as James Bond in *Goldfinger*, 1964.

137 "We need a nation closer to *The Waltons*": George H. W. Bush quote from his speech at the National Religious Broadcasters convention, January 27, 1992.

138 "Front porches, greenery, and no traffic lights": Curt Smith quoted in "Curt Smith Continues His Love for Baseball on Radio and Television; He'll Never Forget the 60s and 70s," by David J. Halberstam, *Sports Broadcast Journal*, January 3, 2023.

139 Richard Nixon had made an awkward appearance: "'Laugh-In' at 50: How the Comedy Helped Elect Nixon and Set the Stage for 'SNL,'" by Marc Freeman, *Hollywood Reporter*, January 22, 2018.

139 "America's future rests in a thousand dreams": Ronald Reagan quote from his speech in Hammonton, New Jersey, September 19, 1984.

140 "You guys aren't watching *The Simpsons*, are you?"; "If our drug czar thinks he can sit down": Quotes by William Bennett and statement from *The Simpsons*, compiled by *The Morning Call*, May 26, 1990.

141 "It was the dumbest thing I had ever seen": Barbara Bush quoted in "In the Eye of the Storm," by Paula Chin, *People*, October 1, 1990.

Excerpts from letters by Barbara Bush and *The Simpsons* producers were released to the press in 1990; on April 18, 2018, physical copies of the letters were scanned and published in "Read the Apology Letter Barbara Bush Once Wrote to Marge Simpson," by Dan Snierson, *Entertainment Weekly*.

141 "So many people, in so many ways": George H. W. Bush quote from his speech at the Environmental Youth Awards, November 14, 1990.

George Bush quotes from his speech at the National Religious Broadcasters convention, January 27, 1992.

142 Andrew Rosenthal, who was covering the event: "In a Speech, President Returns to Religious Themes," by Andrew Rosenthal, *New York Times*, January 28, 1992.

144 A few days later, Pulitzer Prize winner Ellen Goodman: "Goodnight George-Boy," by Ellen Goodman, *Washington Post*, January 31, 1992.

NOTES

144 **"The trouble with America"**: Jay Leno quoted in "Leno Prepares to Host 'Tonight Show' When Johnny Leaves," by Hal Boedecker, *Miami Herald*, February 20, 1992.

144 **"Someone should remind our Republican president"**: "The Waltons Wouldn't Vote for Bush," by Edward J. Julian, *Daily Item*, March 4, 1992.

144 **"I do remember being really furious"**: Yeardley Smith quoted in an interview conducted by the author for "Life As Lisa Simpson," published in *The Ringer* on September 22, 2022.

145 **"yield to the loving authority"**: From *The Strong-Willed Child*, by James Dobson, 1978.

145 **who later accused the makers of SpongeBob SquarePants**: "Conservatives Pick Soft Target: A Cartoon Sponge," by David D. Kirkpatrick," *New York Times*, January 20, 2005.

146 **"If there were a simple, single solution"**: From *Dr. Dobson's Handbook of Family Advice*, by James Dobson, 2012.

146 **"They would go to the mat for each other"**: Yeardley Smith quoted in an interview conducted by the author for "Life As Lisa Simpson," published in *The Ringer* on September 22, 2022.

Material and quotes about alt.tv.simpsons adapted from the article "Best Message Board Ever," by the author, as first published in *Slate Magazine* (www.slate.com), on September 26, 2013.

147 **"Usenet is like a herd of performing elephants"**: Eugene Spafford quoted in *Aether Madness: An Offbeat Guide to an Online World*, by Gary Wolf and Michael Stein, 1995.

148 **"I lurk"; "But *The Simpsons* has been violated so often"**: Matt Groening quoted in "The Simpsons in Cyberspace," by Reid Kanaley, *Philadelphia Inquirer*, December 7, 1994.

Avery Cobern's notes are quoted verbatim from memos to *The Simpsons*' creative staff.

151 **"Your painting is bold but beautiful"**: From *The Simpsons* episode "Brush with Greatness," airdate April 11, 1991.

The excerpt from *The Simpsons* staff's response letter is quoted verbatim.

154 **"a drama done by stupid people"**: Quote by John Swartzwelder, as relayed by Jon Vitti.

155 **What started with a discredited book**: "A doctor helped his patient recall childhood torture by a cult. Their story sparked a global 'Satanic Panic,'" by Sheila Flynn, *The Independent*, March 14, 2023.

155 **In the '80s, there were reportedly**: "Proof Lacking for Ritual Abuse by Satanists," by Daniel Goleman, *New York Times*, October 31, 1994.

NOTES

156 a group known as Bothered About Dungeons and Dragons: "No Role in Dungeons & Dragons for Satan, Sellers of Game Say," by Chuck Bauerlein, *Daily Press*, April 10, 1988.

156 "soft on full-frontal nudity": From *The Simpsons* episode "Itchy & Scratchy & Marge," airdate December 20, 1990.

157 In 2023, a Florida school board: "An Interview with the School Board Chair Who Forced Out a Principal After Michelangelo's *David* Was Shown in Class," by Dan Kois, *Slate*, March 23, 2023.

157 "We are going to keep on trying": George Bush quote from his arrival rally speech at the Republican National Convention on August 16, 1992.

157 Vice President Dan Quayle had also started a feud: "THE 1992 CAMPAIGN: The Vice President; Quayle Tries to Separate Family Values and 'Murphy Brown,'" by Kevin Sack, *New York Times*, September 3, 1992.

160 "Hey, we're just like the Waltons"; And when Bush brought up *The Simpsons* again: Multiple news reports from February and August 1992 cite the use of this line.

CHAPTER NINE: BEYOND BART

Author interviews: Jeff Martin, Joe Boucher, George Meyer, Jay Kogen, Jon Vitti, Larina Adamson, Brian Roberts, Joe Mantegna, Gábor Csupó, Rich Moore.

Conan O'Brien's quotes are from an interview conducted by the author for "Throw Up Your Hands and Raise Your Voice! Monorail! Monorail! Monorail!," published in *The Ringer* on January 17, 2023.

163 "when two best friends work together": From *The Simpsons* episode "Mr. Plow," airdate November 19, 1992.

164 In the midst of disagreements with Brooks and Groening: "Meet Sam Simon, the Dog Nut," *60 Minutes*, March 2, 2007.

164 he called Groening: Matt Groening quoted in an August 29, 2018, interview with *The Weekly*. Said Groening, "I was sitting in the office late at night, the phone rings and I pick it up... 'Hi, this is Michael Jackson.'" Groening assumed it was a prank call because the singer had "a voice that sounds like somebody doing a Michael Jackson bit."

168 The week it debuted in February 1992: "The Making of 'Homer at the Bat,' the Episode That Conquered Prime Time 20 Years Ago Tonight," by Erik Malinowski, *Deadspin*, February 20, 2012.

168 The only question the Hall of Fame shortstop gets more: From an interview with Ozzie Smith conducted by the author for "Homer at the Hall," published in *The Ringer* on May 30, 2017.

NOTES

169 In his 2018 memoir: *Springfield Confidential*, by Mike Reiss with Mathew Klickstein, 2018.

Quotes from Nancy Cartwright, Jon Vitti, Yeardley Smith, Jay Kogen about "Lisa the Greek" from "When 'The Simpsons' Bet Big on the Super Bowl," by the author, published in *The Ringer* on February 9, 2022.

170 Before the fourth season, Fox announced a big change behind the scenes: "'The Simpsons' Producer Changes Animation Firms," by Sharon Bernstein, *Los Angeles Times*, January 21, 1992.

173 co-wrote *L.A. Shortcuts*: "L.A. Shortcuts: A Guidebook for Drivers Who Hate to Wait," by Richard Schwadel and Brian Roberts, January 1, 1989.

173 "As proposed, the $2.6 billion, 16.2-mile monorail": Excerpted from "A Citizens Group Lobbying for the Elevated Ventura Freeway Route Is Headed by a Builder with Ties to Supervisor Mike Antonovich," by Hugo Martin, *Los Angeles Times*, August 17, 1992.

173 a billboard featuring a rendering of a sleek train: From a photograph that appeared on page B5 of the *Los Angeles Times*, August 17, 1992.

175 "Were you sent here by the devil?": From *The Simpsons* episode "Marge vs. the Monorail," airdate January 14, 1993.

177 "Donuts...Is there anything they can't do?": From *The Simpsons* episode "Marge vs. the Monorail."

CHAPTER TEN: HOW NOT TO SCREW UP THE SIMPSONS

Author interviews: Jon Vitti, Greg Daniels, Rich Moore, Jeff Martin, Mike Scully, Jay Kogen, Bill Oakley, George Meyer.

180 convinced that his cut of the show's profits; and he also received yearly royalty checks: "Meet Sam Simon, the Dog Nut," *60 Minutes*, March 2, 2007.

182 "Getting old, I guess": John Swartzwelder quoted in "John Swartzwelder, Sage of 'The Simpsons,'" by Mike Sacks, *New Yorker*, May 2, 2021.

183 When Tracey Ullman sued the company: "Ullman Loses 'Simpsons' Suit," Associated Press, October 22, 1992.

183 in 1993, it [the network] sold: "The Groening of America," by Tom Shales, *Washington Post*, May 12, 1993.

183 under new president Sandy Grushow: "Fox Network to Add Seven New Fall Shows," Associated Press, May 26, 1994.

184 He was the one who came up with: "I wrote this in Season 5 based on my frequent childhood behavior of actually walking through people's hedges pretending I was dimension hopping (and doing great damage to the bushes in the process). Always knew it would become a famous meme." David Mirkin quoted on his X account, January 14, 2019.

NOTES

185 "I, for one, welcome our new insect overlords": From *The Simpsons* episode "Deep Space Homer," airdate February 24, 1994.

185 Groening has said that: Groening discussed this on *The Simpsons* Season 5 DVD commentary of this episode.

186 "There's no trick to it"; "Be like the boy": From *The Simpsons* episode "Bart's Inner Child," airdate November 11, 1993.

186 "I didn't do it": From *The Simpsons* episode "Bart Gets Famous," February 3, 1994.

Bill Oakley's quotes on these pages are from an interview conducted by the author for "The Simpsons Predicted Trump's Mob," published in *The Daily Beast* on November 29, 2015.

188 "You need me, Springfield": From *The Simpsons* episode "Sideshow Bob Roberts," airdate October 9, 1994.

189 "We Want What Is Worst for Everyone": From *The Simpsons* episode "Bart Gets an Elephant," airdate March 31, 1994.

190 He hoped someone would pass along bogus info; "It was the only time in Hollywood": David Mirkin quoted in an interview conducted by the author for "The Making of 'Who Shot Mr. Burns,'" *The A.V. Club*, June 9, 2015.

CHAPTER ELEVEN: WORST EPISODE EVER

Author interviews: Bill Oakley, Rich Moore, Greg Daniels, George Meyer, Jon Vitti, Peter Frampton, Mike Scully.

Yeardley Smith's quotes are from an interview conducted by the author for "Life as Lisa Simpson," published in *The Ringer* on September 22, 2022.

193 "They're giving you thousands of hours of entertainment for free": From *The Simpsons* episode "The Itchy & Scratchy & Poochie Show," airdate February 9, 1997.

197 "Get out of here, you kids!": From *The Simpsons* episode "Homerpalooza," airdate May 19, 1996.

198 "Well, Seymour, you are an odd fellow": From *The Simpsons* episode "22 Short Films About Springfield," airdate April 14, 1996.

198 "That's gonna be on my tombstone": Bill Oakley quoted from an interview conducted by the author for "Best. Episodes. Ever.," published in *The Ringer* on April 17, 2017.

199 "If you lived in any other country in the world": From *The Simpsons* episode "Homer's Enemy," airdate May 4, 1997.

199 "Grimey was asking for it the whole episode": John Swartzwelder quoted in "John Swartzwelder, Sage of 'The Simpsons,'" by Mike Sacks, *New Yorker*, May 2, 2021.

NOTES

200 "Someone very, very high up": Bill Oakley quoted from an interview conducted by the author for "Best. Episodes. Ever.," published in *The Ringer* on April 17, 2017.

201 "a dog with attitude": Quotes from "The Itchy & Scratchy & Poochie Show," airdate February 9, 1997.

203 "despite the vast technical changes": From "Internet History," a post on Dead Homer Society, March 1, 2012.

All fan reviews quoted can be found in the alt.tv.simpsons archive: https://groups.google.com/g/alt.tv.simpsons.

Material and quotes about alt.tv.simpsons adapted from the article "Best Message Board Ever" by the author, as first published in *Slate Magazine* (www.slate.com), on September 26, 2013.

204 "I have to go now. My planet needs me": Quotes from "The Itchy & Scratchy & Poochie Show," airdate February 9, 1997.

207 "we finally spotted a fin": *Jump the Shark: TV Edition*, by Jon Hein, 2003.

207 "so implausible that even the characters were disavowing it": "Mmm...300 Episodes," by Alan Sepinwall, *Star-Ledger*, February 16, 2003.

207 "That's *so* wrong": Harry Shearer quoted in "Shearer Delight," by Robert Wilonsky, *East Bay Express*, April 27, 2001.

207 "refuse to talk about it": Harry Shearer quoted in "Tapping Into the Many Roles of Harry Shearer," by Meredith Goldstein, *Boston Globe*, December 7, 2006.

207 "We make some missteps": Matt Groening quoted in "Q&A: Matt Groening Is Bart Simpson's Real Dad," by Jenny Eliscu, *Rolling Stone*, November 28, 2002.

208 "We have to reach people whose opinions actually matter!": From *The Simpsons* episode "Wild Barts Can't Be Broken," airdate January 17, 1999.

209 "You're not really picking on the weak anymore": Jon Vitti quote from an interview conducted by the author for "Get a Life!," published in *The Ringer* on January 31, 2018.

209 "In episode 2F09": from "The Itchy & Scratchy & Poochie Show," airdate February 9, 1997.

209 "the beetle-browed people on the internet": Ian Maxtone-Graham quoted in "On Air: Behind Every Homer Is a Very Tall Man," by Charlotte O'Sullivan, *The Independent*, June 21, 1998.

210 "Ian just proved why he's the least liked writer around here": All fan reviews quoted can be found in the alt.tv.simpsons archive: https://groups.google.com/g/alt.tv.simpsons.

211 "TV comedies don't go eight, nine, ten years": David X. Cohen quote from an interview conducted by the author for "Best Message Board Ever," as first published in *Slate Magazine* (www.slate.com), on September 26, 2013.

NOTES

CHAPTER TWELVE: THE SIMPSONS DIASPORA

Author interviews: Jeff Martin, David M. Stern, Jay Kogen, Jon Vitti, Bill Oakley, Greg Daniels, Joe Boucher, Lewis Morton.

216 **Stimpy finds a sign:** From the *Ren & Stimpy* episode "An Abe Divided," airdate December 18, 1993.

216 **"Fur ball for fur ball":** Matt Groening quoted in "Gag! It's Ren and Stimpy," by Martin Booe, *Washington Post*, August 10, 1992.

216 **"*Ren & Stimpy* played on MTV":** Mike Judge quoted in "New Kings of TV's Toon Town," by Daniel Cerone, *Los Angeles Times*, October 17, 1993.

217 **"Buffcoat and Beaver":** Ernest Hollings quote reported in "On Senate TV: 'Buffcoat and Beaver?,'" *Newsday*, October 21, 1993.

217 **"I actually wanted to stop a little sooner":** Mike Judge quoted in "Butt-Head, We Hardly Knew Ye," by Howard Rosenberg, *Los Angeles Times*, November 26, 1997.

220 **"Yup." "Yup." "Yep." "Mmm...hmm":** From the *King of the Hill* pilot, airdate January 12, 1997.

222 **The network didn't think the show:** "D'oh! Fox Turned Down 'South Park'?," by Ray Pride, *E! News*, July 14, 1998.

223 **"I loved *The Simpsons*":** Seth MacFarlane quoted in "An Interview with Seth MacFarlane," by Ken P., *IGN*, July 21, 2003.

Matt Groening's quotes are from "Matt Groening: The Creator of 'The Simpsons' on His New Sci-Fi TV Show, Why It's Nice to Be Rich, and How the ACLU Infringed on His Right," by Brian Doherty, *Mother Jones*, March/April 1999.

227 **"I mean, *The Simpsons* is a huge influence":** Lisa Hanawalt quoted in an interview by the author for "That's the Way Life Is," published in *The Ringer* on August 22, 2024.

228 **"They've been on the air for like, thirteen years":** From the *South Park* episode "Simpsons Already Did It," airdate June 26, 2002.

CHAPTER THIRTEEN: SIMPSONS WORLD

Author interviews: Rich Moore, George Meyer, Jay Kogen, Greg Daniels, Bill Oakley, Mike Scully, Jay Kogen, Brian Roberts, Jeff Martin, Jon Vitti.

Conan O'Brien's quotes are from an interview conducted by the author for "Throw Up Your Hands and Raise Your Voice! Monorail! Monorail! Monorail!," published in *The Ringer* on January 17, 2023.

231 **"As my exciting story opens":** Excerpt from *The Time Machine Did It*, by John Swartzwelder, 2002.

231 **"If you read one spy-without-pants book this year":** John Swartzwelder quoted on his X account, January 14, 2021.

NOTES

233 On October 2, 1994, Fox aired "Itchy & Scratchy Land": Material and quotes about "Bort" license plates adapted from the article "What Real-Life 'Bort' License Plates Tell Us About the Power of *The Simpsons*," by the author, as first published in *Slate Magazine* (www.slate.com), on October 7, 2014.

235 In March 2018, Merriam-Webster announced: "Word Created by The Simpsons Added to US Dictionary," BBC, March 6, 2018.

236 "A noble spirit embiggens the smallest man": From *The Simpsons* episode "Lisa the Iconoclast," airdate February 18, 1996.

236 In 2023, Merriam-Webster added "cromulent": Information, quotes, and backstory of "cromulent" appears in the Merriam-Webster entry/article "'Cromulent' Is a Perfectly...Well, Cromulent Word," from 2023.

236 "cromulent" has appeared: "Embiggen" appeared in the *New York Times* crossword puzzle on June 16, 2018; "cromulent" appeared on December 31, 2022.

237 "a catchall term": "The Homeric Odyssey of the Web's Strangest Simpsons Site," by Brian Raftery, *Wired*, May 22, 2017.

238 "a budget crunch from President Trump": From *The Simpsons* episode "Bart to the Future," airdate March 19, 2000.

240 Hall of Fame president Jeff Idelson: Information and quotes about *The Simpsons* at the Baseball Hall of Fame adapted from the author's article "Homer at the Hall," published in *The Ringer* on May 30, 2017.

240 Mattingly later said: Reported on X by Tim Healey of *Newsday* on May 7, 2017.

244 "Nobody rocks like Springfield": From *The Simpsons* episode "The Otto Show," airdate April 23, 1992.

245 "it will be great to see the old gang again": From *The Simpsons* episode "The Front," airdate April 15, 1993.

246 "I thought some people would like some aspects of it": Sam Simon quoted in "Sam Simon's Next Trick," by Ron Rapoport, *Stanford Magazine*, September/October 2009.

INDEX

ABC, 7, 17, 28, 29–30, 32, 44, 82, 104, 181, 223
Academy Awards, 20, 28, 133
Adamson, Larina, 31, 67, 69, 73, 81–85, 118–19, 120, 128–29, 164–65
Adult Swim, 227
AKOM Production Co., 83–85
ALF, 38, 44, 74
Algonquin Round Table, 57
Allen, Irwin, 173–74
All in the Family, 11, 138, 211
alt.tv.simpsons, 147–49
America's Funniest Home Videos, 44, 140–41
America's Most Wanted, 29, 190
Ancier, Garth, 19, 20, 27, 29, 30, 65–66
Andy Griffith Show, The, 138, 218–18
Animal House, 213
anti-intellectual intellectualism, 14–15
Appel, Richard, 220
Apple Pan, The, 72
Apu, 26, 78, 185–86
Aragonés, Sergio, 12

Arbus, Diane, 120
Archer, 227
Archer, Wes, 26–27, 220, 233
Army Man (zine), 39–41
Arsenio Hall Show, The, 158–59
Aspen Comedy Festival, 218
Azaria, Hank, 26, 78
Aztec Theater, 244

Barney Gumble, 76
Barney Miller, 36
Bart Simpson, 2, 23, 53–56, 142, 145, 151. *See also specific episodes*
 merchandise, 93–95, 100–105, 145–46
 one-liners, 75–76, 91, 136
 vs. Bill, 107–15
 vs. Bush, 137–46, 157–60
 vs. commerce, 91–95
"Bart Gets an Elephant," 189
"Bart Gets an 'F'," 113–14
"Bart Gets Famous," 186–87
"Bart Gets Hit by a Car," 130

INDEX

"Bart's Dog Gets an 'F'," 134
"Bart's Inner Child," 186
"Bart the Daredevil," 117–18
"Bart the Genius," 48, 86, 91
"Bart the Murderer," 167–68
"Bart to the Future," 238–39
Baseball Hall of Fame, 240–41
Batman (movie), 9, 87, 121
Batman (TV series), 9–11, 126
Baum, Robert, 103
Bay, Don, 152
Beatles, the, 132, 143–44, 190, 241
Beavis and Butt-Head, 217, 219, 227
Belson, Jerry, 20
Bennett, Tony, 63, 131, 132
Bennett, William, 140
Beverly Hillbillies, The, 138
Beverly Hills, 90210, 66, 109
Big Mouth, 227
Bird, Brad, 214
Black Bart, 100–102
"Blackboard Jungle," 47
Black Lives Matter (BLM), 101
Bleeding Gums Murphy, 43, 50
"Blood Feud," 60
Bobbitt, John, 189
Bob Roberts, 187–88
Bob's Burgers, 227, 242
Bochco, Steven, 214
Boehm, Helen, 95, 104
Boggs, Wade, 1, 168, 240
BoJack Horseman, 227
Borowitz, Andy, 39
"Bort," 233–35

Bothered About Dungeons and Dragons (B.A.D.D.), 156
Boucher, Joe, 57, 69, 74–75, 77, 84, 108, 129, 161–62, 219–20
boycotts, 30, 155
Boylan, John, 121–24
Brady Bunch, The, 11, 37, 89, 189
brain rot, 8
Brando, Marlon, 167
Brandt, Eddie, 120–21
Breaking Bad, 211
Broadcast News, 28, 67, 79
Brooks, Albert, 67, 186
Brooks, James L., 99, 125, 141, 225, 246
 author's formative years and, 3, 4
 background and creation of *The Simpsons*, 19–21, 22–26, 28, 31–33
 background of, 20
 censors, 152, 153
 Groening and Simon's relationship, 127–29, 164
 humanism of *The Simpsons*, 35, 48–52, 68, 146, 199, 221
 "Itchy & Scratchy & Marge," 154
 Jackson and, 123
 "Lisa's Substitute," 133–35
 The Mary Tyler Moore Show, 9, 11, 20, 48, 79, 138
 Mirkin's hiring, 183
 move to Thursdays, 109–10, 111
 network involvement and, 65–67, 152, 153
 no-notes rule, 66–67
 O'Brien and, 174–75
 series premiere, 84–86, 88–89

INDEX

Terms of Endearment, 20, 22, 122
women and gender disparities, 79, 80, 83
Brown, Mordecai "Three Finger," 168
"Brush with Greatness," 132–33, 151–53
Buchanan, Pat, 158
Burger King, 104, 105, 141
Burton, Tim, 9, 87, 214
Bush, Barbara, 140–42, 199
Bush, George H. W., 115, 137–46, 157–60, 189, 199
Butterfinger, 87–88
Butterworth, Kent, 84, 85

Cabbage Patch Kids, 106
Cable Franchise Policy and Communications Act, 17
Cairo, Egypt, 247
Canseco, José, 168
Cape Fear, 179
"Cape Feare," 179–80
"Capital City," 63
Capitol Critters, 214
Carlock, Robert, 246
Carson, Johnny, 18, 38, 108, 144
Carter, Jimmy, 139
Cartwright, Nancy, 26, 124, 126, 169
Carvey, Dana, 140
Cashman, Terry, 241
Cassady, Neal, 195
Castellaneta, Dan, 26, 27, 75, 161, 162, 170
CBS, 7, 17, 28, 44, 104, 138

censors (censorship), 29–30, 150–56, 167
Century City, 69–70
Chase, Chevy, 139
Chase, David, 9
Chast, Roz, 39
Cheers, 19, 20, 36, 41, 44, 67, 104, 109, 211
Chernin, Peter, 110, 111
cigarettes, 71–72
Citizen Kane, 49
"Clair Huxtable Effect," 78
Clemens, Roger, 168
Clinton, Bill, 130, 138–39, 158–59, 188–89
Clinton, Hillary, 188
CNN, 189
"coat hanger network," 2
Cobern, Avery, 150–53
Cohen, David X., 148, 149, 201–5, 211, 224, 236
Cold War, 1, 12–13
Coleman, Gary, 76
color scheme, 3, 24–26, 210
Comedy Central, 222, 226
Connery, Sean, 143–44
"Cool Your Jets, Man," 94
Coppola, Francis Ford, 166
Cops, 29
copyright issues, 101, 149, 245
Cosby, Bill, 107–15
Cosby Show, The, 18, 44, 78, 107–15, 136
Cox, Courteney, 126
Crane, David, 127
Critic, The, 181, 206, 215

INDEX

Crittenden, Jennifer, 79
"cromulent," 236
Crosby, David, 57
Crowe, Cameron, 82
Cruise, Tom, 131
Crumb, Robert, 22
Csupó, Gábor, 24–26, 83–86, 170–71
culture wars, 3–4, 143–44, 159
Curb Your Enthusiasm, 126
Current Affair, A, 189

Dallas, 190
Daniels, Greg, 37, 48–49, 182–83, 194, 243
 "Homer Badman," 187
 jokes and microjokes, 55–56, 117–18
 King of the Hill, 217–22, 227
 "Kiss Kiss, Bang Bangalore," 185–86
 Meyer and, 229–30
 O'Brien and, 130, 183
 Simon and, 180–81, 182
 "22 Short Films About Springfield," 198
David (Michelangelo), 156–57
David, Larry, 218
Day of the Locust, The (West), 23
Dead Detective Mountain (Swartzwelder), 231–32
"Dead Putting Society," 46
"Deep Space Homer," 184–85
Def Jam Recordings, 100–101
De Niro, Robert, 179
Dennis the Menace, 9
Depp, Johnny, 19
DeWolf, Tom, 102

Dick Van Dyke Show, The, 7–8, 11, 20
Die Hard, 28, 69
Diff'rent Strokes, 75–76, 91
Diller, Barry, 18, 19, 20, 28, 32, 88, 105, 109–10, 152
Diner, 119
Diners, Drive-Ins and Dives, 97
Dirty Dozen, The, 28
Disney, 223, 238, 242–43
Disney+, 242–43
Disney Animation Renaissance, 14
Disney parks, 93, 102, 123, 233, 245
Dobson, James, 142, 145–46
"D'oh!", 75
"Do the Bartman," 123, 124, 215
Down and Out in Beverly Hills, 19
Drucker, Mort, 12
Duzan, Gary, 147
Dylan, Bob, 197

Easter eggs, 149
Easy Rider, 12
"Eat my shorts," 76, 91, 93, 136
Elfman, Danny, 70
"embiggen," 235–36
Entertainment Tonight, 114–15, 190
Entertainment Weekly (EW), 111–12
Environmental Youth Awards, 141
Epic Records, 123, 124
Estin, Ken, 20, 22

Fairness Doctrine, 156
Family Dog, 214
Family Guy, 223–24, 227
Family Matters, 13

INDEX

Family Ties, 13, 19
Fat Albert and the Cosby Kids, 36
Fatherhood (Cosby), 113
Fat Tony, 151, 166–68, 167–68, 200
Federal Communications Commission, 156
Ferrara Candy Company, 87–88
Fey, Tina, 246
Fieri, Guy, 97
Fierstein, Harvey, 131
Film Roman, LLC, 171
Fish Police, 214–15, 224
"Flanders' Ladder," 47–48
Flintstones, The, 14, 24, 70, 177
Florida Classic Impressions, 102
Floyd, George, 101
Ford, Gerald, 139
48 Hrs., 69
Fox Broadcasting Company, 1, 3–4, 17–21, 24, 27–30, 222, 242
 series premiere, 86–90
Fox News, 189
Frampton, Peter, 196–97
Frank Grimes, 199–200
Freshman, The, 167
Friedan, Betty, 79
Friedkin, William, 118
Friends, 126–27, 211
Full House, 13
Futurama, 224–26, 242
FXX, 242

Gallin, Sandy, 164–65
Gallipoli, 55
Gammill, Tom, 37–38, 39

Garfield, 171
Geffen, David, 122, 124
gender disparities, 79–83
Gere, Richard, 206
Get a Life, 183–84
Get Smart, 11
Gilbert and Sullivan, 180
Gilded Truffle, 99
Gilligan's Island, 11
Godfather, The, 131, 166–67
Goldfinger, 143–44
Goodman, Ellen, 144
"Good Night," 27
Good Times, 138
Gore, Tipper, 155
Gracie Films, 22, 24, 46, 69–70, 82, 169, 170–71, 181
Graduate, The, 134–35
Graham, Billy, 142
Grammer, Kelsey, 67, 82–83
Grau, Doris, 81
Greaney, Dan, 235–36
Green Acres, 138
Griffey, Ken, Jr., 168, 240
Groening, Matt, 246
 alt.tv.simpsons, 148–49
 author's formative years, 3, 4
 background of, 21–22
 on Bart, 92, 101–2
 censors, 152, 153
 creation of *The Simpsons*, 21–27, 32
 "Deep Space Homer," 185
 Futurama, 224–26
 "Itchy & Scratchy Land," 233
 Jackson and, 123, 164

277

Groening, Matt (*cont.*)
 King of the Hill, 219–20
 Mad magazine parody, 125
 merchandising, 97–98, 101–2
 "Moaning Lisa," 50
 office of, 70
 Ren & Stimpy, 216
 Simon's relationship with, 35–36, 127–29, 164
 The Simpsons Sing the Blues, 122, 123
 "The Principal and the Pauper," 207
Growing Pains, 18
Grushow, Sandy
 advertising, 86–87
 Fox losses, 27–28
 licensing deals, 105
 no-notes policy, 66
 series premiere, 86–87, 89
 success vs. failure, 107, 109, 110, 129
 Sunday night time slot, 183
Gulf War, 158

Hanna-Barbera, 24, 214
Happy Days, 202, 245
Hard Copy, 189
Harding, Tonya, 189
Harrison, George, 133, 190
Hartman, Phil, 130–31, 176
Harvard Lampoon, 36–37, 77, 221, 224
Harvard University, 36–37, 77, 224
Heavy Metal Parking Lot (documentary), 40
Hein, Jon, 207

Heston, Charlton, 130, 163
Hocking, Stuart, 235
Hoffman, Dustin, 133–36
Hollings, Ernest "Fritz," 217
Home Improvement, 223
Homer Simpson, 1, 2, 17, 23, 53–54, 60, 145. *See also specific episodes*
 de-evolution of, 163–63
 "D'oh!", 75
"Homer at the Bat," 168, 240–41
"Homer Badman," 187
"Homerpalooza," 196–97
"Homer's Enemy," 200
"Homer's Envy," 199–200
"Homer's Night Out," 2, 76–77, 153–54
"Homer's Odyssey," 68–69
"Homer the Heretic," 60
"Homer vs. the Eighteenth Amendment," 59
Honeymooners, The, 11, 131
House of the Dragon, 115
Hubble Space Telescope, 1
Humphrey, Hubert, 139
Huston, John, 120

Idelson, Jeff, 240
In Living Color, 109
Inside Edition, 189
internet, 146–50, 194–95, 208–9, 237–38
Itchy & Scratchy, 53, 151, 154–55, 156–57, 201–5, 209
"Itchy & Scratchy & Marge," 154–55, 156–57

INDEX

"Itchy & Scratchy & Poochie Show," 201–5, 209
"Itchy & Scratchy Land," 233–34
It's Garry Shandling's Show, 35, 37, 38, 41, 80, 153

Jackson, Michael, 123–24, 164–66
Jacobs, W. W., 99
James, Bill, 54
James Bond, 137, 143–44
Jazz Singer, The, 169
Jean, Al, 38, 41, 62–63, 80, 232
 Baseball Hall of Fame, 240–41
 The Critic, 181, 206, 215
 departure of, 181, 183
 "Homer the Heretic," 60
 It's Garry Shandling's Show, 38, 41, 60, 80
 "Moaning Lisa," 50
 O'Brien and, 171–72, 174, 175
 showrunning, 164, 168–69, 193
Jebediah Springfield, 92, 236
Jeffersons, The, 138
Jeopardy!, 241
Jerry Maguire, 82
Jetsons, The, 24, 43, 70
Jimbo, 23
John, Elton, 176
Jones, James Earl, 131
Judge, Mike, 216–17, 218–22
Julius Hibbert, 112–13
Just the Funny Parts (Scovell), 80

Kauffman, Marta, 127
Kavner, Julie, 26
Keeler, Ken, 205, 206, 224
Kellner, Jamie, 19, 31, 86, 104, 110
Kent Brockman, 26, 185
Kerouac, Jack, 195
Kerrigan, Nancy, 189
King, B.B., 124
King, Larry, 131
King of the Hill, 37, 218–22, 222–23, 227
"King-Size Homer," 163
Kingsley, Pat, 122
"Kiss Kiss, Bang Bangalore," 185–86
Klasky, Arlene, 24
Klasky-Csupó, 24, 26–27, 83, 170–71
Kogen, Arnie, 12, 42, 62
Kogen, Jay, 17, 23, 33, 42, 51, 62, 64, 66, 67–68, 77, 80, 111, 115–16, 125, 162, 214, 230, 239
 departure of, 181, 182
 Fish Police, 215
 "Homer's Odyssey," 68–69
 Julius Hibbert character, 112–13
 licensing, 97–100
 "Like Father, Like Clown," 169–69
 Mad and formative years, 11–12
 Simon and, 45
 South Park, 222
 Swartzwelder and, 57, 72
 The Tracey Ullman Show, 20–21, 31, 41, 67
 Treehouse of Horror, 116
Kondabolu, Hari, 78
Kopp, Bill, 26–27
Krusty the Clown, 42, 62, 92, 97, 168, 169, 188, 201

INDEX

Larry Sanders Show, The, 153–54, 183
L.A. Shortcuts (Roberts), 172–73
Late Night with David Letterman, 38, 39, 43, 63, 178
Late Show Starring Joan Rivers, The, 18
L.A. Weekly, 21–22
Leave It to Beaver, 9
Lennon, Kipp, 165–66
Lenny and Carl, 76–77
Leno, Jay, 144
Leon Kompowsky, 164–66
Letterman, David, 38, 178
Levinson, Barry, 119
licensing, 87–88, 93–106
Licensing International Expo (1990), 95–96
Licorice Pizza, 21
Life in Hell (comic), 21–22, 25, 27
"Like Father, Like Clown," 169–69
Limbaugh, Rush, 156
Lionel Hutz, 130–31
Liquid Television, 216–17
Lisa Simpson, 23, 60, 145. *See also specific episodes*
"Lisa's First Word," 50–51
"Lisa's Substitute," 133–36, 220
"Lisa the Greek," 169–70
"Lisa the Iconoclast," 235–36
listicles, 237–38
Lookwell, 10
Looney Tunes, 11, 68
Loren, Bryan, 123, 124
Los Angeles Reader, 21
Los Angeles riots, 158

Los Angeles Times, 27, 31, 89, 96, 111, 128, 173, 217
Lovitz, Jon, 131, 215
Lowe, Link, 234–35
Lyle Lanley, 174–78

MacFarlane, Seth, 223
McCartney, Paul, 133, 190
McMahon, Ed, 130
Macy's, 94, 106
Macy's Thanksgiving Day Parade, 88, 106
Mad (magazine), 11–12, 125–26
Madonna, 124
Major League Baseball All-Stars, 168, 240–41
Mandel, David, 126
Mandela, Nelson, 101
"Man in the Mirror" (song), 165
Mantegna, Joe, 166–68
Marge Simpson, 2, 23, 131, 141, 145. *See also specific episodes*
 blue hair, 25
"Marge vs. the Monorail," 177–78
Markoe, Merrill, 39
Maron, Marc, 32, 38
Married...with Children, 18–19, 30, 79, 89, 115, 155
Marshall, Penny, 67, 84
Martin, Don, 12
Martin, Jeff, 5, 162, 213, 232, 244–45
 on Bart, 92, 93, 161, 163
 Bush and politics, 143–44, 158
 departure of, 181, 244
 Family Guy, 223–24

INDEX

"Flanders' Ladder," 47–48
Groening and, 95
"Homer at the Bat," 241
"Lisa's First Word," 50–51
Meyer and, 51, 54
no-notes rule, 66–67
O'Brien and, 175–76
Simon and, 35, 38, 46
songwriting of, 63, 124, 175–76
workday, 72, 74
Mary Tyler Moore Show, The, 9, 11, 20, 48, 79, 138
*M*A*S*H*, 138
Mason, Jackie, 169
Mattel, 103–4, 105
Matthau, Walter, 27, 162
Mattingly, Don, 168, 240
Maude, 138
Max Headroom, 82
Maxtone-Graham, Ian, 209–10
Meadows, Audrey, 131
meals, 72–74
Melrose Place, 66
Mendel, Mike, 69
Menendez, Lyle and Erik, 189
merchandise (merchandising), 95–106, 145–46
 counterfeit, 100–104
 oversaturation of, 103–6
Meyer, George, 53–57, 59–63, 67, 69, 98, 126, 164, 182, 185, 195, 201, 247
 background of, 38–39
 Bush and politics, 145, 159
 cigarette smoking, 71

creation of *The Simpsons*, 27, 36, 38–44, 47
departure of, 229–31
formative years, 7–11, 13–14, 15, 22
on Homer, 162
"Homer the Heretic," 60
"Lisa's First Word," 51
"Lisa's Substitute," 136
Treehouse of Horror, 116–17
writers and gender disparity, 80, 82
Michaels, Lorne, 37–38, 39, 130
Michelangelo, 156–57
microjokes, 55–56
midcentury TV shows, 7–11
Mirkin, David, 183–86, 189, 190–91, 193, 195, 217, 233
Mission Hill, 226–27
Mr. Burns, 26, 40, 43, 60, 62, 68, 97, 124, 151, 152–53, 190
"Mr. Plow," 118, 163, 172
Mr. President, 28
Mr. Smithers, 26, 40
"Moaning Lisa," 50
"Monkey's Paw, The" (Jacobs), 99
monorail, 173, 174–75, 177–78, 220, 245
"Monorail Song, The," 175
Moore, Rich, 14, 23, 108, 118, 119–21, 129, 171, 193, 229, 243, 245
 Brooks and, 49–50, 85
 "Cape Feare," 180
 O'Brien and, 177
Morton, Lewis, 224–26
Mother Jones, 224
Mrs. Krabappel, 56, 113, 236
MTV, 12–13, 216–17

INDEX

Murdoch, Rupert, 18, 19, 109
Murphy Brown, 44, 78–79, 158
Music Man, The, 173–74, 176
My Three Sons, 9

Nagurny, Pete, 102
National Baseball Hall of Fame, 240–41
National Lampoon (magazine), 12
NBC, 7, 17, 28, 44, 104, 108, 109, 111, 112, 114, 178, 218
Ned Flanders, 26, 46, 47–48, 60, 197, 209, 237
Nelson Muntz, 92
New Adventures of Beans Baxter, The, 19
Newhart, 44, 183
New Kids on the Block, 106
New Show, The, 37
New Yorker, 7, 39, 59, 182, 199
"New York, New York" (song), 63
New York Times, 29, 30, 88, 125, 139, 142, 236
Nickelodeon, 171, 216–17
Nimoy, Leonard, 176
Nixon, Richard, 7, 139
no-notes rule, 66–67
NYPD Blue, 214

Oakley, Bill, 37, 126–27, 200, 202, 204–8, 215, 241
 "Homer's Enemy," 200
 internet and alt.tv.simpsons, 146–50
 "Itchy & Scratchy Land," 233
 Meyer and, 55
 Mission Hill, 226–27
 politics, 188–89
 "The Principal and the Pauper," 205–8
 Reiss and Jean and, 62–63, 71–72
 shitposting, 236–37
 Simpsons Motel, 71–74, 184
 Simpsons World, 242, 243
 Swartzwelder and, 57, 59
Obama, Barack, 237
O'Brien, Conan, 64, 65, 75, 171–78
 background of, 10, 171–72
 Daniels and, 183
 Hartman and, 130
 on Homer, 161, 163
 Lookwell, 10
 "Marge vs. the Monorail," 173–78, 245
 prank, 73–74
Odenkirk, Bob, 39, 130
Office, The, 37
O'Neill, Ed, 18
Operation Dizzy Fox, 103
Orr, John, 234
Oswalt, Patton, 119
Ovadia, Al, 87–88, 94–98, 103, 105, 106

Panter, Gary, 21, 23
Parents Music Resource Center, 155
Paris, Daria, 81
Parker, Trey, 222–23, 227–28
Parks & Recreation, 37
Party, The, 78
Peanuts, 23, 57

INDEX

Peluce, Gyorgyi, 25
Peña, Steve, 96, 101, 102, 105
Perlman, Heide, 20
Perot, Ross, 158
Perry, Matthew, 126–27
Philadelphia Inquirer, 148
Pietila, Bonnie, 168, 196
Platt, Polly, 22, 52, 69
Poe, Edgar Allan, 117, 131
Pond, Mimi, 79–80
Poseidon Adventure, The, 173–74
Postal Service, U.S., 239–40
Preston, Robert, 173
"Principal and the Pauper, The," 206–8
Principal Skinner, 56, 197–98, 205–8
Pross, Max, 37–38, 39
Psycho, 154
Public Enemy, 100
Pulp Fiction, 197

Quayle, Dan, 157–58

Raftery, Brian, 237
Rakolta, Terry, 30, 155
Rambo, 92
Reagan, Ronald, 12, 17, 115, 130, 139–40, 155
Reardon, Jim, 171
Reiss, Mike, 38, 41, 62–63, 80, 185, 232
 on Apu, 78
 "Bart to the Future," 238–39
 Baseball Hall of Fame, 240–41
 cigarette smoking, 71–72
 college, 240–41
 The Critic, 181, 206, 215
 departure of, 181, 183
 "Homer the Heretic," 60
 It's Garry Shandling's Show, 38, 41, 60, 80
 "Moaning Lisa," 50
 O'Brien and, 171–72, 174
 showrunning, 164, 168–69, 193
 religion, 60, 142, 145–46
Ren & Stimpy Show, The, 216–17
Return of Martin Guerre, The, 206
rewrites, 37, 51, 70–71, 81, 116, 181
Rhoda, 79
Rick and Morty, 227
Robbins, Tim, 187–88
Roberts, Brian, 62, 86, 159, 239
 Brooks and, 65, 84
 "Brush with Greatness," 132–33, 152–53
 The Cosby Show and move to Thursdays, 110, 111, 113, 114
 L.A. Shortcuts, 172–73
 merchandising, 98
 offices, 69–71
 Simon and, 43, 47, 81, 84, 111, 113, 127–28
 "Some Enchanted Evening," 84, 85
 "Stark Raving Dad," 164–65
 Swartzwelder and, 57
RoboCop, 92
Rocco, Alex, 131, 201
Roger Meyers, 131, 155, 201–2, 204
Ronstadt, Linda, 121

INDEX

Roseanne, 44, 115
Rosenberg, Howard, 89, 96, 128
Rosenthal, Andrew, 142
Rugrats, 171

Sacks, Mike, 199
Sakai, Richard, 22, 69, 82, 184
Satanic Panic, 155–56
Saturday Night Live (SNL), 11, 37–38, 43, 130, 131, 139, 140
Sax, Steve, 168, 240
Scioscia, Mike, 168
Scooby-Doo, 14, 24
Scorsese, Martin, 179
Scott, George C., 28
Scovell, Nell, 80–81
Scully, Mike, 49, 57, 59, 181, 184, 189, 201, 209, 238–39
Seinfeld, 44, 109, 117, 126, 211, 218, 223
Sellers, Peter, 78
Semple, Lorenzo, 9, 10
Semple, Maria, 9
Sepinwall, Alan, 207
Shales, Tom, 113–14, 115
Shandling, Garry, 35, 37, 38, 41, 80, 153
Shearer, Harry, 26, 124, 173, 207
Shirt Shed Inc., 94
shitposting, 236–37
Sideshow Bob, 82, 179–80, 187–88
"Sideshow Bob Roberts," 187–88
Siegel, Debbie, 1–2, 95
Siegel, Stuart, 1–2
Siegfried & Roy, 238
Silverman, David, 26–27, 31–32, 86, 184–85
Simon, Carly, 122
Simon, Sam, 35–38, 74–75, 80, 99, 179–81, 182, 246
 author's formative years, 3, 4
 background of, 20, 32, 36
 "Cape Feare," 179–80
 censors, 152, 153
 The Cosby Show and move to Thursdays, 111–14
 creation of *The Simpsons*, 32–33, 36–38, 44–48
 death of, 246
 departure of, 164, 180–81
 doodles of, 43
 Groening's relationship with, 35–36, 127–29, 164
 Mad magazine, 125
 Mirkin and, 184
 "Mr. Plow," 118
 office of, 70
 The Simpsons Sing the Blues, 122
 staffing *The Simpsons*, 36–38, 41, 42
 taglines, 76
"Simpson and Delilah," 51
Simpson, O. J., 189
Simpsons Motel, 70–71, 74, 182, 184, 246
Simpsons Movie, The, 241–42
"Simpsons Roasting on an Open Fire," 85–86
Simpsons Sing the Blues, The, 122–25, 164
Simpsons World, 242–43

INDEX

Simpsons Writer Pessimist Club, 179, 181–82
Sinatra, Frank, 130
Smigel, Robert, 10, 130
Smith, Curt, 137–40, 143
Smith, Ozzie, 168, 240
Smith, Yeardley, 3, 26, 50, 122, 126, 127, 133–34, 144–45, 146, 170, 210
snow globe, 13
"Some Enchanted Evening," 84–85
Sopranos, The, 9, 211, 242
Sorcerer, 118, 119–20
South Park, 62, 222–24, 227–28
Spade, David, 227
Spafford, Gene, 147
Spielberg, Steven, 214
Spirit of Christmas: Jesus vs. Santa, The, 222
SpongeBob SquarePants, 145–46
Springfield Confidential (Reiss), 78, 169
Springfield Elementary, 56, 162
Springfieldians for Nonviolence, Understanding and Helping (S.N.U.H.), 155
Springfield Nuclear Power Plant, 51, 68–69, 168, 241
Springsteen, Bruce, 139–40
Stanford University, 36
"Stark Raving Dad," 165–66
Starr, Ringo, 132
Stars Building, 70
Star Trek, 131, 147, 176
Star Wars, 87, 96, 118, 119
Steamed Hams Society, 198

Stephens, Jay, 103
Stephney, Bill, 100–101
Stern, David M., 42, 45, 49, 54–55, 108, 109, 113–14, 125, 134, 213–14, 232
Stewart, Rod, 122
Stone, Matt, 222–23, 227–28
Strawberry, Darryl, 168
Streep, Meryl, 170
Sturges, Preston, 57
Super Mario Bros. 3, 1
Survival Research Laboratories, 22
Swartzwelder, John, 8, 38–40, 57–59, 61–62, 90, 247
 Army Man (zine), 39–41
 cigarette smoking, 72, 232
 departure of, 231–32
 "Homer at the Bat," 168
 "Homer's Envy," 199–200
 "Homer vs. the Eighteenth Amendment," 59
 "Itchy & Scratchy & Marge," 154, 157

Takei, George, 131, 176
Tarantino, Quentin, 197
Taxi, 20, 36
Teenage Mutant Ninja Turtles, 1, 87, 92
Temple, Shirley, 70
Terms of Endearment, 20, 22, 122
Tesh, John, 114
"There's No Disgrace Like Home," 43
30 Rock, 246
Three's Company, 183

INDEX

Time Machine Did It, The (Swartzwelder), 231
Tinker, Grant, 42
Tonight Show Starring Johnny Carson, The, 18, 38, 108, 144
Towering Inferno, The, 173–74
Townes, Jeffrey "DJ Jazzy Jeff," 124
Tracey Ullman Show, The, 20–21, 26–27, 31, 36, 40, 41, 67, 69, 80, 82, 87, 88
Transformers, 92
Treasure of the Sierra Madre, The, 120
Treehouse of Horror, 91, 116–17, 131, 151, 208, 246–47
Troy McClure, 130–31, 244
Trump, Donald, 187–88, 238–39
Turell, Brad, 88, 109, 110
20th Century Fox, 18, 19–20, 28, 69, 99, 109, 238, 242
21 Jump Street, 19
"22 Short Films About Springfield," 197–99
Twilight Zone, 117
2001: A Space Odyssey, 184–85

Ullman, Tracey, 20–21, 26–27, 31, 36, 40, 41, 67, 69, 80, 82, 87, 88, 183
"Underachiever" shirt, 94–95, 146
Universal Studios Hollywood, 235, 244–45
University of California, Los Angeles (UCLA), 77, 86, 149
University of California, Santa Cruz, 77

Variety (magazine), 27–28
Vietnam War, 12, 121, 138, 205–6
Vitti, Jon, 37, 39, 64, 85, 131, 169, 185, 196, 202, 210, 215, 232
 on Bart, 92, 93, 98, 100, 102, 116, 145, 146, 208–9
 "Bart the Genius," 86
 Brooks and, 48, 49, 51–52, 86, 133–34
 Bush and politics, 189
 "Cape Feare," 179–80
 censors, 29–30
 formative years, 2, 8, 9
 Groening and, 23–24, 35–36, 92
 "Homer's Night Out," 76–77, 153–54
 King of the Hill, 220, 221
 "King-Size Homer," 163
 "Lisa's Substitute," 133–36, 220
 Meyer and, 41
 Mirkin and, 190–91
 "Mr. Plow," 118
 O'Brien and, 73, 75, 172
 Reiss and Jean, 62, 63
 Saturday Night Live, 38, 130
 Simon and, 35–36, 43–46, 48, 118, 129, 179–80
 Simpsons Motel, 70, 71, 74, 246–47
 Simpsons Writer Pessimist Club, 179, 181–82
 Swartzwelder and, 8, 38, 39, 57, 58–59, 61, 154, 157, 246–47
 writers and gender disparity, 80–81

Walmart, 94
Walsh, Joe, 124

INDEX

Walt Disney Company, 238, 242–43
Waltons, The, 138–39, 142–45, 159
Warner Bros., 120, 121
Washington Post, 103, 126, 139, 216
Watergate, 12, 138
WB, The, 226–27
Weinstein, Josh, 55, 146–47, 150, 188, 193–201, 205, 206, 226, 236
Weir, Peter, 55
West, Adam, 9–10
West, Nathaniel, 23
Wheel of Fortune, 241
White House Correspondents' Dinner, 139
Who Framed Roger Rabbit?, 14
"Who Shot Mr. Burns?", 190
Wiley, Kehinde, 237
Williams, Jack, 241

Williams, Robert, 22
Williams, Scott, 241
Wolodarsky, Wallace, 41, 62, 64, 80
 departure of, 181
 "Homer's Odyssey," 68–69
 Julius Hibbert character, 112–13
 "King-Size Homer," 163
 "Like Father, Like Clown," 169
 The Tracey Ullman Show, 20, 31, 41, 67
Treehouse of Horror, 116
Woodstock, 1
World War II, 28, 138
Wreck-It Ralph, 243

"Ya Got Trouble" (song), 173
Yankovic, Alfred "Weird Al," 121

Zootopia, 243

ABOUT THE AUTHOR

Los Angeles–based *Ringer* senior staff writer **Alan Siegel** specializes in pop culture retrospectives about the making of iconic movies, television shows, and albums. Over the last ten years, there's no subject that he's written about more than *The Simpsons*. He's interviewed dozens of the show's writers, producers, actors, guest stars, and fans for features that are some of his most popular articles.